YOU
MUST
CHANGE
YOUR
LIFE

W. W. NORTON & COMPANY

Independent Publishers Since 1923

NEW YORK LONDON

YOU
MUST
CHANGE
YOUR
LIFE

The Story of

RAINER

MARIA

RILKE

and

AUGUSTE

RODIN

RACHEL
CORBETT

Excerpts from letters by Paula Modersohn-Becker first published in German as *Paula Modersohn-Becker in Briefen und Tagebüchern* © 1979 S. Fischer Verlag GmbH, Frankfurt. English translation © 1983 by Taplinger Publishing Company, Inc. Northwestern University Press edition published 1990 by arrangement with S. Fischer Verlag. All rights reserved.

"Put out my eyes, and I can see you still" and "I read it in your word" by Rainer Maria Rilke, translated by Babette Deutsch, from *Poems from the Book of Hours*, copyright © 1941 by New Directions Publishing Corp. Reprinted by permission of New Directions Publishing Corp.

"Archaic Torso of Apollo," "The Panther," and "Self-Portrait from the Year 1906" from *Translations from the Poetry of Rainer Maria Rilke*, by Rainer Maria Rilke, translated by M. D. Herter Norton. Copyright 1938 by W. W. Norton & Company, Inc., renewed © 1966 by M. D. Herter Norton. Used by permission of W. W. Norton & Company, Inc.

Excerpt from "The Departure of the Prodigal Son" from *A Year with Rilke*, translated and edited by Joanna Macy and Anita Barrows. Reprinted by permission of HarperCollins Publishers.

Excerpts from *Letters to a Young Poet* by Rainer Maria Rilke, translated by M. D. Herter Norton. Copyright 1934, 1954 by W. W. Norton & Company, Inc., renewed © 1962, 1982 by M. D. Herter Norton. Used by permission of W. W. Norton & Company, Inc.

Excerpts from *Letters of Rainer Maria Rilke: 1910–1926*, translated by Jane Bannard Greene and M. D. Herter Norton. Copyright 1947, 1948 by W. W. Norton & Company, Inc., renewed © 1975 by M. D. Herter Norton. Used by permission of W. W. Norton & Company, Inc.

For information about permission to reproduce selections from this book, write to Permissions, W. W. Norton & Company, Inc., 500 Fifth Avenue, New York, NY 10110

For information about special discounts for bulk purchases, please contact W. W. Norton Special Sales at specialsales@wwnorton.com or 800-233-4830

Manufacturing by Quad Graphics Fairfield
Book design by Barbara M. Bachman
Production manager: Louise Mattarelliano

LIBRARY OF CONGRESS CATALOGING-IN-PUBLICATION DATA
Names: Corbett, Rachel, 1984- author.
Title: You must change your life : the story of Rainer Maria Rilke and
Auguste Rodin / Rachel Corbett.
Description: First edition. | New York : W. W. Norton & Company, 2016. |
Includes bibliographical references and index.
Identifiers: LCCN 2016013563 | ISBN 9780393245059 (hardcover)
Subjects: LCSH: Rilke, Rainer Maria, 1875-1926—Biography. | Rilke, Rainer
Maria, 1875-1926—Friends and associates. | Authors, German—20th
century—Biography. | Rodin, Auguste, 1840-1917—Biography. | Rodin,
Auguste, 1840-1917—Friends and associates. | Sculptors—France—20th
century—Biography.
Classification: LCC PT2635.I65 Z66144 2016 | DDC 831/.912 [B]—dc23 LC record
available at https://lccn.loc.gov/2016013563

ISBN 978-0-393-35492-8 pbk.

W. W. Norton & Company, Inc.
500 Fifth Avenue, New York, N.Y. 10110
www.wwnorton.com

W. W. Norton & Company Ltd.
15 Carlisle Street, London W1D 3BS

1 2 3 4 5 6 7 8 9 0

CONTENTS

INTRODUCTION

I FIRST READ *LETTERS TO A YOUNG POET* WHEN I WAS TWENTY years old. My mother gave me the square, slender book with the title words *"Young Poet"* splayed grandly across the cover in gold script. The author's name, Rainer Maria Rilke, was strange and beautiful.

At the time, I was living in a Midwestern college town a few miles from where I grew up, in a mono-colored landscape of bland struggles and unspecial children. Like everyone else I knew, I had no interest in becoming a writer. As graduation loomed, the only drive I felt unmistakably was the will to leave. But I had no money and no clear destination. My mother said she had taken some comfort in the book when she was a younger woman, and thought perhaps I would appreciate it, too.

Reading it that evening was like having someone whisper to me, in elongated Germanic sentences, all the youthful affirmations I had been yearning to hear. *Loneliness is just space expanding around you. Trust uncertainty. Sadness is life holding you in its hands and changing you. Make solitude your home.* I saw how each negative in my mind could be reversed; having no prospects also meant having no expectations; no money meant no responsibilities.

Looking back, I see how Rilke's advice could be taken rather recklessly. But one can hardly blame him for that. He was only twenty-

seven himself when he began writing this series of ten letters to an aspiring nineteen-year-old poet, Franz Xaver Kappus. He could not have fathomed then that they would be canonized as *Letters to a Young Poet*, one of the most frequently quoted texts at weddings, graduations and funerals alike, and what may today be considered the highest-brow self-help book of all time.

As the fledgling poet formed the words, the words formed him, allowing us to witness the making of an artist. What gives the book its enduring appeal is that it crystallizes the spirit of delirious transition in which it was written. You can pick it up during any of life's upheavals, flip it open to a random page, and find a consolation that feels both universal and breathed into your ear alone.

While the genesis of *Letters* is by now well known, fewer readers know that the insight Rilke transmitted to Kappus was not exclusively his own. The poet began sending the letters shortly after he moved to Paris in 1902 to write a book about his hero, the sculptor Auguste Rodin. To Rilke, the raw, rough-hewn emotion of Rodin's art—the hungry lust of the *The Kiss*, the alienation of *The Thinker*, the tragic suffering of *The Burghers of Calais*—gave form to the souls of young artists everywhere.

Rodin was at the pinnacle of his powers when he granted the unknown writer entrée into his world, at first as his hovering disciple and then, after three years, his most trusted assistant. All the while, Rilke wrote down the master's every adage and bon mot and often paraphrased them for Kappus. In the end, Rodin's voice emanates loudly from behind the pages of the letters, his wisdom reverberating from Rilke to Kappus and to the millions of pleading young minds who've read *Letters* in the century since.

OVER THE YEARS I had heard in passing that Rilke once worked for Rodin. The details rarely went beyond this snippet of trivia, but it always remained a curiosity in my mind. These two personas seemed so incongruous that I almost imagined them living in different centu-

ries or continents altogether. Rodin was a rational Gallic in his sixties, while Rilke was a German romantic in his twenties. Rodin was physical, sensual; Rilke metaphysical, spiritual. Rodin's work plunged into hell; Rilke's floated in the realm of angels. But I soon discovered how tightly their lives intertwined: how the artistic development of one mirrored the other and how their seemingly antithetical natures complemented each other; if Rodin was a mountain, Rilke was the mist encircling it.

As I struggled to grasp how these two figures—one in old age, one as a young man—understood each other, my research brought me to empathy. What we understand today as the capacity to feel the emotions of others is a concept that originated in the philosophy of art, to explain why certain paintings or sculptures move people. Rilke studied the theory in college as the word was first being coined, and soon it appeared in seminal texts by Sigmund Freud, Wilhelm Worringer and other leading intellectuals of the time. The invention of empathy corresponds to many of the climactic shifts in the art, philosophy and psychology of *fin-de-siècle* Europe, and it changed the way artists thought about their work and the way observers related to it for generations to come.

As the compatibilities between Rilke and Rodin came into focus, so did the point of divergence that eventually drove them apart. Their relationships with women, and what they believed about a woman's place in society, played a prominent role in the way they saw each other. Both men were attracted to ambitious, independent women, but ultimately married those who sacrificed their own aspirations to support their husbands. Rodin often warned Rilke against womankind's manipulative tendency to distract men from their work, and for a long time Rilke did not question his mentor's chauvinist views. But the death of Rilke's beloved friend, a painter whose genius was cut short by an ill-fated pregnancy, upended everything he thought he knew about what it means to suffer for one's art.

In the end, this book is a portrait of two artists fumbling through the desultory streets of Paris, finding their paths to mastery. But more than that, it is the story of how the will to create drives young artists

to overcome even the most heart-hollowing of childhoods and make
their work at any cost. "You Must Change Your Life" was not just art's
injunction to Rilke, but one which he commands to all the frail and
hungry-eyed youth who hope to one day raise a timid hand in the air,
grasp a tool and strike.

AFTER I READ the last page of the copy of *Letters to a Young Poet*
that my mother had given me, I held the cover closed in my hands
for a few moments the way one does when they've finished a book
they know they'll never fully get over. Then I flipped it back to the
beginning and saw that the book had been previously inscribed to
my mother. A friend had given it to her when she was around my age,
struggling with transitions of her own. He had copied one of Rilke's
most famous passages onto the inside cover: "Perhaps all the dragons
in our lives are princesses who are only waiting to see us act, just
once, with beauty and courage. Perhaps everything that frightens us
is, in its deepest essence, something helpless that wants our love." *Go,*
it seemed to say. *Fling yourself at the unknown. Go where you're uninvited,
and keep going.*

PART ONE

...

Poet

and

Sculptor

CHAPTER
1

⬥

ALL ARTISTS MUST LEARN TO SEE, BUT THE IMPERATIVE was literal for young Auguste Rodin. He squinted through five years of boarding school before realizing that the obscurities on the blackboard were the effects of nearsightedness. Instead of gazing blindly ahead, he often turned his attention out the window at a sight too commanding to overlook: the great Cathédral Saint-Pierre in Beauvais, an ancient village in northern France.

To a child, it would have been a monster. Begun in 1225, the Gothic masterpiece was designed to be the tallest cathedral in Europe, with a pyramidal spire teetering five hundred feet into the sky. But after two collapses in three centuries, architects finally abandoned the job in 1573. What they left behind was a formidable sight: a house of cards in rock, glass and iron.

Many locals walked by without even noticing the cathedral, or perhaps only half-consciously registering the fact of its enormity. But for young Rodin it was an escape from the inscrutable lessons in front of him and into a vision of endless curiosity. Its religious function did not interest him; it was the stories written on its walls, the mysterious darkness contained within, the lines, arches, shadow and light, all as harmoniously balanced as the human body. It had a long spinal nave

caged in by a ribbed ceiling, flying buttresses flung out like wings or arms, with a heart-like chamber at the center. The way its stabilizing columns swayed in the gales off the English Channel reminded Rodin of the body's perpetual steadying of itself for equilibrium.

Although any comprehension of the building's architectural logic was beyond the boy's years, by the time he left boarding school in 1853, he understood that the cathedral had been his true education. He would revisit the site again and again over the years "with head raised and thrown back" in awe, studying its surfaces and imagining the secrets within. He joined the faithful in their worship at the cathedral, but not because it was a house of god. It was the form itself, he thought, that ought to drive people to their knees and pray.

FRANÇOIS AUGUSTE RENÉ RODIN was born in Paris on November 12, 1840. It was a momentous year for the future of French art, also marking the births of Émile Zola, Odilon Redon and Claude Monet. But these seeds of the Belle Époque would spring from very arid, conservative soil. Shaken by both the Industrial and French revolutions, Paris under the monarchy of King Louis-Philippe was the city of depravity and poverty depicted in *Les Fleurs du Mals* and *Les Misérables*. New manufacturing jobs attracted thousands of migrant workers, but the city lacked the infrastructure to support them. These newcomers piled into apartments, sharing beds, food and germs. Microbes multiplied in the overflowing sewer system and turned the narrow medieval streets into trenches of disease. As crowds spread cholera and syphilis, a wheat shortage sent bread prices soaring and widened the gap between *les pauvres* and the *haute bourgeoisie* to historic proportions.

As the city scrambled to register a proliferating class of paupers, prostitutes and unwanted children, Rodin's father found plenty of opportunity for work as a police officer. Like the conflicted vice inspector Javert in *Les Misérables*, Jean-Baptiste Rodin patrolled the streets looking for pimps and courtesans throughout the 1832 Paris Uprising, and then later during the 1848 revolution that finally dethroned the

king. The job suited the impeccably principled and authoritarian man as he gradually ascended the ranks of the force.

When the barricades rose that year on the Rue Saint-Jacques, Jean-Baptiste and his seamstress wife, Marie, sent eight-year-old Auguste to the boarding school in Beauvais. There the elfin redhead remained safely tucked away from the bloody riots underway in Paris, which saw Baudelaire charge through the streets waving a gun and Balzac nearly starve to death.

Auguste was not an impressive student. He skipped classes and received poor grades, particularly in math. Although Beauvais offered an education more befitting of his father's rising professional stature, the tuition became a burden on the family. After five years, Jean-Baptiste decided not to waste any more money on an education that seemed unlikely to end with a career. When Auguste turned fourteen, his father withdrew him from school. The boy had always enjoyed working with his hands—perhaps trade school would suit him better.

When Auguste returned to Paris, his hometown was barely recognizable. The previous year, France's new president, Napoleon III, had appointed Baron Georges-Eugène Haussmann to modernize the city—or to hack it to pieces, depending on who one asked. An obsessive symmetrist, Haussmann carved the landscape into a vast grid, divided into class-segregated arrondissements. He bulldozed the rolling hills to flatten the horizon and impose a sense of order. He widened the old winding brick streets into paved, barricade-proof boulevards that hindered rebels and welcomed strolling shoppers. A comprehensive cleansing initiative went into effect citywide. Engineers designed a new sewer system so advanced it became a tourist attraction. Aboveground the city installed thousands of gas lamps in the streets to light up the night and ward off criminals.

From the rubble of tens of thousands of demolished medieval houses rose five-story neoclassical apartments, built from uniform blocks of stone and aligned into neat, rectilinear rows. The rapid construction estranged many Parisians from their native city, replacing the traditional homes with those that seemed to belong to no place or time at

all. To many, the continuum of scaffolding on the streets looked less like progress than the skeletal remains of their butchered town.

For commercial sculptors, Haussmann's decades-long reconstruction effort meant big business. All of the new building façades needed cornices and stone decorations. The chief training ground for this burgeoning class of craftsmen, as well as for future clock-makers, woodworkers and metalsmiths, was the École Impériale Spéciale de Dessin et de Mathématiques, popularly known as the "Petite École." Tuition-free, the Petite École was the working-class counterpart to the more prestigious Grande École des Beaux-Arts. While the latter groomed graduates like Renoir, Seurat and Bouguereau for careers as fine artists, it was virtually unheard-of for a student from the lower school to show in the official salons.

Rodin, having just returned to Paris unclear of his interests or ambitions, enrolled at the Petite École in 1854. He did not yet consider himself an artist, and he certainly did not share the exalted views espoused by the Grande École professors, who compared art to religion, language and law. Sculpture was then, and would always be, first and foremost a vocation for Rodin.

SOME BIOGRAPHERS HAVE SPECULATED that Rodin's visual shortcomings may have nurtured his hypersensitive tactile intelligence. Perhaps it explained why he was always holding and rounding out lumps of clay in his palms. Even after he finally bought a monocle, he used it only to zoom in on the smallest of details. Most of the time he worked with his nose pressed flush against the clay (or, as one lover wryly noted, against his models).

Like most of his classmates, Rodin entered with the hopes of studying painting. But because it was cheaper to buy paper and pencils than paint and canvases, he settled on drawing classes instead. It was a hardship that had the fortunate outcome, however, of laying Rodin in the capable hands of Horace Lecoq de Boisbaudran, the professor who would first correct, and then truly open, Rodin's eyes.

Each morning, Rodin would gather his art supplies, tie a scarf around his slender neck and set off for his eight o'clock drawing lecture. Lecoq was a squat, soft-faced man, who liked to begin each session with a copying exercise. He believed that keen observation was the indispensable secret all great artists possessed. To master it properly, one had to figure out the essential nature of an object by breaking it down into parts: Copy a straight line from point A to point B, then add in the diagonals, the arcs, and so on until the components take form.

One morning, Lecoq placed an object in front of the class, instructing students to copy it onto paper. As he paced the aisles between desks observing their work, he noticed Rodin sketching only its crude outline and then making up the details on his own. Rodin did not strike Lecoq as a lazy student, so he couldn't understand why he wasn't completing the task correctly. That's when it occurred to him that perhaps the boy simply could not see. And so it was in a single exercise that Lecoq identified basic myopia as the mysterious ailment that had plagued Rodin for more than a decade.

The other transformative revelation from Lecoq's class took Rodin longer to grasp. The professor often sent students to the Louvre to practice observing the paintings. They were told not to sketch them, but to truly memorize their proportions, patterns and colors. The young Rodin passed his adolescence there on benches seated before works by Titian, Rembrandt and Rubens. They were visions that opened up and expanded inside him like music. He rehearsed every brushstroke in his mind so that he could return home at night, still exalted, and reproduce them from memory.

In his free time, he paid visits to the Bibliothèque Nationale to practice copying masterpieces from illustrated books. He made rough sketches of works by the great Italian draftsmen to take home and later fill in the details from memory. The boy became such a fixture at the library that by the time he turned sixteen he was one of the youngest students to ever receive official admission to the print room.

To some, Lecoq's emphasis on copying seemed to train students

only in the reproduction of other people's art. It was in many ways a traditional, mathematical approach to form and dimension that was in line with the curriculum at the Grande École. But Lecoq had a different goal in mind. He believed young artists ought to master the fundamentals of form only so that they might one day break them. "Art is essentially individual," he said. The purpose of the memorization exercises was actually to allow the artists time to acknowledge their reactions to a picture as its properties unfolded to them. Did a gently arched line produce feelings of serenity? Did a densely wound shadow evoke anxiety? Did certain colors trigger memories? Once artists could name these associations they could then begin to harden their own pooling sensations into external forms of their making. Ultimately, Lecoq's modern method encouraged artists to draw things not strictly as they appeared, but as they felt and seemed. Emotion and substance became one.

Rodin's individual style started to emerge at around sixteen. His notebooks from the time reveal an artist already preoccupied with formal continuity and silhouette. In what would become a trademark tendency, he began conjoining the figures in his sketches, linking their bodies together into harmonious groupings that would later evolve into the ring-shaped masterworks of *The Burghers of Calais* and *The Kiss*.

Lecoq's lessons remained with Rodin long after he graduated and had established his reputation over the years as a sculptor of impressions rather than replications. He recalled Lecoq's training decades later, when tasked with modeling a bust of Victor Hugo, who refused to pose for any prolonged period of time. Rodin seized glimpses of the man as he passed by in the hall or read in another room, and then sculpted the images later from memory. One looks with the eyes, Lecoq had taught him, but one *sees* with the heart.

IT WASN'T LONG BEFORE Rodin had mastered the curriculum offered at the Petite École. He finished lessons so quickly that the teachers eventually ran out of assignments. He did not care to socialize

with his classmates; he wanted only to work. The one exception was his uncommonly supportive friend Léon Fourquet, with whom Rodin shared a love of ponderous debates about the meaning of life and the artist's role in society.

The teenagers would stroll through the Luxembourg Gardens wondering whether Michelangelo and Raphael ever despaired for recognition as they did. They fantasized about fame, but Fourquet realized early on that this would be Rodin's fate alone. While Fourquet would go on to master the art of carving marble—a skill Rodin never learned—he always saw an aura of destiny surrounding Rodin and would later spend several years working for his friend. "You were born for art, while I was born to cut in marble what is germinating in your head—that's why we shall always be together," Forquet once wrote him.

By 1857, Rodin had won the school's top drawing prizes. It seemed he had excelled at every subject except one, and it was the gold standard of artistic achievement: to render the human body. To Rodin, the human form was a "walking temple." To model it in clay would be the closest he would ever come to building a cathedral. The human figure had fascinated Rodin for as long as he could remember. As a boy he used to watch his mother roll out and cut cake dough into playful shapes. Once she passed him the floury lump and he joined in, pinching out heads and bulky bodies for his mother to submerge in the bubbling oil. Once the dough men fried to a crisp, she spooned them out, revealing one hilariously disfigured character after another. It was, he later said, his first art lesson.

But since statue commissions went only to the "real" fine artists, trade schools had no reason to offer life drawing classes. If Rodin wanted to study the human form, he would have to transfer to the Grande École. So, in 1857, at the end of his third year at the Petite École, Rodin decided to embark upon the rigorous application.

At the six-day entrance exam, Rodin joined a semicircle of painters and sculptors before a live model each afternoon. According to some accounts, he waved his arms so wildly as he worked that the other students gathered around to watch. Because he was already producing

the disproportionate, heavy-limbed figures for which he would become famous, his art proved as unconventional as his gesticulating and it was, in the end, too much for the admissions committee. He passed the drawing exam but failed in sculpture and his application was denied.

Rodin reapplied the following semester, and the semester after that, and was turned away two more times. The rejections sent Rodin into such despair that his father grew worried. He wrote the boy a letter urging him to toughen up. "The day will come when one can say of you as of truly great men—the artist Auguste RODIN is dead, but he lives for posterity, for the future." Jean-Baptiste knew nothing about art, except that it paid poorly, but he understood the power of perseverance: "Think about words such as: energy, will, determination. Then you will be victorious."

Rodin eventually coped by turning against the pretentious academy, which he decided was filled with nepotists and guarded by elites who "hold the keys of the Heaven of Arts and close the door to all original talent!" He suspected that his exclusion had to do with his inability to supply letters of recommendation from renowned artists, which other boys had been able to obtain through family connections.

Rodin gave up on art school for good. He continued making his own work, but, denied his "heaven," he stopped copying the idyllic Greek and Roman statues and adopted a kind of aesthetic of survival. From then on, his art was to be grounded in life, in all its unexceptional misery. He began to accentuate forms that clung desperately to their existence, and those that had been grotesquely defeated by it.

WHEN HE WAS EIGHTEEN, it came time for Rodin to earn a proper living. So, in 1858, he took a job stirring plaster and cutting molds for building ornaments. He was a cog in an assembly line that began with an architect whose blueprints would call for flowers or caryatids or demon heads, which Rodin would then sculpt in plaster. He then gave the model to a mason to reproduce in stone or metal. Finally it went to the construction worker to affix to the side of a building.

This sculpt-by-numbers approach left Rodin feeling depressed and uninspired. Once he caught a glimpse of himself in the mirror and for a moment saw himself as his uncle, who had also been a plaster craftsman and wore a smock streaked with white paste. He was starting to believe that this job might be it for him. Perhaps he had been foolish to think he could be an artist. "When one is born a beggar, one had better get busy and pick up the beggar's pouch," he lamented to his sister at the time.

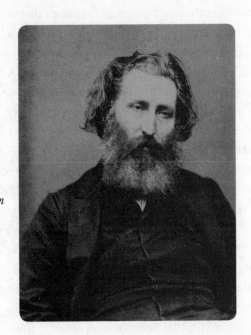

Auguste Rodin
circa 1875.

But the more Rodin eased into the routine of his job, the more a new world began to open up for him there. One day he was gathering leaves and flowers from a garden with his co-worker Constant Simon. After they brought these samples back to the studio to model in plaster, Simon observed Rodin's technique. "You don't go about that correctly," he told his younger colleague. "You make all your leaves flatwise. Turn them, on the contrary, with the tips facing you. Execute them in *depth* and not in *relief.*" The form should push out from the

center and advance toward the viewer, he explained, otherwise it was merely an outline.

"I understood at once," Rodin said. "That rule has remained my absolute basis." He couldn't believe he hadn't come to this brilliantly simple logic sooner. Through the example of a leaf he had learned more than most students did in all of art school, he thought. Young people were so busy copying the sculptures of antiquity that they scarcely even noticed nature. And they were so preoccupied with emulating the latest greats in the salons that they failed to recognize the everyday mastery of craftspeople like Simon.

Perhaps the monotonous labor he endured now was what the cathedral builders felt when they laid brick upon brick to build their masterpieces, Rodin thought. He did not share their devotion to god, but he did feel a love that intense for nature. Perhaps if he could sculpt each leaf as if it were a tiny act of worship, then he could take pride in his work as a humble servant of nature. After all, no cathedral builder was singled out for his work, nor would glory come to any one building ornamenter. The cathedral was a triumph that belonged to all its artisans, and it would outlive every last one of its nameless makers.

"How I should love to sit at the table with such stone carvers," Rodin went on to write. He would later warn young artists to beware of the "transitory intoxication" of inspiration. "Where did I learn to understand sculpture? In the woods by looking at the trees, along roads by observing the formation of clouds . . . everywhere except in schools."

Yet Rodin still had to accomplish one crucial lesson from nature, that of the human form. Without access to live models, he settled for studying humbler versions of anatomy. He became a regular at the Dupuytren, a medical museum just down the street from the Petite École. The diseased body parts on view there undoubtedly influenced the contorted shapes of the hundreds of hands Rodin would sculpt over the years, some of which physicians have since claimed they can diagnose by sight.

Other times Rodin studied animal figures. There were markets

all over town for the buying and selling of dogs, pigs and cattle, but Rodin's favorite was the horse fair on the corner of the Boulevard de l'Hopital, in front of the Salpêtrière psychiatric facility. He watched the owners lead their horses out from stalls and trot them up and down the dirt path. Sometimes he saw the naturalist painter Rosa Bonheur there, dressed as a man to avoid attention as she worked on reproductions of her famous painting *The Horse Fair*.

He also frequented the Jardin des Plantes, a seventy-acre menagerie in southeastern Paris that was home to a botanical garden, the world's first public zoo and a natural history museum, where Rodin enrolled in a course on zoological drawing. It was held in the museum's dank basement, and an uninspiring instructor lectured Rodin's class about skeletal structure and bone composition. When it came time for critique the man shuffled between the sculptors' blocks, muttering little more than, "All right, that's very good." The students, bored by the scientific minutiae, amused themselves by making fun of the old man's cheap suits and the way his shirt buttons fought to contain his paunch.

In a decision he would come to regret, Rodin dropped out before the end of the term. He later learned that the professor was a true master in disguise: Antoine-Louis Barye, one of the finest animal sculptors in European history. Sometimes called the "Michelangelo of the Ménagerie," Barye had been examining the caged carnivores of the Jardin since 1825, often with his friend the painter Eugène Delacroix. When an animal died, Barye was first on the scene to dissect it and compare its measurements to those in his drawings. Once, in 1828, Delacroix notified him of a new cadaver by writing, "The lion is dead. Come at a gallop."

Barye was a former goldsmith who defied the rigid realism of the day with wildly expressive bronzes. In his hands, a gnu being strangled by a python did not merely collapse to the ground in defeat. Instead, the beast's body merged with the serpent's coil as it sucked away its life and identity in what became a potent allegory for the dehumanization of war. Reviewing Barye's work in the 1851 Paris

Salon, the critic Edmond de Goncourt wrote that Barye's *Jaguar Devouring a Hare* marked the death of historicist sculpture and the triumph of modern art.

There was no shortage of demand for work by the great *animalier,* but Barye was a perfectionist who refused to sell anything that did not live up to his exacting standards. Thus he never earned the money to match his talent and went through life looking like a pauper.

It was not until Rodin reached middle age that he finally recognized the significance of Barye's animal studies. The epiphany came to him one afternoon while strolling down a Paris street, gazing absentmindedly into the shop windows. A pair of bronze greyhounds in one of the displays caught his eye: "They ran. They were here, they were there; not for an instant did they remain in one spot," he said of the sculptures. When he looked closer he saw that they bore the signature of his old professor.

"An idea came to me suddenly and enlightened me; this is art, this is the revelation of the great mystery; how to express movement in something that is at rest," Rodin said. "Barye had found the secret."

From then on, motion became the dominant concern in Rodin's work. He began intuiting tiny gestures—the curve of a model's arm or a bend in the spine—and amplifying them into new, large-scale actions. His human figures took on an animal intensity; in sculpting one especially muscular model he said he imagined her as a panther. Years later the critic Gustave Geffroy identified Rodin's debt to his old master. Rodin "takes up the art of sculpture where Barye left off; from the lives of animals he proceeds to the animal life of human beings," he wrote in *La Justice.*

Once Rodin had discovered his task—to express inner feelings through outward movement—his work departed further from that of his historical heroes and began to fall into step with the flux and anxiety of the rapidly modernizing world around him.

CHAPTER
2

✤

I N A CHILDHOOD DREAM, THE YOUNG POET LAY ON A BED OF dirt beside an open grave. A tombstone etched with the name "René Rilke" loomed overhead. He did not dare lift a limb for fear that the slightest movement might topple the heavy stone and knock him into the grave. The only way to escape his paralysis was to somehow change the engraving on the stone from his name to his sister's. He did not know how to do it, but he understood that freedom required rewriting his fate.

The fear of being crushed by a rock became a recurring theme in the boy's nightmares. It wasn't in every case a tombstone, but it was always something "too big, too hard, too close," and it often portended a painful transformation; a rebirth contingent upon the downfall of that which came before him.

Indeed, it was a death that chaperoned the poet's very entrance into the world, on December 4, 1875. A young housewife from a well-to-do family, Sophia Rilke lost an infant girl a year before giving birth to her only son. From the moment he was born, she saw him as her replacement daughter and christened him with the feminine name René Maria Rilke. Sometimes she called him by her own nickname, Sophie. Born two months prematurely, the boy stayed small for his age and passed

easily for a girl. His mother outfitted him in ghostly white dresses and braided his long hair until he entered school. This splintered identity had mixed consequences for Rilke. On the one hand, he grew up believing that there was something fundamentally mistaken about his nature. But on the other, his acquiescence pleased his mother, which was something no one else seemed able to do, especially not his father.

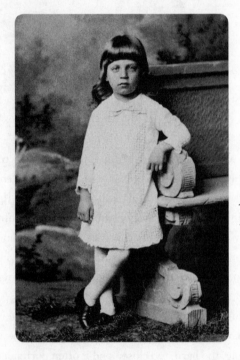

A young Rainer Maria Rilke, dressed as a girl, circa 1880.

Josef Rilke worked for the Austrian army as a railroad station master. He never rose to the officer's rank that his well-bred wife had hoped for, and he spent the rest of his marriage paying for the disappointment. His good looks and early professional promise initially won his bride over, but Sophia prized status above all else and never forgave Josef for failing to bring her the noble title she had bargained for.

Josef, meanwhile, resented the way she babied René, and later blamed her for the boy's incessant versifying. He was not mistaken. Sophia had decided that if they weren't going to be granted nobility, they would

fake it, and so she began teaching René poetry in an attempt to "refine" him. She had him memorizing Friedrich Schiller verses before he could read and copying entire poems by age seven. She insisted he learn French, too, but certainly not Czech. Under the imperial rule of the Austro-Hungarian Empire, Czech was relegated to the servant classes, while German became the dominant language in Prague.

Born into this segregated city, Rilke quickly discovered that gender was not the only boundary that proved contradictory in his early life. He was part of Prague's German-speaking minority, which enjoyed vast cultural and economic advantages over the Czech majority. Liberal families like the Rilkes wanted to live peacefully alongside the Slavs, but they kept to their own schools, theaters and neighborhoods, delineated by street signs written in their own language. Rilke would go on to speak Russian, Danish and French, but he always regretted never learning the language native to his homeland.

When René turned nine, Sophia left Josef. She had become almost fanatically religious and, as Rilke later reasoned, was a woman who "wanted something indefinite of life." By that time René had grown out of his girlish looks into a slender, narrow-shouldered adolescent and his parents sent him to live at the St. Pölten military academy near Vienna. Rilke was not opposed to following in his father's footsteps, but not because he was interested in combat or physical training. He liked the elegant uniform, the order, and the rituals the military represented.

But Sophia and Josef's hope that their son might achieve what his father had not was promptly dashed. While the move had succeeded in replacing René's dolls with dumbbells, it also thrust him into a roost with fifty brutal boys, with whom he had nothing in common. He quickly discovered that life at the academy had little to do with discipline or elegance.

Young Rilke longed only to join the adult world. He was too intellectual to keep company with the working-class boys and he wasn't refined enough for the aristocratic ones. Solitude might have suited him fine, but he wouldn't be so lucky. To his classmates, René was

fragile, precocious and a moral scold—all qualities that aligned into ideal crosshairs for bullies. In an account of one of the many attacks he suffered as a boy it becomes painfully clear why he was seen as a target:

> Once when I was struck so hard in the face that my knees shook, I said to my unjust attacker—I can still hear it—in the calmest of voices "I will suffer it because Christ suffered it, in silence and without complaining, and while you were striking me, I prayed to my dear Lord that he may forgive you." The miserable coward simply stood there for a moment dumbfounded, then burst into a fit of scornful laughter . . .

The boy went to the chapel to recover from his beating and to nurse his righteous indignation. It was around this time that he developed the chronic, undefined infirmity that would afflict him for the rest of his life. Some thought Rilke's mysterious ailments were entirely imagined and, indeed, when a lung infection took the boy out of school for six weeks, he seemed to learn that sympathy could be a deft social strategy. But others who saw him in these states testified that his trembling muscles and pallid complexion were too convincing to discount.

In any case, the sickroom became Rilke's sanctuary at military school. It provided immediate asylum from his antagonizers and, more importantly, allowed him time and space to read. Lying in bed, he rolled around with sentences day and night. He cried into pages of Goethe. His grades in literature classes started to improve, though they dropped in fencing and gym. Despite his failing physical education, Rilke still thought he could be a military officer, and at one point tried to prove it to his instructors by writing an eighty-page "History of the Thirty-Years War."

At the suggestion of teachers, the boy began submitting poems to newspapers, and several were accepted. He survived on these small consolations until he turned fifteen, when, finally, his parents saved

him from that "dungeon of childhood," as he called the academy. But he fared no better at the business school they sent him to next in the Austrian town of Linz. Noticing with "scorn and uneasiness" that his son was still writing poems, Josef tried to convince René to focus more on his studies and write only on the weekends. He saw no reason why his son couldn't maintain both a job and a hobby, which was how he saw poetry. But to René, his poems were his "dream children," and nothing was more upsetting than the thought of sacrificing them to a dull office job. He had decided that the artist who only wrote on the weekends was "not an artist at all."

Within the year, René's Uncle Jaroslav took pity on the boy and offered to pay for a private tutor in Prague so he could finish his studies at home. A prosperous lawyer, René's uncle was now known as Jaroslav *von* Rilke, having achieved the noble title that so painfully eluded his brother. Jaroslav had no trouble covering the expense and, with no surviving sons of his own, saw René as a potential protégé to one day take over his law firm and legacy.

Jaroslav instituted a stipend to support René during the remainder of his high school education and through university. Of course, the aspiring poet had no intention of going to law school. He had made up his mind to become a writer—a detail he was able to spare his uncle, for Jaroslav died of a stroke that winter.

Although Rilke did not carry out his uncle's wishes, he did not squander the man's generosity. The year following his graduation he wrote dozens of short stories, plays, news articles and launched his own literary journal. He joined a writers' group and even made a few friends. In 1894, Rilke published his first book, a volume of gushing love poems titled *Life and Songs* that was inspired by his first serious girlfriend, "a bright shooting-star" called Valerie. The sentimental verses were sodden with the dewy flowers and singing maidens of German Romanticism, and the book did not reward him with the immediate glory he thought he deserved.

When Rilke's psychodramatic playwriting fared no better, he did not consider the possibility that his work was amateur. Instead, he

blamed readers for failing to understand it. Prague was a town of the bygone, filled with graveyards, castles and parochial dilettantes, he concluded. The people there were so stuck in the past they even looked old. "The only progress they know is when their coffins rot to pieces or their garments fall apart," he wrote. While Rilke admired many Slavic traditions, including their folk history and reverence for the land, the people were too poor to concern themselves with literary pursuits. The Austrians were worse because they could afford to embrace the arts, but cared only about status and money.

When Rilke turned twenty, he realized that if his poetry didn't take off soon his parents would have their doubts validated. He would be forced to take a job at a bank or law firm in Prague and stay there, maybe forever. The city was not an environment hospitable to creativity, with its air that could hardly "be breathed, thick with stale summer and unconquered childhood," he wrote.

Rilke had met young people who moved to cities known for nurturing artists. Many had gone to Paris, but Rilke believed the French exerted too much influence over the artistic production of Eastern Europe. He saw a better option in Munich, then the intellectual nerve center of Europe, where the most coveted social seat in town was at the lecture hall. At the cafés, secular youth debated Nietzsche's declaration of "the death of God," while the artists revolted against the academy, resulting in the Munich Secession of 1892—five years before Gustav Klimt led the movement in Vienna.

Rilke could continue living on his uncle's stipend there as long as he was in school. So, in the fall of 1896, he enrolled in classes at the University of Munich with the intention of rejecting everything that had defined him thus far. His mother's zealous Catholicism, his father's military aspirations, Prague's provincialism—even his own name—he was prepared to leave it all behind.

AN INTELLECTUAL TREND in German-speaking countries at the end of the nineteenth century was the study of individuals and how

they functioned within societies. Philosophers and neurologists were combining expertise to create new sciences of the mind. Phenomenology was founded to study the nature of consciousness; psychoanalysis for the unconscious. Art, and the study of art known as aesthetics, became a common point of convergence within these disciplines. Psychologists began to see how looking at people's emotional responses to art, and the motivations that drove some to create it, could help explain aspects of human nature that had never been tested in laboratories.

The German doctor Wilhelm Wundt accidentally forged the birth of psychology in the 1860s, while he was conducting some routine research on reaction times. He had rigged the pendulum of a clock into a timer he called a "thought meter," when it occurred to him that perhaps his experiment measured not only a neurological phenomenon, but an unconscious one. Reaction times seemed to bridge the gap between voluntary and involuntary attention, between the brain *and* the mind. If science could measure the former, he couldn't see why it wouldn't also apply to the latter. In 1879, Wundt founded the world's first laboratory for psychological experimentation in Leipzig.

It took a philosopher from the next generation, Theodor Lipps, to draw the link between Wundt's new discipline and his own, aesthetics. Lipps had been a forerunner in the creation of phenomenology, but started to break away from the field and its figurehead, Edmund Husserl, in order to pursue a psychological approach to his central question: Why does art give us pleasure?

At the time, scientists largely reduced art appreciation to mathematical properties. They believed that certain unities of geometry were simply more agreeable to the mind's eye than others. But Lipps refused to settle for this rigid, retinal explanation. He thought it could help explain perception, but that it had little to do with pleasure, which he suspected involved more subjective forces, like an individual's mood or educational background.

Perhaps the equation could be reversed, he decided. Rather than art grafting pleasure onto the eye, maybe the eye made the art. After all, the distribution of paint on canvas could not be considered beauti-

ful without a beholder to see it as such. (A contemporary of Lipps's in Vienna, the art historian Alois Riegl, later called this the "beholder's involvement.") In this view, colors are simply pigments until a mind filters them into what one might call tones, or hue-based triggers of memory and emotion. The moment a viewer recognizes a painting as beautiful, it transforms from an object into a work of art. The act of looking, then, becomes a creative process, and the viewer becomes the artist.

Lipps found a name for his theory in an 1873 dissertation by a German aesthetics student named Robert Vischer. When people project their emotions, ideas or memories onto objects they enact a process that Vischer called *einfühlung*, literally "feeling into." The British psychologist Edward Titchener translated the word into English as "empathy" in 1909, deriving it from the Greek *empatheia*, or "in pathos." For Vischer, *einfühlung* revealed why a work of art caused an observer to unconsciously "move in and with the forms." He dubbed this bodily mimesis "muscular empathy," a concept that resonated with Lipps, who once attended a dance recital and felt himself "striving and performing" with the dancers. He also linked this idea to other somatosensory imitations, like yawns and laughter.

Empathy explained why people sometimes describe the experience of "losing themselves" in a powerful work of art. Maybe their ears deafen to the sounds around them, the hair rises on the backs of their necks or they lose track of the passage of time. Something produces a "gut feeling" or triggers a flood of memory, like Proust's madeleine. When a work of art is effective, it draws the observer out into the world, while the observer draws the work back into his or her body. Empathy was what made red paint run like blood in the veins, or a blue sky fill the lungs with air.

Paradoxically, then, empathy is by definition a selfish emotion: we empathize with the external in order to enjoy ourselves. Empathy is life-affirming, it allows us to permeate the world. On the other hand, when art fails to activate this response, people may say that it doesn't

"move" them. That it is "impenetrable" or they cannot wrap their "head around it." In these instances, perception is the only sense at work.

Intellectuals across Europe quickly took note of Lipps's research on *einfühlung* and began to build upon it. Art historians had been attempting to explain why certain cultures created certain art, what Riegl called *Kunstwollen,* or the "will to art." In 1906, one of Lipps's students, Wilhelm Worringer, proposed a seminal theory that coupled his professor's writing on empathy with that of another professor, the Berlin sociologist Georg Simmel. Adopting Simmel's use of binaries—a relativist view that held that to understand one concept, such as symmetry, one should also consider its opposite, asymmetry—Worringer described the binary that he believed defined all of art history, and titled his book after it, *Abstraction and Empathy.*

But it was psychologists who transformed the obscure term from German art history into the cornerstone of human emotion that we understand as empathy today. In Vienna, the young professor Sigmund Freud wrote to a friend in 1896 that he had "immersed" himself in the teachings of Lipps, "who I suspect has the clearest mind among present-day philosophical writers." Several years later, Freud thanked Lipps for giving him "the courage and capacity" to write his book *Jokes and Their Relation to the Unconscious.* He went on to advance Lipps's research further when he made the case that empathy should be embraced by psychoanalysts as a tool for understanding patients. He urged his students to observe their patients not from a place of judgment, but of empathy. They ought to recede into the background like a "receptive organ" and strive toward the "putting of oneself in the other person's place," he said.

Little known outside of specialist circles today, Lipps was a kind of intellectual celebrity and a highly sought-after speaker. On Friday nights he hosted a lively psychology club, where participants debated the distinction between actions and nonactions, and logicians pitted themselves against psychologists. For a time Lipps also edited an art journal that had the ambitious aim of chronicling the history of art, not dating back to the earliest paintings, but to the origins of creativ-

ity itself. When he was appointed chair of the University of Munich's philosophy department in 1894, thinkers and artists from around the Continent signed up for his classes. The Romanian artist Constantin Brancusi was a student, as was Wassily Kandinsky, from Russia. Lipps's foundational aesthetics course was also one of the first Rilke enrolled in upon his arrival from Prague.

BY RILKE'S OWN ADMISSION, he still felt like a child when he arrived in Munich. He moved to Schwabing, a district in the center of town known for a high concentration of students and artists. Apart from Lipps's class, he signed up for courses on Darwin and Renaissance art, taking an especially keen interest in the paintings of Sandro Botticelli, whose sad, pleading-eyed Madonnas seemed to "stand at the heart of the longing of our time."

Soon enough, Rilke found himself moving within social circles alongside Siegfried Wagner, the composer's son, and Jakob Wassermann, the German novelist. Wassermann introduced Rilke to the work of the Danish writer Jens Peter Jacobsen, whose book about a young "dreamer, floundering around in a slough of doubt and self-analysis," *Niels Lyhne*, would become an essential source of comfort to Rilke for years to come. But even this would not compare with the gift Wassermann gave him when, in 1897, he introduced the poet to Lou Andreas-Salomé. For a woman of any era, Andreas-Salomé's intellectual influence was extraordinary. For a radical Russian feminist in the nineteenth century, it was almost inconceivable.

Louise von Salomé, as she was named at birth, was an accomplished philosopher and writer, but today she is better remembered as a muse. She had rejected two marriage proposals from Friedrich Nietzsche, who once called her "by far the smartest person I ever knew," and another from Nietzsche's friend the philosopher Paul Rée. Although she didn't want to marry either man, she was fascinated by their minds and suggested they all live together in an intellectual "holy trinity." Astonishingly, they agreed.

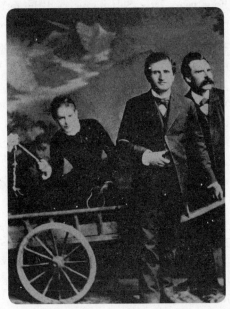

*Lou Andreas-Salomé
with Friedrich Nietzsche
and Paul Rée, 1882.*

A photo taken in 1882 to celebrate their "Pythagorean friendship," as Nietzsche called it, shows the two men hauling Salomé, then twenty-one, in a wooden cart while she brandishes a whip. The trio's amusement didn't last long, however, before jealousy set in and destroyed the union before it had a chance to materialize. Salomé decided that she wanted to spend the winter in Berlin with Rée alone. He was only too happy to comply, writing, "I really ought to be thinking about 'the origin of conscience in the individual,' but, dammit, I am always thinking about Lou."

Nietzsche, feeling betrayed and abandoned, met Rée and Salomé at a train station in Germany only to storm off and never see them again. He wrote a letter soon after to inform them that their cruelty had compelled him to take an "enormous quantity" of opium. But instead of committing suicide, Nietzsche actually retreated to northern Italy, where in ten days he wrote *Thus Spoke Zarathustra*, which includes the famous line thought to refer to Salomé, "Thou goest to women? Do not forget thy whip!"

Four years later, Salomé married the forty-one-year-old philolo-
gist Carl Andreas. (He, too, reportedly threatened to kill himself, if
she rejected him.) Her consent came with two considerable caveats,
however: no sex and no children. She was to remain free to continue
her affair with Rée or anyone else she might fancy, and Andreas could
also take lovers. She even offered to help introduce him to prospective
paramours. The arrangement did not always go smoothly—Andreas
fathered a child with their housekeeper, who lived with the couple for
the rest of her life—but they never parted.

Andreas-Salomé's main gift was her acutely analytical mind. She
had an uncanny ability to comprehend abstruse ideas from the era's
most formidable thinkers, often illuminating aspects of their own
arguments that they had not even conceived. She was a kind of intel-
lectual therapist: listening, describing, analyzing and repeating back
their ideas in order to illuminate the places where shadows fell in
their logic.

Rilke added himself to Andreas-Salomé's long list of admirers
almost from the moment he learned of her existence. He had just writ-
ten his "Visions of Christ" cycle, a Nietzsche-inspired challenge to
Christian dogma, when an editor friend suggested he read her essay
on similar themes, "Jesus the Jew."

As he pored over her words, an intimate literary kinship formed in
Rilke's mind overnight. Soon he began mailing her unsigned poems.
She did not learn who this anonymous correspondent was until the
spring of 1897, when she paid a visit to Munich. When Rilke heard she
was coming to town he convinced Wassermann, a mutual friend, to
stage an introduction over tea.

Andreas-Salomé, fourteen years Rilke's senior, arrived to Wasser-
mann's apartment in a dress of loose, cottony layers that softened her
muscular contours. She had a wide, Russian face and tied her ashy hair
in a tousled knot atop her head. Rilke quickly saw that she was a mes-
merizing storyteller. She commanded the room's attention with her
direct, matter-of-fact descriptions of people and places, yet, strangely,

she told narratives out of order, without regard to temporality or lin-
earity at all. Rilke gazed at her "gentle dreamy lost smile," while she
remarked later in her journal upon his soulful eyes. Less kindly, she
also wrote that he had "no back to his head."

Rilke was so instantly enraptured with Andreas-Salomé that he
wrote to his mother that night to tell her about meeting "the famous
writer." The next morning he wrote another letter, this time to
Andreas-Salomé, confessing that the late nights he had spent reading
her work had aroused in him a sense of intimacy: "Yesterday was not
the first twilight hour I have spent with you," he told her, adding that
he hoped he might one day read her some of his own verses. "I can
think of no deeper joy."

Andreas-Salomé was more compelled by Rilke's "human qualities"
than by his poetry at first. She could not remember the verses he had
enclosed in those early, unsigned letters, but she reread one of her
responses to them now and it led her to believe that she "must not have
liked them very much." She did, however, like Rilke's "manly grace"
and his "style of gentle but inviolable control and dominance." She
thought his physical appearance was in perfect accord with his person-
ality. Two weeks after their first meeting they took a weekend trip to
a Bavarian lake, where they immediately became lovers.

They spent the next several months together, with Rilke reading to
her by day, and Andreas-Salomé cooking borscht for him in the eve-
ning. He soon adopted her bohemian habits of walking barefoot and
eating a vegetarian diet. And he now shunned stiff professional attire
in favor of tunics and loose peasant garb.

Rilke felt for Andreas-Salomé the kind of reckless passion he
would later ascribe to young people who "fling themselves at each
other, when love takes possession of them, scatter themselves, just as
they are, in all their untidiness, disorder, confusion." Andreas-Salomé
did not return Rilke's unhinged adoration, but she began to genuinely
appreciate his talent and believed that the qualities she disliked in him
could be fixed with a little grooming. She began to mold the poet into

a version of himself that she found more attractive. She advised him to copy her courtly style of handwriting and to cultivate his masculinity. The name René was too French and feminine, she said, and suggested he change it to the sturdier, Germanic Rainer.

The poet hungered to become her creation. More than his first great lover, Andreas-Salomé was his confidante, his mentor, his muse, even a kind of mother—if not to the young man, then at least to the artist maturing inside him. "I am still soft, I can be like wax in your hands. Take me, give me a form, finish me," he wrote in an autobiographical story when he met her. Rilke welcomed her rechristening him with this enigmatic new name, which would take on an almost mythical identity of its own. To the author Stefan Zweig, the letters looked as if they ought to be hammered into fine threads of gold. "Rainer Maria Rilke," wrote another friend, "your very name is a poem."

Within the year, Rilke dropped out of the university in Munich to follow Andreas-Salomé to Berlin. Her native Russia was becoming a kind of mythopoetic symbol of the Slavic identity Rilke felt he had been denied growing up under the Austrian Empire. She had been teaching him the language, and he now hoped to learn it well enough to translate Russian literature.

In 1899, the pair took their first trip to Moscow together. To outsiders, the tall older woman and the meek young poet did not always register as a couple. The literary critic Fyodor Fiedler mistook Rilke for Andreas-Salomé's "pageboy," while the writer Boris Pasternak remembered a chance encounter at a train station with the poet and "his mother or older sister." To confuse matters more, Andreas-Salomé's husband joined them.

But the lovers paid no attention to the gossip. There was only one matter that concerned them in those days: to meet their shared idol Leo Tolstoy. It was no easy task. The novelist, by then retired and in his seventies, was not a welcoming man. He now only wrote bitter screeds denouncing modern art and the godless young people responsible for it. That might have served as a warning to his young visitors, but they were resolute. Andreas-Salomé called on some of her well-

placed Russian acquaintances and managed to secure an invitation to his house for tea.

When they arrived, the stooped old man greeted them grumpily. He was bald, with a white beard that had endured a lot of pulling and twisting. Almost immediately he started shouting at Andreas-Salomé in a rapid-fire Russian incomprehensible to Rilke. But it did not take long for him to figure out that the only reason Tolstoy had accepted the meeting was because he had taken issue with some of Andreas-Salomé's writing and wanted to tell her off. A devout convert to Christianity, Tolstoy told her that she overly romanticized Russian folk traditions in her work and warned her not to partake in peasant superstitions.

The conversation was interrupted by a man's shrieks in the other room. Tolstoy's adult son, noticing that Rilke and Andreas-Salomé's coats were *still* hanging in the hall, had cried out, "What! all the world is still here!" The intruders took that as their final cue to leave and rushed out the door, with Tolstoy ranting behind them the whole way. They could still hear his voice bellowing halfway down the street until finally the sound of church bells drowned it out.

Despite their traumatic introduction to Tolstoy, the pair decided to try and meet him once again the following summer. When they arrived at his country estate this time he gave them a choice between joining his family for lunch or taking a walk, just the three of them. Anyone acquainted with the Tolstoys knew that the only person sur-lier than Leo was his wife, Sophia, so the guests eagerly accepted the second option. A conversation about literature began benignly enough, but soon Tolstoy started raving about poetry as an impoverished art form. To make matters more awkward for Rilke, the man spoke almost exclusively to Andreas-Salomé, ignoring the poet altogether. Rilke later wrote in his diary that Tolstoy seemed to have "made a dragon out of life so as to be the hero who fought it."

Rilke might have been more devastated by Tolstoy's rejection had it not given him insight into his next project, a book of poetry in the form of a medieval prayer book. Once he returned to Berlin, he began

writing *The Book of Hours,* a chronicle about his search for a poetic god, which he would complete in three parts between 1899 and 1903. When the book came out, he inscribed a copy to Andreas-Salomé:

LAID IN THE HANDS OF LOU
for all time.
Rainer.

Rilke largely had her to thank for inspiring what would become the most prominent book of his lifetime. "You took my soul in your arms and cradled it," he later told her. Her emphatic criticism of his sentimentality had begun to strengthen his verses, while his passion for her drove him to write one of the headiest love poems ever written:

Put out my eyes, and I can see you still,
Slam my ears to, and I can hear you yet;
And without any feet can go to you;
And tongueless, I can conjure you at will.
Break off my arms, I shall take hold of you
And grasp you with my heart as with a hand . . .

In those days, Rilke might actually have enjoyed blindness if it meant that Andreas-Salomé would guide him. He relied on the care of others to what might seem a selfish degree had he not loved them back just as lavishly. But by the summer of 1900, his neediness started to annoy her. His letters stalked her everywhere she went. Once, in Russia, she left him behind for a few days to visit some family abroad and he threw a tantrum. A letter begging her to return contained some of his ugliest prose yet, she thought, and persuaded her only to stay away longer. Abandoned for ten days, Rilke sank into despair. When she returned to find him trembling and feverish, she announced that she would be returning to Berlin on her own; he ought to make his own plans. She had told him that she longed to "be more by myself, as I was until about four years ago," when they first met. But privately she

wished in her diary that she could tell him to "go away, *go completely away.*" To achieve that, "I would be capable of brutality. (*He must go!*)"

The impending separation devastated Rilke, but he did not dare defy her. The day after they returned to Berlin he accepted an invitation to visit a friend at an artist colony in northern Germany. It would give her some space for now, but, as Rilke's verse had promised, she would not be able to swat him away so easily. For the rest of his life, he would cry out to Andreas-Salomé whenever he couldn't write, or whenever he tumbled into recesses of himself so remote that he feared he might disappear forever. Each time, she would come, take him calmly by the hand and lead him back into the light.

CHAPTER
3

⚜

AFTER ABANDONING HIS STUDIES AT THE JARDIN DES PLANTES in the late 1850s, Rodin spent four years working as a trade sculptor and making his own art in the mornings and at night. He rented his first studio near the Gobelins tapestry factory, in an unheated, barely converted horse stable. It cost ten francs a month, which left him with nothing to hire models, who often earned as much in a few hours as he did in an entire day. Instead he was forced to make do with amateurs desperate enough to pose for his poverty rates.

For a little extra drinking money, an elderly Greek handyman known as Bibi was happy to offer his services to Rodin. The man had a broken nose and such a "terribly hideous" face that Rodin could hardly bear the thought of modeling it at first. It "seemed so dreadful to me," he said. But the man was cheap and already worked in the studios three times a week as a sweeper, so, beginning in the fall of 1863, Rodin faithfully began to sculpt one pit and furrow after another into a bust, treading across the clay as heavily as life had tread across Bibi.

Over the next eighteen months, Rodin started to notice occasional glimpses of handsomeness in Bibi's face. He had a nicely shaped head and, beneath the ravaged façade, there was a certain nobility to the bone structure. His was not entirely unlike the faces on view at

the Louvre, Rodin thought, so many of them also being Greek and timeworn.

The bust Rodin completed in 1863 was a radical departure from the polished portraiture of the day. Baudelaire wasn't being entirely hyperbolic when he provocatively titled an essay fifteen years earlier, "Why Sculpture Is Boring." Until then, sculpture had been made almost exclusively as decoration—filigree on a cathedral, for example, or a war memorial in a park. Before the latter part of the century, even the best new sculpture was still being mounted on the sides of buildings, like Carpeaux's drunken dancers on the façade of the Paris Opera. If a freestanding work made it into a museum, it was probably because its original habitat had been destroyed.

Whether Rodin knew it or not, his *Man with the Broken Nose* was a brazen affront to this long, unquestioned tradition. The unknown man's face would never have appeared on a monument or a building, except perhaps as a symbol of sin. But Rodin's Bibi was truly ugly, not allegorically ugly. He was a self-contained being, not intended as a denunciation of something else, as Rilke would later notice: "There are a thousand voices of torment in this face, yet no accusation rises. It does not plead to the world; it carries its justice within itself, holds the reconcilement of all its contradictions."

The 1864 Paris Salon seemed like the right time for Rodin to introduce the bust to the public. The names of his contemporaries—Monet, Cézanne, Renoir—were starting to become well known, even if they were not yet fully accepted by the establishment salons. Two-thirds of the submissions to the previous year's official salon were rejected, including Manet's scandalous *Déjeuner sur l'herbe*. But they went on view in a separate show, derisively dubbed the Salon des Refusés, which ultimately proved far more popular than the main event, and made Manet a cult hero.

But before Rodin had a chance to submit his bust to the jury that winter, the temperature in his studio dipped below freezing. The back of the terra-cotta head cracked off and shattered on the floor. When Rodin went to work one morning and saw the mess, he stared at it for

a long while and then decided it actually looked better this way. The mask now bore the reality of Bibi and Rodin's impoverishment on its surface, expressing the coldness of life in a most literal way.

Rodin submitted the work to the 1864 salon as a mask rather than a bust, but jurors rejected it that year, and again the following year. Rodin did not take the news as hard as he might have in the past. He knew the sculpture marked a crucial revelation, whether anyone else realized it or not. Bibi had taught Rodin that beauty was about truth, not perfection. "There is nothing ugly in art except that which is without character . . ." he would conclude. The human being, flawed creature that it is, cannot relate to perfection. But people can empathize with scars, wrinkles and lines, which together add up to the semblance of a lifetime.

"The mask determined all my future work," Rodin later said. "It was the first good piece of modeling I ever did." As he started to acknowledge his talent, he also realized that it came, like many gifts, with a catch. Artistic gifts had to be shared with others or else they lost their worth. The burden fell on him to find an audience and to make seen that which is inherently invisible. As such, many gifts go unrealized, while the gifted go on suffering, carrying the absence inside them like an unreturned love. Rodin, like Rilke, spent his youth crushed under the weight of his gift's imperative. It was not until 1864 that he met the woman who would act as his witness and committed guardian for life.

ROSE BEURET WAS EIGHTEEN and already a seasoned laborer when she met the twenty-four-year-old sculptor in 1864. She had recently moved from her family's vineyard in Champagne to take a job as a seamstress. Down the street from Rodin's studio, Beuret was stitching flowers to adorn ladies' hats while he was sculpting them out of stone for a new opera house, the Théâtre de la Gaîté, which was being built to replace the one Haussmann tore down on the Boulevard du Temple, or, as it had become known, the "Boulevard of Crime."

Beuret had dusty brown hair that curled around the edges of

her bonnet. She had a tough, tense face and easily agitated eyes that impressed Rodin from the start. "She didn't have the grace of city women, but all the physical vigor and firm flesh of a peasant's daughter, and that lively, frank, definite masculine charm which augments the beauty of a woman's body." He invited her to model for him at once. Beuret, probably welcoming the extra income and a friend in the city, gladly agreed.

She came to the job as "tough as a cannon ball," Rodin said. She posed in his cold studio for hours with one arm stretched downward, as if setting a mirror on a nightstand, and the other sweeping up her hair. "I had put into her all that was in myself," he said of the figure he made in Beuret's likeness, which was to become his first life-sized figure, titled *Bacchante*. Rodin worked on it on Sundays and in the mornings before reporting to his job sculpting clay maquettes for the popular Romantic artist Albert-Ernest Carrier-Belleuse. While he was saving the money to have *Bacchante* cast, he set it aside and moved on to other projects. Eventually, he filled his studio and needed to relocate to a larger space. As the movers carried his patient *Bacchante* away, the figure started to wobble in their arms and fell to the floor. When Rodin heard the crash he ran toward the sound and, to his horror, saw that "my poor bacchante was dead."

The flesh-and-blood Beuret would not depart so easily, however. After her first modeling session, "she attached herself to me like an animal," Rodin said. The pair soon became lovers and formed a formidable partnership built around their labor. Sculpting was Rodin's job; Rodin was hers. She became his best studio assistant, posing for him in the mornings, then returning again at night to cover the unfired mounds of clay with damp rags to keep them from drying out. She continued working as a seamstress on the side and, every once in a while, Rodin helped her sew buttons.

Rodin was loath to admit how much he depended on Beuret. When asked about their relationship he would say with a shrug, "It is necessary to have a woman." But he didn't believe a man needed a wife, so when she gave birth to their son out of wedlock in 1866 the boy's birth certifi-

cate read Auguste-Eugène Beuret, father "unknown." Nonetheless, they remained together for the rest of their lives, with Beuret acting as Rodin's chief adviser, partner, lover and, ultimately, the sustainer of his gift.

RODIN WENT TO GALLERIES as an observer over the next decade. Eleven years had passed since the Paris Salon rejected his *Man with the Broken Nose*, and he had not submitted another work since. Sensing that an artist could stake a career on a single statue, he was determined to return only when he had realized a masterpiece.

He was confident in his technical abilities, but unsure of how to synthesize his miscellaneous education into a proper life-sculpting practice. Lecoq had taught him the rules of attention; Barye taught him movement; but still no one had taught him the human form. So, in 1875, he went to Italy to learn straight from the source: Michelangelo.

He packed a bag with French sausage so he wouldn't have to eat the seemingly iron-deficient Italian cuisine, and then boarded a train. He took the scenic route, passing through France and Belgium to see the Gothic cathedrals along the way. "Dinant is picturesque, but Reims, its cathedral, is of a beauty I have not yet encountered in Italy," he wrote to Beuret.

All of Florence was celebrating Michelangelo's four hundredth birthday when Rodin arrived that winter. He visited the Medici Chapel, where Michelangelo's statue of Lorenzo de Medici sat in a contemplative pose much like *The Thinker* would. He went on to examine the contours of every Michelangelo figure he could find in Florence before traveling on to Rome to see the paintings at the Sistine Chapel. The experience totally destabilized Rodin. Every decision Michelangelo made seemed to run counter to what Rodin had learned from the Greek artists at the Louvre. " 'Hold on!' I said to myself, 'why this incurving of the body? Why this hip raised, this shoulder lowered?' " Yet he knew Michelangelo would not have miscalculated.

Now that he was a student again, Rodin re-created Lecoq's old exercises, filling his notebooks with sketches "not directly of his works,

but of their scaffolding; the system I'm building in my imagination in order to understand him," he wrote to Beuret. Gradually, "the great magician is letting me in on some of his secrets."

When Rodin returned home a month later, he was brimming with ideas. He set to work at once on the statue that would finally win him entrée into the salons. He found his model in a young Belgian soldier with a graceful musculature. The man posed with one fist clutching a spear-like rod, the other hand raised to his head as if in distress. Rodin examined his form obsessively, from the front, back and sides, then in three-quarter profiles. He climbed up a painter's ladder to capture the view from above, then crouched on the floor to look from below. He spent three months on one leg, and altogether a year and a half modeling each successive contour inch by inch.

The result was an uncannily realistic plaster man, which Rodin titled *The Age of Bronze*. His eyes half closed, this was someone who had seen something terrible, as if he had just come upon the slain body of his lover, or as if he realized that he was the one who had killed her. Rodin eventually removed the spear in order to preserve an unobstructed view of the figure's profile, a decision that only added to the already enigmatic pose.

The salon admitted *The Age of Bronze* in 1877. It was received with such enthusiasm that the French government asked to purchase a version of it for the city. But then the salon opened in Paris and Rodin's fastidious accuracy backfired. Critics complained that *The Age of Bronze* was *too* realistic. It was a "study rather than a statue, a too servile portrait of a model without character or beauty; an astonishingly exact copy of a low type," wrote Charles Tardieu in *L'Art*. Others went further and accused Rodin of casting it directly from the body, a dishonorable process known as *surmoulage*.

The government sent experts to inspect the work in person. They concluded that even if it was not a life cast "in the absolute sense of the word, casting from life clearly plays such a preponderant part in it that it cannot truly be regarded as a work of art."

Of all the insults Rodin would endure in his long, controversial

career, the charge of *surmoulage* would rank among the most vicious. It was tantamount to accusing a writer of plagiarism. "I am literally bruised in body and in spirit," he told Beuret. But he did not show it in the passionate letters of defense he sent to newspapers. He begged officials to look at photographs of his model; they would see that the man was slightly heavier in real life than in the sculpture, proving that it could not be a cast. He rallied a group of the day's leading sculptors, including Alexandre Falguière and Rodin's former boss Carrier-Belleuse, to sign a statement refuting the charges of *surmoulage*. They went on to further praise the statue as an example of "a very rare power of modeling, and even more of great character."

Finally, after three years, the testimony convinced the newly appointed arts undersecretary Edmond Turquet. In 1880, he reissued the state's order for the work in bronze. In an added gesture of goodwill that year, Turquet gambled on the untested artist by awarding him a second commission. The city was planning to build a new Museum of Decorative Arts and sought an artist to design the entrance.

Rodin saw the commission as an opportunity to prove himself as more than a mere decorator. Although the task required him to make ornamental doors, he would propose the most monumental doors Paris had ever seen: a twenty-foot-tall bronze gate with more than two hundred tiny nude figures inspired by Dante's *Divine Comedy*. The idea had been simmering in his mind since he had seen Lorenzo Ghiberti's bronze cathedral doors the *Gates of Paradise* in Italy, as well as Michelangelo's series of half-carved slaves struggling to break free from their marble prisons. After Rodin had returned home he found himself rereading the *Divine Comedy* so often that he kept a copy tucked in his back pocket.

The state accepted his design and awarded him eight thousand francs and a free studio in the government-owned Marble Depot. It wasn't enough to allow him to quit his day job at a porcelain factory in Sèvres, where he would spend a decade manufacturing vases. But it marked the birth of the *Gates of Hell*, the project that would consume him for the rest of his life.

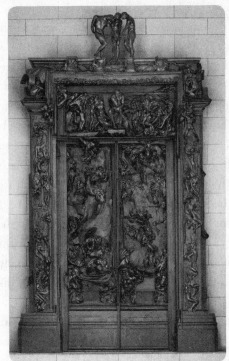

Rodin's Gates of Hell
as later cast in bronze.

STONE SLABS LITTERED THE grassy courtyard of the Marble
Depot, some tipped over whole, others half carved, then discarded.
The studio complex was situated between the Rue de l'Université and
the edge of the Seine, on a sliver of land once known as the Isle of the
Swans. The state sent the stone remains of deposed kings and dam-
aged military monuments to the site, where they awaited conservation
after the wars. Many languished there for so long that sculptors even-
tually salvaged them for parts.

Rows of studios lining the perimeter of the courtyard were reserved
for artists working on official state commissions. In 1880, Rodin moved
into Studio M, which he shared with a younger artist, Joseph Osbach.
As the *Gates* grew bigger and bigger over the years, he would take
over Studio H and Studio J, too.

Blocks of damp clay gave the studio a cold wet air. The only

source of heat came from a small cast-iron stove. But it was a vast improvement over Rodin's old studio in the stable and he set to work "with a fury." The vision had been throbbing in his head "like an egg ready to hatch." Now that the state had supplied him the chisel to crack open this cache of accumulating images, he began by bringing to life Ugolino, the starving father who gnawed the flesh off his own children in the lowest circle of hell, and the adulterous lovers Francesca and Paolo. He considered seating a Dante on a rock in front of the couple, but then decided that would be a too obvious reference to the text, which he didn't want to slavishly illustrate.

Instead of representing a famous figure, he opted to make it an anonymous man. He would situate him at the top of the *Gates*, with "his feet drawn under him, his fist against his teeth." He would not be engaged in any heroic act; he would simply be thinking. "The fertile thought slowly elaborates itself within his brain. He is no longer dreamer, he is creator," Rodin said.

Rather than beginning with the feet and working from the ground up, Rodin started with the torso. He roughed out a small C-shaped spinal curve in clay to get a sense of the muscular proportions. The right shoulder leaned down toward a raised thigh, mirroring the contours of Apollonios's ancient *Torso of Belvedere*, the extraordinary marble fragment that sculptors have been copying since the Renaissance. Rodin then modeled increasingly detailed maquettes until he completed a twenty-seven-inch figure. In later years he had his plaster and bronze technicians triple it in size to seventy-nine inches.

Rodin originally titled the figure *The Poet*, possibly after Dante or Baudelaire. (Rodin had drawn an early sketch of the sculpture in the margin of a *Fleurs du Mal* poem that told the story of a writer who sat on a rock trying to maintain his concentration while a woman wearing nothing but jewelry paraded her flesh before him.) Or Rodin may have meant the title in the ancient Greek sense of the word *poïesis*, which referred to the poet not merely as a verse writer, but as a kind of magician, philosopher, sculptor or any other creator.

The Thinker, as Rodin ultimately renamed the figure, was in part a young sculptor's exploration of what it looked like to be an artist. To Rodin, the artist was a laborer, and the sculpture paid homage to that struggle. The figure is so immersed in concentration that it bears down upon his entire body, burrowing into the trench of his brow, bowing his neck. His shoulders stoop like Atlas's but the global burden he carries is that of his own head. A palm collapsed against his jaw, he does not speak; eyes cast down, he does not see the suffering all around him. While typical statuary glorified war heroes and aristocrats, this anonymous figure paid rare tribute to the common man. It was a prayer pose for the modern artist.

The photographer Edward Steichen sealed the mythology of *The Thinker* as a self-portrait of Rodin a few years later with an image that now hangs in the Metropolitan Museum. It shows Rodin standing before the sculpture with his own fist propped under his chin. The photo's dark exposure blurs the boundaries between the man and the material, recasting them as persona and alter ego, rather than artist and creation. Shadows envelop the two figures from the neck down, as if their diaphanous bodies had gathered solely to support the weight of their mighty heads. Rilke later wrote that *The Thinker*'s "whole body has become head and all the blood in his veins has become brain."

Rodin mounted a version of *The Thinker* onto the fifteen-foot-tall wooden frame that would become *The Gates of Hell.* When visitors asked about the mass of wood taking up all the room in his studio, he would reply, "It is my door." Often by candlelight, Rodin modeled its reliefs and figures in clay before attaching them to panels on the armature. He made them too small for anyone to question whether they were cast from life, but big enough to show off his figurative skills. He used his knowledge of Gothic architecture to arrange the wailing lost souls into sculptural configurations that manipulated shadow for the most dramatic effect. He stretched and distended the bodies, as if their insides were being drawn out of them.

Although the *Gates* are widely considered Rodin's crowning achievement, he never actually completed the work. It just kept growing and accumulating detail, eventually reaching more than twenty feet high and thirteen feet wide. He showed a plaster version in 1900, but otherwise he worked on it for thirty-seven years without ever seeing it cast in bronze as intended. More lucrative commissions caused delays and he claimed he could never find enough help. Every assistant he hired was either too talented to stick around or not talented enough to retain.

In truth, Rodin was an unrelenting tinkerer. He may have had the hands of a genius, but his mind was "a mishmash of Dante, Michelangelo, Hugo, Delacroix," wrote Edmond de Goncourt upon a visit to Rodin's studio two years into his work on the *Gates*. To Goncourt, the epic jumble looked like a coral reef and Rodin seemed to be "a man of projects, sketches, fragmenting himself in a thousand imaginings, a thousand dreams, but bringing nothing to complete realization."

THERE WAS ONE OTHER persistent diversion in Rodin's life then: the young sculptress Camille Claudel. In 1882, Rodin took over teaching a small Friday afternoon art class as a favor to his friend Alfred Boucher, who was leaving for a research sabbatical in Florence.

It is not hard to imagine what the artist saw in the talented student with warm chestnut hair and cold blue eyes. She had a frank, some might say savage, disposition—sighing loudly when bored and muttering comments under her breath in a strong country accent. She struck many as rude, but to Rodin she was irresistible. In a playful questionnaire she filled out at the time, she displayed her defiant charm:

> Your favourite qualities in man:
> *To obey his wife.*

Your favourite qualities in woman:
To make her husband fret.
Your favourite virtue:
I don't have any: they are all boring.

It is equally understandable why the eighteen-year-old girl did not immediately return the affections of her forty-two-year-old teacher. Encouraged by a teacher to pursue her art in Paris, she had just moved with her family from a rural village in France to the heart of Montparnasse. Surrounded by artists in nearly every unit of her apartment building, for the first time she wasn't an outsider. In the scheme of all this excitement, her middle-aged teacher probably did not rank terribly high. Compared to the artistic possibilities that now lay before her, marriage and motherhood were of trivial significance.

But within a year, Rodin had fallen desperately, pathetically in love with Claudel. At times when she refused to see him, he found excuses to call on her friend who he thought might be with Claudel. "Have pity, mean girl. I can't go on. I can't go another day without seeing you," he wrote to her in 1883.

Despite their substantial differences, Claudel and Rodin were bound by a few undeniable affinities. He genuinely believed in her talent and took every opportunity to promote her professionally. Meanwhile, Rodin's "rapid and luminous suggestions" about Claudel's art began to impress the young artist. They shared a devotion to work, and the belief that it deserved primacy above all else.

In 1885, Rodin needed to hire help to complete a major new commission. *The Burghers of Calais* was to be a memorial for six men from the French port town who offered up their lives in a bargain to save their fellow villagers from English siege in the fourteenth century. For the first time, Rodin enlisted women to assist him in his atelier— Claudel and her friend Jessie Lipscomb.

Claudel quickly became Rodin's top assistant, both on the *Burghers* and the *Gates*. While the other assistants chatted and smoked

cigarettes around her, she stayed concentrated, quietly sculpting the little hands and feet that Rodin entrusted to her alone. By the following year, Claudel and Rodin were madly in love. Their relationship reached such an intensity that Rodin wrote a contract for Claudel promising not to teach or sleep with other women. He pledged to leave Beuret and take Claudel to Italy for six months, after which they would marry.

During the years of his relationship with Claudel, Rodin's interest in women expanded more generally, both as subjects for his art and in life. His social circle widened to include more progressive artists, many of whom had married women who were accomplished in their own rights. Female forms began appearing more frequently in Rodin's sculpture, too, sometimes bearing Claudel's visage. He experimented with erotic positions, such as the life-sized marble lovers in *The Kiss*, completed in 1889. The man and the woman are locked in an embrace so intimate that an observer can walk around the entire sculpture and never find an entry point to view their faces. Divorced from the prying eyes of outsiders, the couple form their own private universe, just as Claudel and Rodin had done, at least for a little while.

AS RODIN TURNED FIFTY, his work baffled critics more than ever. They did not know how to categorize this figure who had not attended the Grande École and had never apprenticed to a living master. More bizarrely, he seemed to embrace his amateur qualities. Rather than correcting or covering up mistakes, he highlighted them.

But while critics watched askance, artists were quicker to appreciate Rodin's talent. Paul Cézanne was such a fan that, upon their first meeting in 1894, he was reportedly moved to tears. They were at Monet's house in Giverny with Octave Mirbeau, Gustave Geffroy and Georges Clemenceau when Cézanne gushed to Geffroy, "He's not proud, Monsieur Rodin; he shook my hand!" The painter, then

fifty-five, stooped to one knee to thank the sculptor for gracing him with the gesture.

Stefan Zweig held Rodin in similar reverence. While visiting the sculptor in his studio, the Austrian writer watched as he started to make little adjustments to a bust he had been working on. He was supposed to be showing Zweig around, but became so absorbed in the work that he forgot about his visitor altogether. When he finally looked up, he was startled to see Zweig standing there. The sculptor started to apologize, but Zweig stopped him short. "I merely grasped his hand in gratitude. I would have preferred to kiss it."

When Émile Zola was appointed head of the Society of Men and Letters in 1891, his first order of business was to award Rodin a commission for a monument to Honoré de Balzac. Zola thought it was a disgrace that there was still no monument to the great naturalist writer three decades after his death. He could think of no better candidate for the job than Rodin, the great naturalist artist who was sometimes labeled, derisively, the "Zola of sculpture." Critics considered both men "touched by erotic madness" and promoters of a crude, warts-and-all realism.

When Rodin agreed to the commission he did not say what the statue would look like, quite possibly because he didn't have a clue himself. He still had to conduct extensive research, beginning with a trip to the author's hometown, and then locate a model with just the right physiognomy. At the same time, he was completing several other monuments to French genius, to Hugo, Baudelaire and the painter Claude Lorrain.

Delaying matters further, he and Claudel were fighting worse than ever. As Rodin's fame grew during these years, so did attention from his models and other admirers. Claudel felt that he had allowed these outsiders to encroach on their sacred privacy, and her jealousy flared up more and more. She had also begun to doubt whether he would ever fulfill his promise to leave Beuret.

Beuret was keenly aware of Rodin's affair with Claudel. Although

it tormented her, she preferred to look the other way rather than sur-
render him altogether. But unlike with his previous infidelities, she
sensed for the first time that Claudel posed a serious threat and she
knew she couldn't just stand by. The two women became bitter rivals,
with Beuret once reportedly pulling a gun on the young mistress
after catching her spying from the shrubs outside their house. Clau-
del, meanwhile, gave Rodin a series of drawings depicting Beuret as a
broomstick-wielding ogress and, in another, a feral beast crouched on
all fours. Rodin often appears in them, too—shackled, shriveled and
stripped nude. Rodin pretended that the situation was entirely out of
his hands. He had no problem continuing separate relationships with
both women, and couldn't fathom why Claudel couldn't appreciate that
she was the favored one.

Eventually the resentments and failed promises became more
than Claudel could bear. Her emotions had started consuming all
of her energy and distracted her from work. By 1893, she felt she
had lost something of herself in Rodin and initiated a separation.
Rodin, devastated but unwilling to put up a fight, slunk quietly
away and began looking for property outside of Paris for himself
and Beuret.

Ending the relationship with Rodin proved to be only the begin-
ning of Claudel's troubles, however. Emerging from beneath the
massive shadow he had cast over her career proved far more compli-
cated. Her reputation as his mistress was by then well known, and
that made it nearly impossible to carve out a style for herself that did
not remind people of his. Her strategy was to confront the rumors
head-on and speak out unreservedly about the ways he had taken
advantage of her vulnerability, as a much younger woman and as an
aspiring artist.

Much to Claudel's horror, Rodin continued trying to promote
her career. A year after their split, he visited an exhibition that
included one of her busts and announced to the press that it had "hit
me like a blow of the fist. It has made her my rival." For years he
went on quietly securing her jobs and exhibitions behind her back.

When Claudel found out that his influence had factored into one commission, in 1895, she turned the work into a withering rebuttal. She spent four years crafting the three life-sized bronze figures into an elaborate revenge fantasy: A winged hag drags a feeble old man, one of his arms hanging back in the direction of a nude woman, who has fallen to her knees. The girl reaches out for the man, imploring him to come back. But it is too late, the she-beast has him in her claws for good.

When the work, titled *The Age of Maturity*, debuted in 1902, already tense relations with Claudel's family worsened. Her mother and sister blamed her for tarnishing the family name. Her brother, the Christian poet Paul Claudel, described his horror at seeing the sculpture for the first time: "This young nude girl is my sister! My sister Camille, imploring, humiliated, on her knees; this superb, this proud young woman has depicted herself in this fashion."

Claudel locked herself up in her studio for nearly twenty years. Worried she'd forget how to speak, she took to talking to herself. Rodin's covert machinations on her behalf fueled a paranoid belief that he was following her and stealing her ideas. She lived in filth and impoverishment until, in 1913, her brother committed her to a mental institution. He was convinced that the demon from *The Age of Maturity* had ripped more than Rodin from her. It had torn away "her soul, genius, sanity, beauty, life, all at the same time."

Others were not so sure of her insanity, however. Several friends who visited Claudel reported back that she seemed in full possession of her wits and wanted nothing more than to return home. A number of letters she wrote at the time suggest the same. "I am so heartbroken that I have to keep living here that I am no longer human," she wrote to her mother in 1927. She could not understand why she was the one being punished when it was Rodin, an old "millionaire," who had exploited her. Yet her pleas went unanswered and she remained at the asylum for thirty years, until she died at age seventy-nine. She was buried there in a mass grave.

Perhaps even more tragic, however, is the reality that Claudel suc-

cumbed to her greatest fear, that her name would be eternally entwined with Rodin's. During her lifetime alone, the affair became popular tabloid gossip and fodder for dramatic works like Henrik Ibsen's 1899 play *When We Dead Awaken*. After Claudel's death, her brother donated many of her works to the Musée Rodin, which today houses the largest collection of Claudel's sculptures in the world.

CHAPTER
4

❊

I N THE TWENTY-FIVE YEARS LEADING UP TO THE TURN OF
the century, the population of most major European cities doubled, if
not tripled. Writers took to describing the rapid urbanization in terms
of disease. The smog-engulfed metropolis became a festering sore,
oozing sewage into the rivers, sulfurizing the air and breeding bac-
teria as residents piled on top of each other in apartment complexes.

A fear of contagions bred citywide panic, and soon panic itself
became a disease. As medical schools began to introduce a condition
known as hysteria, thought to be caused by the uterus, more than five
thousand mentally ill, epileptic, poor or otherwise incurable women
in Paris were banished to the Salpêtrière, a former gunpowder factory
turned hospital next door to the Jardin des Plantes.

Some would have called it a death factory. "Behind those walls, a
particular population lives, swarms, and drags itself around: old peo-
ple, poor women, *reposantes* awaiting death on a bench, lunatics howl-
ing their fury or weeping their sorrow in the insanity ward or the
solitude of the cells . . . It is the Versailles of pain," wrote the journalist
Jules Claretie. Patients slept three or four to a bed. Its own director
called it "the great emporium of misery."

Presiding over this hell was Jean-Martin Charcot, the founding

father of neurology, who earned the nickname "Napoleon of Neuro-
ses." He transformed the Salpêtrière from a "wilderness of paralyses,
spasms and convulsions" into a leading teaching and research hospital.
Charcot was a brilliant scientist, but he bellowed from the pulpit of his
morning lectures like a snake-oil salesman. Crowds lined up early to
see him conduct live hypnotisms and tame hysterical women onstage.

In 1885, Charcot's lectures attracted a young neurologist from
Vienna, Sigmund Freud. "Charcot was perfectly fascinating: each of
his lectures was a little masterpiece in construction and composition,
perfect in style, and so impressive that the words spoken echoed in
one's ears, and the subject demonstrated remained before one's eyes
for the rest of the day," he said. Freud's studies with Charcot derailed
him from his research-based track and he returned to Vienna ready to
embark on a clinical path. He spread Charcot's theories on hysteria to
his colleagues and would soon incorporate them into his own inven-
tion, psychoanalysis.

Freud described Charcot as a *visuel*, "a man who sees." Because
Charcot had been unable to pinpoint a neurological basis of hysteria, he
focused instead on its symptoms—on the way it *looked*. He diagnosed
by intuition. An amateur artist, Charcot drew illustrations of some of
hysteria's most common manifestations: contorted facial expressions,
convulsive tics, strained postures. Charcot accumulated so many casts
and illustrations of tormented bodies during his career that he eventu-
ally opened the Charcot Museum, one of several anatomical museums
that were launched in response to the growing fascination with dis-
ease and decay in those days. The institutional context lent a scientific
authority to a process of observation and representation that might
otherwise have been considered purely artistic.

Seeking to bridge this gap between art and science, Charcot wrote
a book diagnosing characters in historical paintings and, by extension,
the artists themselves. His disciple Max Nordau went on to become a
best-selling author with a book that similarly medicalized degener-
ate art. He claimed that the Impressionists were hysterics with dull
vision and stunted color perception, which explained why Puvis de

Chavannes painted in "whitewash" and Paul-Albert Besnard used "screaming" primary colors.

Gradually, hysteria shifted from a purely clinical condition to a cultural one. Zola wrote twenty novels about the nervous decline of a family in his Rougon-Macquart series. Rodin's vision of Dante's hell in the *Gates* mirrored the realities of life in Paris at the *fin de siècle*. The twisted figures pantomimed Charcot's illustrations of agonized ambivalence and neuroses. In Rodin's inferno, the inhabitants were everymen living in a nightmare of their own earthly passions. Love was war, desire undid reason. To him, hell had nothing to do with justice; punishment was the condition of the living.

ALL THROUGHOUT HIS drawn-out heartbreak with Camille Claudel, Rodin was meant to be working on the monument to Balzac. He had promised to deliver it within eighteen months, but it ultimately took him seven years. He had started with a series of naturalist studies of Balzac, but threw them all out when he decided that the man's physical appearance did not adequately express his genius. It was the same false start he had made with *The Thinker*, in which he had attempted to portray the writer, Dante, rather than the mind behind it.

In another version, Rodin tried to convey the essential nature of Balzac's creativity with a nude version of the man gripping himself at the source of masculine "creation," but nudity seemed too disrespectful. Still another pose looked too academic. The neck was too weak at first, then too strong. At last Rodin concluded that draping Balzac in his dressing gown was the only truthful way to depict him.

"Does an inspired writer dress otherwise when at night he walks feverishly in his apartment in pursuit of his private vision?" Rodin explained to one of his biographers. "I had to show a Balzac in his study, breathless, hair in disorder, eyes lost in dream . . . there is nothing more beautiful than the absolute truth of real existence."

Rodin's statue was once again *too* truthful, however, for many of those who attended its debut at the 1898 Salon de la Société Natio-

nale. The *Balzac* was billed as one of the event's top attractions and lured many of the author's fans who might not otherwise have visited the art show. But to their horror, they found not their beloved *littérateur* posing obediently with a book in hand, but a colossal monster—with something very different in his hand. Rodin's Balzac had meaty lips, sagging jowls and a belly that bulged out from under a shapeless bathrobe. Critics were gleefully appalled: Was it a melting snowman? A slab of beef? A penguin? A lump of coal? they asked. Why was he wearing a hospital gown? And was he fondling himself under that robe?

Rodin's Monument to Balzac, *as photographed by Edward Steichen in 1908.*

It was too much even for those who wanted to give Rodin the benefit of the doubt. "Help me find something beautiful in these goiters, these growths, these hysterical distortions!" wrote one critic of his attempt to see what Rodin's followers saw. Alas, "I did not, and I've covered my forehead with ashes. I shall never belong to the Religion."

The members of the society that commissioned the work—with whom Zola had pleaded to maintain patience and faith during the years of delays—rejected it on the spot.

Rodin's friends again rushed to his defense. Monet praised the "absolutely beautiful and great sculpture" and urged Rodin to ignore *tous ces imbéciles.* Its head was "gorgeous," said Oscar Wilde. Toulouse-Lautrec, Maillol, Debussy, Baudelaire and Anatole France also added public declarations of their support. Noticeably absent from this chorus was Zola, who did not sign the letter expressing "the hope that in a country as noble and refined as France, Rodin would not cease to be treated with the consideration and respect to which his great integrity and admirable career entitle him."

By now Zola was retired from his post at the society and thoroughly embroiled in a scandal of his own. The French military had sent an innocent Jewish army captain to a penal colony on Devil's Island four years earlier on the charge of treason. But an investigation revealed that the man convicted, Alfred Dreyfus, was not the spy and had been framed by an anti-Semitic intelligence chief trying to protect the real culprit and the military's reputation.

Zola wrote an impassioned four-thousand-word exposé demanding that Dreyfus's case be reopened. The newspaper *L'Aurore* published it on its front page under the headline *"J'Accuse!"* The explosive letter polarized intellectuals in France into bitterly opposing factions. Cézanne, Edgar Degas, and Paul Valéry sided with conservatives in their case against Dreyfus, while Monet and Marcel Proust supported Zola, who became the face of the pro-Dreyfusard left. When a court sentenced Zola to a year in prison for libel, he fled to England.

The debate raged on for more than a decade, yet Rodin never once spoke out in support of his old friend and ally. It is unclear whether Rodin espoused anti-Semitic views or simply wished to remain apolitical. He almost never voiced opinions about news that did not directly affect him. Friends were often astounded at the things he did not know about contemporary culture, like who Charles Darwin was. Sometimes his ignorance offended them, as it did Zola, who never forgave Rodin for failing to support him during the worst years of his life.

Oddly, the *Balzac* benefited from Rodin's association with Zola

all the same. Many of the sculptor's biggest supporters were pro-Dreyfusards who did not know about his falling-out with Zola. Many came to see the embattled *Balzac* as a symbol of the wrongfully accused and associated it with Dreyfus. Private collectors began making Rodin offers to buy the sculpture, while an English artist society tried to convince Rodin to let them show it in London.

In the end Rodin had the last word. He decided not sell *Balzac* at all. He issued a statement saying that the work was too important to him and "I have made up my mind to remain the sole possessor of my statue." Although he admitted that the society's decision not to buy it would cause him "financial disaster," he claimed he was too old to defend his art anymore.

IT IS PLAUSIBLE THAT Rodin refused to "defend" his art not because he was too old, but because he knew he didn't really have to. The French may not yet have embraced him wholeheartedly, but the English adored him more than ever. The year of the *Balzac* debut, England was home to ten casts of the *Man with the Broken Nose*, while no one in France owned one. Meanwhile, the patron William Rothenstein, who would become one of the artist's greatest champions in England, organized a show of Rodin's erotic drawings to go on view the following year at his new London gallery. Rothenstein found the works both classical and prophetic, anticipating a dimension of sculpture that not even Rodin had yet dared to broach.

The English also placed a higher value on bust portraiture then. "Motor cars and hunters are passing things and drop into wreckage: but a bust outlasts Rome," the London writer George Moore told Lady Nancy Cunard, urging her to order one quick, for Rodin was aging. "When Rodin's hand begins to fail and his eye begins to see less clearly there will be no more sculpture. The opinion of every artist is that no sculpture has been done since antiquity that for beauty of execution can compare with Rodin's," Moore said.

Young English artists began migrating to Paris to study with the

maitre. Alphonse Legros, Rodin's old friend and classmate under Lecoq, was now a professor at the Slade School of Fine Art, and he helped connect his Paris-bound students with Rodin for private tutoring. Among them was the English poet Robert Browning's son, Pen Browning. Under Rodin's instruction, the boy sculpted a small bronze Apollo next to a nymph. It so impressed his father that Browning took Rodin to dinner to thank him. "Like Rembrandt, he makes misery live, and finds beauty and poetry even in age-bowed backs," he said of Rodin.

Teaching came naturally to Rodin, whose childhood dream was to become an orator. While at boarding school in Beauvais, he sometimes practiced speaking in front of an empty classroom. One day some of the other boys caught him between classes, sitting in the teacher's chair, lecturing and gesturing to no one. The boys watched from the doorway until their snickering startled Rodin back to reality.

Now that the international demand for Rodin's teaching had grown so high, he found himself in a position to open his own school. In the fall of 1899, he and two former assistants, Antoine Bourdelle and Jules Desbois, established the Institut Rodin on the Boulevard du Montparnasse. This time every seat in the classroom was filled, with thirty students signing up as soon as it opened enrollment.

"Once you had seen him, once you had talked to him, you wanted to go to work right away," said one student of Rodin. *Kunst und Künstler* magazine soon speculated that the Institut Rodin could pose a serious threat to the Grande École. Nothing could have pleased Rodin more. He had never forgiven the academy for shutting him out and now he had a chance to turn young minds against its rigid traditions.

Rodin's wasn't the only new institution challenging the Grande École's long-standing sovereignty over art education in Paris. Other artist-led programs, like the Julian and Colarossi academies, were launched as alternatives as well—and they, too, opened their doors more widely to women and foreign students. Among those who enrolled in the Institut Rodin's first class was the American artist Sarah Whitney, the Scottish artist Ottilie McLaren and the German sculptor Clara Westhoff.

———

HAILING FROM THE northern town of Bremen, Westhoff was awkwardly tall, with a heavy jaw and dark eyes. She had features as still and shadowy as a woodland, and kept nearly as quiet. At seventeen, she went to study sculpture in Munich, where she met the older painter Fritz Mackensen. When he told her about a reclusive artist colony he had founded in the village of Worpswede, near her hometown, she followed him there. The introverted sculptor felt at ease amid the majestic moors and fellow misfit artists for a while. But by the time she turned twenty-one, she knew she was too ambitious to stay in the tiny colony forever.

When Westhoff heard that the great sculptor Rodin had opened his own academy in Paris, she packed her bags at once. In the winter of 1899, she hiked up five flights of stairs to her tiny hotel room in Montparnasse. At that time most of the city's artists still lived in Montmartre, a rustic, hilly territory only incorporated into modern Paris thirty years earlier. Bohemians had colonized it for its cheap rents and cheap thrills, like the cabaret Le Chat Noir, and Le Moulin Rouge, with its famous windmill façade that mimicked the actual windmills of Montmartre. But tourists soon began to crowd these theaters of "authentic" Parisiana and landlords cashed in. Suddenly they demanded their rents be paid on time—and not on credit, on canvas or in verse. The gentrification of Montmartre set in motion a great southward migration toward Montparnasse. The year before Westhoff arrived, the Dôme opened to join La Closerie des Lilas as the first of many cafés that would soon serve the throngs of loafing "Montparnos" on their way.

Westhoff's best friend from Germany, the painter Paula Becker, moved into the room next door a few months later. The night she arrived, they stayed up talking until dawn. They had become friends the previous year in Worpswede, when Becker noticed Westhoff's tender handling of a bust. She thought it suggested that the sculptor was an equally gentle person and, before long, they were braiding lilies into

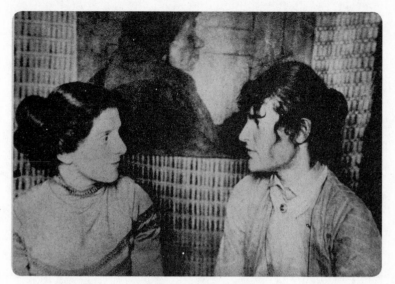

Paula Becker and Clara Westhoff in Worpswede, circa 1899.

each other's hair by day and dancing waltzes after dinner. They were in many ways complementary opposites: Becker was a petite copper-blonde with huge brown eyes that consumed everything in sight. Westhoff was downcast and reserved. When Westhoff's shyness overcame her in social settings, Becker's enthusiasm bubbled over for two.

In Paris, they found new common ground as "women artists" in a city where no one cared about German art in the slightest. They explored the city together, scouting out shops that sold cheap barley coffee and the pastries they liked. They attended the salons and discovered the leading French artists, like Monet and Cézanne. The latter was such a revelation to Becker that Westhoff once watched her friend spin around in circles at a gallery showing the artist's work. She had apparently discovered in his flatly painted canvases an affirmation of the work she had been making, and which she had not found among the Worpswede naturalists.

Paris did not quite electrify Westhoff the same way it did her friend. While Becker was exhilarated by the city's frenetic energy and cosmo-

politan fashions, Westhoff's only interest was working and making an impression on Rodin, a pursuit she found increasingly frustrating. A pleasant first exchange at his studio had set her hopes high. "He was very sweet to me, and showed me all kinds of things he was working on at the moment," she told her parents. "Unfortunately I won't be able to work alongside the men, for a thousand reasons which he explained to me." But she still believed then that her work would transcend the superficial division, and "then I'll ask him sometime to look at my work in my studio."

Westhoff found Rodin to be a rousing lecturer. His lessons were straightforward and he had a knack for simplifying complex ideas into pithy, digestible principles. "Smaller men try to make a mystery of their work and pretend there is nothing in it that can be taught, but there's a very great deal that can be taught if there is someone who has the power to teach," said his student Ottilie McLaren. But Westhoff wanted more than Rodin's example. She wanted him to look at her work and critique it individually. Yet he came to her studio only once or twice a month. Eventually, he even began sending assistants in his place.

Rodin was busy then raising funds to meet the deadline to participate in the 1900 World's Fair. The city had not invited him to officially show in the event, but would allow him to display his work on municipal land so long as he provided his own pavilion.

Up to that point, the closest Rodin had come to exhibiting in the World's Fair was in sculpting the details on works shown by other artists. Even though the pavilion would cost him eighty thousand francs, it was an opportunity he could not pass up. The population of Paris then was not quite three million; during the World's Fair, the city would host fifty million people. Rodin would be the only artist there with a pavilion all his own.

He asked the city to use the Place de l'Alma, a triangular patch of land at the well-trafficked intersection of Cour-la-Reine and Avenue Montaigne. The city council was divided in its opinion on Rodin and did not immediately approve the request. It took a sympathetic politician who moonlighted as a poet to nudge the proposal through. The

sculptor knew how lucky he was: "If Paris had been Italy in the time of the Borgias I should have been poisoned," he said.

Determined not to squander his good fortune, Rodin drained his savings and borrowed money from three bankers to build a six-sided, Louis XVI–style pavilion with a steel frame and stucco walls. The leaves of the trees on the site tinted the light streaming through the tall, arched windows, giving the pavilion the lush, fertile feel of a greenhouse. For Rodin, sculpture was meant to be seen outdoors, where lighting was always at its best.

The project consumed all of the artist's time and, in April, just a few months after opening his academy, he closed it for good. Disappointed, Westhoff packed her things to return to Germany. But she could not leave before witnessing the extravaganza the World's Fair was about to unleash on the city. She and Becker had been peeking through the construction fences for months as workers built walls for the new exhibition halls. The city had spent four years preparing to hold court before the entire world and prove that Paris was queen of the Belle Époque, ready to reign well into the twentieth century.

ALMOST AS SOON AS Parisians turned their calendars from 1899 to 1900, the hopelessness and anxiety that had defined the city at the *fin de siècle* gave way to a new millennial optimism. Where once people feared machine-powered industry, the possibilities of technology now excited them. Manufacturing elicited new consumerist desires, while intriguing advances in neurology and psychology quelled the fear of hysteria.

Paris hosted the fourth edition of the International Congress of Psychology that year at the World's Fair. The research presented there revealed a broader cultural embrace of the unknown. Furious debates broke out over papers on the topics of hypnosis, ESP and parapsychology. A few months earlier, Freud had published his *Interpretation of Dreams*, wherein he declared dreams the "royal road" to the unconscious. Some researchers considered these mysteries to be fascinating areas of inquiry; others thought they were an embarassment to the profession.

The Eiffel Tower lit up during the Exposition Universelle of 1900.

The World's Fair was a mass-market utopia, "a phantasmagoria that people enter in order to be amused," as Walter Benjamin later wrote. When the carriages rolled in on opening day, the ladies in cantilevered hats and men with walking sticks expected to be astonished by the latest innovation in motion pictures, motorcars, colonial exotica, art and electricity. French engineers unveiled the Métro subway and its Art Nouveau stations, connecting what had been a patchwork of hamlets into an integrated city. On either side of the Seine rose a replica town modeled after Arabian souks, alpine chalets and other exotic architecture. A new *flâneur*-friendly bridge, the arched steel Pont Alexandre III, connected the Champs-Élysées to the Eiffel Tower, which was eleven years old but gleaming like new in a fresh coat of gold paint. The centerpiece of the fair was the Palais d'Electricité, a sixty-foot-tall zinc building topped with a fairy riding in a chariot. Inside, water fountains and mirrors reflected the dazzling spectacle of the electric lightbulb.

The new glass-domed Grand Palais and the trapezium-shaped Petit Palais were built to showcase the top French art. One showed work from the last century, including paintings by Delacroix, Courbet and Renoir. The other focused on art from the past decade (although it somehow managed to exclude Impressionism entirely). Three works by Claudel went on view, including her *Profound Thought*, which many saw as a feminist rebuke of Rodin's *The Thinker*. It showed a woman in a thin dress kneeling inches from a lit fireplace, her hands clinging to the mantel. Claudel's Thinker was the picture of vulnerability, without a shred of the manly muscularity of Rodin's. Dangerous, ambivalent, damning, this was what intellectual life might have looked like to a woman at that time.

Rodin showed a bust and *The Kiss* in the exhibition, but that was an inconsequential display compared to his personal, four-hundred-square-meter show down the street. He installed 165 sculptures in the pavilion, including *Balzac, The Walking Man*, a plaster version of *The Gates of Hell* and numerous bodily fragments.

It was by far his largest exhibition to date, yet it did not immediately bring the attention he had hoped for. Rain dampened the opening festivities in June, while the light shows and dancers diverted the public's eye from the non-spectacle showings. When Rodin complained to Jean Lorrain of the sparse foot traffic outside his pavilion, the poet agreed, "There's not even a cat on avenue Montaigne."

But more serious-minded visitors knew Rodin's historic undertaking was not to be missed. One of Rodin's assistants noticed that at least those who did come on that first day seemed more interested in looking at the art than at each other. Word soon spread about Rodin's strangely sexual, fractured forms and, within a few weeks, the artist found himself greeting Oscar Wilde, members of the royal von Hindenburg family and the modern dancer Isadora Duncan. When the young artist Edward Steichen came by and caught a glimpse of Rodin standing beside his *Balzac* he vowed to photograph him someday.

Duncan was so taken by Rodin's work that she found herself defending sculptures to passersby who were grumbling ignorances like,

"Where is his head?" or "Where is her arm?" Duncan would correct them, "Don't you know that this is not the thing itself, but a symbol—a conception of the ideal of life."

The reviews soon delivered more good news for Rodin. The essayist Rudolf Kassner declared him "the most modern among living artists. From the standpoint of history, he is the only one who is necessary. It is not empty phrase when I claim that the development that starts with the Greeks and reaches its midpoint with Michelangelo would not be complete were it not for Rodin." He was "literally epoch-making."

Westhoff and Becker were no less moved by the show. "I was there yesterday, and today again, and these days have simply created an epoch in my life in Paris," Becker wrote to a friend back in Worpswede, urging them to pay a visit. Rodin, especially, "has captured life and the spirit of life with enormous power. For me, he is comparable only to Michelangelo, and in some ways I even feel closer to him. That such human beings exist on earth makes living and striving worthwhile." The show galvanized the women in time for their return to Worpswede that summer, their minds already fermenting with ideas.

CHAPTER
5

❊

WHILE TRAVELERS ACROSS THE GLOBE STREAMED INTO
Paris to witness the first World's Fair of the new millennium,
some artists rebelled against the spectacle of modernity by withdraw-
ing from society altogether. In Germany, one such group fled the
country's urban centers for Worpswede, a village of thatched-roof cot-
tages tucked into a flat bed of farmland.

In the mid-1880s, the Düsseldorf Art Academy student Fritz Mack-
ensen started making summer pilgrimages to Worpswede to paint its
sun-saturated landscapes. The silvery birch trees contrasted with the
black, peat-gorged lakes. Ripe apples fell from the trees. It was just the
spiritual rejuvenation he needed after enduring the aggressive pace of
city life and the drain of art school's tedious academicism (which was
the standard insult slung at the moralistic realism favored in those
days). Mackensen soon lured his friends there from Düsseldorf, Hein-
rich Vogeler and Otto Modersohn, with the promise that this village
of peasants and peat harvesters would do the same for them.

By 1889, they had all decided not to return to Düsseldorf and the
artist colony was born. Newcomers joined with the hope that if they
breathed the air of this fertile landscape, its creativity would germi-
nate within them, too. To Worpsweders, nature was the only teacher

and artists could learn as much by staring up at the clouds as they could with a paintbrush in hand. Within a decade, a younger generation started to arrive, including Clara Westhoff and Paula Becker, and, in August 1900, Vogeler invited a young poet he had met at a party in Florence, Rainer Maria Rilke. They had agreed that Vogeler would draw a selection of romantic, fairy-tale-style illustrations to accompany some of his poems. Now Vogeler invited Rilke to join him so they could collaborate in person.

"How large the eyes become here! They want at all times to possess only sky," Rilke wrote upon his arrival to Worpswede. While most of the colony's residents lived in old farmhouses, Vogeler converted his home into a Jugendstil monument. He built an arched bannister leading up a flight of steps to the house's pristine white walls, covered in vines. Vogeler, who had matte-brown eyes and a delicate, boyish face, greeted Rilke warmly and offered him his "blue gable room," reserved for guests of honor.

When he went on to explore the communal rooms, Rilke found young people lounged in oversized chairs. Wildflowers filled the vases. Someone played Schubert on the piano. The girls draped themselves in rose garlands, while the men wore the stiff, upturned collars in popular vintage fashion.

It was exactly the relaxed setting Rilke needed after a year of rejections, from Andreas-Salomé, Tolstoy and, most recently, Anton Chekhov. Rilke had sent the playwright multiple letters asking him to read his recent translation of *The Seagull*, but Chekhov never responded. Rilke had also written desperate letters to the dance impresario Sergei Diaghilev, then an editor at the Russian magazine *World of Art*, pleading for his support on an art exhibition Rilke had been trying to organize in Berlin. Diaghilev refused, and the show never happened.

But in Worpswede Rilke found the comfort of a warm, tight-knit colony that believed in the fusion of love, friendship, and art. "I place great trust in this landscape, and will gladly accept from it path and possibilities for many days," he wrote. "Here I can once again simply go along, become, be someone who changes." The

Worpsweders, however, were less sure of what to make of the poet. While the men dressed in velvet vests and long English overcoats, Rilke arrived in a pair of sandals and a breezy peasant's blouse. He was striving for a fashionable bohemian look but ended up coming across more like a Slavic servant or a Czech nationalist, and even the housekeepers laughed behind his back.

His poetry did not immediately impress his colleagues, either. On one of his first nights there, he joined the group in the candlelit music room for their weekly salon. When it was Rilke's turn to share his work, he raised his calm, baritone voice over the crowd and recited his verses. As he heard himself speaking the lines his confidence in the poem grew. He noticed two women in white dresses watching him intently from a pair of velvet armchairs. It was Becker and Westhoff, just back from Paris.

When Rilke finished, an older professor in the audience, Carl Hauptmann, spoke up. He suggested that perhaps the poem would be better if Rilke cut the last line. The poet stiffened at this barbaric idea. It was all the more insulting coming from a man who'd just read his own "contrived, abstract," and "labored" prose from a huge pigskin journal, as Rilke complained in his diary later. Worst of all, the man had humiliated him in front of the women, who Rilke insisted loved the poem all the same.

Becker, in her own diary, did not entirely agree with Rilke's con-clusions. She thought Hauptmann had presented "a difficult and stolid text," but one that was "great and profound." Her impression of Rilke was dominated more by his physical meekness than his words: his "small, touching hands" and "sweet and pale" face. He had clear tal-ent, but she couldn't compare his sentimental poems to Hauptmann's because they were so different. Theirs was a "battle of realism with idealism," she said, and it would drag on well after the candles burned out that night.

Rilke spotted the women in white again on another Sunday. He had been gazing out his window when they emerged from the heathland like two lilies. That day the lively Becker arrived at the salon first,

beaming beneath a wide-brimmed hat. Then came Westhoff, a tower-
ing goddess in a high-waisted Empire dress that fell in long folds to her
bare, blistered feet. Rilke noticed how her dark curls breezed alongside
her "beautiful dark face" as she entered the room. She was the star that
night; the whole house seemed to light up once she arrived. "Every
time I looked at her this evening she was beautiful in a different way,"
Rilke wrote. "Especially in her listening."

But soon enough Hauptmann managed to spoil the mood once
again with his theorizing. He dominated the discussion that night and
then, when it was over, launched into a drinking song. Rilke knew
that whenever nights ended with wine he would end up alone. He did
not care for alcohol, and he did not dance, either. Sure enough, the
next time Rilke cast a glance in Hauptmann's direction he was dancing
with Westhoff. Rilke tried at first to participate in the festivities. "I shake
hands with some, with others not, I smile and don't smile, rouse myself
and stiffen, sit in a corner, smell the beer and breathe the smoke." The
whole scene was "sickening," he thought, a highly German display of vul-
garity: men leaning over their mugs, tobacco smoke stifling the air, the
desperation of their drunken laughter. At last he stood up to go to bed.

He didn't make it far before he noticed, to his pleasant surprise,
that the women in white were following him. Fresh off the dance floor,
their cheeks were pink with laughter and they radiated heat. Rilke
pushed open his window for them and they sat to cool themselves at
the sill. As their breathing slowed, they turned their attention to the
moonlight. Rilke watched them, no longer "disfigured" by their rev-
elry, start to gaze deeply into the night. He saw in this moment a
portrait of transition, framed by the window. It was as if Becker and
Westhoff had transformed from girls into observant artists in a single
second. After they left, the vision of the girls moved him to write a few
lines of verse in his diary, where he described them "half held in thrall,
yet already seizing hold . . ."

Rilke came to the conclusion that the life of an artist should ideally
begin at the precise moment when childhood ends. When one is open
to the world with the unexpectant awe of a child, images come freely

streaming in, like the moonlight to Becker and Westhoff's eager eyes that night. But the poet now had to learn how to channel these images into art, and Worpswede seemed like the best place to do it. "The Russian journey with its daily losses remains for me such painful evidence that my eyes haven't ripened yet: they don't understand how to take in, how to hold, nor how to let go; burdened . . . And if I can learn from people, then surely it is from these people, who are so much like landscape themselves."

Rilke first sought out Otto Modersohn, a tall, red-bearded painter who was, at thirty-five, older and more established than many of the other artists at the colony. Rilke found his studio lined with moody landscape paintings and display cases filled with dead birds and plants, which he used to study color and the way it faded. Rilke told him about his desire to experience the world through the point of view of a visual artist, and Modersohn agreed that young people ought to approach life as receptively as bowls. They should not expect to be filled with answers, but, if they were lucky, with images, he said.

From Modersohn's studio, Rilke went on to visit Paula Becker. Discovering how easily they "made toward each other through conversations and silences," he found himself becoming more attracted to the "blond painter" than the "dark" sculptress. But Clara Westhoff's art continued to interest Rilke more than Becker's (as did sculpture in general over painting, which he once derided as "a delusion"). Westhoff was drawn from the start to the poet's boyish blue eyes, which distracted her from some of his less appealing features. Meanwhile, a quiet courtship was developing between Otto Modersohn and Becker. He was already married, but when his wife died suddenly that year, the pair got engaged. After that, Rilke turned all of his attention to Westhoff.

His attraction was rooted primarily in respect for her work. Her reserved nature made it more difficult for a romance to develop. But their intimacy grew gradually over the coming weeks as she began to teach him about sculpture and told him stories about studying with Rodin. Afterward he would return to his room and recount these con-

versations in the pages of his journal. Once he suggested they cowrite an essay on Rodin. Over time, their rapport turned more tender, and his prose turned into poetry. He began writing verses about her strong hands, a feature that Rilke had always admired in artists, for he believed a sculptor's hands could remake the world.

AFTER SIX WEEKS, Rilke left Worpswede for Berlin. He had never intended to join the colony permanently and didn't want to overstay his welcome as a guest.

In his absence, Rilke and Westhoff stayed in touch through letters. He was so impressed by the descriptive imagery in her writing that sometimes he felt his responses were merely rephrasings of her experiences. In one remarkable passage he confessed his desire to load "my speeches with your possessions and to send my sentences to you, like heavy, swaying caravans, to fill all the rooms of your soul."

In February, Westhoff visited Rilke in Berlin. He did not idolize her the way he had Andreas-Salomé, but perhaps that was part of the appeal. He hinted once in his diary that the relationship with Andreas-Salomé had emasculated him. "*I* wanted to be the wealthy one, the giver, the one offering invitations, the master." Yet he felt time and again that he was only "the most insignificant beggar" to her. He had nothing to offer his brilliant older lover, but this "maiden" Westhoff never seemed to doubt him. Her admiration felt refreshingly pure and uncomplicated.

Rilke and Westhoff surprised everyone with their engagement announcement the following month. When they returned to Worpswede to share the news with their friends, Otto Modersohn wrote to Paula Becker asking if she could guess who he saw that day: "Clara W. with her little Rilke under her arm." By then Becker was away at a cooking school in Berlin, having submitted to pressure from her father to devote herself completely to her fiancé. He told her in a rather depressing birthday letter that she ought to "have his welfare constantly in sight" and not let herself "be guided by selfish thoughts . . ."

By March, Becker was miserable. "Cooking, cooking, cooking. I cannot do that anymore, and I will not do that anymore, and I am not going to do that anymore," she wrote to Modersohn, warning him, "You know, I can't stand not painting much longer." Becker promised herself that she would wait to have children until she had fulfilled her own dreams. But she feared that Westhoff was not so strong-willed. Becker predicted from the start that her friend's new union would prove to be Westhoff's sacrifice alone. Becker had felt Westhoff slipping away ever since she met Rilke. Why couldn't they all live together again as a community, like they'd always dreamed? Becker wondered. "I no longer seem to belong to her life," she wrote. "I have to first get used to that. I really long to have her still be a part of my life, for it was beautiful with her."

The news of the engagement dismayed Andreas-Salomé even more. Her objection did not stem from jealousy, she claimed, but from a concern that the commitment would stifle Rilke's creativity just before it blossomed. She also knew he wasn't mature enough to shoulder the responsibilities of a family. She wrote him a "last appeal" urging him to reconsider—or else not to contact her again. At the last minute she enclosed a concession, writing on the back of a milk receipt that she would in fact see him if he was desperate, but only in his very "worst hour."

The ultimatum was harsh, but not unfounded. Family had been a mythology to Rilke ever since he was born. He had embodied his mother's fictions as a daughter, as fake nobility, and now he was concocting his own domestic fantasy. He once described in a letter to Westhoff his baroque mental picture of marriage: He was standing at a stove, cooking for her in dim lamplight. There would be honey gleaming on glass plates, cold ivory slices of butter, a Russian tablecloth, a rocky loaf of bread, and tea that smelled of Hamburg rose, carnations and pineapple. He would drop lemon wedges into the teacups to "sink like suns into the golden dusk." There would be long-stemmed roses everywhere.

In reality, Rilke was eating oatmeal every night. But he believed that marriage was part of becoming a man, and that a child had to first

become a man before he could be an artist. Plus, it seemed like everyone in their Worpswede community was getting married that spring: Heinrich Vogeler had just wed a young woman from the village, Martha Schröder, and Becker and Modersohn were engaged to marry the following month.

Rilke married Westhoff at the end of April 1901, in her parents' living room in Oberneuland. He told a friend, with no shortage of condescension, that "the meaning of my marriage lies in helping this dear young person to find herself."

Rilke in Westerwede in 1901, the year he married Clara Westhoff.

The following month they moved into a thatched-roof cottage in Westerwede, a village neighboring the artist colony. At first, the dead-end road isolated the couple in their work. Over the next year, Westhoff filled the house with sculptures and Rilke wrote a monograph on five of the Worpswede painters. Then, in one week, he completed the second part of the *Book of Hours*. But their quiet solitude was soon interrupted when Westhoff found out she was pregnant and, by the end of the year, gave birth to a daughter. They gave her "the beautiful biblical name" Ruth.

For all the molten emotion that poured from Rilke's pen over the years, he managed to describe his daughter only in surprisingly vague abstractions. "Life has become much richer with her" was among the most effusive lines he came up with. To Rilke, Ruth completed the family unit and marked a necessary transition into maturity. But the unsayable hungers and tears of this "little creature" bewildered him.

A few months after Ruth's birth, in February 1902, Westhoff wrote to Becker about how she felt "so very housebound" now. Gone were the days when she could just pick up a bicycle and pedal off for an afternoon in the sun, bringing whatever she needed on her back. "I now have everything around me that I used to look for elsewhere, have a house that has to be built—and so I build and build—and the whole world still stands there around me. And it will not let me go . . . Therefore the world comes to me, the world which I no longer look for outside . . ."

The letter enraged Becker. It wasn't so much what she said, but how she said it. Westhoff's words didn't sound like her own. They sounded like Rilke's. Becker tore into her friend with all the hurt and resentment that had been building for months. "I don't know much about the two of you, but it seems to me that you have shed too much of your old self and spread it out like a cloak so that your king can walk on it." Why wouldn't Westhoff wear her own "golden cape again"? she wondered.

To make matters worse, Westhoff had forgotten her friend's birthday. "You have been very selfish with me," Becker wrote. "Must love be stingy? Must love give everything to one person and take from the others?" Becker then turned her pen against Rilke. Enclosed in the same letter she wrote, "Dear Reiner [sic] Maria Rilke, I am setting the hounds on you. I admit it."

She begged him to remember their communal love of art, of Beethoven and the happiness they once shared as a little family in Worpswede. She thanked him for sending his latest book—it was "beautiful." But in the next breath she insulted his writing: If he was going to respond to her letter, "please, please, please, don't make up riddles for us. My husband and I are two simple people; it is hard

for us to do riddles, and afterward it only makes our head hurt, and our heart."

Two days later, Rilke fired back a withering retaliation. He told Becker that her love must be too weak for his new wife, for it had failed to reach her at a time when she needed it most. Was Becker really so selfish that she could not celebrate her friend's newfound happiness? Why did she refuse to acknowledge the sacrifice he and Westhoff had made in order to be together?

He reminded Becker that she herself had always praised Westhoff's solitary nature. It made her a hypocrite to chastise her friend now for the very quality she had always admired. Why not "rejoice" in antic- ipation of the time when Westhoff's "new solitude will one day open the gates to receive you? I, too, am standing quietly and full of deep trust *outside* the gates of her solitude," he said. Then, authoring what would become one of his most lasting mythologies about marriage, Rilke added: "I consider this to be the highest task of the union of two people: that each one should keep watch over the solitude of the other."

Becker surrendered. No matter how self-serving Rilke's rhetoric was, one could hardly compete with it when rendered this majestically. Becker responded only in her diary, writing of the inconsolable lone- liness she had felt during the first year of her own marriage and that she had believed Westhoff was the only person in the world who could alleviate it. Now she had to face the painful likelihood that their paths would never cross again.

As Becker slipped into depression, Modersohn blamed it on Rilke and Westhoff. He complained in his journal that they never bothered to ask his wife about her work, nor did they ever visit. Now Rilke had displayed an inexcusable arrogance with his claim that Becker should remain on the other side of Westhoff's gates until Rilke's "lofty wife . . . opens them up," Modersohn wrote. What about Becker? "The fact that *she* is somebody and is accomplishing something, no one thinks about that."

Selfish or not, Rilke was not exaggerating the hardships facing his new family in those days. His fatherhood status had disqualified him

from the college stipend he had been receiving from his uncle Jaro-slav's estate. He wasn't making much money from his writing, either. Critics had panned his recent story collection, *The Last of Their Line*, and bookstores were scarcely selling it.

Rilke's wife Clara Westhoff with their daughter Ruth.

Meanwhile, art exhibitions he had organized in Vienna and Ber-lin fell through. Publishers passed on his book proposals and newspa-per editors had been rejecting his applications for art critic positions. He thought he might eventually be able to cobble together enough assorted university credits to eventually earn a doctorate degree, but that, too, would require money he did not have.

Rilke's father offered to help him get a job at a bank in Prague, but the poet only replied that the suggestion made him physically sick. It would mean giving up all he had struggled for and going back to the very thing he had fled. It would be "a frost, in which everything would have to die." He knew his father meant well, but why couldn't he understand that this profession would destroy his art? Why did art have to be seen as arrogance? To Rilke, art was his duty, no less com-

pulsory than some treated military service. Rilke decided he would rather starve, and let his family starve, than work as a bank clerk. That fate "would be like death without the grandeur of death."

Finally, in the spring of 1902, the German publisher Richard Muther told Rilke about his series of artist monographs which would include volumes on Manet by Julius Meier-Graefe and on Leonardo da Vinci by Muther himself. He knew Rilke had just finished the Worpswede monograph and suggested the poet write one on Rodin. The pay was a paltry 150 marks, but Rilke desperately needed the money and accepted the offer on the spot. Privately, he also saw it as a way out of the house and out from under the oppressive routines of domesticity. He longed "to feel, to be, real among real things" like he had been before his marriage. If he went to Paris, he would be able "to work in the libraries, to collect myself, and to write about Rodin whom I have loved and revered for a long time."

Rilke's decision to leave town just a few months after having a baby struck some as unforgivably selfish. "How appalling: first marry and have a child, and then think about how to earn a living," wrote Modersohn in his journal. But Westhoff could not have objected too strongly because she used her connection as a former student of Rodin to facilitate an introduction. She sent the sculptor a letter including some images of her work as a reminder. At first, no response came. As it happened, Rodin was in Prague at the time, attending one of the largest surveys of his work ever staged. After that, Rodin traveled to Vienna to see the Secession Exhibition and visit with Gustav Klimt, who had just debuted his monumental *Beethoven Frieze* there. When Rodin saw the painting in person, he took Klimt's hand in his and said, "What an artist you are! You understand your *métier*."

After Rodin's return to Paris in June, Rilke followed up with another letter to say that he would like to come to the city that fall to research a monograph on him. He also implored the artist to respond with even "a single word" for Westhoff, who waited anxiously for the master's acknowledgment.

Fortunately for Rilke, Rodin was a devoted bibliophile. He had

sculpted dozens of works inspired by literature and, in turn, authors had been among his biggest supporters. Rodin was thought to be so influenced by writers and critics that he routinely made adjustments to his work in order to conform to their reviews. At the very least, Rodin had nothing to lose by granting access to this enthusiastic young writer. He responded warmly, but briefly, to say that he remembered Westhoff as a capable and imaginative sculptor, and that he would be happy to receive Rilke for his research. Rodin would be available in Paris in September or November should he like to visit then.

Rilke wrote back in August that he would arrive the following month. He again made a push for his wife, asking if the master might also be willing to critique some of her sketches in person if she came along. Then he spent the rest of the summer studying and becoming "utterly absorbed" in Rodin's work. He was "growing and growing for me the more I hear and see of his works. Does anyone exist, I wonder, who is as great as he and yet is still living," Rilke wondered. The expressive intensity of Rodin's work held a natural appeal for the young romantic. The physical strain of *The Thinker*'s ruminations seemed to materialize a state of mind, while the embracing marble lovers of *The Kiss* embodied concentrated emotion.

In life, Rilke admired Rodin's compulsive devotion to his craft: he sacrificed luxury and material pleasures for the preeminence of his art, which he valued more highly than gold or bread. He was known for living humbly and spending all of his time at work, in the company of his creations rather than friends or family. Rodin was one for whom "the whole sky was but a stone," as Rilke once wrote. This ascetic covenant resonated with the poet, who believed that deprivation leavened the soul.

It occurred to him that perhaps Rodin would be the master for whom he had searched and failed to find in Russia. Rilke hinted at this hope in another letter to Rodin: "It is the most tragic fate of young people who sense that it will be impossible for them to live without being poets or painters or sculptors, that they do not find true counsel, all plunged in an abyss of forsakenness as they are; for in seeking a powerful master,

they seek neither words, nor information: they ask for an example, a fervent heart, hands that make greatness. It is for you that they ask."

IN AUGUST 1902, the poet folded his clothes and arranged them into an immaculate constellation in his suitcase. He was preparing to leave behind his wife and baby to embark on a quest not merely to write, but to understand how an artist should be.

Rodin could not have imagined the magnitude of the poet's devotion to the cause, which was of almost biblical proportions. Rilke would worship the sculptor's art as if it were a religion, and Rodin himself as a savior. Like Joshua following Moses to the Promised Land, Rilke saw this journey as the beginning of a new future. Everything in his life felt uncertain except for this.

PART
TWO

...

Master

and

Disciple

CHAPTER
6

RILKE ARRIVED AT PARIS'S GARE DU NORD RAILWAY STATION
on a steamy August afternoon. Travelers were advised to imme-
diately entrust their belongings to a porter to avoid thieves and pick-
pockets who preyed upon tourists bewildered by the crowds at the
enormous glass station.

As he stepped out into the street, his shirt buttoned to the top and
trousers creased, Rilke's eyes bulged at the sight of this alien city. He had
never seen an industrialized metropolis like this before—the motors,
the speeds, the shapeless enormity of the crowds. Machine-powered
labor had replaced human jobs and pushed many of the disenfran-
chised workers into the streets. He spotted disease-ravaged bodies
split open with abscesses, trees scorched bare by the sun, beggars with
eyes "drying up like puddles." There were hospitals everywhere.

The crowds of people reminded him of beetles, crawling through
garbage, scurrying to survive beneath the giant footsteps of life. Before
the advent of big cities and public transportation, one rarely had to
look at other people. Here they were everywhere, forming masses that
seemed to contain no individual faces, only needs.

The visual field corresponded with the economic spectrum, so that
in a single pan of the eye one saw the full gamut of the city's wealth

and poverty. At the bottom were the ragpickers fashioning shanty-towns out of the waste of the bourgeoisie, whose carriage horses trotted overhead, leaving trails of litter and horse manure behind them. Somewhere in the middle were the dogs, often quicker than the beggars at snatching up scraps of food.

Parisians seemed to feel the will to live more keenly than others. Rushing commuters "made no detour around me but ran over me full of contempt," as if Rilke were a pothole in the street, he wrote. The newfangled subways and streetcars, meanwhile, sped "right through me." It soon became clear that no one would stop to help him here. Unlike in Munich, they did not care that he was a young, struggling artist. Everyone was struggling here just to survive.

*Rilke shortly before he
met Rodin.*

But as Rilke hopped over heaps of trash on the way to his hostel, he began to feel terribly excited. The sights were all so new—the bridges, the wagons, the brick streets—that it felt as if they had been made for his eyes alone, like the set of a play to which no one else paid attention. He pronounced the foreign street names to himself and let the rhythmic French syllables loop around his head: *André Chénier, vergers* . . . Paris was filthy, yes, but at least this was the filth of Baudelaire and Hugo, he thought.

By the time Rilke crossed the Seine to reach the Latin Quarter he felt feasted upon and exhausted. The neighborhood had since lost its bohemian reputation as artists began climbing the hill to Montmartre, where they squatted in *maquis* or moved into the fabled Bateau-Lavoir studio building, as Picasso and Kees van Dongen would soon do. Now the quarter was dominated by students from the Sorbonne, just down the street from Rilke's hostel on the narrow Rue Toullier.

Opening the door to his cramped room gave him little comfort. There was an armchair indented by all the greasy heads that had previously rested on it, a threadbare rug and a pail with an apple core left in it. A single window looked out onto a stone wall, a view that Rilke would accuse of stifling his breathing over the next five weeks. Worse, the dozen windows on the building seemed to stare back through his curtains, watching him "like eyes."

He lined up his pens and papers into orderly rows on the desk and lit the wick of a kerosene lamp. He sat down to reflect on his journey thus far, leaning back into the hollow of the chair, already molded into the slumped shape of a weary traveler.

AT JUST BEFORE three o'clock on Monday, September 1, Rilke walked from his hostel along the Seine to Rodin's studio in the Marble Depot to introduce himself to his future master. The courtyard of the building looked as rough and undeveloped as a quarry, with sheds lined around the edges for studios. Sometimes a sign hung on the door to Atelier J informing visitors, "The sculptor is in the Cathedrals."

Luckily that was not the case on the day that Rilke knocked. The door opened onto a dark room, "sparsely filled with gray and dust," he noticed. There were a few bins of clay and a pedestal. Rodin had cropped hair and a soft gray beard. He stood scraping at a chunk of plaster in his hand, paying no attention to a model posed nude before him. His clothes were hardened with the splatter of earthy pastes. He was shorter than Rilke expected, yet somehow more noble-looking. A

pair of rimless glasses balanced on his nose, which extended from his forehead like a "ship out of a harbor," Rilke observed.

*Rodin circa 1898,
with* The Kiss.

When the artist looked up at his young visitor he stopped what he was doing, smiled shyly, and offered a chair. Next to the lionesque artist, Rilke looked even more like a mouse. His face gathered into a point right where his nose joined a few droopy whiskers. He was twenty-six years old, narrow-shouldered and anemic, while the stout Rodin, then sixty-one, plodded around heavily, his long beard seeming to draw him even closer toward the ground.

Rilke labored through all the French pleasantries he had memorized before Rodin, thankfully, took over the conversation. The sculptor gestured around the room, pointing out one remarkable object after another: There's a plaster hand, there's a hand in clay, he would say. Here's a *création*, there's a *création*. How much more exquisite that word, *création*, sounded in French than it did in German—*Schöpfung*—Rilke thought. There was a surprising lightness to the man. He had a laugh that was simultaneously joyous and embarrassed, "like a child that has been given lovely presents."

After a while, the artist went back to work, inviting his visitor to stay in the studio and observe for as long as he liked. Rilke was astonished to see how easy Rodin made sculpture look. He approached a bust like a child making a snowman, rolling up a ball of clay and plopping it on top of another ball to make a head, then cutting a slit for the mouth and two thumbholes for eyes. As the work progressed, so did Rodin's energy. Rilke noted the way the artist would lunge at his sculptures, the floor creaking and moaning under his heavy feet. He would fix his heavy eyes on a detail and zero in so close that his nose pressed up against the clay. With a few pinches of his fingertips, a face, and from the rough gashes of his pick or chisel, a body. He worked rapidly, as if "compressing hours into minutes," Rilke noticed.

Rilke could have watched Rodin all day, but he did not want to impose on his first visit. He told the sculptor that he would be on his way and thanked him for the fascinating introduction to his work. To Rilke's delight, Rodin invited the poet to join him again the next day. He would be working at his country studio then and it might be useful for Rilke to see the way things operated there. The poet wholeheartedly agreed.

Rodin's generosity with his time buoyed Rilke's spirit when he returned home that evening. He could not have hoped for a more kind and engaging subject. "He is very dear to me," he wrote to Westhoff that night. "That I knew at once."

THE NEXT MORNING, Rilke rehearsed a few French phrases, put on a cheap but tidy suit and then boarded the nine o'clock train from Gare Montparnasse. He could hardly wait to see Rodin's workshop in the suburb of Meudon, and to finally breathe in some much-needed country air.

Meudon was only twenty minutes southwest of Paris by train, but seemed to exist in another century altogether. The hills swallowed up

the city's smokestacks, which could be seen chugging in the distance. The old cottages slouched like sheep in a field, Rodin thought when he first visited this landscape. It had awakened in him the "untroubled happiness" of childhood. He felt so at home there that he bought a petite Louis XIII–style chateau called Villa des Brillants and built a studio on the property in 1895—two years after his split from Camille Claudel, who was likely a consideration in his withdrawal from Paris.

As Rilke's train lurched toward town, the view did not charm the poet nearly as much as it did Rodin. The road leading into the station was dirty and steep and the houses cramped the Seine River valley too tightly. In town, all the cafés reminded him of the dingy osterias he had seen in Italy. It was not the setting Rilke had imagined for such an illustrious artist.

To be sure, Meudon was no Giverny, the lush suburb where Monet owned his compulsively manicured estate. Whereas the painter nurtured beds of exotic flowers and built a footbridge over his pond of water lilies, Rodin let his estate grow wild. Passing through the gates to the Villa des Brillants, Rilke crunched along an unpruned path paved with equal parts chestnuts and gravel. The simple red-brick building at the end of the drive was not much of a sight, either.

When Rilke knocked on the door, an apron-clad woman with soapsuds on her arms opened it. She stared at him, looking as tired and gray as an antique, while Rilke recited his French greeting and told her that he had an appointment with Monsieur Rodin. Just then the artist appeared at the door and invited Rilke in.

The sparsely furnished rooms reminded Rilke of Tolstoy's austere home in Russia. There was no gas or electricity and Rodin did not hang paintings on the downstairs walls, in order to focus the view out the windows. The only decorations he displayed were his antiques, a growing collection of terra-cotta vases, classical Greek nudes, Etruscan artifacts, and broken Roman Venuses. There was a simple trestle table and a few straight-backed chairs, for Rodin believed that cushions were indulgent: "I do not approve of half going to bed at all moments

of the day," he once said. This led one visitor to remark that Rodin's home "gives one the feeling that the act of living itself plays hardly any role for him."

Rodin then took Rilke outside for a tour of the grounds. As they walked, Rodin began to tell Rilke about his life, but not in the way one might speak to a journalist on assignment. He understood that Rilke was a fellow artist, and so he framed his stories as lessons that the young poet might take as examples. Above all else, he stressed to Rilke, *Travailler, toujours travailler.* You must work, always work, he said. "To this I devoted my youth." But it was not enough to make work, the word he preferred to "art"; one had to live it. That meant renouncing the trappings of earthly pleasures, like fine wine, sedating sofas, even one's own children, should they prove distracting from the pursuit.

Rilke listened to Rodin's advice as best he could through the rapid French. But whereas Rilke's intense eye contact held his company close, Rodin rarely looked directly at listeners at all. The artist could become so absorbed in a topic that he sometimes forgot who he was talking to altogether, much less whether they were still paying attention.

When Rodin finally paused to take a breath, Rilke seized the opening to say that he had brought the master a small gift. He pulled out some pages of poetry and presented them to Rodin, who politely flipped through them. Although they were written in German, Rilke thought for certain he detected in Rodin's nodding an approval at least of their form.

At noon, they sat for lunch at an outdoor table, joined by a red-nosed man, a girl of about ten and the woman, in her late fifties, who had answered the door earlier. Rodin did not bother introducing Rilke to any of his guests. He addressed them only to complain that the meal was late. The woman's face narrowed in rage and she slammed the dishes in her hands onto the table. She fired back some sharp words that Rilke didn't understand, but their intent was perfectly clear. There could only be one explanation for such an inti-

mate display of resentment at the table, Rilke thought. This must be Rodin's wife.

Eat up! Rose Beuret barked at her guests. Rilke obeyed, nibbling nervously around the edges of his plate to avoid the meat. A waiter mistook Rilke's vegetarianism for shyness and pushed more meat on him still. Rodin, oblivious to it all, noisily spooned himself mouthfuls as if he were dining alone.

When the meal was finally through, Rodin stood up and invited his visitor to join him in the studio. Relieved, Rilke rounded the corner of the house with Rodin and discovered that on just the other side stood the artist's pavilion from the World's Fair. After the exhibition closed in November 1900, Rodin had purchased a patch of land from his neighbor and shipped the entire pavilion to his property.

It served as a daily reminder of Rodin's greatest success to date. He had sold two hundred thousand francs' worth of art and received so many visitors that after he shipped the works to Meudon, the German publisher Karl Baedeker wrote the suburb's mayor to inquire about the hours of the town's "Musée Rodin."

It occurred to Rilke that Rodin surrounded himself with his own sculptures the way a child does his toys. Nothing made the man happier than spending his days in the presence of his most prized possessions.

They then went to the studio, a long building encased almost entirely in glass. When Rodin opened the door, the sight left Rilke speechless. It contained what looked like the "work of a century." The workshop pulsed like a living ecosystem, with white-smocked crafts-men carving away at hunks of marble, setting flames inside brick kilns, and hauling blocks of stone across the floor. The sun poured in through the arched glass, lighting up the rows of plaster bodies like angels, or "inhabitants of an aquarium," as Rilke wrote. The bright whiteness seared his pale eyes like snow blindness; it was almost too much to bear. But that didn't stop him from greedily trying to take it all in anyway.

After a few minutes, Rodin left his awestruck visitor to look around on his own. Rilke didn't know where to begin. There were acres of half-made sculptures: limbs piling up on tabletops, a torso with the wrong head attached; arms and legs intertwined, striding and reaching. It looked like a storm had torn through a village and scattered body parts everywhere. There were works that Rilke had only read about in books, including several yard-long sections of *The Gates of Hell*, uncast and strewn about shelves and display cases.

It became clear that Rodin prized hands above all other parts of the body. A well-informed visitor knew that to please the *maitre* one should ask him, *May I look at the hands?* They appeared around the studio in all configurations: old wise hands, a pair of clenched fists, two fingertips pitched into a cathedral spire. Rodin once claimed to have sculpted twelve thousand hands, only to have "smashed up" ten thousand of them. Just as he had previously spent years molding hands and feet for his old employer Carrier-Belleuse, Rodin now tested prospective apprentices on their facility with hands.

Rilke understood immediately the lesson contained in all these hands, often "no bigger than my little finger, but filled with a life that makes one's heart pound . . . each a feeling, each a bit of love, devotion, kindness, and searching." Whenever Rilke had described hands in his poetry they were always extensions into the world. They were need: a woman reaching for her lover, a child grasping its mother, a mentor pointing the way to a disciple. For Rodin, a hand was its own landscape, complete and internally resolved. It was not merely a sentence in the narrative of the body, it told its own story in lines and contours that added up like verses of a poem.

Rodin seemed to dream with his hands rather than his head, Rilke thought, enabling him to make his every fantasy real. Rilke only wished that Rodin would now take the poet into those transformative hands. He believed his calling was predestined; he just needed a master to animate it. Only Rodin, a man whose hands had set metal men into motion and roused heartbeats from stone, seemed to possess the life-changing touch that Rilke described in his *Book of Hours*:

I read it in your word, and learn it from
the history of the gestures of your warm
wise hands, rounding themselves to form
and circumscribe the shapes that are to come.

By three o'clock, Rilke had filled his eyes with as much as they could take for one day. When he returned to Paris in the early evening, they were aching and exhausted by all they had seen. Still, he managed to dash a letter off to Westhoff that night to say that the visit had restored his hope in Paris and his decision to come there. "I am glad that there is so much greatness and that we have found our way to it through the wide dismayed world." But now he was smearing the ink and ought to sign off: "My eyes are hurting me, my hands too."

RILKE RETURNED TO MEUDON a few days later. He again shared an awkward meal with Rodin and Beuret and, again, they were joined by the same young girl. (Rilke assumed it was Rodin's daughter, but most likely it was a neighbor, since the couple only had a son.)

After lunch, the two men retired to a bench in the garden. The girl followed them and sat down on the ground nearby, turning over and inspecting pebbles from the path. A couple of times she came over and looked up at Rodin, watching his mouth move while he spoke, only to retreat again unnoticed.

A few moments later she came back, this time presenting him with a tiny violet. She placed it timidly in his huge hand and waited for him to say something. Instead, he looked "past the shy little hand, past the violet, past the child, past this whole little moment of love," Rilke noticed. Rodin carried on talking to Rilke and eventually the girl gave up. He had been telling the poet about his education and had launched into a tirade about art school, which he believed taught students to slavishly copy their subjects. Most teachers were not like Lecoq, he said, who had taught him to see with his emotions, with an eye "grafted on his heart."

The girl returned to make one final bid for the man's attention. This time her bait, a snail shell, caught the master's eye. He turned the shell over in his palm and smiled: *"Voilà."* Here was a perfect facsimile of Greek art, he told Rilke. Its surface was smooth, its geometry simple, and the shell seemed to radiate with inner life. It bore the infallible laws of nature on its exterior, just like an exquisite figure model.

And, *voilà*, the snail might have also presented Rilke with an unexpected model of Rodin's mind: an inwardly spiraling coil, oblivious to anything outside its own will. Rilke watched the girl recede once again into the background and he spoke up at last. Carefully suppressing his bulky German accent, he asked Rodin his opinion on the role of love in an artist's life. How should one balance art with family? Rodin replied that it is best to be alone, except perhaps to have a wife because, well, *un homme a besoin d'une femme.*

That evening Rilke took a walk alone in the woods to think about the harsh truths Rodin had shown him. The sculptor's house was depressing. There seemed to be no love in his family. Yet Rodin knew all of this and didn't care. He knew what he was, that he was an artist, and that was all that mattered to him. He abided by his own code, and no one else's standards could measure him. He contained within himself his own universe, which Rilke decided was more valuable than living in a world of others' making. In fact, it now seemed like a good thing that Rodin couldn't understand Rilke's poetry, nor speak any other language. That ignorance secured him more soundly within his sacred realm.

As the poet breathed in the cool, damp air he felt a space open up inside him. It was the relief that came from realizing now the destination, even if he did not yet know how to get there. He had faith in Rodin and his assurance that hard work would guide him.

When Rilke returned from the woods, everything looked different. He now saw only beauty around him: the still sky, three swans floating in the lake, rose blooms that bent from their vines toward the sun. Even the chestnut-littered driveway seemed to serve a new purpose: to guide the way forward. Life may grow thickly around its path, but the

true artist stays focused on the way ahead. He must "look neither right nor left," Rilke wrote to Westhoff that night. That was why great men like Rodin and Tolstoy each lived a meager life, "stunted like an organ they no longer need," he wrote. "One must choose either this or that. Either happiness or art."

One wonders how that news might have sat with Westhoff in Germany, caring for their daughter Ruth on her own. Rilke preferred to describe himself and Westhoff as artists first, on parallel but parted paths, rather than as a couple on the same track. He championed Westhoff's art but was less sympathetic to her frustrations over child-rearing. When she complained of exhaustion, Rilke told her it was healthy to be a bit tired. Sometimes he tried to sweeten this condescension with a word of pseudo-praise: You are so strong and courageous, he would say, "one night will be enough to relieve you of it."

But that September, Westhoff did not acquiesce so easily. She insisted that she wanted to be in Paris, too, and to gain access to Rodin once more. Rilke agreed, but convinced her not to bring Ruth. Paris was no place for a child, he said. It was wretchedly expensive, the hotels were cramped, and there was no time for anything but work. Rodin felt the same way, Rilke told her. "I spoke of you, of Ruth, how sad it was that you must leave her,—he was silent a while and then said, he said it with a wonderful seriousness: Yes, one must work, nothing but work. And one must have patience."

Westhoff arranged for Ruth to stay with her parents in Oberneuland, a town near Worpswede, and made plans to join Rilke the following month.

AFTER JUST TEN DAYS with Rodin, Rilke sent his new master a letter. He confessed that it might seem strange to write since they saw each other so often, but he felt the language barrier prevented him from fully expressing himself. In the quiet of his little room he could work out the words to tell Rodin precisely how much he had inspired him. He had given him the strength to suffer through loneliness, to

accept sacrifice and to "disarm even the anxieties of poverty." He told him that his wife had agreed with him on this, and would be joining him in Paris soon. If they could both find work there, they hoped to stay indefinitely. He sensed that this journey would prove "the great rebirth of my life."

Rilke also sent Rodin a few lines of poetry that had come to him during a recent stroll through the Luxembourg Gardens. "Why do I write these verses? Not because I dare to believe that they are good; but it is the desire to draw near to you that guides my hand," he wrote. Rodin had "become the example for my life and my art." Rilke knew his German verses would be incomprehensible to Rodin, but he longed to have the man's eyes rest upon them all the same. Then he came to the real point of his letter: "It is not just to write a study that I have come to you," he confessed, "it is to ask you: how should I live?"

We don't know whether Rodin replied to the letter, but he offered the poet an open invitation to his studios over the next four months, which was all the encouragement Rilke needed to attach himself to Rodin at every possible moment. On the best days, the master invited him to Meudon in the mornings. Rilke would come prepared with a list of questions and they would sit by the pond or take a walk, their discussions often carrying on well into the afternoon. Rodin enjoyed coining new metaphors for his disciple and Rilke dutifully scribbled them down, like a pigeon pecking up bread crumbs. "Look, it only takes one night; in a single night all these gills are formed," Rodin said once of a mushroom he plucked from the ground. Turning it over to reveal its underside, he explained, "That's good work."

Other days Rilke stood by in the studio to watch Rodin in action. He observed the way the artist wielded his tools like swords, remorselessly amputating limbs and heads with a single slice, slashing out swaths of clay until he ran out of breath. He chiseled into plaster until a cloud of dust filled the air. He was an additive sculptor and he broke his work down into parts before reassembling it. One minute he would snatch up a limb, like meat in a raptor's talons, only to toss it into the trash a moment later. Sometimes he left bodies armless or legless

entirely. The end result was often "not like a house, solidly built from top to bottom," said the writer Jean Cocteau, "but only like part of a staircase, a balcony, or a fragment of a door."

Rodin did not await inspiration, for some pure expression to flow from his soul onto passive materials, as Rilke had always done. To Rodin, god was "too great to send us direct inspiration." Instead, it was up to the artist to create "earthly angels." That's why Rodin approached unformed clay "without knowing what exactly would result, like a worm working its way from point to point in the dark," Rilke would write in the monograph. He would grab hold of it with his huge hands, work it over, spit on it and come to know it entirely, energizing the object and stirring it to life in the process. "The creative artist has no right to select. His work must be imbued with a spirit of unyielding dutifulness," Rilke wrote.

Rodin's hyper-animated style of sculpting produced no less dynamic bodies of work. Rodin manipulated light to enhance the sense of movement in his figures. When the geometry of the planes aligned just right, light would coast and dart across the surfaces and create the illusion of motion. Sometimes Rodin measured the success of this effect by employing a candle test, which illuminated the points of intersection between light and shadow. Rodin once demonstrated the test to a student at the Louvre. Arriving in the evening, just before the museum closed, he held up a candle to the Venus de Milo. He instructed the student to watch the light as he moved it around her contours. Notice how it glided across over the surfaces without jumping at a single hollow, rift or seam. Candlelight revealed all flaws, he believed.

TOWARD THE END OF Rilke's first month in Paris, Rodin received a commission for a portrait that would take up an inordinate amount of time. He began working through the weekends and became too busy to continue the long chats with Rilke. The poet decided to give the artist some space by spending more time on his own in Paris. He could trace Rodin's artistic development there by following the sculp-

tor's footsteps across his native city. Rilke went to the Louvre, where he was surprised to find himself suddenly formulating strong opinions about art: The *Winged Victory of Samothrace* was a "miracle" of motion to him now, whereas the *Venus de Milo* looked too passive and static for his liking.

Rilke spent a week, every day from nine until five, at the Bibliothèque Nationale, where Rodin had copied so many illustrations as a boy. Rilke's goal was to do the same with the great French Symbolists, to trace the lines of Baudelaire and Valéry until he could glide across their grooves as smoothly as a fingertip on wet clay. He also pored over reproductions of the Gothic cathedrals—those "mountain ranges of the Middle Ages"—which he knew Rodin worshipped.

Each day after the library closed, the poet walked back toward his hostel along the Seine, pausing at the Île de la Cité to watch the sun set over the two towers of Notre Dame. The cathedral built for the Virgin Mary had been ravaged and restored in battle after battle, its ornaments were looted, yet its walls stood as strong as its namesake's will was chaste. To Rilke, it was all the more beautiful for enduring that humiliation. This was the hour when the river turned to "gray silk" and the city lights glowed like stars fallen from the sky. Once darkness fell, people would once again pollute the air with their music and perfume, but cathedrals always offered asylum from the senses. Like a forest or an ocean, a cathedral was a place where the world hushed up and time stood still.

It's nearly impossible to stand before a cathedral and not consider the labor that went into building it. The painstaking process of its creation is as compelling as the consummate structure. Rilke marveled at the thought of the cathedral builders returning to work day after day, year after year, setting one stone on top of another. The cathedrals would "never have been finished if they had had to grow out of inspirations," he thought. The vision alone would have been too daunting. They were completed only because the artisans chose to make this work their lives.

Rodin's mantra, *Travailler, toujours travailler,* contradicted every-

thing Rilke had learned about the fusion of art and life in Worpswede. But the poet had spent years watching the clouds, anxiously awaiting a muse that never came. Rodin's example gave him permission to act. Now, to work was to live without waiting. More than that, Rilke concluded, "to work is to live without dying."

CHAPTER
7

🙰

BIOGRAPHERS WOULD BEGIN AT THE BEGINNING. THEY WOULD describe a boy too busy etching his dull blade into wood to eat. A young man working at a vase factory in Sèvres. They would identify his early influences—Dante, Baudelaire and Michelangelo—and the moment of his prophetic awakening, the flash point upon which his future genius hinged. It would be both "common and touching."

But this would be the wrong way to tell the story of Auguste Rodin, or at least not the way Rilke wanted to tell it. In October, Rodin went to visit a friend in Italy, leaving Rilke with three uninterrupted weeks to write his monograph. At his broken-down desk in the hostel, he began to imagine all the ways he might approach the dreaded first page.

He stared out the window at the brick wall on the other side. He paced and procrastinated. Unaccustomed to shutting his windows, he suffered the fatty stench of *pommes frites* wafting in and commingling with iodine vapors from the hospitals. When the odor became over-whelming, he took a walk to the Luxembourg Gardens, leaned his head against the gate and took a deep breath. But even then the smell of flowers, packed too tightly into their sidewalk gardens, irritated his delicate senses.

He would always return to the hotel by eight o'clock, before the

drunks invaded the streets. Back at his desk, the smell replaced by burnt kerosene from the lamp, he considered starting the book with explanations of the sculptures that made Rodin famous. But Rodin's fame had nothing to do with his work, he decided. He wrote it down on his stationery: "Fame is no more than the sum of all the misunderstandings that gather around a new name."

Nor could it begin with Rodin's childhood, because, after observing the sculptor in the flesh, Rilke had concluded that Rodin was born great. His eminence felt as eternal as that of a Gothic cathedral, or a chestnut tree in full bloom. To tell that story, Rilke would have to start in the branches and grow backward, reaching down into the trunk, then plunging into the dirt where the cracked seed lay.

Rilke laid down in bed, knowing he wouldn't sleep. The vibrating trams kept him from fully relaxing. Even if he did doze off for a moment, the neighbors would soon be coming home, stomping up the steps so loudly that he'd jolt upright in fear that they would barge right through the door.

Lying there awake, he would summon Baudelaire, like a guardian angel. Rilke would recite to himself the beginning of his prose poem "One O'clock in the Morning" from *Paris Spleen*: "At last! I am alone! . . . the tyranny of the human face has disappeared." But then he would begin to compare himself to Baudelaire and a new anxiety would set in.

Rodin never had this problem. He never questioned why he was an artist, or whether he should be. He knew that such doubts only distracted one from work, and Rilke was beginning to accept that work was all there was. He had spent so much time with the master by now that he could hold an entire conversation with him in his head:

"What was your life like?"

"Good."

"Did you have any enemies?"

"None that could keep me from my work."

"And fame?"

"It made work a duty."

"And your friends?"

"They expected work from me."

"And women?"

"I learned to admire them in the course of my work."

"But you were young once?"

"Then I was like all the rest. You know nothing when you are young; that comes later, and only slowly."

IN RODIN'S ABSENCE, Rilke sought out the company of other artists he admired. He met the Spanish portrait painter Ignacio Zuloaga, who was only five years older than Rilke but already well established in Europe, with several works on view at the Venice Biennale that year. From his barrel chest and thick black mustache the Basque artist exhaled an effortless confidence. He did not bother making sketches for his paintings, instead outlining figures in black streaks of charcoal directly on the canvas, then filling them in with a dark palette of paints.

Rodin had been so impressed with Zuloaga that he once traded him three bronze sculptures for one painting. Rilke would later conclude that, aside from Rodin, Zuloaga was the only figure in Paris "who affected me deeply and lastingly." But their connection seems to have been largely one-sided. Despite several letters expressing Rilke's admiration for the Basque painter, Zuloaga never responded as enthusiastically as Rilke probably would have liked. Yet Zuloaga did allow him to visit his studio once, where he introduced him to the work of another great master: El Greco. The stormy biblical scenes of the Greek-born Spanish Renaissance painter struck Rilke with a violent intensity he had only before known in nightmares. El Greco's misproportioned bodies, long and sinuous as candle flames, seemed so far ahead of the present day, much less that of the sixteenth century, when they were painted.

That month, Rilke also had to arrange for his wife's imminent arrival in Paris. He rented them each apartments a few blocks south of his Latin Quarter hostel, at 3 Rue de l'Abbe de l'Éppé. They would

share the same roof, but keep separate rooms. The couple saw each other only on Sundays, when they often read each other passages from *Niels Lhyne*. For her birthday, Rilke bought her a volume of Gustave Geffroy's essays, *The Artistic Life*, and inscribed it, "To Clara. The beloved mother. The artist. The friend. The woman." No mention of the wife or the lover. But Westhoff may not have minded the omission then. She had already received several sculpture commissions within that first month, so this second residency in Paris was already proving far more rewarding than her first.

Most importantly, she finally had access to Rodin's eyes. She brought him her work for critique nearly every Saturday, when he hosted an open house at his studio. "The nearness of Rodin, which does not confuse her, gives to her effort and becoming and growth a certain security and peace—and it proves to be good for her to be in Paris," Rilke wrote. Of a visit to Meudon with her husband, she recalled a feeling "of being set free, of being surrounded by everything that did one good. The beautiful figures and fragments stood next to one in the grass or against the sky, the lawn invited one as if to children's games, and in the middle of a little depression an antique torso stood in the sun."

By this time, Rilke had nearly finished writing the monograph. He had observed and considered Rodin's art from every angle and it had changed the way he saw the world: "Already flowers are often so infinitely much to me, and excitements of a strange kind have come to me from animals. And already I am sometimes experiencing even people in this way, hands are living somewhere, mouths are speaking, and I look at everything more quietly and with greater justness." But while Rilke was learning to see like an artist, he had not yet mastered the handicraft of one. Where was the "tool of my art, the hammer, *my* hammer"? he wondered. How could he build objects out of words? How could he apply the principles of Rodin's art to his poetry?

Rodin suggested that Rilke try out an assignment that he himself had undertaken as a student many years earlier. *Regardez les animaux*, professor Barye had told young Rodin. To the aspiring figurative sculptor, staring at beasts had seemed a second-rate task. But Rodin

soon understood why animals have been objects of reverence for artists dating back to the cave painters.

Zoos at that time were research centers for the study of heretofore undiscovered specimens and symbols of colonial might. Displaying a lion or monkey at home paid tribute to France's brave explorers abroad. For artists, they were museums of animals, providing contact with previously unseen aesthetic forms. For Barye, the Jardin des Plantes "was his Africa and Asia," the author Henry James once said. The painter Henri "Le Douanier" Rousseau also spent years seated on a bench there, taking inspiration for his dreamlike jungle tableaux.

For Rilke, the menagerie of bears, gazelles, flamingos and snakes was a sanctuary compared to the human zoo on the other side of the gates. He began to study the caged animals, displayed behind bars like objects, the way Rodin looked at sculptures on pedestals. Each one was a frontier to be discovered. To guide him on this journey, Rilke recalled the teachings of his old professor from Munich, Theodor Lipps, and devised a process of conscious observation, which he would come to call *einsehen*, or "inseeing."

Inseeing described the wondrous voyage from the surface of a thing to its heart, wherein perception leads to an emotional connection. Rilke made a point of distinguishing inseeing from inspecting, a term which he thought described only the viewer's perspective, and thus often resulted in anthropomorphizing. Inseeing, on the other hand, took into account the object's point of view. It had as much to do with making things human as it did with making humans *thing*.

If faced with a rock, for instance, one should stare deep into the place where its rockness begins to form. Then the observer should keep looking until his own center starts to sink with the stony weight of the rock forming inside him, too. It is a kind of perception that takes place within the body, and it requires the observer to be both the seer and the seen. To observe with empathy, one sees not only with the eyes but with the skin.

"Though you may laugh," Rilke wrote to a friend, "if I tell you where my very greatest feeling, my world-feeling, my earthly bliss was, I must confess to you: it was, again and again, here and there, in such in-seeing in the indescribably swift, deep, timeless moments of this godlike in-seeing."

In describing his joy at experiencing the world this way, Rilke echoed Lipps's belief that, through empathy, a person could free himself from the solitude of his mind. At the same time that Rilke was studying at the zoo in Paris, Lipps was in Munich working on his theory of empathy and aesthetic enjoyment. In his seminal paper on the subject he identified the four types of empathy as he saw them: general apperceptive empathy: when one sees movement in everyday objects; empirical empathy: when one sees human qualities in the non-human; mood empathy: when one attributes emotional states to colors and music, like "cheerful yellow"; and sensible appearance empathy: when gestures or movements convey internal feelings.

Animals provided Rilke with a uniquely rewarding case study of his old professor's teachings. One can relate to animals on the basis that they possess drives similar to those of people, but because they do not share a common language they remain fundamentally mysterious to us. Artists can scrutinize animals as curiosities, then, but unlike objects, animals look back. The two-way gaze tethers these separate lives together and fulfills the "beholder's involvement," which the Austrian art historian Alois Riegl argued was a necessary component in a successful work of art.

Rilke returned to the zoo day after day, practicing his inseeing skills before returning home at night to draft rough portraits of the creatures he had seen. He found himself especially drawn to a solitary panther, pacing in its cage. It reminded him of a small plaster panther that Rodin kept in his studio. The sculptor adored the thing so much—"'C'est beau, c'est tout,'* he says of it"—that Rilke had gone to the Bibliothèque Nationale to see the original bronze version it was modeled after. He visited that display cabinet again and again until he finally began to understand what Rodin saw in it:

And from this little plaster cast I saw what he means, what antiquity is and what links him to it. There, in this animal, is the same lively feeling in the modeling, this little thing (it is no higher than my hand is wide, and no longer than my hand) has hundreds of thousands of sides like a very big object, hundreds of thousands of sides which are all alive, animated, and different. And that in plaster! And with this the expression of the prowling stride is intensified to the highest degree, the powerful planting of the broad paws, and at the same time, that caution in which all strength is wrapped, that noiselessness . . .

The plaster panther stirred in Rilke a sensation much like what Rodin had felt when he stumbled upon Barye's greyhounds in the shop window, when he realized that an inanimate object could move with as much vitality as a living beast. Rilke had this in mind when he began to describe the panther in one of his impressionistic zoo sketches, which he called his "mood-images," and later when he developed it into "The Panther," one of his most celebrated poems. It begins with an image of the cat circling its cage:

> *His vision from the passing of the bars*
> *is grown so weary that it holds no more.*
> *To him it seems there are a thousand bars*
> *and behind a thousand bars no world.*

A reader might be tempted to see the panther's pacing as a reference to Rilke's own artistic plight. Yet there is no poet present here. Rilke no longer draws attention to himself with florid descriptions. He tells us nothing about the panther's size, for example, or the texture of its fur. He instead defines it only in terms of its captivity: It becomes the freedom it does not possess. The "passing" bars move, while the animal has become the cage, become *thing*.

The perspective then shifts from Rilke's to the panther's when it begins to hear the sound of its feet padding around. In doing

so, Rilke makes the circuit of empathy itself a subject of the poem. Near the end, Rilke returns to the panther's eyes: "the curtain of the pupil / soundlessly parts—" Then images enter the animal's vision, tunnel into the center of its body and into its heart, where they are captured and consumed for eternity.

Rilke had at last found a way out of himself and into the material world of objects. Just as young Rodin memorized paintings in the Louvre, the poet now allowed images to gather and take shape inside him before writing. He received them rather than created them, waiting while *they* formed *him*. It was as his future protagonist Malte Laurids Brigge would say, "Poems are not, as people think, feelings (those one has early enough)—they are experiences."

Written in November 1902, "The Panther" was Rilke's first composition for his breakthrough collection of *New Poems*, which he often referred to as his "thing-poems." This sculpturally composed work, deeply bearing the mark of Rodin, was also his first attempt at a kind of alchemy of mediums. It was a radical poetic experiment, "as revolutionary as anything by Eliot or Pound," wrote John Banville in the *New York Review of Books* years later. But this one poem did not bring about the artistic transformation that Rilke sought so desperately then.

As fall turned into winter he ran out of ideas. The wordless days turned to months, and "still nothing has happened," he said. He continued to see Rodin as a stream rushing in its path, leaving behind the people and facts of his daily life to "lie there like an empty riverbed that he no longer flows through." But the poet could not stop his creativity from splintering off into dozens of aimless channels, no matter how badly he wanted to "course through one riverbed and become great."

Was he too weak? Did he want it too desperately? He had once believed that digging his roots into the ground with a house and a family would render him "more visible, more tangible, more factual." But while the reality was certainly more concrete, "it was a reality *outside* me," he said. It did nothing to help him achieve the existential change "for which I yearn so strongly: To be a real person among real things."

———

THAT FALL, WHILE RILKE was writing "The Panther," a nineteen-
year-old Austrian cadet named Franz Xaver Kappus sat in the shade
of a hundred-year-old chestnut tree with a book of poetry. A student
at the Theresian military academy, Kappus was an aspiring writer dis-
guised in a soldier's uniform. When he heard about a radical new poet
who was modernizing German Romanticism, he picked up the author's
recent collection *In Celebration of Myself* and settled into the grass.

Rebelling against the Romantic tradition, Rilke had begun filling
his pages with saints, angels and gods, harnessing the potency of reli-
gious symbolism, but secularizing it. In one work, a Christ character
sleeps with prostitutes and mourns his failure to impregnate Mary
Magdalene. Rilke's irreverence made him a hero among a younger
generation. The Austrian writer Stefan Zweig recalled how he and
his classmates used to copy Rilke and Nietzsche verses into their text-
books to read while the teacher delivered some "time-worn lecture"
about Friedrich Schiller.

One can imagine that Kappus, not two years younger than Zweig,
felt similar awe at discovering Rilke's disaffected verses for the first
time. The cadet became so engrossed in the book that afternoon
that he almost failed to notice that one of his favorite teachers, Franz
Horaček, had come over. The professor took the book from Kappus's
hands and looked at the cover: "Poems of Rainer Maria Rilke?" He
flipped through the pages, glancing at the verses and running a finger
along the binding. Then he shook his head and said, "So our pupil
René Rilke has become a poet."

Horaček explained that he had been chaplain of St. Pölten some
fifteen years earlier, when the pale, sickly boy was a student there. He
described Rilke as "a quiet, serious, highly endowed boy, who liked to
keep to himself." He had "patiently endured" life at the junior academy
until his fourth year, but after he graduated on to the next level of
military school, his parents withdrew him. Horaček had not heard any
news of him since.

Kappus could not help but begin lining up the similarities between Rilke and himself. Both poets had come to military academies from Slavic cities in the east, Rilke from Prague and Kappus from the Romanian town of Timișoara. They both had lingered at the threshold of military careers that they felt were "entirely contrary" to their nature, as Kappus put it. As he thought about how the two young men had learned from the same teacher, worn the same uniform, and shared the same dream, Kappus thought to write a letter to Rilke, the poet in whom he "hoped to find understanding, if in any one." He told Rilke about their mutual acquaintance Horaček and enclosed a few of his own poems, asking for Rilke's opinion.

RILKE WAS HARDLY QUALIFIED to give career advice at that point in his life. In December, he turned in the Rodin monograph, but the measly fee hardly made a difference. He still could not even afford to send friends copies of his books—"I cannot buy them myself," he admitted at the time. Meanwhile, royalties from previous projects were running thin.

He and Westhoff spent the holidays in Paris, lonely for their friends and family abroad. Rilke wrote Otto Modersohn a New Year's letter to soften the tensions with his old friend. He complained about Paris, saying that "the beautiful things there are here do not quite compensate, even with their radiant eternity, for what one must suffer from the cruelty and confusion of the streets and the monstrosity of the gardens, people, and things." He urged Modersohn to "stick to your country!" The only good thing about Paris was Rodin, he said. "Time flows off him, and as he works thus, all, all the days of his long life, he seems inviolable, sacrosanct, and almost anonymous."

Rilke did not need to convince Modersohn. "That dreadful wild city is not to your taste—Oh I can believe that," he wrote back to Rilke. To him, cities bred the sicknesses of egotism, Nietzscheanism and modernism. "Nothing, nothing at all is more important to me than my peaceful, serious countryside. I could never endure living in

such a city—I should look at and enjoy the art that is stored up there and then quickly return to my peace and quiet."

But while Modersohn was content to sink into the sofa, pipe in mouth, and stay there all night, his wife had not yet exhausted her curiosities about foreign landscapes. Paula Becker was, at twenty-five, too young to give up and become one of those hard Worpswede peasant women, bitter and "bound to the plow," as Rilke once wrote. The village's monotonous routines, and the staid landscape painting it had been producing, was starting to dull her senses. Ever since she and Westhoff had gone to Paris three years earlier, German artists looked so obedient compared to the French. No one in Paris seemed to care whether their work achieved consensus. The mere thought of returning there quickened Becker's pulse.

Now that the Rilkes were back in touch, she saw her chance. Modersohn did not love the idea of his wife traveling alone. But he knew he still owed her for the sacrifice she made by attending the ghastly cooking school, and agreed that she could make the trip in February 1903.

Becker could barely contain her excitement when she boarded the train for Paris that winter, just in time for her twenty-seventh birthday. She imagined her Parisian life picking up right where it had left off, with days occupied by art galleries, champagne and philosophical discussions with Westhoff, then Saturdays spent galavanting around the countryside. When she arrived, Becker rented the same little hotel room where they had stayed as students.

On the first evening Rilke and Westhoff were free to meet, Becker rushed over to their Latin Quarter building, eager as a puppy. She regaled them with gossip about Worpswede, but they seemed not to care, as if her small-town stories were beneath them. It wasn't that they were rude; it was worse than that. They were *cordial*. There was no warmth, no familiarity and, on top of it all, they seemed totally miserable. All they did was complain about money and feeling overworked. When Becker tried to convince them to take some time off and join her on a day-trip to the country they declined, insisting they had to work.

The Rilkes "trumpet gloom," Becker wrote to her husband the next day. "Ever since Rodin said to them, '*Travailler, toujours travailler,*' they have been taking it literally; they never want to go to the country on Sundays and seem to be getting no more fun out of their lives at all." Rilke spoke incessantly about Rodin and the monograph, a project that Becker believed was little more than thinly veiled social climbing. "Rilke is gradually diminishing to a rather tiny flame which wants to brighten its light through association with the radiance of the great spirits of Europe: Tolstoy, Muther, the Worpsweders, Rodin, Zuloaga, his newest friend," she wrote to her husband. Westhoff's latest work, a series of fragmented bodies, was also beginning to resemble Rodin's a little too closely. "We shall see how she plans to avoid becoming a little Rodin herself," Becker wrote.

The only benefit to the Rilkes' obsession with Rodin was that it opened the door for Becker to meet the famous sculptor herself. Rilke told her that Rodin hosted an open house for friends and colleagues at his studio every Saturday. Rilke would write a note identifying her as the "wife of a very distinguished painter"—an insult not lost on Becker—which should secure her entry.

When she arrived the following weekend a crowd had already gathered at the studio. She hesitated at the edge of the room, attempting to compose herself before approaching the master to present her pass. When she finally summoned the nerve, she cautiously went up to him and held out the note. He nodded her along, not even glancing at it.

Once inside, Becker was free to examine the sculptures standing around the room as closely as she liked. Not each work resonated with her, but they gathered such force collectively that she decided she trusted Rodin's intentions completely. "He doesn't care whether the world approves or not," she thought. On her way out she worked up the courage to ask him if she might one day visit his studio in Meudon. To her amazement, he didn't flinch: Come next Sunday, he said.

When she arrived by train that weekend, an assistant informed her that Rodin was busy at the moment but she had his permission to wander the grounds on her own. Becker took a walk and revisited

the pavilion of works she had first seen at the World's Fair, recognizing now how deeply they expressed their maker's "worship of nature." After a while Rodin joined her and brought her to the studio. When he pulled out several reams of drawings, she was surprised to see how his process began with simple pencil lines that were then doused with watercolors. How unusual that such wild, blazing colors could come from such a mild man, she thought.

Before long Rodin launched into a familiar soliloquy: "Work," he said, "that is my pleasure." It was the precise rhetoric that exasperated her when it came from Rilke, but out of Rodin's mouth every word was intoxicating. Becker believed that Rodin truly lived by his words; the proof surrounded her in every corner of this room. But Rilke, who had only a few mediocre books to show for all his complaining, merely quoted them. Becker wrote to her husband that he must come to Paris at once, if only to be near Rodin. "Yes, whatever it is that makes art extraordinary is what he has."

Becker's exhilaration was interrupted as soon as she returned to the Rilkes and their contagious misery, however. For a while she had been determined to salvage her trip and accommodate their interests over hers. Instead of a picnic in the countryside she went with them to see a show of Japanese paintings that contained flowing, childlike lines unlike anything she'd ever seen. But in March, Rilke fell ill again with his third bout of flu that winter. Becker brought tulips to him in bed but announced to Modersohn afterward that "I can't stand him anymore." She kissed her wedding ring and decided to cut her stay in Paris short.

As she waited for the train back to Worpswede she wrote to her husband that she believed Westhoff would be better off if Rilke went away for a while. Her bust commissions were picking up and his wallowing only brought her down.

RILKE'S OPINION OF HIMSELF was not much higher than Becker's at that time. Having finished the Rodin monograph, he was left worrying once again where his next paycheck would come from, and

where—or if—the inspiration for his next book would arise. "I cannot bring myself to write at all; and the consciousness alone that a connection exists between my writing and the days' nourishment and necessaries, is enough to make my work impossible for me," he wrote that spring to his friend Ellen Key, a Swedish psychologist and patron of the poet. "I must wait for the ringing in the silence, and I know that if I force that ringing, then it really won't come."

His desk was now bare, apart from a stack of unanswered mail. Finally, in February 1903, he sat down to respond to a letter that had come from a student at the military academy he had attended as a boy. Rilke did not know this young man by the name of Franz Xaver Kappus, but he was pleased to see a reference to Professor Horaček. Rilke had always liked the man, who was the only teacher on staff who wasn't also a military officer.

"My Dear Sir, Your letter only reached me a few days ago. I want to thank you for the great and kind confidence. I can hardly do more," Rilke wrote in his looping black calligraphy.

Kappus had almost given up on a reply when the envelope bearing a blue seal and a Paris postmark arrived. The address was written in "beautiful, clear, sure characters," he said. It "weighed heavy in the hand."

When he opened it he found that Rilke had sent eight full pages in response to his two. Rilke, knowing how anxiously he had been waiting for his own bell of creativity to toll again, advised the young poet now to consider carefully whether he was prepared to bear the burden of the artistic condition.

"Search for the reason that bids you to write; find out whether it is spreading out its roots in the deepest places of your heart," Rilke wrote. Then ask yourself, "would you die if it were denied you to write. This above all—ask yourself in the stillest hour of the night: *must* I write?" If the heart utters a clear, "I *must*, then build your life according to this necessity," but be prepared to surrender to the imperative forever, for art was not a choice, but an immutable disposition of the soul.

Rilke declined to critique the poems Kappus sent, other than to say that they possessed no distinctive voice and were "not yet independent." He urged the poet not to send them to editors or critics again, himself included. That could only provide external validation, and a poet's testament must come from within. Besides, nothing was further removed from art than criticism, Rilke said, and reviews "always come down to more or less happy misunderstandings."

Rilke's response moved Kappus to write back immediately. We do not know what he said because his side of the correspondence was never published, but we know that they exchanged some twenty letters over the next five years. We also know that Kappus found Rilke's wandering reflections on solitude, love and art so touching, so deeply felt, that he astutely predicted that the letters would also stir the hearts of other "growing and evolving spirits of today and tomorrow." Shortly after Rilke's death he brought the letters to Westhoff and Ruth Rilke to ask if they'd like to have them published.

Rilke viewed his prolific letter-writing habit as a part of his poetic practice. He took such care in composing his correspondence—he would sooner rewrite an entire page of script than mar its surface with a crossed-out word—that he gave his publisher permission to posthumously release it. When Rilke died in 1926, Ruth and her husband, Carl Sieber, began sifting through the surviving seven thousand letters. They took several collections to his publishers: a set that Rilke wrote to the head of his Dutch publishing house in the last year of his life appeared in 1927, while another to his biographer Maurice Betz came out in 1928, as did his series of letters to Rodin. In 1929, Insel-Verlag released his correspondence with Kappus under the title *Letters to a Young Poet.*

Little is known about Kappus because Rilke's family decided not to include the cadet's name or biography in the original publication, although some later editions include a brief introduction by him. Nor is it known why Rilke maintained such a long correspondence with a stranger from whom he had nothing to gain. But from the way his letters often read as though they were written to his younger self, it is

clear that Rilke sympathized with this young poet and fellow victim of that "long terrifying damnation" known as military school.

More importantly, however, was probably Kappus's timing. His letter reached Rilke just as the poet had been trying to locate his own footing within Rodin's in Paris, so he appreciated the desire to find one's form. Just as the puppet Pinocchio became "a real boy" once his father saw the good in him, young artists are often affirmed when they see their reflection in a master's eye.

Even though Rilke was himself sublimely naive at the time, Kappus had tacitly anointed himself Rilke's disciple, and the older poet took this responsibility to heart. He wrote Kappus letters in a tone of authority that only an amateur would dare—trying on the master's robe and liking the way it fit. But Rilke knew he was in no position to offer professional instruction then, having told a friend that spring, "I have written eleven or twelve books and have received almost nothing for them, only four of them were paid for at all." Instead of advising Kappus on the profession of poetry, he opted to guide him on the poetic life. That was what Rilke had asked of Rodin, and from then on his letters to Kappus would serve as his field notes.

CHAPTER
8

❧

TWO DAYS AFTER PAULA BECKER DECLARED THAT RILKE ought to leave his wife alone for a while, the poet did just that. Still ailing from an especially resistant case of the flu, he came to the conclusion that only the balmy Mediterranean could soothe his winter-worn body. He left Westhoff to finish her work in Paris and, aided by some money from his father, boarded a crowded train, curled up in a camel-hair blanket and shivered all the way to Tuscany.

At the edge of the marble mountains of Carrara, Rilke reached the elegant seaside resort Viareggio. He suited up in his black-and-red-striped swim trunks first thing and strolled barefoot along the beach, a copy of *Niels Lyhne* in hand. The soft sand and sun normally should have nourished him, but something was not quite right. The sea looked monotonously flat and the salty air made him thirsty. The tables at the restaurant were unfortunately round, rather than square. Worst of all, the sound of German echoed around him everywhere.

Even though he hid behind a French newspaper, the waiters took his order in German. The honeymooners at the table next to him murmured to each other in German. Tourists loudly chattered away in German small talk. "I underlined my silence with the thickest strokes; it was no good," he wrote to his wife. It was like hearing the voices

of his family members at every turn. German had been the weapon of his mother's snobbery, wielded to assert her superiority over the Czechs, and it was the language of the military government that had crushed his father's pride. To Rilke, German was the sound of bullies and unearned dominance. He began taking meals alone in his room.

Unable to concentrate on his reading, Rilke wrote two letters to the young poet Franz Kappus in April. He tried to make peace with the uncertainty he felt at the time, even praising it by saying, "There is here no measuring with time, no year matters, and ten years are nothing. Being an artist means, not reckoning and counting, but ripening like the tree which does not force its sap, and stands confident in the storms of spring without the fear that after them may come no summer. It does come. But it comes only to the patient," he wrote. This was how Rilke once described Rodin, "sunk in himself" like a tree that has "dug a deep place for his heart."

Whether or not the words comforted Kappus, they did little for Rilke, who himself still felt like a seedling. He advised Kappus to seek a mentor and named the two who had taught him the most about creativity: "About its depth and everlastingness, there are but two names I can mention: that of Jacobsen, that great, great writer, and that of Auguste Rodin, the sculptor, who has not his equal among all artists living today."

But perhaps Kappus was wise to have sought his master from afar. Rodin's towering influence had inspired Rilke, but it also cast a diminishing shadow. He feared that his poetry lacked the potency of a tangible medium like sculpture. "I actually experienced the physical pain of not being able to render a bodily form," he wrote. A verse would never fill a gallery, nor could a verb move through space like a gesture.

The anxiety that paralyzed Rilke now resurrected his childhood nightmare of "the nearness of something too hard, too stone-like, too great," he wrote. Days began to pass without his writing a single word. He was homeless and adrift, imagining he would return to Westhoff in Paris, but not knowing what he would do when he got there. Perhaps

he would write a book on Rodin's friend Eugène Carrière, the popular painter of brooding, sepia-toned portraiture.

Before Rilke left Italy, his slim book on Rodin came out. Rather than offer dry academic criticism of the kind he had denounced to Kappus, Rilke savored Rodin's art like wine, inhaling and swirling it into maximalist descriptions matched only by the melodrama of Rodin's own work. Of the *Gates of Hell*, Rilke wrote: "He has created bodies that touch each other all over and cling together like animals bitten into each other, that fall into the depth of oneness like a single organism; bodies that listen like faces and lift themselves like arms; chains of bodies, garlands and tendrils and heavy clusters of bodies into which sin's sweetness rises out of the roots of pain."

Because the study had served largely as an exercise in Rilke's own powers of observation, the resulting book reveals as much about its author as it does its subject. "From no other book of his," wrote H. T. Tobias A. Wright in the introduction to a 1918 collection of Rilke's poetry, "can we deduce so accurate a conception of Rilke's philosophy of Life and Art as we can draw from his comparatively short monograph on Auguste Rodin."

Nearly every critic who reviewed *Auguste Rodin* commented on Rilke's exalted opinion of the artist: It was "enthusiastic," "too attached," "saturated with sensitivity," or "panegyric." "It is a poem in prose. To the eternally sober much will appear as excessiveness and pomposity, but all poetry thrives on exaggeration," said one Austrian newspaper.

Rilke asked his wife to hand-deliver a copy to Rodin, along with a letter expressing his regrets that the master would not actually be able to read it in the German. But he promised, truthfully, that it would not be his final word on the artist. "For with this little book your work has not ceased to occupy my thoughts," he wrote, "from this moment on it will be in each one of my works, in each book that I am granted to finish." He also confessed to him that he hadn't been able to concentrate since he'd left Paris and that sometimes he read about Rodin just "to hear your voice, together with those of the sea and of the wind."

When Rodin received the package, the sculptor replied with a simple note: "Please receive my warmest thanks for the book that Mme Rilke has brought me." He hoped that it would be translated into French someday.

Then the lines of communication between the two men fell silent. As a storm moved up the coast of the Tyrrhenian Sea, Rilke felt a familiar stirring. Day after day the weather brought "restlessness and violence" to the town, wrapping the sky like a gray shawl. It drove Rilke into his room, where, in one sequestered week that April, he wrote the third and final part of his *Book of Hours*. The urban smog and concrete of Paris darken the palette of these thirty-four poems, subtitled "The Book of Poverty and Death," in a sharp departure from the bucolic Worpswede setting of the first two parts.

In the book, Rilke acknowledges that he is starting to change. A cry to god invokes the rock that once threatened to crush him in his childhood dreams, but now it reappears as the stony will of a master. In the verse, he believes the force can squeeze creativity from him, like spice from a seed, and this time it is a transformation he welcomes:

> *But if it's* you: *weigh down until I break:*
> *let your whole hand fall upon me . . .*

These creative outpourings emptied Rilke out. Completing the book felt less like a birth than a loss of purpose. Rilke returned to Paris in May, but instead of beginning a new project, he promptly fell ill once again. Now that he was out of work and Westhoff's commissions were complete, they had no way to pay for their apartment in Paris. When Heinrich Vogeler invited them to come back to Worpswede, they had little choice but to accept. While Westhoff packed up her studio, Rilke lay in bed, dreading the loss of solitude that would accompany a return to the community. But then he considered that it would also bring him nearer to Lou Andreas-Salomé. He had resisted contacting his estranged friend for two and a half years, since the

announcement of his engagement to Westhoff. But now he was more desperate for her guidance than ever. Remembering the caveat she had scrawled on the back of her "last appeal," Rilke decided that he had reached his "direst hour."

In June, just before leaving Paris, he wrote her a letter. "For weeks I have wanted to write these words and dared not for fear that it might still be much too soon," he told her. But now that he would be back in Germany he begged her to allow him to visit her for even a single day. She had moved near Göttingen, a university town in the north where her husband had recently accepted a professorship.

By the time Rilke's letter and a copy of the Rodin mongraph arrived, Andreas-Salomé had become "a peasant woman," she joked, with a dog and a chicken coop. She was living in a valley of beech trees, just beyond a sylvan range of mountains. She began reading the book slowly at first, finding herself becoming gradually more engrossed as the days went on. Eventually she realized that Rilke had done much more than write an appreciation; he had mapped out a philosophy of creativity. This achievement, which must have required a major "psychic reorientation," outshadowed any annoyances she had felt toward him in the past.

When Rilke unfolded her reply a few days later, the sight of that familiar upright penmanship, so like his own, put him instantly at ease. She professed that the Rodin book had nearly rendered her speechless. "That you gave yourself to your opposite, your complement, to a longed-for exemplar—gave yourself the way one gives oneself in marriage—. I don't know how else to express it,—there is for me a feeling of betrothal in this book,—of a sacred dialogue, of being admitted into what one was not but now, in a mystery, has become," she wrote. It was "beyond doubt" the most important work he had published to date. "From now on you can depend on me," she promised.

Rilke's hands shook as he held the letter. He didn't know where to begin with his reply, he had so much to tell her. "I won't complain," he lied, unable to prevent the outpouring of anguish that followed. He

told her about the three fevers he had suffered that winter, the torment of Paris and his recent writer's block. "I can ask no one for advice but you; you alone know who I am," he said.

With that, the "two old scribblers" eased back into their old habit of letter-writing as if nothing had happened. Rilke told her about how many of his youthful fears still haunted him. He sometimes felt so invaded by the lives of others that he worried whether the boundaries between him and them might break down altogether. Other people's misery seeped into his mind like ink bleeding across paper. Did he even possess a self of his own? Perhaps not, he once thought, telling Andreas-Salomé, "There is nothing real about me."

He gave her an example of one such trauma that had arisen in Paris. He had been on his way to the library when he found himself walking behind a convulsive man displaying what Dr. Charcot would have called St. Vitus' dance. The man's shoulders shuddered, his head nodded and jerked. He walked in syncopated skips and hops. Rilke watched him with such curiosity that he felt as if his vision had tunneled inside the man's body. He saw the tension accumulating in his muscles, gradually crescendoing toward the explosion of spasms that was sure to come.

At the same time, Rilke felt a similar pressure start to rise in his own body, as if he had contracted the man's ailment visually. He could not help but follow him through the streets, "drawn along by his fear [which] was no longer distinguishable from my own."

After describing this episode across several pages of the letter, Rilke concluded that the day had ended in utter derailment. He never made it to the library—how could one read after such a shock? "I was as if consumed, utterly used up; as if another person's fear had fed on me and exhausted me." This sort of thing happened all the time, he said. But instead of transmuting these fears into art, they swallowed up his creativity. How, he asked Andreas-Salomé, might he learn to channel such powerful feeling into poetry?

Her answer was unequivocal: You already have. She wrote back to him that his description of the man had resonated with her so vividly

that it no longer lived only within him, but in her, too. He could stop worrying about whether he would ever realize his talent and accept now that he already had—its evidence was right there in that last letter.

Having begun an intensive study of Freudian psychology, Andreas-Salomé recognized Rilke's anxiety as a common *fin-de-siècle*-era symptom. Growing concerns over crowds and urban alienation had pushed many theorists of the mind to adopt a more sociological approach to their work. The inquiry into individual consciousness that had led Descartes to declare, "I think therefore I am," three hundred years earlier now became a question of, how do other people think? And how do we even know that other people have selves?

The latter was the question to which Rilke's old professor Theodor Lipps's empathy research eventually led him. He had reasoned that if *einfühlung* explained the way people see themselves in objects, then the act of observation was not one of passive absorption, but of lived recognition. It was the self existing in another place. And if we see ourselves in art, perhaps we could also see ourselves in other people. Empathy was the gateway into the minds of others. Rilke's prodigious capacity for it, then, was both his greatest poetic gift and probably his hardest-borne cross.

Andreas-Salomé understood this predicament and urged Rilke to let his defenses down. He should nurture his gift as if it were a seed growing inside him: "You have become like a little plot of earth into which all that falls—and be it even things mangled and broken, things thrown away in disgust—must enter an alchemy and become food to nourish the buried seed . . . it all turns to loam, becomes *you*." He should approach the sick and the dying like a pickpocket, scavenging their misery for poetry.

Rilke tried to take her advice and identify with the convulsive man rather than block him out. He had already learned to "see into" animals and flowers, and now he could advance like an artist from still lifes to human models. Perhaps the spasmodic pace of the convulsive man was not so different from that of a poet, he thought. Both were people who simply moved through life differently than others.

He began to reassemble these perceptual fragments in letters to Andreas-Salomé over the coming months. Gradually, an image emerged not only of the sights and sounds of Paris, but of a person who might experience them. Rilke gave this figure a name, Malte Laurids Brigge. The protagonist of what would become Rilke's only novel, Malte is a young Danish poet and, like Rilke, he, too, goes to Paris and must defend himself against the onslaught of stimuli. And he, too, is disturbed by the sight of a man with a Tourette's-like tic, recounted in *The Notebooks of Malte Laurids Brigge* almost exactly as Rilke described it in his letter. As Rilke drifted away from his friends and family in the coming months and years, Malte was to become his closest companion.

RILKE AND WESTHOFF'S REUNION with the Worpswede community was not a happy homecoming. Heinrich Vogeler had spent the last year planting a garden, renovating his home, and now had a second baby on the way. Rilke, the newly stoic disciple of Rodin, was disappointed to see that his old friend had made domesticity, rather than art, his primary creative act. His embrace of conventional comforts conflicted with Rodin's gospel, leading Rilke to conclude that the Worpsweders seemed "small and inclined toward irrelevancies."

They, meanwhile, were no more impressed with Rilke and Westhoff, particularly when the couple demanded two separate rooms. Rilke's monograph on the Worpswede artists came out earlier that year and had not gone over well in the community. Rilke had accepted the assignment purely for the money, without necessarily thinking very highly of its subjects, apart from Otto Modersohn. But since he had not wanted to disparage them, either, he suspended judgment from the text altogether. Instead he wrote portraits of young artists "in the process of becoming," as he explained in the introduction. He described their childhoods and their lives in the colony. When Becker read the book she found the writing pompous and the mythologized content irrelevant. "There is a lot of talk and beautiful sentences, but

the nut is hollow at its core," she said. It couldn't have helped that Rilke managed to omit Becker—the colony's best painter—from the book completely.

The Rilkes underwent another unhappy reunion that summer when they paid a visit to Ruth, who was living in an old farmhouse nearby with Westhoff's parents. She was now a wild toddler, running naked outdoors. She had somber blue eyes that did not recognize her parents at first. She came up to Rilke tentatively and, after a few days, took to calling him "man" and "good man." He felt incapable of addressing her with the attention she surely wanted. The pressure to bond with this mysterious little life unsettled him. Caring for her forced him out of his solitude and all but assured that he would disappoint her. By the end of August, he was eager to leave Worpswede behind.

It felt like as good a time as any for Westhoff to take Rodin's advice and study the sculpture in Rome, as he had once done. Rilke decided to join her for a "Roman winter" and pursue his newfound interest in Gothic architecture. Rilke would have preferred to live deeper in the countryside, but they rented a villa just outside the city for a few months. Then, as spring set in, so did the sound of German-speaking tourists, closing in on Rilke like soldiers cresting a hill. Westhoff stayed in Rome, but Rilke could not bear to stick around for another season.

He took off wandering the Continent again, from Rome to Sweden and Denmark. He had started writing *Malte* in Italy, but since his young protagonist was Danish, Rilke now felt the pull to go to Copenhagen, "Jacobsen's city." In those days, "it was difficult to reach Rilke," recalled his friend and fellow writer Stefan Zweig. "He had no house, no address where one could find him, no home, no steady lodging, no office. He was always on his way through the world, and no one, not even he himself, knew in advance which direction it would take."

Westhoff forwarded Rilke his mail in Scandinavia, including, in July, a two-month-old letter from Franz Kappus. Rilke was grateful to her for sending it, explaining that the young man was "having a hard time" then. Kappus had apparently been worrying about whether

having had a difficult childhood had drained him of all his strength for adulthood. It must have been an especially fretful note, for Rilke praised his "beautiful concern about life." He agreed that "sex is difficult; yes" and told him that he had waited to reply until he had had some thoughtful advice to impart. His miserable summer in Worpswede had finally shown him his message.

Outgrowing your friends is a deprivation that frees yourself for growth, he told Kappus. As the world around you clears out, others may become fearful of the solitude you possess. But one must remain "sure and calm before them and do not torment them with your doubts and do not frighten them with your confidence of joy, which they could not understand." One must seek nourishment in that emptiness, which, thought of another way, is a vastness. As one moves more deeply inside it, be kind to those left behind.

Rilke had advised the young poet to forgo the big romantic questions in his first letter: "Do not write love-poems," he had said. As Rodin had taught Rilke, simplicity precedes significance and small things often grow into big things, like the cell or the seed that eventually sprouts to life. That was why Kappus should focus now on everyday "things," the "things that hardly anyone sees, and that can so unexpectedly become big and beyond measuring."

NO MATTER WHERE RILKE traveled, sicknesses flared up along the way: an oppressive toothache, a stinging in the eyes, an inflamed throat, "mental nausea." Worse, he had no will to write and no means to earn a living. Unlike other writers of his ilk, Rilke refused to dilute his practice with a trade like teaching or journalism. Toward the latter he felt a special "nameless horror" because reporters had to operate within their times and he felt resolutely out of touch with his. Instead, Rilke claimed these in-between phases for "research."

He considered returning to school but decided that maybe he'd done too much studying already. All of that reading "words about words" and "conceptions of conceptions," what had it really taught him? Even

at the Bibliothèque Nationale, he had grazed vast pastures of French literature only to realize that when he lifted his head from the book he had produced pages of notes, but no writing of his own.

In May 1904, Rilke decided to design his own syllabus for an independent course of study. It was an ambitious and sprawling agenda that included learning Danish, reading the Grimm Brothers dictionary, reading biology books, writing monographs on Jens Peter Jacobsen and Ignacio Zuloaga, reading Jules Michelet's history of France, translating literature from Russian and French, attending scientific lectures and experiments, and writing his new book: a work of "firm, close-knit prose," which would become *Malte*.

There was little art history or philosophy on his list. He wanted to ground himself instead in the "real." To study nature was like gathering the rocks and leaves that would sink him into the earth. "There are starry heavens, and I do not know what mankind has learned about them, I do not even know the disposition of stars," he said at the time. Wouldn't such an education "enable me to attack and hold onto my work with greater confidence, would it not also be a means of reaching that *'toujours travailler'* which is the crux of everything?"

For Rilke, all of life became an education. Every city, every emotion was a subject to master. As Rilke was devising his new curriculum, he wrote to Kappus to tell him that even love should be treated as a subject of inquiry, perhaps the foundation course. "To love is good, too" because loving is "difficult. For one human being to love another: that is perhaps the most difficult of all our tasks, the ultimate, the last test and proof, the work for which all other work is but preparation. For this reason young people, who are beginners in everything, cannot yet know love: they have to learn it."

This logic created a lifelong paradox for Rilke. If learning demands solitude, then learning to love also required doing so without other people. "Love is at first not anything that means merging, giving over, and uniting with another," he told Kappus. The outlines of two people must remain clear, and if they can endure love "as burden and apprenticeship, instead of losing ourselves in all the light and frivolous play

. . . then a little progress and an alleviation will perhaps be perceptible to those who come long after us; that would be much."

There was also a second task on Rilke's syllabus: "Discovering some specific person willing to help me, so that the general process of education can become an affair between two people." For that he wanted a "teacher of stature," but also someone who was patient. Someone who would be willing to mentor him one-on-one and endure his many "questions and wishes, with my huge wealth of inexperience," he wrote.

Rilke identified a possible candidate for the job in Georg Simmel, the German sociologist whom he had met through Andreas-Salomé. Simmel was an enormously popular lecturer who had risen to widespread acclaim the previous year for his essay "The Metropolis and Mental Life." In it, he made his native Berlin a case study for examining the neurotic psychology of the modern city dweller.

Simmel argued that urbanites were evolving to develop "protective organs" that defended them against the sensory overload of cities. But these organs also blunted their emotional receptors in turn, resulting in populations that were less sensitive, more intellectual and more apathetic. "There is perhaps no psychic phenomenon which is so unconditionally reserved to the city as the blasé outlook," Simmel wrote.

Rilke recognized in Simmel's milieu a setting he could use for *Malte*. The Danish character, like Rilke, would undergo the "rapid telescoping of changing images" and the "intensification of emotional life" that were characteristic of Simmel's metropolis. Gradually, Rilke had come around to Andreas-Salomé's view that these emotional fevers had an advantage. As he wrote to Kappus in November, "Every intensification is good, if it is in your entire blood, if it isn't intoxication or muddiness, but joy which you can see into, clear to the bottom."

In early 1905, Rilke wrote Simmel to ask whether the professor would be teaching in Berlin the following semester.

Simmel replied that he would not, he was taking time off from

teaching to research a paper on artistic manifestations of modern anxiety. In fact, he had wanted to ask Rilke a favor: Could he introduce him to Rodin? Simmel believed that Rodin's works gave form to the restless modern spirit. "By inventing a new flexibility of joints, giving surfaces a new tone and vibration, suggesting in a new way the contact of two bodies or parts of the same body, using a new distribution of light by means of clashing, conflicting, or corresponding planes, Rodin has given to the human figure a new mobility that reveals the inner life of man . . ." he would write. To Simmel, Rodin marked the endpoint on a continuum that began with the Renaissance. Whereas four hundred years earlier Michelangelo's *David* posed in a comfortable contrapposto, and his female figures lolled on lounges, Rodin's works teemed with tension and instability, stalled in states of eternal becoming.

Rilke was proud to be of service to the two great thinkers and swiftly made the introduction. As Simmel set off to write one of the greater essays in the canon on Rodin, "Rodin's Work as an Expression of the Modern Spirit," Andreas-Salomé offered Rilke an unmissable opportunity to visit her in Göttingen. He had just finished revising the manuscript for *The Book of Hours*, which the prestigious publishing house Insel-Verlag would publish in April, and was in high spirits when he set off for the long-awaited reunion.

The stay at Loufried, as the house was called, was everything Rilke had hoped for. The old friends read to each other in the garden and she cooked his favorite vegetarian meals. When her beloved dog Schimmel grew abruptly ill and died, Rilke mourned with her. Watching Andreas-Salomé cry confirmed his belief that "one should not draw into one's life those cares and responsibilities which are not necessary, just as I felt it as a boy when my rabbit died." When he was getting ready to leave, Andreas-Salomé assured him that a room at Loufried would always be open to him, his green leather slippers waiting by the door.

One can only speculate how Westhoff felt about her husband's reunion with his former lover, whom she had not yet met. Rilke tried to explain that, because Andreas-Salomé played such a formative role

in his "inner history," she should be considered "indispensable and essential" to Westhoff, too. It's possible that Westhoff did not need any reassurance at all. She had by now left Rome and was setting up a studio for herself in Worpswede, where she could teach art classes and be with Ruth.

Paula Becker was thrilled to hear that Rilke was off on one of his trips "to study something or other." Now that she had her best friend back in Worpswede the women spent nearly every day together. While Ruth, who was growing into a plump, "cuddly little creature" of four, played on the floor nearby, Becker began painting a portrait of her old friend wearing a white dress and a remote expression. Westhoff posed with a red rose held to her clavicle, her lower lip pressed firmly into the upper. Her eyes are averted to one side, seemingly focused on nothing. They appear useless to her in this moment, as if Westhoff existed so entirely within her own mind that Becker could hardly exteriorize her in painting.

They spoke often about independence—about how Westhoff did not necessarily mind having so much distance from her husband, and how Becker craved more of it from hers. When Rilke informed his wife that Georg Simmel had returned to Berlin from Paris and that the poet planned to travel there next from Göttingen, Westhoff seemed to think it was a good thing that Rilke was "getting to see the intelligentsia of Europe," Becker wrote.

One cold day in the studio, as Becker scooped peat into the oven, she told Westhoff how badly she wanted to leave Worpswede. Westhoff saw for the first time the gravity of her friend's sadness. As she spoke, "one tear after another rolled down her cheek while she explained to me how very important it was for her to be out 'in the world' again, to go back to Paris again." To her, Paris was "the world."

Becker's depression had become palpable to Modersohn, too. But he blamed his wife's dissatisfaction with rural life on her ambition. For the first time, he disparaged her painting, writing in his journal, "What Paula is doing with her art now does not please me nearly so much as it used to. She will not accept any advice—it is very foolish

and a pity." Her nude figures with big heads resembled the primitive paintings that had come into fashion in Paris. He thought she should instead be looking at more "artistic" paintings.

Women artists, in general, were too stubborn, he decided. West-hoff was a good example: "For her there is only one thing and its name is Rodin; she blindly does everything the way he does it," Modersohn wrote. Becker agreed that her friend was still "very much under the influence of [Rodin's] personality and his great, simple maxims."

For that reason, it was all the more exciting when Rilke rushed Westhoff a letter that fall bearing incredible news from Rodin. The poet had spent nearly three weeks in Berlin attending Simmel's lec-tures; then, the day before he was scheduled to leave, Rodin sent him a letter. The sculptor had found Rilke's address in Berlin to let him know that he had finally read a translated edition of the monograph. Although Rodin didn't offer any specific impressions of the book, he must have been pleased, telling Rilke, "My very dear friend, I am writ-ing to assure you of the fullest friendship and admiration which I bear for the man and the writer whose work has already had a pervasive influence through his labor and talent."

Rilke hand-copied the letter for Westhoff so that she could savor each word for herself. The unexpectedly warm tidings from Rodin lifted Rilke's spirits and rekindled a desire to visit him. "It is the need to see you, my Master, and to experience a moment of the burning life of your beautiful things that excites me," he wrote in his reply. He told him that he and Westhoff were planning a trip to France that fall. Would Rodin be available for a visit in early September?

The artist not only agreed to meet with the couple, he invited them to stay in Meudon as his guests. On the back of the letter, his secre-tary added a postscript emphasizing that Rodin indeed *requests* that the poet stay at his home, "so you can talk."

While Westhoff began to fantasize with Rilke about a trip to the cha-teau in Meudon, with "its garden looking out far and wide," Becker stood quietly by. "Follow my example," Westhoff would tell her, and Becker resolved to do just that. She did not yet know how, but she would start

by stashing away every coin she found from that moment on. Whatever it took, she promised herself that she would return to Paris someday.

"WITHOUT DOUBT THERE EXISTS somewhere for each person a teacher. And for each person who feels himself a teacher there is surely somewhere a pupil," Rilke wrote during his first stay in Worpswede. He had been searching then for a mentor to replace Andreas-Salomé, and now he had found himself looking at Simmel as a potential replacement for Rodin.

At the same time, Rodin was searching far and wide for his next pupil. In February 1905, he saw promise in Edgard Varèse, a twenty-one-year-old music student with dark Italian features whom he had hired as a model. As they got to talking, Rodin grew impressed with the young man's interest in reimagining music as sound sculpture. Varèse had been fascinated by Roman cathedrals while living in Turin as a boy and now wanted to translate that style of architecture into "blocks of sound," as sturdy as granite. Rodin offered him a job working in Meudon as his secretary, with the promise to help him make connections in return. The sculptor had well-known friends in the field, like Claude Debussy, whom Varèse adored.

But Rodin could scarcely find the time to hold up his end of the bargain. In June he left for a road trip through Spain with the painter Ignacio Zuloaga, while Varèse stayed behind answering the artist's mail. On their trip, Zuloaga, then thirty-three, introduced Rodin to bullfighting, which the sculptor found to be a "revolting slaughter." He then took the sculptor to see the paintings of Francisco Goya and El Greco, which impressed Rodin even less. El Greco simply "doesn't know how to draw," he muttered over and over. When an art dealer offered Zuloaga an El Greco altarpiece of St. John the Baptist for just one thousand pesetas, Rodin told him he was insane to buy it. Luckily, Zuloaga thought better and purchased it anyway.

Rodin came back from Spain disappointed, and Varèse was not

sympathetic. The young man, who had a hot temper to begin with, was irritated that Rodin had failed to take any meaningful steps to further his career. All the old man did was lecture him with "asininities as if he were God almighty." Rodin "didn't know a damn thing about music," Varèse decided, and, in September, he called him *un con*—an ass—and stormed out of the studio.

A decade later, Varèse moved to New York and almost single-handedly pioneered its electronic music scene. "We have actually three dimensions in music: horizontal, vertical, and dynamic swelling or decreasing," he once wrote. He wanted to invent new instruments to add a fourth dimension, "sound projection—that feeling that sound is leaving us with no hope of being reflected back . . . a journey into space."

As luck would have it, Rilke's train delivered him back to France within a week of Varèse's departure. It was nearly three years to the day since the poet had come to Paris for the first time. As he took a walk on his old route from the Luxembourg to the Louvre by way of the Seine, he sensed that little had changed. His favorite vegetarian restaurant was still there and he stopped in to order the usual: figs, melon, artichoke and tomatoes with rice.

But when he arrived in Meudon, where he planned to stay for ten days, he realized that much had changed for Rodin. The artist had made vast improvements to the estate, which was far more functional now, if not quite modern. He'd added electricity and built new studios and housing for his growing army of assistants. He had also purchased an adjacent plot of land where he installed the neoclassical façade and several columns from a castle he'd salvaged at the old site of Château d'Issy after it had been bombed in 1871 and left for ruin. "Much more world has grown about him," Rilke wrote. "It is wonderful how Rodin lives his life, wonderful."

When he knocked on the door, Rodin greeted him "like a big dog," Rilke recalled, "recognizing me with exploring eyes." Rodin inquired about Westhoff, whose father had died abruptly in August, causing her to stay behind in Germany with her mother. Then, as the old friends

visited, Rilke quickly began to realize how dramatically the sculptor's life had changed since he'd met him three years earlier.

After the 1900 World's Fair, Rodin's fame had spread east to Bohemia and west to America, where he held his first solo show in 1903. At home that year he was promoted to commander of the Legion of Honor. He was now the highest-paid artist in the world and aristocrats lined up with blank checks hoping to have their faces immortalized in one of his busts. He now had the freedom to pick and choose whomever he wanted to sculpt and often favored eminent cultural figures, including Joseph Pulitzer, Gustav Mahler and Victor Hugo. Some collectors tried to persuade him with invitations to extravagant parties, but Rodin seldom took pleasure in these events. He'd usually spend them complaining about being tired and then excuse himself early for his nine o'clock bedtime. If the event was being held in a foreign country, Rodin, who spoke only French, would just nod or bow his head when asked a question he didn't understand, amusing his hosts with this strange formality.

Although Rodin was pleased to reap financial reimbursement for his years of unpaid labor, the delayed recognition could never "make good the wrongs . . . done to me—not even if I live for another two hundred years," he said. Success came altogether too late for Rodin to enjoy it. He never developed a taste for expensive food or material possessions, apart from his art collection.

He also didn't know how to handle the hangers-on who had begun to crowd in his spotlight. Rodin began to suspect his friends of using him for his money and connections. He accused employees of stealing from him. Anytime he tried to help someone, it seemed to backfire.

Rilke began to see how isolated Rodin had become. "My pupils think they have to surpass me, to overtake me," he told Rilke. "They are all against me. Not one of them comes to my aid." This was why the master was so excited to see his most loyal disciple again, the one who had returned.

Rodin invited Rilke to stay with him for as long as he wished. He

welcomed him into his inner circle immediately, taking him to lunch with Eugène Carrière and the critic Charles Morice. Rilke attended gatherings at Rodin's Paris studio. The artist even asked Rilke for advice on titling sculptures, a task at which Rodin was never very talented.

At the end of Rilke's stay, Rodin had an idea. He still needed to fill Edgard Varèse's position with someone he could trust. He had briefly tried to employ his son, but the younger Auguste could not keep up with the pace of Rodin's correspondence. Who could be more suited for the role than a faithful writer like Rilke? Rodin offered him the job.

In those days, a secretary position was typically held by a man and consisted of managing the day-to-day correspondence of celebrities and the wealthy. Rodin would pay Rilke two hundred francs a month to open his mail and answer letters, and would provide housing in a cottage on his property in Meudon. He promised that the job would not be too taxing, only about two hours each morning, which would leave plenty of time for Rilke's own work.

The poet was so honored that the master would entrust him with his important business matters that the offer made his "head spin."

But wasn't his French too poor? he asked. Rodin shrugged; the poet seemed to be a fast learner.

Now Rilke was delirious. It was "his deepest desire fulfilled: to move in with Rodin, to belong to him totally," Andreas-Salomé later reflected.

Rilke could not have agreed more. "I shall come to the great man, dear as a father, the Master," Rilke wrote to a friend of the job. "He wants me to live with him, and I could not do otherwise than accept; so I shall be allowed to share all his days, and my nights will be surrounded by the same things as his." Rilke used nearly the same words to write his acceptance letter to Rodin, telling the artist that it would be his honor to listen to him day and night, "if you'll deign to speak to me."

And so, in September 1905, Rilke became not just a fervent disciple of Rodin, but his trusty, day-to-day associate. Rilke moved into his personal three-room cottage with views of the Sèvres valley. As he looked out the window, the bridge linking the two banks of the Seine "has become a stanza. And there my life is." A renewed sense of "*joie de vivre*" rushed through him as never before.

CHAPTER
9

❧❦❧

RILKE ROSE WITH RODIN AT SEVEN O'CLOCK EVERY MORNING. Sometimes he saw the artist out his window, pacing the garden in his robe before changing into his country attire of sandals and a floppy beret. They sat down together for a light breakfast of fruit and coffee, and then the poet faced the mail pile.

"Rilke plunged into the work," recalled one of Rodin's assistants. "For the first time Rodin's correspondence was punctual, his files in order." It was no easy task. Rodin rarely conducted sales through an art dealer, which made him responsible for all his own paperwork. He monitored and micromanaged every word his secretaries wrote in letters. He also changed his mind rapidly, made perpetual revisions and asked that every fleeting observation that passed through his lips be recorded. He never knew if it might become relevant for a speech or text down the line.

Other than a visit from Westhoff in October, Rilke saw virtually no one but Rodin over the next few months, and that was fine by him. They talked about "everything" together, and just as often sat side by side in silence. Sometimes Rilke waited for Rodin to return from Paris so they could watch the sun set over the pool, which was graced with Rodin's young swans. Rodin loved these birds so much that when the

first ones appeared, wild and gray, he hired hunters to kill all the frogs and toads they could find in the woods to feed to the swans.

After sundown Rodin would bid Rilke good night with the words, *Bon courage.* The sentiment confused Rilke at first, but later the poet thought he understood. Rodin must have wished him strength because he knew "how necessary that is, every day, when one is young."

Now that Rodin had so much assistance in his studio, he had more free time to travel. Whenever possible Rilke joined him on these day trips to the cathedrals or the countryside. He had decided to make use of his renewed proximity to Rodin to gather material for a second essay on the artist, which he would eventually publish as part two in all future editions of the monograph. Rilke wrote down everything now, like young Plato recording the words of Socrates, the master who never put pen to paper.

Three mornings in a row the pair rose at five o'clock to catch a train, then a carriage, to Versailles, where they walked for hours in the park. "He shows you everything: a distant view, a movement, a flower, and everything he invokes is so beautiful, so known, so startled and young," Rilke told Westhoff. "The smallest things come to him and open up to him."

Rilke would point out interesting sights and Rodin would draw conclusions from them. While Rodin was ethralled by a cage of Chinese pheasants at the zoo one winter day, Rilke jotted down descriptions of sickly monkeys with eyes as big and vacant as tuberculosis patients'; the sight of a flamingo's tropic-pink feathers "blossoming in this chill air" was almost painful. He then turned the sculptor's attention to the baboons, "flinging themselves against the wall." It was as if Mother Nature had been too busy to correct their "unspeakable hideousness," he said, and her cruelty had driven them mad.

Well, Rodin reasoned, it must have taken a lot of experimentation before she was able to perfect life with the human form. One could at least be grateful to the baboons for that.

Sometimes Rose Beuret joined them on these excursions and Rilke began to see why Rodin had stayed with her all these years. She was

able to identify all the species of birds and trees in the woods. She was so like Rodin in this way, taking joy in a purple burst of crocus or a magpie balanced on a branch. Once she found an injured partridge and they had to leave early so she could care for it. She was a "good and faithful soul," Rilke decided.

There was a tenderly muted affection between Rodin and Beuret. One December afternoon, the three of them attended the two o'clock Advent Sunday service at Notre Dame. Beuret, always anticipating her companion's needs before he did, set out two chairs for the men. The artist sat down, put his hat in his lap and closed his eyes. For nearly two hours he stayed there with his head bowed, beard splayed across his chest, listening to the organ and the soprano, whose voice soared up the cathedral like a "white bird," Rilke thought. Sometimes a faint smile crossed his face. When the music ended, he got up, went to Beuret, who had been waiting patiently, and they left the church, without a word spoken the entire afternoon.

Together the three of them formed a little family in Meudon. In November, the poet joined Rodin and Beuret to celebrate the sculptor's birthday with a cake decorated with sixty-five candles. The following

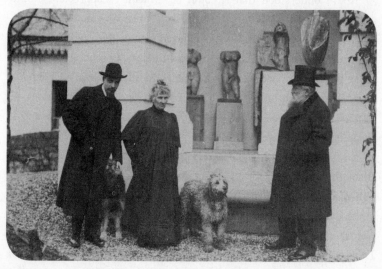

Rilke, Rose Beuret, and Rodin in Meudon.

month, the three of them again treated themselves to pastries for Ril-
ke's thirtieth birthday.

A few weeks later, Rilke returned to Germany to spend Christmas
with Westhoff and Ruth. By now his wife had moved their daughter
out of her mother's house and into a place of their own. When Rilke
arrived she was sculpting a bust of Ruth, which was not an easy task
with a restless four-year-old. It had been so long since they were all
together as a family that they agreed to forgo work for a few days and
enjoy the holiday.

In Rilke's absence, the letters piled up in Meudon. When he
returned in January, he was saddled with more work than ever. He
did not realistically have time to accept Rodin's invitation to visit
the cathedral in Chartres that month. But this was the "Acropolis of
France," Rodin said, and he insisted that there was no lesson "so useful
to study as our French Cathedrals and, above all, this one!" Rodin often
said he wished that he had skipped art school altogether to spend the
time bowed before the Chartres cathedral instead. The cathedral was
the wisest master, he thought, a masterpiece of light and shadow that
could have taught Rembrandt everything he knew about chiaroscuro.

Rodin understood that it could be difficult to appreciate Gothic
architecture at first. The labyrinthine decorations could easily over-
whelm an untrained eye. But he believed that people ought to relearn
how to see the cathedrals, and to recall the kind of schoolboy wonder-
ment that he had once felt before the church in Beauvais. "The chief
thing is to humble one's self and become a little child, to be content not
to master all at once, to be obedient to what Nature can teach, and to
be patient through years and years," he wrote.

So on a gray, lightless January morning, Rilke and Rodin passed
through wheat fields for an hour on the train, arriving in Chartres at
half-past nine. The church sat alone at the center of town like an old
stone gargoyle. From around its huge walls, the clusters of cottages
unfurled like a diorama village. Built between 1194 and 1235, the Notre
Dame of Chartres is one of the largest cathedrals in France, with a
nave nearly twice as wide as the Notre Dame of Paris.

Rilke and Rodin stood at a reverent distance, tilting their heads back to take in the full scale of the structure's two towers, which were mismatched as a result of a fire. The fifty-foot-tall buttresses aged from blond at the base to a weathered black at the tips. Stone vines and arabesques uncoiled across every inch of surface. Normally Rodin would have taken it in inch by inch without a word, but on that day he kept interrupting the silence to grumble about the shoddy restorations that scarred its surface. The right lateral portal was stripped of its "suppleness," and parts of the stained glass were missing from the windows. The damage was even worse here than at the Notre Dame in Paris.

The numbing cold became another distraction as a gust of wind barreled into Rilke as hard as a man shoving through a crowd. He glanced over at Rodin to see if he felt it, too, but the man stood there oblivious, as sturdy as the tower. Then another gust blew in violently from the east and whipped around the slender stone body of an angel that stood on a southern corner of the church. It smiled a wise and serene smile, like that of the Mona Lisa, Rilke thought, and it held a sundial in its hands.

In the presence of this blissful stone being, the windbeaten poet felt even more mortal, as if he and Rodin were "two damned souls."

At last Rilke spoke: "There's a storm coming up."

"But you don't understand," Rodin countered. "There is always this kind of wind around the great cathedrals. They are always enveloped by a wind that is agitated, tormented by their grandeur."

The freezing weather drove the two men back to Paris early that day. But not before the sharp gusts of wind had opened Rilke up and lodged an image of the stone angel firmly in his mind.

IN THE CRYPT OF the Panthéon lie the remains of the foremost intellectual figures in French history. "For great men the grateful nation," reads the inscription carved into the façade of the domed mausoleum where Voltaire, Zola, Rousseau and Hugo were laid to rest. More than

a burial ground, the Panthéon became the illustrious mise-en-scène of France's national memory in the years after the French Revolution.

It was the highest endorsement of Rodin's career to date, then, when the city of Paris agreed to erect *The Thinker* in front of the Panthéon's grand staircase in the spring of 1906. It filled Rodin with pride to know that his statue would memorialize all of the thinkers housed within its walls, a monument to end all monuments.

The art historian Élie Faure saw the plan as France's attempt to correct its mistreatment of Rodin after the "outrage inflicted on him for so long." The doors that had been closing on him for half a century, ever since he failed to enter the Grande École as a boy, had finally swung open. Newly initiated into this civic shrine, Rodin began to enjoy what he called his period of "liberation."

But the master's liberation was beginning to usher in his disciple's enslavement, or so Rilke described his workload that winter. It had taken Rodin two years to negotiate the bureaucracy and raise funds to cast *The Thinker* in bronze, all of which heaped more paperwork onto his secretary. Rilke found himself struggling to keep up with the boxes of unanswered letters, which now filled two rooms of the house. It took Rilke twice as long to write in French than in German and he refused to settle for less than perfect grammar. Between Rodin's correspondence and his own, Rilke found himself writing hundreds of letters each day.

The job dragged on well past the agreed-upon two hours, and was cutting sharply into his personal writing time. Sometimes he felt the "mass of untransformed material" swelling so large inside him that he fantasized about hopping on the first train out of town and heading to the Mediterranean. The book he had finished there, *The Book of Hours*, had just come out in November and was already attracting far more acclaim than anyone had expected.

Supposedly Rilke never read reviews because doing so felt about as enjoyable as listening to another man admire the woman one loves, he once said. But critics widely praised the *Book of Hours'* ambition in grappling with "the most elevated theme a lyric can attain: the

theme of the Soul's search for God," as the German patron Karl von der Heydt wrote in an early review. Each of the five hundred copies in the print run would sell within two years, and a second run would be issued at more than twice the original size.

While Rilke was contending with the unprecedented attention, he also needed to update an earlier collection, the *Book of Pictures*, for its second edition. "But I need 'only time,' and where is it?'" he wondered to Andreas-Salomé. When several German universities invited him to lecture that winter, it seemed like a legitimate occasion to request a little time off, especially since the subject of the tour would be Rodin.

With some reluctance, Rodin granted Rilke the leave, and the poet set off for Germany in February. He was received like royalty at his first stop, near Düsseldorf. But almost as soon as he arrived, news came that his father had fallen ill and might not recover. Rilke made no sudden move toward Prague, instead delivering an electrifying lecture before continuing on to Berlin. He was eager to see both Andreas-Salomé and Westhoff there and to introduce them to each other for the first time. The meeting between the women apparently went beautifully, and afterward, Rilke thanked Andreas-Salomé for treating his wife so warmly.

While Rilke was mingling with aristocracy, his father lay dying in Prague. After two weeks, Rilke received word that Josef had died and there was no one else to tend to his remains. When Rodin heard the news, he rushed the poet a telegram offering his condolences and money, if he needed it. The poet at last made his way to Prague, where he would face his father's body, pale and propped up on pillows, and arrange for his burial. He did not invite his mother to join him at the grave site.

At the end of his life, Josef Rilke had come to accept, in a sorrowful way, his son's profession. But the poet maintained the belief that his father was fundamentally "incapable of love," and that perhaps Rilke had inherited this deficiency from him. Rilke's delayed response to his father's death probably had less to do with a shortage of love, however,

than it did with a desire to avoid the unhappy childhood memories of Prague. He could not bear to stay there for more than a few days before boarding the train back to Paris.

When he arrived back at the master's house in Meudon, he walked into another depressing scene. Rodin was buried under blankets in his big mahogany bed, suffering from a terrible fever. The old man rarely got sick, but when he did it completely hobbled him. He was also grieving his own loss, that of his dear friend Carrière, who had died of throat cancer that month. Carrière had been not only one of Rodin's earliest artistic advocates, but also a president of the committee to mount *The Thinker* at the Panthéon.

But now the inauguration had been abruptly disrupted, just weeks before it was scheduled to take place. Almost as soon as Rilke had left in February, hostility toward the *The Thinker* grew so intense that it threatened to derail the project altogether. Critics who opposed the plan said that a statue whose pose "suggests a scatalogical idea," as the novelist Joséphin Péladan described *The Thinker*, did not deserve the prestigious Panthéon placement. Max Nordau, a physician and disciple of Dr. Charcot's who wrote a book on degenerate art, ridiculed the figure, saying its "bestial countenance, with its bloated, contracted forehead, gazes as threateningly as midnight."

A vandal had even scaled the Panthéon's fence and taken a hatchet to a plaster placeholder of the statue. "I avenge myself—I come to avenge myself!" the police heard the man yell. When they hauled him off it became clear that he was mentally ill and believed that *The Thinker*'s fist-to-mouth pose was mocking the way the poor man ate his cabbages. Even though the attack did not end up being personal, Rodin was shaken by the violent incident.

The prospect of another public scandal drove Rodin nearly to the edge of his sanity. He became so paranoid in those days that once, when a package came in the mail from an unknown sender, he insisted it contained a bomb and buried it in the yard. Some time later a friend wrote back wondering whether Rodin had enjoyed the jar of Greek honey he had sent.

Rilke had to set aside his own concerns now to come to Rodin's aid. He did not dare abandon his besieged master at this vulnerable hour, believing that Rodin was in "need of my support, insignificant as it is, more than ever." Rodin, meanwhile, was oblivious to Rilke's rising stature abroad and the growing demand for his work.

Rilke managed to preserve this precarious balance for a while, but it could not withstand the disruption that came in April. That month, the Irish playwright George Bernard Shaw hired Rodin to sculpt his bust. Then forty-nine years old, the writer was eager to have his portrait done before he "had left the prime of life too far behind." Shaw's renown as a drama critic for the *Saturday Review* was being increasingly surpassed by his own theater productions, satirical morality plays that now routinely debuted at London's Royal Court Theatre, including, most recently, his comedic drama *Major Barbara*. A socialist and a vegetarian, Shaw infused his plays with passionate political messages that were tempered by his lively wit.

Rodin, who possessed neither drive and spoke no English, did not know Shaw's work at all when they met. Since the sculptor was still recovering from the flu at the time, he asked the writer to come to him in Meudon for the twelve sittings, rather than to his more conveniently located studio in Paris. Shaw agreed and paid twenty thousand francs for the sculpture in bronze. One would have to be a "stupendous nincompoop" to have a bust done by any other artist, he said.

But Shaw was wholly unprepared for the grueling weeks ahead. In their first sessions, Rodin took a big metal compass to Shaw's head to measure it from the top of his red crown to the tip of his forked beard. Then he molded the face from sixteen different profiles. Once Shaw was sure he had been examined from every possible angle, Rodin told him to lie down on the sofa so he could capture the views from behind the forehead and below the jaw. Finally, once Rodin approved of the basic form, he began scooping out the features.

Mesmerized by Rodin's meticulous process, the playwright later wrote about it in a remarkable essay from 1912:

In the first fifteen minutes, in merely giving a suggestion of human shape to the lump of clay, he produced so spirited a thumbnail bust of me that I wanted to take it away and relieve him of further labor . . . After that first fifteen minutes it sobered down into a careful representation of my features in their exact living dimensions. Then this representation mysteriously went back to the cradle of Christian art, at which point I again wanted to say: 'For Heaven's sake, stop and give me that: it is a Byzantine masterpiece.' Then it began to look as if Bernini had meddled with it. Then, to my horror, it smoothed out into a plausible, rather elegant piece of 18th-century work . . . Then another century passed in a single night; and the bust became a Rodin bust, and was the living head of which I carried the model on my shoulders. It was a process for the embryologist to study, not the aesthete. Rodin's hand worked, not as a sculptor's hand works, but as the Life Force works.

Perhaps it was during those long hours sitting for Rodin that Shaw first developed his sympathies for artists' models. A few years later he would rewrite the Greek myth of Pygmalion, an artist who fell in love with his own sculpture, but from the point of view of the model. Shaw named this figure Eliza Doolittle.

Despite Shaw's admiration for Rodin's work, the two men were opposing personalities from the start. Shaw was a playful raconteur and Rodin was virtually humorless, especially in those days. During the countless hours they spent together, Shaw recalled seeing the sculptor laugh only once—a light chuckle when he watched Shaw feed half his dessert to Rodin's dog, Kap.

But because Shaw refused to take anything seriously, Rodin's severity became all the more amusing to him. Seated in a child's chair, Shaw fought back laughter while Rodin spat water onto the clay head without noticing that it also splattered the man posed behind it. He watched with "indescribable delight" as Rodin whacked creases away

with his spatula and, once, sliced through the neck with a wire and tossed the decapitated head casually aside.

Shaw's attempts to crack jokes through his broken French did nothing to ease matters. When someone once asked Rodin what the two men talked about during their sessions, he replied, "M. Shaw does not speak French well, but he expresses himself with such violence that he makes an impression." Rodin, whose English was even worse than Shaw's French, confused everyone when he pronounced the name of his sitter, "Bernarre Chuv."

Rilke was as ignorant of English literature as Rodin, but he found Shaw to be a far more entertaining guest. He thought the man was every bit as clever as Oscar Wilde, but with none of the pretension. As the originally planned sittings stretched out into three weeks, he also became impressed by him as a model. Rather than merely standing still, Shaw stood with purpose and determination, like a column that supports more than its own weight. Soon Shaw was spending many of those afternoons chatting with Rilke instead of Rodin.

Rilke began to wonder if perhaps Shaw should be the subject of his next work. He wrote a letter to the playwright's publisher, praising the man as an excellent, energetic model. "Rarely has a likeness in the making had so much help from the subject of it as this," he said. He then asked whether they might send him some of Shaw's books so he could consider writing about them.

At last, Rodin received some news to lighten his mood that spring. A committee of prominent artists, politicians and the president of the Society of Men and Letters, which had previously rejected Rodin's *Balzac*, united in support of installing *The Thinker* at the Panthéon. The committee overpowered Rodin's critics and the statue was officially unveiled on April 21.

Rilke sat with Shaw and his wife during the celebration. They watched the city's arts undersecretary Henri Dujardin-Beaumetz welcome *The Thinker* and Rodin with a lofty speech. After years of misunderstanding, "this truly creative artist, so shaped by humanity and

conviction, is finally able to work peacefully in the shining light of universal admiration," he said.

Joining the group for the festivities was Shaw's friend Alvin Langdon Coburn, an artist who had come from London to photograph Rodin. Shaw, who was an amateur photographer himself, had been carrying around a box camera in Meudon when Rodin noticed it and invited him to take as many pictures as he liked. Shaw shot one photo of Rilke leaning against a stone rail in Meudon, looking heavy-lidded and worn. But when it came to capturing Rodin, Shaw told Coburn that he ought to be the one to do it. "No photograph yet taken has touched him: Steichen was right to give him up and silhouette him. He is by a million chalks the biggest man you ever saw; all your other sitters are only fit to make gelatin to emulsify for his negative."

Coburn jumped at the opportunity. He took dozens of photographs over the next few days, of Rodin, his art, and one of the sculptor and Shaw together with the bust-in-progress standing between them. Shaw had not overstated his description of Rodin, Coburn thought. "He looked like an ancient patriarch, or prophet."

On Shaw's last day in Paris, he was preparing a bath when an idea came to him. Once he got out of the tub, he told Coburn to take a photo of him assuming the pose of *The Thinker*—but nude. The men laughed while Coburn took the shot and then they boarded the next train back to England.

When the photo went on view at the London Salon later that year, critics responded with revulsion and disbelief that Shaw would participate in such a shameful portrayal. He tried to defend himself by saying that busts conveyed only a person's reputation, while full-body portraits showed nothing "except their suits of clothes with their heads sticking out; and what is the use of that?" This photo showed Shaw as he really looked. Or perhaps it was simply a joke that spiraled out of hand.

Shaw was stunned when he laid his eyes on the three completed busts—in plaster, bronze and "luminous" marble. "He saw me. Nobody else has done that yet," Shaw said of Rodin. His wife said it looked so

much like her husband that it scared her. On the forehead sat the two locks of hair that parted like red devil horns. The subtlest hint of a smile lurked behind an otherwise expressionless face.

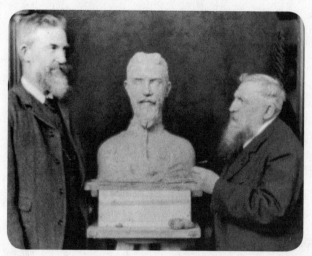

George Bernard Shaw with Rodin and his bust of Shaw, 1906.

Years later Shaw said that the dictionary would one day define him with the entry, "Shaw, Bernard: subject of a bust by Rodin: otherwise unknown."

CHAPTER
10

B Y 1905, RODIN'S STUDIO IN PARIS WAS STARTING TO LOOK
more like a brothel than a workshop. While many poorer artists
had to content themselves with using their wives as models, Rodin
could now afford to hire women to pose for him at all times, whether he
had use for them or not. At any given time a model might be stretched
out on a pedestal, while another undressed behind a screen. Others
just traipsed around looking bored.

Rodin never knew when one was going to make an interesting
movement, so he left out wine and food and let them wander freely. If
one caught his eye he would watch, casually turning a chisel over in
his hand. Then: *Halt!* he might suddenly shout as he groped for a tool,
never taking his eyes off the model. *Don't move.*

He typically preferred this spontaneity to stiff, mannered postures.
But sometimes an idea would strike and he'd suggest a pose, manipulat-
ing the model's body like clay. They had become such objects to Rodin
that once when he heard that one of his favorites had to have her appendix
removed he erupted with rage for the doctor who had made "mince-meat"
out of her. "They've opened up that young body which they ought to be
worshipping, to take out a bit of gut," he complained. He often compared
his models to animals, once describing a Japanese woman who hadn't "an

ounce of fat" as a fox terrier, while he thought English women had legs like horses. He liked models in all shapes and sizes, including pregnant ones.

Rodin stayed up late into the night sketching figures by candle-light. Sometimes his neighbors in the building would see him pacing the dark halls in his smock and carrying two candlesticks, like a wizard. In a few short years he managed to produce several hundred drawings of women's bodies, often with their legs spread, in extreme close-up. Sometimes he showed them touching each other or masturbating. To some, this graphic body of work registered as plain perversity. When W. B. Yeats visited with his lover Maud Gonne and the poet Ella Young, the women refused to enter Rodin's drawing room. After the artist insisted that these were his greatest works, Yeats went in out of respect, but was unable to convince Gonne and Young to join him. "He is mad, brutally and sensually mad," Young said.

But Rodin was hardly the only European thinker venturing deeper into the realm of sexuality at the time. In Freud's book from that year, *Three Essays on the Theory of Sexuality*, the psychoanalyst argued that sexuality motivated all human behavior, and that it developed from infancy either normally or abnormally depending on the conditions of one's life. It had been six years since Freud introduced his principles of the unconscious in *The Interpretation of Dreams*; now he identified sex as the primary driver of unconscious desires, frustrations, and pleasures. To Rodin, as well as to many Viennese artists like Gustav Klimt and Egon Schiele, representing these innermost aspects of the human psyche was an irresistible challenge.

While it was unfair for critics to call Rodin's style during this period purely pornographic, it is equally inaccurate to claim that he was innocent of that temptation. "Of course I'm a sensual human being," Rodin told Georg Simmel during the sociologist's study of him that spring. His senses were routinely aroused by his models, but this was "not the sensuality of sex." Rodin preferred to depict both men and women in the nude, but said he was more drawn to women because they "understand me better than men. They are more attentive. Men listen too much to their friends."

But it wasn't womens' ears he was groping and praising. As word got out about the indecent state of affairs in Rodin's studio, rumors began to circulate that he was going mad from "erotomania." "The whole of Paris was talking about the not very savory details of his erotic adventures," said Simmel. He acquired the nickname "Sultan of Meudon."

Some women refused to pose for the notoriously carnal artist; others did so only apprehensively. "Nothing is so amusing as a model on her first visit," Rodin once said. "She takes off her clothes in fear and trembling, as if she had caught some infection of modesty from her other studios. Is my reputation as bad as all that?" he wondered to an assistant.

It was, and sometimes rightly so. Rodin's gaze alone felt predatory to some. When a woman's physical attributes captured his interest, he stared with an attentiveness that bordered on aggressive. Anyone could fall prey to his wolfish stare—the daughters of art dealers or the wives of patrons. The effect was heightened for models who had to endure posing for his contour sketches, a method in which he drew his subject without ever glancing down at the paper or lifting pencil from the pad. It was not so much about seeing the model's curves as it was about feeling them in his fingertips—a visual caress that apparently struck some models as unnervingly palpable.

Aside from the symbolic threat of Rodin's phallic pen, the artist also crossed real boundaries with his models. The young American dancer Ruth St. Denis once stood stiffly nude in Rodin's studio while he knelt before her and kissed her arms from elbow to wrist. It wasn't until a journalist walked in that Rodin released St. Denis, who tore off in fright.

Some forgave Rodin's behavior as an artistic eccentricity; still others were seduced by it. There was always a young woman waiting in the next room for him to finish working, noticed Alma Mahler, wife of Austrian composer Gustav Mahler, who once sat for a bust. She recalled in her memoirs how "some girl or other with scarlet lips invariably spent long and unrewarded hours there, for he took very little notice of her and did not speak to her even during the rests. His fascination must have been powerful to induce these girls—and they were girls in what is called 'society'—to put up, unabashed, with such treatment."

One such lingerer was the young Welsh art student Gwen John, who became Rodin's steady *cinq-à-sept* mistress, or the woman one sleeps with before returning home after the workday. This lasted for several years before John developed a paralyzing obsession with the artist and he had to break it off with her.

Rodin's appeal to young women may have been similar to that which initially attracted Rilke. Many saw him as a Pygmalion figure whose great hands could mold and reshape them. This was how Isadora Duncan described her attraction to Rodin when she was dancing in Paris in her twenties. Tired of the mannered, self-conscious feel of ballet, Duncan developed a style all her own. She had started choreographing performances that incorporated spontaneous, natural movements, which to her meant dancing with the entire body, from the head to the heels. She often performed barefoot. "The details hardly mattered to her," her friend Jean Cocteau said. "She wanted to live massively, beyond beauty and ugliness, to seize hold of life and live it face to face, eye to eye. She belonged to the school of Rodin."

Isadora Duncan.

Like Rodin, Duncan, too, looked to the art of ancient Greece for inspiration, copying the kneeling poses of women in Tanagra figurines, their loose tunic dresses, and the silhouettes of Greek vases. When they met in person, Rodin offered her a private tour of the

sculptures in his studio. She recalled the encounter years later in a particularly lustful passage of her autobiography:

> He ran his hands over them and caressed them. I remember thinking that beneath his hands the marble seemed to flow like molten lead. Finally he took a small quantity of clay and pressed it between his palms. He breathed hard as he did so. The heat streamed from him like a radiant furnace. In a few moments he had formed a woman's breast, that palpitated beneath his fingers.

Duncan then took Rodin back to her studio and showed him *her* art. Apparently Rodin was impressed with the dance.

> He gazed at me with lowered lids, his eyes blazing, and then, with the same expression that he had before his works, he came toward me. He ran his hands over my neck, breast, stroked my arms and ran his hands over my hips, my bare legs and feet. He began to knead my whole body as if it were clay, while from him emanated heat that scorched and melted me. My whole desire was to yield to him my entire being . . .

But Duncan's timid side got the better of her that evening. She broke free from Rodin's grip and covered herself up, sending him away before anything more could happen.

"What a pity!" she later wrote. "How often I have regretted this childish miscomprehension which lost to me the divine chance of giving my virginity to the Great God Pan himself, to the Mighty Rodin. Surely Art and all Life would have been richer thereby!"

NONE OF RODIN'S AFFAIRS matched the intensity of his love for Camille Claudel, until 1904, when he met the Duchesse Claire de Choiseul. Despite her name, Choiseul was not French—a fact that French society was keen to make known—and she wasn't by most standards

a duchess, either. Born Claire Coudert, she was a wealthy New Yorker who had married a French marquis, Charles-Auguste de Choiseul, thirteen years earlier. He had lost his fortune gambling, but elevated his own title from "marquis" to "duc" in a social register one summer anyway, and his wife went along with it. The daughter of a prominent lawyer in New York and sister-in-law to the *Vogue* publisher Condé Nast, what mattered to the "duchesse" was a title, not money.

Choiseul met Rodin after her husband wrote the artist wondering whether the sculptor could offer an opinion on a bust he had inherited, and probably wanted to sell. At some point, his wife and Rodin began corresponding on their own and, within a few years, she was calling herself his "little wife." That was the first sign to many of Rodin's friends of the long power struggle that lay ahead. To them, the "duchesse" was the worst imaginable caricature of an American. She reeked of chartreuse and brandy. She howled at her own practical jokes. She covered stale makeup with more makeup, and dyed her hair with a henna that matched her lipstick. Worst of all, she knew nothing about art.

But Choiseul, twenty-four years younger than Rodin, enlivened the artist, who was by then sixty-four. He did not care whether Choiseul had poor manners—many had thought the same about Claudel—he had he never laughed so much in his life. The bust he would sculpt of Choiseul is one of the few faces he ever made smile.

By most accounts she dominated Rodin completely. Finding him "very poorly dressed, gauche in his manner, disheartened and almost beaten" when she met him, she gave him a makeover. She began instructing him on what to wear, what to eat, how to style his hair. At her insistence he hired a barber to trim and perfume his beard each morning. He traded in his loose tunic for an expensively tailored suit and top hat, which looked about as natural on him as a walrus wearing a turtleneck.

Choiseul saw herself as Rodin's ambassador to the modern world. When a *New York Times* reporter asked her whether it was true that Rodin was really spending so much time with an American, she

responded, "Yes, I am proud to be both—the muse of the greatest sculptor in the world and a daughter of the greatest country in the world . . ."

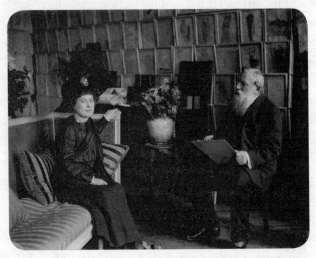

Rodin with the Duchesse de Choiseul in his studio.

Choiseul was hardly content to be merely Rodin's muse, however. She intended to be his dealer, his accountant, his wife and, ultimately, executor of his estate. She soon tightened the open-door policy of his studio, requiring that friends now get passes from the concierge before entering. Sometimes she refused them admittance altogether. When the aspiring sculptor and heiress Gertrude Vanderbilt Whitney, whose grandfather owned an apartment down the block (rented out at the time to Edith Wharton), came to study with Rodin, she was shocked to find the duchesse turning away his guests. "No use disturbing him since I am here. I handle everything. I am Rodin!" Choiseul reportedly said. Her tyrannical gatekeeping led one journalist to nickname her the Cerberus of Rodin's studio. Others called her "The Influenza."

BACK IN MEUDON, Rilke was oblivious to the tawdry rumors spreading about Rodin in Paris. The poet had been too consumed with the

artist's correspondence and the visits with Shaw to spend much time in Paris at all.

On April 23, two days after George Bernard Shaw had returned to London, Rilke was working on Rodin's mail when an unexpected letter arrived in the post. It was from William Rothenstein, one of Rodin's biggest patrons in London. Rothenstein had recently come to Paris as a favor to his friend Roger Fry, the newly appointed paintings curator at the Metropolitan Museum, to lend his opinion about some works he was considering buying. While he was there, Rothenstein also visited Rodin, who introduced him to Rilke.

The poet was fond of this new acquaintance and had sent him a note soon after their meeting. Rilke wrote about how delighted he and Rodin would both be if he would one day visit them in Meudon. He went on to describe the success of the Panthéon celebration and repeated his praise for Shaw, whose new bust radiated the man's "astonishing intensity."

The letter that arrived in Meudon on that April day was Rothenstein's cordial reply. He returned Rilke's pleasantries and thanked him for the kind words. Even though nothing he said was out of the ordinary, Rodin flew into a rage when he saw the note. He had not given Rilke permission to write *his* friend a personal letter. It didn't matter to Rodin that the words had been innocuous, he saw the act itself as an unforgivable breach of trust.

Rodin tore through his files and soon uncovered a second unauthorized letter, this one written to Rilke in German from another prominent collector and writer, Baron Heinrich Thyssen-Bornemisza. Rodin confronted his employee with the evidence in hand. Rilke, who withered in the face of any confrontation, struggled to explain that although the baron's letter was indeed addressed to him, it was done so *as Rodin's secretary*. He reminded Rodin that he had approved the original outgoing letter to the baron. Perhaps the master had simply forgotten?

As for the more serious violation, the exchange with Rothenstein, Rilke argued that Rodin had introduced him to the Englishman as a friend, not an employee. As such, Rilke had thought there was no harm in writing an innocent note to his new acquaintance.

Rodin refused to hear Rilke's excuses. His obstinacy surprised Rilke,

but others who knew the artist then had become accustomed to it. "Rodin's disposition had begun to change; he was impatient and despotic, and his commands fell like swords upon innocent necks. His warmest friends turned from him in dismay," wrote his close friend Judith Cladel.

Rodin dismissed Rilke from his job at once, "brutally and unjustly," thought Cladel when she heard the news. To Rilke, it was as if he were being thrown out "like a thieving servant." After nine months of devoted service, banishment was a harsh punishment for the crime of opportunism. Rothenstein himself said he was shocked to learn years later that the letter he had sent to "poor Rilke" that day had been such "a source of grievance to Rodin." But he also recognized that Rodin was a notoriously "difficult person to deal with."

This was far from the first time Rodin had exploded at an employee. He responded to any misstep like a lion startled from his sleep, lashing out in rage, then acknowledging his overreaction later. He repeatedly fired and rehired his assistants. With one of his favorites he went through this cycle five times in just two years.

When directed at his work, the artist's destructive energy resulted in fascinating amputations and fragments. When directed at people, it was merely destructive. When one young model, the future silent film star Lou Tellegen, brought his own clay figure to Rodin for critique—the first he ever made—the artist took one glance, picked up a tool, and started hacking into it himself.

"When he was through, there was hardly anything left of my original figure. Of what remained, he destroyed the whole mass and saying, 'Begin it over again,' walked away," Tellegen wrote in his memoirs. Rodin "always called a spade a spade—that is, if he could think of no more vulgar name for it."

By the time Rilke arrived, Rodin's fame had made him even more sensitive to perceived betrayal. It also could not have helped to see his most loyal disciple fawning over Shaw during those stressful weeks leading up to the Panthéon inauguration, when he had needed support the most. By evening, Rilke had packed his belongings from the little cottage in Meudon and was gone.

—

RODIN DID NOT HAVE time to interview candidates for Rilke's replacement. So when an acquaintance from a well-known painting family, Albert Ludovici, suggested his son for the position, Rodin hired him on the spot.

The twenty-five-year-old English writer Anthony Ludovici had admired Rodin's work since he first saw it at the 1900 World's Fair. But when he arrived for his new job in Meudon, to say he was disappointed would be an understatement. The sculptor looked old, hardened, and exhausted by the endless stream of visitors to his studio. He was consumed almost entirely with bust commissions then, yet the rest of his production galloped on relentlessly. Rodin now ran a veritable factory, churning out replicas of old works in multiple sizes and materials. For each wax or clay work that Rodin sculpted, his assistants made up to a dozen versions in plaster. Some of these would then be cast in bronze or sent out to a stone workshop to be carved in marble.

Rodin's rough, country demeanor horrified the young sophisticate, who found him to be "uneducated, coarse, ill-mannered, and intimately associated in his home life with a woman," Rose, who was "very much beneath him." Unlike Rilke, Ludovici did not think he could learn anything from talking to Rodin and decided to take his breakfasts alone.

Ludovici also thought Rodin could be colossally unfair, requiring his staff to treat him with "unflinching sympathy, tolerance and devotion," to the point of their own self-effacement, yet rarely returning the goodwill. He was not surprised when one of Rodin's maids told him that his predecessor's departure was a case of "the proverbial *pot de terre et le pot de fer.*" In Aesop's story, the delicate clay pot always cracks when it tries to play with the overpowering iron pot.

Like Rilke, Ludovici, too, wrote a book about his time with Rodin, but what his *Personal Reminiscences of Auguste Rodin* lacks in unbridled awe, it makes up for in cool objectivity. Ludovici uses it to point out Rodin's cruel treatment of his son, Auguste Beuret, whose name he never once heard the artist utter. Ludovici saw firsthand the heartbreaking letters Auguste wrote his father, often addressed to "Mon-

sieur Rodin, Statuaire, Commandeur de la Legion d'Honneur." Auguste would see his father's name in the newspaper and then write to congratulate him on whichever award or exhibition was making headlines then. Ludovici also knew that these letters usually went unanswered.

Auguste embarrassed his father, who wrote off the boy as slow-witted his entire life. It is unclear whether Auguste suffered from an actual disability, or whether Rodin's assessment was overly harsh. Some biographers have claimed that Auguste fell out of a window as a child. But this story has never been confirmed, nor were any diagnoses of brain damage made. In any case, Rodin saw the boy as a burden from the outset and for several years sent him to live with his aunt.

In adulthood, Auguste fared no better in his father's eyes. Ludovici was troubled to learn that, despite Rodin's fortune, the young man lived like a pauper, barely eking out a living as a secondhand clothes salesman.

After six months, Ludovici, feeling overworked and underappreciated, quit his post as Rodin's secretary. He later wrote that his tenure had ended much like Rilke's had, "in a violent quarrel over a trifling misunderstanding in which Rodin was insufferably rude."

Ludovici went on to become a conservative Christian writer and a Nietzsche scholar of some renown. But his early support for Hitler and the eugenics movement soon relegated him to obscurity. A year after World War II ended, Ludovici took a break from writing about the feminist and black invasion of Great Britain to review a new English edition of Rilke's monograph on Rodin. Ludovici wrote that he had initially expected the poet to have used the opportunity to write some vengeful words against Rodin for firing him.

In fact, Rilke had briefly considered it. When it came time to publish his second essay in the book, the poet debated whether to write it in a more critical tone. He had begun to worry that his early enthusiasm for the artist had been colored by "the demands Rodin taught us to make," and not necessarily his actual achievements. He ultimately decided, however, that the timing was not right "to say anything new about Rodin now." Introducing contradictory opinions on the artist would only confuse readers and spoil the book's celebratory spirit.

Ludovici admired the conviction and originality of Rilke's book. He concluded in his review that "Rilke was much too generous and understanding a nature, and too profound in his knowledge of humanity, to allow mere accidents of temper in an over-worked and much lionised artist to influence his interpretation of that artist's life-work."

IN THE GOSPEL OF Luke, the parable of the Prodigal Son tells the tale of a wayward son's return home to his father. The younger of two brothers, he withdraws his inheritance early and spends it all traveling the world, while the elder boy stays home and works for their father. Eventually the prodigal son's money runs out and he must return home, tired, hungry, and penniless.

Upon seeing his long-lost son, the father rushes to embrace him. *Prepare a feast*, he tells the other boy, who is horrified by the suggestion. Why should they celebrate his reckless, selfish brother, especially when he had been loyal for years and received no such honor? The father responded that it did not matter what the prodigal boy had done in the past. All that mattered was that he had come back.

This parable of forgiveness was on Rilke's mind as he looked for a new home in Paris. To his surprise, his lifeline came from another prodigal child adrift in the city, his old friend Paula Becker. Three months earlier, Becker had left Worpswede in the middle of the night, while her husband slept. She wrote a letter to Rilke telling him of her plan to come to Paris, declaring in it, "I'm not Modersohn and I'm not Paula Becker anymore either. I am Me." She told him that she was eager to see him again, to see Rodin and, most of all, to work.

Rilke hadn't expected Becker to make it this long on her own, but she was content living with nothing but an easel, a pine-board chair and worktable. She had moved into her usual hotel a few blocks north of the Luxembourg Gardens, at 29 Rue Cassette. It was cramped but cheap, and allowed week-to-week leasing. When Rilke called on her looking for lodging in May, she helped him rent a room upstairs.

He immediately moved into the apartment, which looked out onto a church nave that plunged into the sky like a sinking ship, Rilke thought. He sat down at his new desk to break the news of his firing to Westhoff. He tried to bear the insult with grace, writing to her that perhaps Rodin had sensed his suffering and dismissed him out of mercy. The arrangement had to end at some point, he reasoned; maybe this was actually a "happy" outcome.

But Rilke exposed his true anguish in a letter to Rodin the next day. "I am profoundly hurt by this," he wrote. Rodin's casual dismissal made him feel like a mere employee, while he had seen himself as "a private secretary in external terms only," and, as Andreas-Salomé later said, "in reality a friend in a full and free exchange."

"It was not to your secretary that you gave those familiar quarters," Rilke continued in the letter. He defended his actions once again, claiming that the infractions were mere misunderstandings, not breaches of trust. But regardless of what Rodin ultimately believed, Rilke pledged his everlasting devotion: "I understand that the wise organism of your life must immediately reject anything which appears detrimental to maintaining its functions intact . . . I shall see you no more—but, like those apostles who remained lamenting and alone, life begins anew to me, the life which will celebrate your great example and will find in you its consolation, its honesty and its strength."

For Rilke, exile from Rodin was more than merely hurtful. It also cut short the crucial progress he was making as an artist. He felt like a grapevine pruned at the wrong time, and "what should have been a mouth has become a wound." He captured his vulnerable state in "Self-Portrait from the Year 1906," a poem he wrote that month:

> In the glance still childhood's fear and blue
> and humility here and there, not of a servile sort,
> yet of one who serves and of a woman.
> The mouth made as a mouth, large and defined,
> not persuasive, but in a just behalf
> affirmative.

As he wrote these lines, Rilke also became the subject of another portrait. Becker needed to practice figure painting for her classes at the Académie Julian, but could not afford to pay model fees. Rilke had agreed to pose for her in the mornings. But then, during one sitting, a knock came at the door. Becker peeked between her curtains onto the street, then yanked them shut again. She spun around and whispered to Rilke, "It's Modersohn."

Her husband had been writing letters accusing her of being selfish and cruel. She insisted that she couldn't be heartless because art was itself a form of love. He begged her to come back; she begged him to let go.

Rilke had managed to avoid their conflict so far, but now he felt trapped between his two friends. He worried that if he encouraged Becker's painting too much it would look like he had chosen her side. When he left that day, Becker talked with Modersohn but remained resolved in her decision to live in Paris, writing him soon after, "Please spare both of us this time of trial. Let me go, Otto. I do not want you as my husband. I do not want it. Accept this fact. Accept this fact. Don't torture yourself any longer."

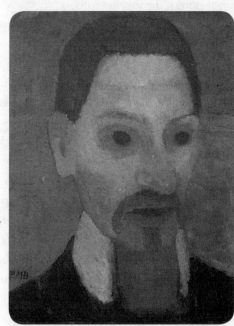

Paula Modersohn-Becker's painting of Rilke, 1906.

Becker's sister was furious with her, while her old friend Carl Haupt-mann called her ignorant and weak. Rilke did not directly weigh in either way, but he implied to her his judgment by never returning for another sitting. Becker gave up the portrait and turned instead to still lifes.

In a way, the incomplete painting is a more accurate portrait of its subject, still an outline of a man himself. Becker left the eyes as dark featureless circles, rather than filling in their pale blue color and drowsy lids. These are poet's eyes: wide open, absorbing and defense-less against their visions. The mouth stretches as "large and defined" in the painting as it does in the poem. But in Becker's image it hangs slightly open, like the freshly pruned grapevine Rilke had described. Both works are portraits of transition, but Becker's was the more pre-scient in its depiction of a poet on the verge.

Distancing himself from Becker, Rilke spent the next month shut up in his hotel like a monk. He would "kneel down and rise up, every day, alone in my room, and I will consider sacred what happened to me in it: even the not having come, even the disappointment, even the forsakenness," he told his wife.

If poetry was Rilke's god, then angels were the words that would lead him to it. So it was that the stone angel from Chartres returned to him then with a verse. In "The Angel with the Sundial," Rilke comes to terms with the distance that separates his world from the angel's. He recalls how the wind that nearly knocked him down that day had no effect on the stone sculpture. And he questions how well this angel, which holds its sundial out both day and night, understands his realm, writing in the last line, "What do you know, O stone one, of our life?"

The ideas that had been accumulating in Rilke's head over the past nine months began to pour out of him in a great exhalation that would become the first part of his two-volume *New Poems*. Although he was at least writing again, he still was penniless and lost. Not for the first time in his life, he felt like the outcast Prodigal Son.

Only now that he had been ejected from the "father's" house against his will, he saw the tale in a different light. Perhaps the prodigal's

journey into unknown territory was not selfish, but brave. Indeed, one could even pity the older son for staying. Because that boy believes that one's destiny is contingent on where one is born, his life will slog on without change. The Prodigal Son would go on adventures, taste freedom and maybe even find god.

This was the kind of Prodigal Son Rodin had depicted with his bronze boy kneeling on the ground, his arms flung toward the sky. The work was originally titled *The Prodigal Son*, and later changed to *Prayer*, but Rilke recognized neither title as correct, writing in the monograph, "This is no figure of a son kneeling to his father. This attitude makes a God necessary, and in the figure thus kneeling are present all who need Him. All space belongs to this marble; it is alone in the world."

Rilke subverted the parable this way in his poem "The Departure of the Prodigal Son," which begins:

> *Yes, to go forth, hand pulling away from hand.*
> *Go forth to what? To uncertainty,*
> *to a country with no connections to us*

He then uses the poem's last lines to applaud the son's exit, rather than his return:

> *To let go—*
> *even if you have to die alone.*
>
> *Is this the start of a new life?*

For Rilke, it was at least the start of a new chapter. He had officially left the house of Rodin and, by the end of July, would move on again, first briefly to the coast of Belgium and then to Berlin. His patron Karl von der Heydt had sent him two thousand marks to help support him during these uncertain times. "This last period has been confused, the

leave-taking from Paris difficult and inwardly complicated," Rilke had told him. In September the poet set his sights on Greece and made an elaborate appeal to von der Heydt to fund the trip as well. He told him that he needed to complete the second essay on Rodin, and could think of no better setting for this work than Greece, the sculptor's spiritual homeland.

But then those plans evaporated when a baroness invited Rilke to be her guest in Capri for the winter. By then, von der Heydt's patience had started wearing thin. He scolded Rilke for his neediness, arguing that a poet might require financial support in the beginning, but should ultimately strive for financial independence.

Rilke replied to the accusation with predictably tangled logic, claiming that it was *because* he placed such a premium on independence that he had not been able to support himself. Rodin's employment had imprisoned him at the expense of his work for too long and he refused to relinquish that freedom again for a job.

In the end von der Heydt sent the money and off Rilke went, arriving in Capri on his thirty-first birthday.

RILKE'S PATRON WAS NOT the only person becoming frustrated by the poet's capricious and costly travels. Back in Berlin, Westhoff complained to her new friend Andreas-Salomé about Rilke's prolonged absences. Their so-called "interior marriage," based on letters and distance, had left her to raise Ruth alone, and she often barely scraped by on her teaching income.

Andreas-Salomé was horrified. She advised Westhoff to notify the police if Rilke did not begin fulfilling his paternal obligations soon. Westhoff must have known that the mere suggestion of legal action—particularly coming from his dear Lou—would humiliate Rilke, hopefully into compliance. She wrote to her husband to tell him what his friend had said.

As she expected, the letter detonated on Rilke's Italian vacation. He wrote an impassioned defense to his wife and, in a roundabout way, to

Andreas-Salomé, whom he knew would hear about it. He accused his old friend of hypocrisy, reminding them how Andreas-Salomé had always urged him to elevate his art above all external demands. Being a father was an honorable pursuit, but a poet's calling was an imperative, he said, ignoring the fact that Andreas-Salomé's actual advice was to not start a family at all.

Rilke pleaded with his wife for understanding and then he praised her. But he stuck to his resolve to pursue the prodigal path: "I will not give up my hazardous, so often irresponsible position and exchange it for a more explainable, more resigned post until the last, the ultimate, final voice has spoken to me," he said.

It's not that Rilke didn't value love, he just preferred it as an intransitive verb: without object, like a radiating circle. Otherwise to love was to possess another, while to be loved was to be possessed. Or, as he would more pointedly put it in *Malte*, "To be loved means to be consumed in flames. To love is to give light with inexhaustible oil. To be loved is to pass away; to love is to endure." To Rilke, the home's hearth was the brightest-blazing fire and he would rather jump out a window than risk burning alive; if he fell flat, at least a scarred face was better than one that resembled somebody else's. To Rilke, family was the ultimate annihilation of self.

He failed to see that his wife at least partly agreed—except that it was she who wanted to fulfill *her* calling. So while Rilke spent his Christmas in Capri, Westhoff made her way to Egypt, where some friends had offered her a few commissions and a place to stay while she worked. Rilke had not seen her so determined in years: "Since that first contact with Rodin she has not reached out for anything with so much need and real hunger as now."

As he entered a fallow period in his own career, he was perhaps a bit envious of her industriousness, too. His trip to Italy had proved to be an utter mistake. There were too many distractions there: drunken German tourists thundered through town, while his hostess's friends did too much socializing and too little work. Although one could always locate remote corners in Italy to find peace, Paris was the only place where he had truly been able to work. The city had treated him

a bit like military school, forcing him to overcome his fears by writing through them. Except this time Rodin drove him out before he had the chance to complete his education.

"I have again stored up so very much longing for complete solitude, for solitude in Paris. How right I was when I considered that the next necessity, and how much harm I did myself when, contrary to all understanding, I half missed, half wasted this opportunity. Will it come again? On that, it seems to me, everything depends," he wrote in February.

He bided his time until spring, when Westhoff returned from Egypt. They spent two weeks together in Italy, but any lingering trace of passion between them was now permanently gone. Rilke had been eager to hear her tales from Africa but she came back with nothing to say. She walked around with a look of disappointment on her face that reminded him of Beuret, whose perpetually grimaced look made one acquaintance exclaim, "My god, was it really necessary for her to make herself look so unloved?" Then Westhoff and Rilke's paths diverged once again; this time she left for Germany and he went to France, alone. Although the pair maintained a close bond for years to come, the image of their marriage was one they no longer tried to frame.

Rilke knew Paris would be different this time around. He was nobody's son now, nobody's secretary. He was scarcely even a father or husband anymore. Let lovers consume each other like wine, he reasoned, he had finally disentangled himself from those vines. When Franz Kappus once complained that the loved ones in his life were going away, Rilke told him that he should instead see how "the space around you is beginning to grow vast." This was the empty place where he found himself now, somewhere between the lines, where he could breathe free at last.

CHAPTER
11

❧

A S THE TWENTIETH CENTURY TORE OFF FROM THE NINE-teenth, a new generation of artists ventured into unknown territory without looking back. In Western Europe, many embraced the colonial spirit of exploration in their work by appropriating "primitive" African art and toying with sexual taboos. In a few short years, the cottony brushstrokes of Impressionism had hardened into the spiky lines of Cubism, and Monet's parasol-adorned ladies had stripped down to Toulouse-Lautrec's feathers and garters.

Simultaneous strides toward Cubism in France, Futurism in Italy and Expressionism in Germany all paved the way for a new abstract art, which promised to either liberate painting or destroy it, depending on whom you asked. If there was such a thing as a literary manifesto for the moment, it was the German art historian Wilhelm Worringer's 1908 book *Abstraction and Empathy: A Psychology of Style*.

The work was originally intended solely as a dissertation, and the twenty-six-year-old doctoral candidate never anticipated the widespread enthusiasm that greeted the text upon its publication. The idea for the book had come to him by chance. As he explained in a foreword to a later edition, he had been searching long and aimlessly for

a research topic when it hit him one day in 1905, during a visit to the Trocadéro, Paris's museum of ethnographic art.

Many Parisians avoided the musty, run-down building, which was a relic from the 1878 World's Fair. There was no one else there that spring day, apart from Worringer and two older gentlemen, he later recalled. Then he recognized one of them as none other than Georg Simmel, his former professor in Berlin. The sociologist was in Paris for the meeting with Rodin that Rilke had helped arrange for him.

The professor apparently did not see his former student that day and they never spoke. Yet it was during those hours, coexisting in the museum "in a contact consisting solely in the atmosphere created by his presence," that Worringer experienced "in a sudden, explosive act of birth the world of ideas which then found its way into my thesis and first brought my name before the public."

When Worringer returned home he set to work on a sprawling, speculative inquiry into why artistic movements occurred when they did throughout history. He never explained precisely what effect Simmel's presence had on him that day. But it undoubtedly reminded him of the sociologist's research into social upheavals and the creative movements they fostered. Worringer now merged these ideas with the theories of another former professor, Theodor Lipps, whose research on *einfühlung* informed Worringer's belief now that two categories encompass all art: abstraction and empathy. The entire continuum of art history spanned these two poles, he argued. The point at which any one art movement appeared on the spectrum had to do with the psychological health of the society that produced it.

Empathic art tended to be representational and to flourish during times of prosperity. Artists in these periods developed techniques to convey dimension, depth, and other painterly illusions in order to surround themselves with reflections of their blissful reality. Worringer argued that holding up mirrors to the outside world allowed artists like those of the Italian Renaissance or Greek antiquity to identify with its beauty.

Meanwhile, abstraction arose out of turmoil. Artists who endured

war or famine attempted to organize their chaotic lives through the use of orderly mathematical forms, like the geometric mosaics of the Byzantine Empire or the pyramidal architecture of ancient Egypt. Repetition was soothing, Worringer argued, while the angular shapes ran counter to the soft roundness of the human figure in an attempt by artists to distance themselves from their miserable realities.

When he finished the manuscript, Worringer mailed copies to anyone he thought might give it a cursory glance. One recipient was the critic Paul Ernst, who did not realize that it was an unpublished student paper when he decided to review it in the popular German art magazine *Kunst und Künstler* and praised it for its prescient timeliness.

Worringer's binary may have been overly simplistic, but its bold scope garnered immediate curiosity. As soon as the issue hit newsstands, bookstores started receiving orders for the text that was not yet even bound. The Munich publisher Reinhard Piper also inquired about receiving a copy. When he discovered it didn't yet exist, he had his company publish *Abstraction and Empathy* in 1908. It has since undergone twenty reprints, nine translations and inclusion in "more editions than any other theoretical work of German modernism," according to the art historian Ursula Helg.

Simmel himself was among the first to congratulate Worringer on the book. It turned out that the *Kunst und Künstler* reviewer was a friend of Simmel's and had sent the professor a copy early on. When Simmel wrote the young author to tell him how impressed he'd been, the letter had "the effect of establishing a bridge, both mysterious and meaningful," Worringer said, to his "happiest hour of conception."

A few years later, Andreas-Salomé sent a copy of the book to Rilke, who probably did not realize his tangential role in its genesis, in arranging for Simmel to be in Paris at the same time as Worringer. He wrote back that he had found himself "in absolute agreement." (Andreas-Salomé was less impressed and told Rilke to keep her copy since he had liked it so much.)

By proposing that art functions as an articulation of the self, Worringer's book became a testament to the German Expressionist move-

ment and to artists like Wassily Kandinsky, August Macke, and Franz
Marc, who formed the spiritualist art collective Der Blaue Reiter.
"Finally, for once, there was an academic who was receptive to and
understanding of these new ideas, who would perhaps step up for them
and defend them against so many conservatively inclined art histo-
rians, who rejected from the outset everything new and unusual, or
didn't even bother with it to begin with," wrote Macke's wife, Elisa-
beth Erdmann-Macke.

The book debuted at such a serendipitous cultural moment that
it accorded Worringer an almost prophetic status. During the two
years he had spent writing about premodern abstract art movements,
Georges Braque and Pablo Picasso were in their studios inventing a
new one by flattening time and motion onto singular planes. The year
Abstraction and Empathy came out, Matisse complained that Braque's
contribution to the 1908 Salon d'Automne was nothing but a bunch of
"little cubes."

The previous year, Picasso painted *Les Demoiselles d'Avignon*, the
apocalyptic masterpiece that came to define the end of one era and the
beginning of another. Like Cézanne's bathers, the flattened nude pros-
titutes in Picasso's 1907 painting reject classical rules of perspective.
Lacking depth, the three women on the left side seem to advance to
the front of the canvas, as if soliciting the viewer. The two on the right
wear African masks. Picasso went to cruder extremes than Cézanne,
sharply slicing up the figures and piecing them back together to form
new geometries.

Like Worringer's dissertation, the idea for Picasso's *Demoiselles*
came to him during a visit to the Trocadéro Museum. It was there
that Picasso caught his first glimpse of Congolese masks, which had an
artistic logic that both he and Worringer tried to explain. For Worrin-
ger, the mask was a catalyst toward abstraction because it concealed
its wearer and withdrew him from a frightful society. To Picasso,
the masks were "weapons," used to protect tribal artists against evil
spirits. They believed that by giving form to their fears they would
purge themselves of them. It was then and there in the Trocadéro

that Picasso "understood why I was a painter," he said. *"Les Demoiselles d'Avignon* must have come to me that very day, but not at all because of the forms; because it was my first exorcism painting—yes absolutely!"

Around that time, Picasso saw an El Greco painting hanging in his friend Ignacio Zuloaga's studio that confirmed his ambitions for *Les Demoiselles.* He returned again and again to look at this picture of a saint with an elongated body, beckoning the stormy heavens. The painting, *The Vision of St. John,* was the same El Greco canvas that Rodin had tried to dissuade Zuloaga from buying during their trip to Spain two years earlier. With that painting, which today hangs in the Metropolitan Museum of Art, Picasso concluded that Cubism proceeded from El Greco and thus was "Spanish in origin."

THE TWENTIETH CENTURY REVIVAL of El Greco, an artist Rodin for so long despised, was a sign of the sculptor's growing alienation from the new generation. He thought Cubism was a contrived movement and that "young people want to make progress in the arts too quickly." They were "striving for originality, or what they believe to be originality, and they hasten to imitate it."

As European artists increasingly took inspiration from far-flung colonies, Rodin's heroic monuments to French culture began to feel out of touch. In 1908, the year Picasso ventured most deeply into his African period, Rodin finished *The Cathedral,* a sculpture of two marble hands whose fingertips meet in an A-shape. They frame an internal space shaped like that of a cathedral vault. The new guard rolled their eyes at what they saw as typical Rodin schmaltz. The sculptor was becoming the symbol of art's most tired traditions. "For the majority of young artists, looking to develop their own identity, the problem was Rodin," wrote the art historian Albert Elsen.

"When I began to do sculpture I didn't understand [Rodin] at all," said Aristide Maillol. "His works made absolutely no impression on me. I found them bad, that's all."

Whereas Rodin's work expressed movement and emotional inten-

sity, younger artists now strove for static, mathematical indifference. Maillol, along with Amedeo Modigliani, thought Rodin's art was overly representational and that his precise method of copying every last line and wrinkle made it feel slavishly constrained. They were interested in stripping away all that detail to reduce forms to their essential parts.

When the twenty-eight-year-old Romanian sculptor Constantin Brancusi moved to Paris in 1904, he got a job as an apprentice to Rodin, only to quit a few weeks later. He realized that he had been unconsciously imitating the artist's work and decided that "nothing grows under big trees." In principle he agreed with Rodin that an artist should try to convey the essence of their subject, but his views diverged sharply when it came to its execution. "It is impossible for anyone to express anything essentially real by imitating its exterior surface," he said.

Three years after Brancusi quit, he made his own sculpture called *The Kiss*. He summarized the pose of Rodin's embracing lovers with the briefest of forms: a single limestone cube, divided down the center by a line. Brancusi etched long hair and a breast into one side, but otherwise showed no trace of Rodin's arch-naturalism or emotionality in his primitive form, carved by Brancusi's own hand.

Henri Matisse, too, declared his independence from Rodin after receiving an unproductive critique from the sculptor in 1900. Matisse, then thirty, had brought some of his drawings to Rodin, who received the artist kindly in his studio, but showed little interest in the work. "He told me I had facility of hand, which wasn't true," Matisse recalled. Rodin then advised the young artist to "fuss over it, fuss over it. When you have fussed over it two weeks more, come back and show it to me again."

Matisse never returned. He wasn't interested in fussy drawings and he was put off by Rodin's dismissive attitude. That day Rodin "merely showed his petty side," he recalled years later. "He could not do otherwise. For the best of what the old masters possess, that which is their raison d'être, is beyond their grasp. Having no understanding

of it, they cannot teach it." He claimed that Rodin's feedback mattered little to him anyway by then. His practice was rapidly becoming "the reverse" of Rodin's. He saw that while Rodin could chop a hand off his *St. John the Baptist* and work on it in a separate room before reattaching it, Matisse could only see a work in terms of its overall architecture. It was a practice based on "replacing explanatory details by a living and suggestive synthesis."

The same year as their disagreeable studio visit, Matisse remade a version of Rodin's *Walking Man*. He hired the same Italian model and sculpted the man in a nearly identical stance, armless and paused mid-stride. But Matisse's figure, titled *The Serf*, is lumpier, cruder and less anatomically defined. Matisse had manipulated Rodin's expressive vocabulary to create a more unified, painterly form.

Each passing insult seemed to entrench Rodin more firmly in the past, and he embraced the position with ever more defiance. He turned his back on the future altogether, becoming "a man of the Middle Ages," as Cézanne once described him. He began to amass a serious collection of antiquities from Greece, Egypt, the Orient and Rome, and he filled his library with antiquarian books. He bought up funerary sculpture, votives, reliefs, vases, Tanagra figurines, busts and torsos with such indiscriminate gusto—everything was, *Que c'est beau!*—that some of his dealers began inflating their prices and selling him forgeries. After his death, the *Connoisseur* magazine suspected that Rodin probably owned more fake antiques than authentic ones. But this never seemed to detract from the pleasure his collection gave him. "At home, I have fragments of gods for my daily enjoyment," he once said. These works "talk to me louder, and move me more than living beings."

ANTIQUE DEALERS WERE NOT the only opportunists to notice Rodin's careless accounting. Whether she meant to exploit him or help him, the Duchesse de Choiseul was a brilliant businesswoman. She nimbly marketed Rodin to American art collectors, who had previously been unmoved by his "obscene" nudes. When the artists Edward

Steichen and Alfred Stieglitz brought Rodin's erotic drawings to a New York gallery in 1908, American critics denounced the exhibition. "Stripped of all 'art' atmosphere they stand as drawings of nude women in attitudes that may interest the artist who drew them but which are not for public exhibition," declared the *New York Press.*

Choiseul saw an ingenious opportunity, however, to tap into America's capitalistic national psychology. She knew that collectors there were more likely to buy art as a means of displaying their wealth than their taste. So Choiseul raised Rodin's prices solely for American collectors, then sat back and watched the demand grow. In particular, she marketed Rodin's busts to them, predicting that portraiture would appeal to their vanity. It worked: When Rodin met Choiseul, she claimed he was making less than $12,000 a year. Once she started personally handling all of his Paris sales, she boasted of raising it to $80,000.

When the American railroad and tobacco tycoon Thomas Fortune Ryan came for his bust sitting, Choiseul pushed her strategy further. First she stoked his pride with a bit of patriotic camaraderie, bragging about how their country was the greatest in the world. The United States harbored more talent and potential than anywhere else, but she lamented the way its elite failed to support the arts the way they did in France. Ryan, however, was in a unique position to change all that, she said. Wouldn't it be a shame to waste his fortune on this life? she asked. Why didn't he start thinking about his legacy? Wouldn't he consider buying more of Rodin's work to donate to the Metropolitan Museum? Didn't he want to go down in history as the philanthropist who enlightened the American people to great art?

Her provocation worked. The industrialist soon purchased several works by the artist to give to the Metropolitan Museum and donated $25,000 for the institution to make further acquisitions. Choiseul hoped this would give the Met an incentive to one day establish a permanent gallery dedicated to Rodin.

In 1910, she and Rodin hosted the chairman of the museum's sculpture committee, Daniel Chester French, and his family at the Hôtel

Biron. French's wife adored the "wonderful palace" and said of Rodin that "my daughter and I were flattered because he seemed quite as pleased at our liking his work as if our criticism had been really valuable." Shortly thereafter, French and his colleagues voted to devote a gallery in the north corridor of the museum to Rodin, which would open two years later with a collection of forty sculptures.

Americans would ultimately become some of Rodin's biggest supporters. Shortly after the artist's death, the American movie-theater mogul Jules Mastbaum bought up well over one hundred Rodin works and opened the Rodin Museum in Philadelphia in 1929. It remains today the largest collection of the artist's work outside of Paris.

The American embrace of Rodin did little to endear him to his European compatriots, however. Of a bust Rodin had recently made of a young financier, the critic Georg Brandes described it as "a young American, like so many one meets, not stupid and not intelligent, not dull and not interesting—a commission." When the count and patron Harry Kessler met Choiseul for the first time, he found it "astonishing how the old man has the stamina for all these Americans."

To keep up with the demand, some believed that Rodin and Choiseul started exploiting the ignorance of Americans and selling them inferior works. One assistant claimed that the marble *Pygmalion and Galatea* that went to the Metropolitan "was not among his best things," and that Rodin himself had kept it stored away from the studio to avoid looking at it.

It is also possible that he simply lost track of his inventory. His output had grown so large by then that it was impossible for him to oversee everything that was made and sold in his name. He outsourced nearly all of his stone carving and authorized an inordinately large number of foundries to produce works on his behalf. He made three hundred bronze versions of *The Kiss* alone in his lifetime. Although it made him enormously wealthy, Rodin recognized that his prolific production came at a price, once telling a writer, "All the world sees in these days are copies, and a copy always loses something of the first freshness of inspiration."

———

EIGHT YEARS AFTER HIS bitter meeting with Rodin, Matisse became the de facto general of the avant-garde. He led the artistic revolution alongside, and sometimes in opposition to, Picasso, who had his own ideas about what modern art should look like. The Spaniard once complained that there were "no vertical lines in Matisse's paintings," while Matisse declared Cubism too rigid and dogmatic. Their rivalry remained cordial, however, until Matisse learned that Picasso had been throwing toy darts at one of his paintings.

Twelve years older and far too dignified for such puerile pranks, Matisse was profoundly hurt by this. When he was a student at the École des Beaux-Arts, his classmates nicknamed him "the Professor." The tweed-clad painter fulfilled that prophecy in January 1908, when he opened a small art academy in Paris. He was one of the few modern masters of his generation to teach as well as make his own work, so when he announced that he would hold classes free of charge, hundreds of students enrolled immediately.

But those expecting untamed, paint-splattered lessons with the fauvist, or "wild beast," himself were sorely disappointed. Matisse taught traditional modeling and still-life skills. Even though he had broken all the rules of his own training, he promoted the mastery of classical techniques to his students, often quoting Courbet to explain: "I have simply wished to assert the reasoned and independent feeling of my own individuality within a total knowledge of tradition." But those who stuck with his classes, including Gertrude Stein's brother and sister-in-law, and the American painter Max Weber, found an exceedingly thoughtful mentor. In the end, Matisse required them to copy nature only so that they could identify an image's basic parts, strip it down, and ultimately give expression to their individual artistic styles.

In May 1908, Matisse expanded his school into a larger space at 77 Rue de Varenne, at the corner of the Boulevard des Invalides. It was a former *hôtel particulier* in a quiet neighborhood of stately private man-

sions built by noble families in the eighteenth century, many of which were later turned into government buildings.

By the time Matisse arrived, the once-glorious mansion had fallen into a state of disrepair. It was constructed in the early 1700s, with an entrance gate to the property wide enough for carriages to pass through and a doorbell stationed at horseman's height. The building later became known as the Hôtel Biron, when it was briefly, but lovingly, inhabited by the Duc de Biron, who renovated the interiors and doubled the size of the gardens.

The Hôtel Biron.

After the duke died, the Emperor of Russia occupied the mansion briefly, followed by three nuns who bought it in 1820 to open the Sacré-Cœur school for girls. The nuns stripped down the rocaille interiors, sold the mirrors and paneling and let the gardens overgrow. They tore the wrought-iron banisters off the curved staircase. Moss grew up the front steps and nearly onto the checkered parlor floor.

After a century of ravaging and remodeling, the building looked like it might collapse when the government made its first move toward evicting the nuns in 1904. That year, France passed the Law of Separa-

tion to strengthen the divide between church and state and the school was shuttered. When the last nun moved out in 1907, a liquidator took over and offered cheap rent to anyone who dared inhabit the derelict building before its eventual demolition.

But the landlord wildly underestimated the decadent allure of the Hôtel Biron, as it came to be known, and artists flocked to it like flies to rotting fruit. "An uproarious horde rushed in, and soon every chink and corner was crawling with their lice," wrote the art critic Gustave Coquiot.

The low rent was all the incentive Matisse needed to move into one of the apartments and rent a studio, which he divided with a curtain to share with students. Although he had received top billing at the Salon d'Automne that year, his reputation in France lagged woefully behind the regard he received in America and Russia. The Hôtel Biron was the best he could afford.

At least the gardens gave his sons space to play, and there was a pavilion in the courtyard where he could hold classes. Since most of Matisse's early admirers lived abroad, so, too, did many of his students. Coming from Norway, Russia, Romania and the United States—just about anywhere except France—some of these young expats started sleeping in the attic.

When Jean Cocteau, the future author of *Les Enfants Terribles*, was still something of an *enfant terrible* himself, he stumbled upon the mysterious property while playing hooky from school one afternoon. He crept around the gardens, imagining how there must be years of secrets concealed in the tangled trees and rosebushes. The grounds seemed "to mark the end of the discoveries that Paris held in store for those who searched through it, like a local flea-market." Already envisioning the moonlit garden parties and masquerade balls he would throw there, he pushed open the heavy door and asked the concierge if he could look around.

The yellowing walls reminded him of the hotel where Baudelaire met with his Club des Haschischins to hold opium- and hash-fueled séances, which the writer believed broke down the barriers to cre-

ativity. When Cocteau learned that an entire year's rent at the Hôtel Biron cost the same as one month in a cheap hotel, he handed over his allowance from his mother on the spot and rented a room. That night he hauled up a piano, couch and stove to his new second-floor pied-à-terre.

Before long, the aging, proudly plump cabaret singer Jeanne Bloch had moved into a room next door to Matisse, while the swashbuckling Romanian actor Édouard de Max, then starring onstage opposite Sarah Bernhardt, moved into the chapel. Isadora Duncan rented a long gallery on the garden wall for her dance rehearsals. Like so many artists in those days, Duncan wanted her work to commingle with other art forms, and the Hôtel Biron was the perfect place to surround oneself with an inventive mix of sculptors, poets, playwrights or, at the very least, interesting characters.

Joining this motley crew shortly after Matisse was the sculptor Clara Westhoff. She had left Ruth behind in Germany to once again work near Rodin in the hopes of receiving his feedback. Accustomed to securing her own lodgings without Rilke, she now asked a few artist acquaintances if they knew of any affordable housing in the city. A friend told her about a bargain-priced corner studio in a former convent; the building's future was uncertain, but artists were taking advantage of it while the city decided what to do with it.

Westhoff pushed the iron gate open onto the courtyard, where the faded gray mansion stood in a field of weeds, as if out of a ghost story. But any hesitation dissipated the moment she went inside and saw the light flooding in through the enormous windows, and all the space she'd have to spread out. Westhoff went to the office and rented a room at once.

CHAPTER
12

※

EXACTLY ONE YEAR AFTER RILKE'S RUPTURE WITH RODIN, in May 1907, the poet returned to Paris. In Italy he had prayed for even an hour of solitude; now it would follow him everywhere. Since Rodin had cast him out, and he had pushed Becker and Westhoff away, he had little choice but to embrace his seclusion.

At first Rilke celebrated his homecoming by checking into the Hôtel du Quai Voltaire, one of his favorite inns, with a view directly overlooking the Seine. Wagner and Wilde had stayed there, and it was where Baudelaire finished writing *Les Fleurs du Mal* exactly fifty years earlier. Rilke wasted no time taking in the sights. He indulged in a day trip to the Turkish baths, visited Notre Dame and went to the Bagatelle Palace to see Édouard Manet's painting of a nude woman lounging in the park alongside her suited male companions, *Le Déjeuner sur l'herbe*, and thought, *That is a painter.* At the Bernheim-Jeune gallery he saw a painting by Van Gogh of "a night café, late, dreary . . ." To Rilke, the artist's style of painting lamplight as concentric circles "overpowers: one becomes positively old, wilted, and drowsily disconsolate before it."

He returned, too, to his beloved museum of animals, the Jardin des Plantes. Whereas once he had been captivated by the panther, now

it was three gazelles that seized his imagination. They rested and stretched in the grass like women lying on chaise lounges, he thought. Their muscular hind legs reminded him of rifles. "I couldn't go away at all, they were so beautiful," he wrote.

But after a few days at the Quai Voltaire, he had to downgrade to cheaper lodging. He went back to the hotel on Rue Cassette, where he and Paula Becker had last stayed. The place looked exactly the same, but there was one indelible difference: Becker was gone. She had told Westhoff a few months earlier that she had changed her mind about Paris and gone back to her husband in Worpswede. She was "no longer so full of illusions," she said. She had been wrong to believe that she was "the sort of woman to stand alone in life."

She had doggedly tried to make her own way in Paris. But one by one her clients started canceling sales, backing out of appointments and generally becoming *too busy* to associate with the single woman. Her friends either took Otto Modersohn's side outright or, like Rilke, withdrew in trepidation. In a desperate moment she asked Rilke if she might join him and Westhoff on a trip they had planned to the Belgian coast. But he, too, had turned her down.

After a few months of this, Becker's resolve had worn thin. She wrote Modersohn an apology, confessing that perhaps she had been confused. "Poor little creature that I am, I can't tell which path is the right one for me," she said, and invited him to join her in Paris for a few months. They would work and sleep side by side until, at some point, she got pregnant. By winter's end, he had convinced her to return with him to Worpswede.

Becker's letter informing Rilke of her decision filled the poet with guilt. She did not tell him much, only that she was going home, that she hoped it was the right decision, and that she was happy to hear how rewarding Westhoff's trip to Egypt had been—"If only we can all get to heaven," she said.

Rilke admitted in his reply that perhaps he had treated her too harshly and been too "inattentive in a moment of our friendship in which I ought not to have been so." He assured her that she was acting

bravely now, and that her freedom lived inside her, so it would be with her in Worpswede, too.

While Becker learned the bitter lesson that freedom does not always feel free—especially for a woman—Rilke was starting to see that it was not all he had imagined it would be either. It had been five years since he'd knocked on Rodin's door for the first time, and yet he felt more lost in Paris than ever. The city then had felt "strange and frightening right at the first moment and yet full of expectation and promise and necessity to the smallest detail," he told Westhoff. But the promise that he felt back then had a source—Rodin. Now that that promise was gone, he saw only its loss.

Rilke was consistently reminded of his estrangement from Rodin, whose ubiquitous presence within the city's art scene alienated Rilke from many events. In June he received an unexpected invitation to a Legion of Honor award banquet for the Norwegian painter Edvard Diriks. Rilke hardly had time to savor the surprise before he remembered that Rodin would surely be going. He did not dare face him in public. What in the past "would have been an urgent reason for being there" had become "through the circumstances just as decisive a one for staying away. Strange," he wrote.

Lonely and purposeless, Rilke fell into a familiar depression as summer wore on. He could not concentrate in his hotel because the next-door neighbor was a student with a medical condition that caused one eyelid to shut while he studied. This sent the young man into such fits of rage that he would stomp around and fling books at the walls. In a way, Rilke sympathized with him, writing, "I at once grasped the rhythm in that madness, the weariness in that anger, the task, the despair you can imagine." Nonetheless, it also made him want to move out.

Unfortunately, Rilke could not afford any other hotel. He could not even spare the francs to buy books or tea, or take carriage rides. This reality became embarrassingly clear when he offered his money to a carriage driver for a ride one day and the man glanced at the change in Rilke's palm, then chased him out of the front seat and into second class. Rilke rode the rest of the way home underneath the baggage,

"with sharply bent legs, as is proper. That was clear. And I have taken it to heart."

In the Mediterranean he had longed for Paris. Now in Paris he could think only of German meadows. When Westhoff mailed him a few sprigs of heather from Worpswede, their earthy scent filled Rilke with nostalgia. The aroma was like "tar and turpentine and Ceylon tea. Serious and shabby like the smell of a begging friar and yet again resinous and hearty like costly frankincense." His longing to leave worsened as the air chilled into autumn and reminded Rilke why the only thing worse than Paris in the summer was Paris in the winter. "Already the misty mornings and evenings are beginning, when the sun is only like the place where the sun used to be," he wrote. The geraniums "scream the contradiction of their red into the fog. That makes me sad." Rilke was just about ready to ride this gloomy cloud back out of town when he was abruptly reminded why the city, despite its difficulties, continued to lure him there time and again.

When the Salon d'Automne opened its doors in October, a mob of people had already assembled on the steps of the Grand Palais, waiting to get in. Entering its fourth year, the show had come a long way since it first launched in 1903 as a scrappy, artist-led alternative to the official salon. Cézanne had derisively dubbed the mainstream show the "Salon de Bouguereau," after the omnipresent painter William-Adolphe Bouguereau, whose slick, schmaltzy nudes the Impressionists despised. (The feeling was mutual at the Salon de Bouguereau.)

The Salon d'Automne promptly incited outrage, particularly at the 1905 edition, when artists including Matisse, Maurice de Vlaminck and André Derain displayed canvases blazing with pink trees, turquoise beards, green faces, and other flagrant inaccuracies. Dubbed the *fauves*, these artists saw color as a tool for expression, rather than illustration. But many visitors simply saw them as "color-drunk."

By 1907, the public came to gawk, gossip and mock the salon as much as they came to look at the art. At first Rilke, too, was more intrigued by the spectacle than the work on view. But that changed the moment he set foot inside a gallery that was hung top to bottom with

paintings by Cézanne. It was one of two rooms dedicated as a memorial to the artist, who had died the previous year.

This introduction to the painter came late for Rilke, as it did for the many critics who had long dismissed Cézanne for his slanted perspectives, gloomy coloration and seemingly inchoate compositions. Even just two years earlier, at the same salon, the collector Leo Stein watched as visitors "laughed themselves into hysterics" in front of Cézanne's paintings.

That Cézanne spent most of his life on the fringes of society did nothing to win him recognition, either. A Provençal, he hailed from Aix, stayed there, and secluded himself in his studio for most of his life. When local children saw the bushy-bearded man passing through town in his knee-high military boots they threw rocks at him, "as if at a bad dog," Rilke later wrote. It's possible that Cézanne scarcely noticed; he was so preoccupied with painting that he skipped his own mother's funeral to spend the day in the studio. He rarely bothered to attend his own openings, either, which may have been for the best, given his total lack of savoir faire. Cézanne did not care for bathing and, at dinner, he was known to lap up every last drop of soup and strip each strand of gristle from the bone.

But by the 1907 Salon d'Automne, critics had become increasingly intrigued by the flattened look of Cézanne's paintings. He constructed his compositions out of geometric forms, puzzling together cones, cubes and cylinders with the belief that these shapes were the building blocks of nature, and thus were those most readily apparent to the human eye. This architectural approach naturally appealed to the Cubists—Braque and Picasso, who met each other in Paris that year—and sealed Cézanne's stature as a visionary painter.

Rilke's eyes darted around the fifty-six canvases on view at the salon. There were paintings of workmen playing cards, nude women emerging from a pool, and a self-portrait rendered with what Rilke thought was the "unquestioning, matter-of-fact interest of a dog who sees himself in a mirror and thinks: there's another dog." The poet

decided then and there that, when it came to Cézanne, "All of reality is on his side."

Rilke returned to the salon the next day, and then again nearly every day after that for the rest of the month. He stared at a portrait of Cézanne's wife seated in a red armchair for so long that the color seemed to flow in him like blood in his veins. This armchair—"the first and ultimate red armchair ever painted"—felt as alive as he was. "The interior of the picture vibrates, rises, and falls back into itself, and does not have a single moving part," he wrote. After seeing this, Rilke questioned whether the artists whose work hung at the Louvre even understood "that painting is made up of color."

Each time he visited the show it unleashed new insights and sensations, which he then raced home to record in letters to Westhoff. When he described to her one of Cézanne's "gray" backgrounds, he immediately wrote back with an apology. The pedestrian word choice was unfit for the richly nuanced color Cézanne used. "I should have said: a particular type of metallic white, aluminum or something similar."

The painter approached color like an archaeologist, starting with its depth and then bringing to the surface the subtler tones contained within it. Thus grays often gave way to folds of violet or melancholy blue, as in Cézanne's paintings of Provence's Mont Sainte-Victoire. "Not since Moses has anyone seen a mountain so greatly," Rilke wrote.

The poet was so taken by the range of blues in Cézanne's work that he thought he might write an entire book about the color. Because Cézanne never settled for a straightforward blue in his work, Rilke's descriptions followed suit: it was always "thunderstorm blue," "light cloudy bluishness," "bourgeois cotton blue," or "wet dark blue."

The poet never did write the book on blue, but he did complete the sonnet "Blue Hydrangea," drafted on blue stationery. In it, he compares the flower's mottled blue leaves to a palette of drying paints. One petal reminds him of a schoolgirl's pinafore. Another one in a paler shade is like the same blue dress years later, after it has washed out and

the girl has grown up. Thus, contained within these tiny petals, Rilke sees a metaphor for the fleeting nature of childhood.

In a single month, Cézanne became the third of what Rilke called his "Homeric elders," following Tolstoy and Rodin. He began to feel protective of the art at the salon, as if it were his own collection at home. It infuriated him to see visitors complaining that the show was boring, and to observe women vainly comparing their own beauty to that of the ladies in the portraits. When his friend Count Harry Kessler joined him in Paris to see a gallery show of paintings by Cézanne, Renoir and Bonnard, among others, Kessler noticed that Rilke was "so totally obsessed with Cézanne that he is blind to everything else."

Rilke saw in Cézanne's work a continuation of Rodin's philosophies. Both artists empathized with inanimate objects, with Cézanne painting everyday sights like fruit, jars and tablecloths as if they possessed inner lives. "I will astonish Paris with an apple," the painter once said. They also both believed movement represented the essence of life. In one of Cézanne's scenes of the Orangerie, he dashed its surfaces with bright streaks of paint that seemed to flicker and jump about the canvas.

Some have said that if Rodin taught Rilke form, then Cézanne showed him how to fill it with color. Or at the very least, the sculptor gave Rilke the framework he needed to appreciate Cézanne. "It is the turning point in these paintings which I recognized, because I had just reached it in my own work," he wrote to Westhoff, who, at the urging of the philosopher Martin Heidegger, published this series of letters as a book, *Letters on Cézanne*, in 1952. Paintings he once would have walked by with only a passing glance now gripped his attention for hours. Rilke suddenly had "the right eyes."

AT SOME POINT DURING Rilke's research on Cézanne he discovered their shared affinity for Baudelaire. "You can imagine how it moves me to read that Cézanne in his last years still knew this very poem Baudelaire's 'Carcass' entirely by heart and recited it word for word," Rilke wrote in one of the *Letters*.

It was then that he made the connection between the painter and his own work. Rilke had been reading Baudelaire's poem "A Carcass" in *Les Fleurs du Mal*, in which the narrator and his lover stumble upon a dead body. The woman's corpse is rotting and crawling with maggots, yet Baudelaire describes it with the cold precision of a medical examiner. This was what Malte strived to do, Rilke realized. He was still unclear about what should happen to his young protagonist, but "I know much more about him now," Rilke told Westhoff.

In *The Notebooks of Malte Laurids Brigge*, Malte comes to the same conclusion Rilke did about Baudelaire. "It was his task to see," Malte says. He had to look past his repulsion and connect with this corpse, to identify "the Being that underlies all individual beings." This communion represented the ultimate test: "whether you can bring yourself to lie beside a leper and warm him with the warmth of your own heart."

To Rilke, an author in perfect mastery of his sight also became a master of his emotions. When artists tried to sentimentalize or beautify their subjects they sacrificed certain perceptual truths; Baudelaire's adherence to observation was what ultimately allowed him to write like a visual artist, molding "lines like reliefs to the touch, and sonnets like columns," Rilke wrote.

Rilke recognized Cézanne as an artist for whom Baudelaire's challenge was not too great. Cézanne penetrated a thing's innermost reality "through his own experience of the object," Rilke wrote. But then, to the poet's great distress, the Salon d'Automne closed at the end of the month. Rilke spent every moment of those final days in front of the painter's canvases, absorbing all the colors his greedy eyes could contain before the paintings were hauled off and an automobile show rolled in.

APART FROM THE Cézanne show at the Salon d'Automne, there was one other exhibition in the fall of 1907 that left a lasting impression on the poet. Galerie Bernheim-Jeune had staged the first major exhibition of Rodin's drawings, and they were unlike anything the artist had shown before.

The previous year, a few weeks after Rodin had fired Rilke, the King of Cambodia invited the sculptor to a special French performance of the Cambodian Royal Ballet. Rodin did not know much about dance, but he found the androgynous ballerinas with their cropped hair and sinewy bodies enthralling. They crouched and shuddered and articulated their fingers in ways he had never seen before. Their bone structures looked as if they had been chiseled in granite.

The dancers reminded him of something ancient, as if they had leapt out of a temple's bas relief onto the stage. Or perhaps from the side of the cathedral; in their perfect equilibrium and antique grace they recalled the stone angel that Rodin and Rilke had admired in Chartres two years earlier. But only now that he had seen the Cambodian dancers had he understood the beauty of the angel. He'd returned to Chartres to look again at the statue and felt modernity and antiquity, religious rite and artistic rite unite within him. "This angel is a figure from Cambodia," he now said.

The day after the performance Rodin had visited the troupe at the gardens of their guest villa to observe and draw them. When they had left for the next stop on their tour to Marseilles, he followed. Within a week Rodin had produced a full 150 watercolors of the dancers.

Forty of those were among the more than two hundred drawings on view at Bernheim-Jeune when Rilke visited that fall. The dancers had no faces, only wildly outlined limbs blanketed in sweeps of rich color. The lightness and mystery of these drawings left Rilke "in a state of blissful astonishment," he wrote. He returned to the gallery again and again. After several days of this he could not bear to keep his excitement to himself any longer. He wrote to Rodin to tell him how many mornings he'd spent with the drawings. Then Rilke wrote another letter the following week to say that they were *still* having their effect on him. "You have entered far more deeply into the mystery of the Cambodian dances than you realize," he said. "For me, these drawings were a revelation of the greatest profundity."

Rilke then boarded a train east to begin a reading tour and avoid another Parisian winter. He made his first stop in dreaded Prague, at

the literary club Concordia, where the audience that November eve-
ning looked old and dull. Among its members were his mother and her
friends, the "ghastly old ladies that I used to wonder about as a child,"
he said. Phia Rilke followed her newly famous son around, clinging
to him and bragging to anyone who'd listen. She was still the "pitiful,
pleasure-seeking creature" that Rilke remembered, still stubbornly
pious, and in denial of her age. Every time he saw her it was "like a
relapse," he once said.

He read a few selections in progress from *Malte* and the *New Poems*
and then went to a tea hosted by an old mentor. He was disheartened
to see that the party was populated by all the same faces that were
there when he left Prague a decade earlier. He would have liked to
leave town immediately, but instead spent four long, obligatory days
there visiting old friends and family.

When it finally came time for him to check out of his hotel, the
concierge notified him of a letter that had arrived from Paris. Rilke
recognized the familiar seal; it was from Rodin. He carefully opened
the envelope, which broke at long last the year-and-a-half-long silence
with his former master.

Rodin had written to ask the poet his opinion about a man by the
name of Hugo Heller, who owned a bookstore in Vienna. Heller wanted
to show some of Rodin's Cambodian drawings there to coincide with
an upcoming talk Rilke was giving on the artist. Rilke, who was on
his way to Heller's shop in Vienna at that very moment, was happy to
send Rodin his assurances of the man.

The letter to Rilke, written by a secretary and only signed by
Rodin, was no grand gesture. But it elated the poet all the same. He
analyzed every word, pointing out to his wife how Rodin had used
the affectionate address, *Cher Monsieur Rilke*. The artist also told him
that he planned to have Rilke's second essay about him, published that
year in the monograph and reprinted in *Kunst und Künstler* magazine,
translated into French so that he could read it.

Rilke tried to temper his excitement but could not stop himself
from replying immediately. He told his wife that he had responded

"just as factually, but spoke of all the matters that had accumulated." At the very least, Rilke knew that reopening the lines of communication with Rodin would make many practical matters in his life much easier. Building a reputation as an expert on an artist with whom he could not contact had proven troublesome. Already he had had to admit to *Kunst und Künstler* that he could not ask Rodin for images to run with the article.

When Rilke arrived in Vienna he discovered another letter from Rodin. This one was longer, with a clearer conciliatory tone. Rodin had now read the magazine essay and found it to be *"très belle."* To Rilke's amazement, he went on to invite the poet to visit him the next time he was in Paris. "We have need of truth, of poetry, both of us, and of friendship," Rodin told him. There were "so many things, so many things" to discuss: the nineteenth century shift from idealized forms in art to naturalized ones, and why Rodin now believed it had taken so long for his own work to come into style. Come anytime, he told Rilke. He always had a room waiting for him at his old *petite maison* in Meudon.

"I could hardly believe it and read it over and over," Rilke wrote to Westhoff. "The dear, just man who lives things so honestly from his work outward! The just man. I have always known that he is that, and you knew it too."

This time Rilke let his euphoria pour out in his response to Rodin. "I have an infinite need of you and your friendship," he wrote. He also knew that he'd made great professional strides on his own since their break and now stood on more equal ground with his former master. "I am proud that I have advanced sufficiently in my work to share your glorious and simple desire for truth," he wrote.

By then Rilke's publisher was in the process of printing a second run of his sold-out *Book of Hours*, the text that was to be the most widely read in his lifetime. Rilke had even started behaving a bit like the literary celebrity he was becoming. He now wore a fashionable black cloak to his readings and approached the lectern with confidence, peeling off his gloves and slowly lifting his eyes to meet the audience. He spoke with a "full, resonant voice that had nothing of boyishness or

immaturity about it," recalled the writer Rudolf Kassner, who saw him speak at the event in Vienna. Afterward, the poet shook hands with guests who crowded around to greet him.

Rilke had even managed to win over his harshest critic in recent months: Paula Becker. She wrote to him in October to tell him how much she, too, had enjoyed the new Rodin essay. In her journal, she wrote, "It seems to me that the youth with his fragile exuberance is vanishing now and the grown man is beginning to emerge with fewer words but which have more to say."

WHEN PAULA BECKER had told Rilke that she was leaving Paris and going back to her husband in Worpswede, she had neglected to mention that she was also pregnant. Now her due date was one month away and she spent nearly all her time at home, reading, painting when she felt up to it and fantasizing about Paris, as always.

She had heard about the Salon d'Automne and how "fifty-six Cézannes are on exhibit there now!" as she wrote to her mother. The painter remained one of only about three artists who had struck her "like a thunderstorm." She and Rilke had not kept in close touch since he had distanced himself from her in Paris, but she knew that he had written lengthy letters on Cézanne to Westhoff and she asked her friend if she would send them to her. "If it were not absolutely necessary for me to be here right now, nothing would keep me away from Paris," she told Westhoff in October. Westhoff promised she would do better than that and come read her the letters personally.

Becker gave birth to a daughter, Mathilde, on November 2. A few days later, Westhoff arrived at her friend's bedside with Rilke's letters on Cézanne in hand. Becker was weakened from what had been a long, painful labor that ended with the doctor chloroforming her and delivering the baby with forceps. But Becker smiled sweetly at her beloved friend and Westhoff promised to return in a few weeks to read to her when she was feeling better.

Two weeks later, Becker finally rose from bed. She sat at the mirror

in her nightgown and braided her long golden hair. She wove it into a crown around her head and pinned roses to it from the vase on her nightstand. The room had been filled with candles and flowers sent by friends and family. It looked as beautiful as Christmas, she thought.

She called out for someone to bring her Mathilde. When the baby was brought to the bedroom and laid in her arms she felt a sudden weight in her foot. It was as heavy as iron. She lay back to elevate it and gasped, "A pity." A moment later, she was dead.

The doctor ruled the cause of death an embolism. She was thirty-one years old. Westhoff was traveling in Berlin then and did not hear the news until a week later when she returned to Worpswede, as promised, to see Becker and read her the letters. She arrived early in the morning and walked up the birch-lined path that the friends had "so often walked along together." On the way she picked a bouquet of autumn flowers for her. When she went to the house she found it empty. Modersohn was gone, Becker's sister had taken the baby, "and Paula was no longer there."

CHAPTER
13

❦

THE NEWS OF BECKER'S DEATH REACHED RILKE IN ITALY, where he was taking a vacation after his reading tour and visiting a new love interest, Mimi Romanelli. Just ten days into his trip, he packed his bags and returned to Germany. He stayed with his family there over Christmas and for nearly two months afterward. He fell ill with a flu that kept him bedridden for a month and compelled Westhoff to care for him, even though their marriage had long since existed in name only. Rilke even put up a picture of Romanelli in the house and apparently Westhoff agreed that she was very beautiful.

Once Rilke felt well enough he went back to Italy, but by then his desire for Romanelli had faded and a longing for Paris had taken its place. He traveled the country up and down for two months, during which time he remained all but mute on the subject of Becker's death. It would take a full year for his guilt to find its expression.

The poet made his return to Paris on May 1, 1908, and this time he did not go back to his and Becker's usual hotel on Rue Cassette. Instead he subletted from a friend a tiny studio in Montparnasse, on the Rue Campagne-Première. "Scarcely three steps wide and three

long," it was hardly as nice as Westhoff's palatial apartment in the Hôtel Biron, but it would do for now.

Rodin had invited Rilke to stay in his old room in Meudon two more times, but the poet had grown less and less committal as the days wore on. His once-beloved cottage now sounded like a cage. Even if he was no longer bitter over the treatment he had endured from Rodin, something had changed in him. His subordinate position to Rodin had come to embarrass him and, in later years, he would deny ever having been his secretary at all. When the literary historian Alfred Schaer once asked about his early influences, Rilke adamantly downplayed the "rumor" of his old job as "not much more than an obstinate legend" emerging from the fact that he once assisted Rodin with his correspondence "temporarily, for five months (!)." It was as Rodin's *student*, Rilke clarified, that he had really come to know the sculptor.

Rilke politely declined Rodin's offer to stay in Meudon, writing that he had fallen behind on work and needed to lock himself up at home for the time being. But he looked forward to arranging a meeting at a date sometime in the near future, he said. This was not altogether untrue since his publisher did expect him to complete the *New Poems* by the end of summer.

Rodin did not get the hint, writing back the same day: "Come to Meudon tomorrow afternoon, if you can."

Nearly three months passed before Rilke wrote to Rodin to tell him that he was still "locked in my house like a nut in its fruit." Again Rodin responded instantly, writing that he was happy to hear the poet was working with such gusto, but couldn't he come for dinner some Sunday soon? "It would be a pleasure to see you, to talk, to show you the antiques," Rodin wrote. Once, while the poet was out the artist came by and left a fruit basket on his doorstep.

Rodin, it seems, was lonely. In the years since he had moved to Meudon, Paris had become the city of the Moulin Rouge, of stand-up comedy and gay bordellos. Twenty-four-hour electric lamps now outshone the dappled sunlight that had inspired the Impressionists of the previous generation. Meanwhile, Picasso and other young émigrés had

led the settling of Montmartre, forging an inextricable link between the art scene and the neighborhood's notorious nightlife.

Rodin once tried to go out to a Montmartre cabaret with Van Gogh, Gauguin and Toulouse-Lautrec. A fog of smoke hovered overhead in the basement club. Drunks slumped in their chairs, their heads occasionally bobbing back to life when the perfumed breeze of a can-can dancer passed in the audience. Rodin admitted to being "very scared" of this raucous crowd. The women with their advancing cleavage, over-rouged cheeks and piles of "love locks" were too crude, while the men seemed like sinister wastes of time and money.

Rodin left it to the younger artist among them, Toulouse-Lautrec, to capture the seedy scene in his art. Over the years, Toulouse-Lautrec drew on cabaret walls and sketched hundreds of caricatures of the debauched clientele. Once he drew Rodin as a hunched-over lump of beard and coat.

The sculptor was far happier to spend his Saturdays sipping tea with Monet in Giverny, or sitting by the pond in Meudon. He had come to mourn the loss of his and Rilke's old conversations there.

Ultimately, it was Rilke's wife who laid the groundwork for the pair's reunion, albeit inadvertently. At the end of the summer, she decided to pay an extended visit to a friend in Hanover, allowing Rilke to take over her studio in the Hôtel Biron. Rilke moved into the oval-shaped apartment with soaring ceilings at the end of August and rented a second room, too, with a terrace that opened onto the gardens. Though it cost five hundred francs more than he could really afford each month, he was about to turn in the *New Poems* and claimed he needed a change of air in order to transition into a new body of work.

With just a few swift touches, he made the space feel like a little Bohemia in Paris. He set out fruits and flowers on the table, the breeze from the open window dispersing their sweet aroma around the room. He placed a bust by Westhoff in the corner and left the rest of the room bare, allowing the brilliant sheets of sunlight to be the décor. When Rodin learned that Rilke could not afford a desk, he gave him a big oak tab'

which the poet placed in front of an open window and promised to make it the "great fertile plain" where he would complete the *New Poems*. In return, Rilke bought Rodin a wooden statue of Saint Christopher, the muscular martyr who carried the Christ-child across the river. "This is Rodin, bearing his work, ever heavier, but containing the world," Rilke said.

In these quaint quarters Rilke reminded his friend Count Harry Kessler of a little old maid. The smell of apples overwhelmed the room like in "an old country house," he said. But Rilke knew there was one person who would appreciate its rustic charm as much as he did.

"You ought to see the beautiful building and the room I have inhabited since this morning," Rilke wrote to Rodin the day he moved in. "Its three bays look out prodigiously across an abandoned garden, where from time to time one sees unsuspecting rabbits leap across trellises as if in an ancient tapestry."

Not two days passed before Rodin paid a visit to see the space for himself. Reunited at last, the old friends talked for hours. They agreed that Beethoven was the most fearless composer in history and Rilke recited for Rodin one of his favorite quotes by the composer, from when the man was losing his hearing and having suicidal thoughts: "No friend have I, I must live with myself alone; but I know well that God is closer to me than to others in my art, I go about with him without fear, I have always recognized and understood him; I am also not at all afraid for my music, that can have no ill fate; he to whom it makes itself intelligible must become free of all the misery with which others are encumbered."

Rodin not only loved hearing this quote from Rilke, he already knew it. Someone else had mailed Rodin the passage to comfort him during *l'affaire Balzac*.

They also discussed once again the role of women in an artist's
ed whether there could be such a thing as love without
leir views diverged acutely, with Rilke, for the first time,
sagree with Rodin. The sculptor believed that women
nents to man's creativity, but a nourishment, like wine,

to man himself. Rilke thought this was severely stunted logic. To him, the ability to sustain meaningful relationships with women, outside of sex, had always symbolized a mark of manhood. To think of women purely in terms of pleasure and consumption was to think like a child.

Rodin thought women were inherently conniving and sought only to "hold men fast." Rilke tried to convince Rodin that he had known plenty of women who were interested in much more than marriage. But even as he spoke he knew he'd never change the old man's mind. Rodin was obstinately tied to the past, "bound to the rites traditional in him, even to those which are not meant for us and yet were necessary in the cult of his soul in order to mold him," Rilke wrote to Westhoff after his friend's departure that day.

Of course, Rilke's feminism was tinged with hypocrisy, given that his own wife was fundamentally "held fast" by the parenting burdens he had imposed on her. It's possible that Rilke recognized this contradiction, for he made a point of telling Westhoff that he had emphasized to Rodin the many independent women he knew in northern Europe—a roundabout compliment to his northern German wife, who he always hoped would come to see her struggle as a strength on her part, rather than a weakness on his.

Despite Rilke's rather inconsistent views on women, Becker's death had awakened his sympathies for them, and for women artists in particular. Rodin's complaints seemed superficial to Rilke now, compared to the sacrifice that women made every time they had children. Rodin may have chosen art over "life" in the sense of certain material comforts, but at least it was a choice he had the freedom to make.

Rilke doubted that Rodin would ever recognize the unfairness of his logic, but for now the poet reveled in the satisfaction that at least he had spoken his mind. No longer was he exclusively the listener; his voice had resounded in Rodin's reality loud and clear. He vowed in his letter to Westhoff that it would "not drop out of it again."

But although he claimed to have forgiven Rodin for the past, in the next sentence he fantasized about dethroning his old master. He imagined how gratifying it would feel if his own artistic powers one day

eclipsed Rodin's, leaving him "to need us now a thousandth as much as we once needed him."

RODIN HAD FOUND RILKE'S new quarters in the Hôtel Biron so enchanting that, in September 1908, he rented out all the available rooms on the ground floor and several on the first floor, including one that Rilke had privately hoped to take for himself. Rodin had long ago transferred his fabrication operations to Meudon, so he turned the new space into a magnificent showroom to receive collectors and members of the press. He kept the main salon simply furnished, with little more than a wooden table, a bowl of fruit and a single Renoir painting. He turned four other rooms into drawing studios and lined the walls from floor to ceiling with his watercolors.

It was to become his sanctuary away from Meudon, a place where "no one will find him," as Rilke wrote. Rodin set up a bedroom so he could spend nights there with the Duchesse de Choiseul, while the gardens provided an oasis for quiet contemplation. The knotted forest of acacia trees pressed up against the windows of his studio, while scorpion grass grew so thickly across the panes he could hardly open them. The garden insulated the property from the sounds of the city, enclosing it into what Jean Cocteau called "a pool of silence."

Rodin scattered his *Walking Man* and other sculptures throughout the tall grass in the garden, where they looked like crumbling old tombstones in a graveyard. Sometimes he would watch his American housemates Isadora Duncan and Loie Fuller spinning around in the grass, teaching dance lessons to young girls. Rodin often observed them out there while he sat with his notebook and wrote. "How long I wait, how many vexations I accept in order to enjoy a few hours of solitude in this garden, alone with the trees which greet me amiably, alternating in beauty with the sky! My torpid thoughts, when with-drawn from their lodging, come now and run their course."

Inside, the Hôtel Biron hummed with activity at all hours of the day and night. The duchesse had convinced Rodin to buy a gram-

ophone and liked to invite friends over to watch her dance jaunty bourrées. She tarted up the old folk dances with high-kicks and shawl teases. The ostrich feathers in her hat swayed to and fro as she charged around the room with such force that she collapsed breathlessly on the sofa when the song was through.

Rodin used the machine to play huge, ponderous Gregorian chants. These were albums "which nobody wants," except for maybe the Pope, Rilke thought, yet he saw how they mesmerized Rodin completely. Written to fill the volume of a cathedral, the music had the power to "modulate silence as Gothic art models shadow," Rodin said. The shrieking castrati singers reminded the artist of damned souls crying out to tell the living what hell felt like. The poet watched Rodin grow silent and closed off while he listened to the music, "as before a great storm."

A moment later Choiseul might walk into the gloomy scene and wind the gramophone up again with one of her American folk jigs. It occurred to Rilke that maybe she was good for Rodin in this way. "Perhaps Rodin really needs that now, someone like that to go down with him cautiously" from the perilous peaks of his mind and return him to reality. Before, "he used to stay up on top, and God knows how and where and through what sort of night he finally got back." Her presence turned Rodin into a bit of a helpless child, but at least she lightened him up.

Choiseul was responsible for much of the carousing that went on at the Hôtel Biron. When the flamboyant actor Édouard de Max came to visit a friend living in the building, the woman asked if he'd like to meet her famous neighbor downstairs. Rodin was not there, but they were greeted instead by the duchesse, to whom de Max raved about the building's architecture. The place was an absolute jewel, he told her.

"Come live here, then," she said.

"But isn't the building fully occupied?" he asked.

"Yes, but the chapel is empty."

With that, the Hôtel Biron's most notorious tenant arrived. De Max renovated the chapel into his own private boudoir. He outfitted it with new doors, a marble floor and installed a bathtub. It also became

a flophouse for guests who couldn't make it home at the end of one of his all-night garden parties.

Contributing to the chaotic scene was de Max's friend Cocteau, the young writer who had just gotten his first big break, thanks to a poetry reading de Max had organized for him at a Champs-Élysées playhouse. Cocteau had a nervous energy, long limbs, bedraggled hair and was known for staging elaborate practical jokes. Once, when he was waiting for a friend to arrive to the Hôtel Biron, Cocteau strapped on a Santa Claus beard and waited for him in the gardens. When the man came out back looking for Cocteau, he saw an ominous bearded figure prowling around the weeds instead. Was that Rodin? the man wondered. But why would he be out wandering so late—had the old man gone mad? Not wanting to find out, he spun around and ran the other direction.

At night, Cocteau hosted regular salons for artists. An aging Catulle Mendès recited his poetry while the Venezuela-born musician Reynaldo Hahn played songs for his guests. Sometimes Cocteau staged reenactments of Baudelaire's séances and would stay awake for days on end, sitting on his goatskin rug, drawing writings and writing drawings.

Occasionally his experiments with drugs actually proved productive (or at least weren't entirely counterproductive). Cocteau published the literary magazine *Schéhérazade* out of his room at the Hôtel Biron. It was designed in the fashionable Art Nouveau style, and the brightest creative luminaries of the day made appearances in its pages: drawings of Isadora Duncan, poetry by Guillaume Apollinaire, writing from Maurice Rostand and Edmond Rostand, among many others.

Rilke rarely joined in all the social activity around him. He found Choiseul's music fatuous and Duncan too loud. He did not drink or take drugs, and he most certainly didn't dance. It was only in later years that Cocteau discovered that Rilke even lived in the same building. He had often seen the gas lamp glowing from the window of that corner room, but he hadn't given any thought to who its reclusive inhabitant might be.

Little did Cocteau know that Rilke's words would one day soothe him during some of the most painful periods of his life. When he underwent treatment for opium addiction in the late 1920s he wrote about his longing to have a copy of Rilke's *Malte* with him there to ease the agony of spitting up bile.

But back in the days of his youthful frenzy at the Hôtel Biron, Cocteau was too self-absorbed to realize his proximity to greatness. "I believed I knew many things and I lived in the crass ignorance of pretentious youth," he wrote in his memoir *Paris Album*. "Success had put me on the wrong track and I did not know that there is a kind of success worse than failure, and a kind of failure worth all the success in the world. Neither did I know that the distant friendship of Rainer Maria Rilke would one day console me for having seen his lamp burn without knowing that it was signalling to me to go and singe my wings against its flame."

NOVEMBER MARKED THE ONE-YEAR anniversary of Paula Becker's death, and still Rilke had scarcely uttered a word about it to anyone. But now her memory came rushing back to him in a current of guilt so forceful he had no choice but to follow it wherever it may lead. Rilke was beginning to see that perhaps the hardest part of Becker's death was not necessarily the loss of his beloved friend so much as the birth of a new presence, which was Becker in death.

Over three sleepless days he extracted a long poem, "Requiem to a Friend." It was partly an extended apology for failing his friend, who had "but one wish, for a lifetime of work—which is not done." He needed at last to expel this ghost, announcing in the first line: "I have my dead and I have let them go."

Rarely does Rilke let anger cut through his work as sharply as he does here. He writes that the real tragedy of Becker's life was not her death, but the fact that her death was not her own. To him, death was the most personal of human experiences. It was, as he wrote in *Malte*, a seed which everyone is born with, and which grows inside

us a little more each day. Thus a raging, painful death would have been preferable to the one taken from Becker in such an arbitrary and old-fashioned way. Rilke blames himself, her husband, and the entire male gender for the injustice of Becker's passing: "I accuse all men."

But maybe there was still hope for her in death, Rilke wrote. Whereas male artists were free to give creative births whenever they pleased, women's bodies condemned them to the physical realm. Rilke begged Becker, now freed of her body, to complete her transformation, to stop haunting the living and reject life at last: "Do not return. If you can bear it, stay / dead with the dead . . ."

Rilke immediately mailed his publisher the manuscript, which he dedicated to Clara Westhoff. Since it was not quite the length of a book, they decided he would write a second requiem and publish them together in a single volume. Rilke chose for his other subject a young poet by the name of Wolf Graf von Kalckreuth. Rilke had never met the man personally, but he was known in Worpswede for having killed himself at just nineteen years old. His potential cut short, he was another artistic amputee and a kind of spiritual twin to Becker

Rilke imagined in the poem what might have kept Kalckreuth alive. If only the boy had lived long enough to see the kind of things Rilke had seen in the past few years with Rodin. If only he had witnessed the joys of labor and a workplace, "where men were hammering and day achieving / simple reality . . ." He might have then understood the lesson Rilke learned in Paris: that language is not a tool to "tell us where it hurts," but to build something out of the pain.

Having exorcised Becker from his mind, Rilke was able to turn back to the deadline at hand, the final draft of *New Poems*. Rilke worked so intently during these first months at the Hôtel Biron that it's no surprise Cocteau wasn't aware of him. The only person Rilke saw was Rodin, who sometimes dropped by to offer a word of encouragement. Embrace your solitude, he would say, it is the ultimate happiness. Once he told Rilke that the way the poet painted the truth with words made all other writers seem mundane to him by comparison.

Shortly after he completed the "Requiem," Rilke finished the *New*

Poems. The collection would not be the defining achievement of his career, but it would veer him permanently from his old course and into a new direction. As the title declares, the book was unlike anything Rilke had written before. In spare, unsentimental prose he chiseled out portraits of odd, nonhuman subjects, like worms, wounds and animals. Like Cubism, Rilke's *New Poems* collapsed figure and ground and examined objects from multiple vantage points.

In the *New Poems,* or "thing poems," as he called them, people disappeared almost entirely. Even the things in question often recede into the background or appear only as negative space. He shades in surroundings to form outlines that bring the things into focus. A poem ostensibly about a swan, then, is also about the water on which it rests, as much as it is about dying: "to let go, no longer feel / the solid ground we stand on every day."

The book divided Rilke's critics. Some of his early German supporters felt betrayed by his break with romantic lyricism. Those in Vienna tended to embrace the book's *fin-de-siècle*-style emotional detachment. While some argued over whether to categorize the *New Poems'* author as a German, Austrian or Bohemian poet, Rilke snubbed them all with a dedication to a Frenchman: *À mon grand Ami Auguste Rodin.*

When his publisher suggested that he at least translate the dedication into German to match the rest of the book, Rilke insisted it remain in Rodin's native French. He had heard his master's words—*travailler, toujours travailler*—and it had resulted in probably the most productive period of his career to date. In spite of whatever differences were beginning to arise between them, Rilke would always have Rodin to thank for that.

More than that, Rodin's example had given him a blueprint for a new way to write. "Prose wants to be built like a cathedral; there one is truly without name, without ambition, without help: among scaffoldings, with only one's conscience," Rilke wrote in a letter to Rodin over New Year's, soon after the book's publication. "I would have to explain myself at length to anyone else. But you, my dear and only friend, you will know what that means."

———

RILKE HAD HARDLY SAVORED the accomplishment of the *New Poems* before diving back to work in the winter of 1909. He vowed to push himself to the edges of the creative fever that had begun with the *Requiem*, telling his publisher in January that he would commit himself to nothing but *Malte* from that day forward. He didn't care that that meant locking himself in his room at the Hôtel Biron, and virtually taking meals "through a little sliding window, like a prisoner," he wrote. He would not receive visitors and would not take vacations until he finished the book that summer.

But no sooner had he made this promise than he found himself compelled to break it. Lou Andreas-Salomé, Clara Westhoff and his Italian love interest, Mimi Romanelli—the three most important women in Rilke's life then—all happened to be planning trips to Paris that May.

A meeting between Romanelli and Westhoff went apparently without incident, although Rilke did not write much about the visit, perhaps because the arrival of Andreas-Salomé would, as usual, eclipse all else. He was eager to facilitate an introduction that would impress her, for once, rather than the other way around. When she came to see him at the Hôtel Biron, he brought her down the hall to meet Rodin. They spent an afternoon in the sculptor's garden-side suite, where the French doors were swung open onto the lawn of wild springtime blooms.

Rodin told Andreas-Salomé how he had been so preoccupied with work lately that he sometimes found himself confusing his statues for real people. The distinction between fantasy and reality had caused him trouble for as long as he could remember. He said that because he "'had not accomplished his childhood,'" and had instead avoided it, he had started to "put things of fiction in its place."

Rilke also took Andreas-Salomé to visit Westhoff and to see Rodin's studio in Meudon. After she returned home to Germany she wrote Rilke to tell him how meaningful the trip had been for her. She

said that if she could gaze at any one object for a length of time it would be Rodin's *Balzac*, standing just as it was that day in Meudon, in a patch of clovers. She also reiterated her heartfelt approval of West-hoff: "I feel more affection for her than she can possibly know."

When Rilke's guests departed he might have been ready to return to work, but he felt a familiar sickness creeping into his body. By then he was so accustomed to illness that "even now my best moments are those of a convalescent," he wrote that summer. But this felt worse than the usual flus. The muscles in his forehead tensed up, spreading down to his cheeks and then his tongue, throat and esophagus.

In September, he traveled to the Black Forest to purify himself in the mineral springs and soak up pine-needle "air-baths." When that didn't work he went to Provence, where he tried to soothe himself with pastoral visions of sheep grazing in fields of thyme. He had no name for this mysterious ailment, but it may as well have been Malte. The character had been growing inside Rilke like a tumor for seven years. Other projects had come and gone, yet this shadowy figure had overpowered them all, trailing Rilke across the Continent on scraps of paper, in letters and ripped-out diary pages. But now this unresolved poet stood firmly in Rilke's path, demanding to be made real. The only way to move past Malte was to go directly through him.

That fall, Rilke finally shut himself up in his drafty room at the Hôtel Biron, seeing almost no one, as planned. He even missed the inauguration of Rodin's marble monument to Victor Hugo at the Pal-ais Royal in September. When Count Kessler stopped by to see him the following month he found the poet shivering and sick, "as if spider webs covered him." Rilke now spent all his time cobbling together the scraps of ideas he'd accumulated for the new book, trying to assemble them into a coherent manuscript.

With the *New Poems* he felt he had a well-defined task, one "which I answered clearly and surely with pure achievement." *Malte*, on the other hand, was a more difficult, disorderly undertaking. He was locked in a duel with his doppelgänger, and so far Malte was winning. His fictional creation was proving "infinitely stronger" than Rilke was. To

get inside his opponent's head, Rilke had to reacquaint himself with the madness that had authored his "Requiem." He had to live through Malte's sickness and, if it came to it, die his death so that he could truly understand him.

The task before him looked so insurmountable that the only thought that gave Rilke any comfort was the possibility of quitting writing altogether. It was the first time Rilke seriously doubted his ability to go on. But right now he could hardly find the strength to move, much less to work. When his writing went well, his mind moved so fast his pen could hardly keep up. But in times like this, entire days could pass without putting down a single word.

Rilke and "Poor Malte," as he often called him, had reached a stalemate. Unsure of his fictional poet's fate, Rilke considered two possible endings, both of which he considered tragic: kill Malte off, or convert him to Christianity. He decided against the first option and wrote an ending where Malte considers religious salvation through a meeting with Tolstoy, who, as Rilke knew from his own unpleasant encounter with the author a decade earlier, became deeply devout at the end of his life.

Enacting a kind of revenge fantasy against his old hero, Rilke's protagonist meets Tolstoy and finds that the author's religiosity seems to be the symptom of his failure as an artist. Unable to invent his own god, Tolstoy had had to settle for the surrogate god of Christianity. As Rilke once said, "Religion is the art of the non-artistic."

But after tinkering with several versions of this ending, Rilke ultimately discarded it, moving on to a possibility inspired by another author. Rilke had not been reading much in those days but a friend had recently given him a copy of André Gide's latest book, *Strait is the Gate*, and Rilke couldn't put it down. The fable about the failings of love and faith led the poet to conclude that Gide was unlike any other Frenchman. He wrote with originality and precision about "the very great task of love, which none of us has been able to accomplish."

Rilke raced through Gide's other books, coming at last upon his short story "The Return of the Prodigal Son." Gide had rewritten

the ending of the Bible parable so that the younger boy returns home to his father not out of repentance or obligation, but because he had exhausted his curiosity. "I was not seeking happiness," Gide's prodigal tells his mother.

"What were you seeking?" she asks.

"I was seeking . . . who I was."

That Gide's story picks up almost exactly where the Bible parable left off gave Rilke the idea to write his own ending to the tale. But before he could sit down to do it, the more pressing question arose of *where* he could do it.

THE TENANTS OF THE Hôtel Biron had largely ignored the "For Sale" sign that had been posted on their door since the summer, but in December, the owners of the building announced plans for a sale. Now eviction appeared imminent.

Rilke scanned his address book for names of patrons who might offer him money, or perhaps a guesthouse by the sea. But he did not have to look long before a guardian angel unexpectedly arrived that month.

Princess Marie von Thurn und Taxis was one of the highest-ranking noblewomen of the Austro-Hungarian Empire. She hardly needed to apologize for writing Rilke a letter out of the blue, but she did, explaining that she was in town for just a few days and she admired his work so much that she hoped he might meet her for tea on Monday at five o'clock. Should he accept, they would also be joined by her friend, the countess-poet Anna de Noailles.

Not one to turn down a princess, Rilke needed no persuading. He also already knew Noailles's work, and had praised it in an essay two years earlier. Rilke wrote back that day expressing regret that he could not have responded even sooner. He felt the desire to meet Thurn und Taxis "imperiously and urgently."

When Noailles caught sight of Rilke entering the Hôtel Liverpool the following week, she called out across the room, "Herr Rilke, how do you feel about love and how do you feel about death?" This greeting

must have rattled the poet, who did not take such topics lightly. Nor did he respond well to confrontations or outbursts of any kind. Still, he must have come up with a response that satisfied her, because their meeting went on for two hours.

Rilke was a natural when it came to charming aristocratic women— it helped that he had grown up watching his mother pretend to be one. Over the years he developed an extreme sensitivity to etiquette, or what Andreas-Salomé once referred to as his "delicate lordliness." As a boy he acted like a little gentleman, always minding his manners and using words he didn't understand. To this day, he rarely addressed friends with the familiar *du* pronoun and he never, under any circumstance, swore.

The princess was impressed by her first conversation with the poet. He was exceptionally gentle and his soft-spoken nature made him seem quite distinguished. Their encounter ultimately resulted in the longest, most sustaining patronage of Rilke's life. Rather than merely accepting his benefactors' money and invitations with gratitude, Rilke tended to cultivate genuine emotional bonds with them, and with the princess in particular.

These relationships did not always appear so sincere to outsiders, however. Rilke's castle-hopping lifestyle naturally provoked irritation and envy among many of his peers. "Those Rilke-hags surely must have been awful, and I'm not making an exception for the princesses and countesses with whom the Austrian snob maintained a correspondence," complained the German writer Thomas Mann.

Princess von Thurn und Taxis was not ignorant of Rilke's opportunistic impulses. Of their first meeting, she wrote, "I believe that he was immediately aware of the great sympathy I felt for him and knew he could build on it." Still, this knowledge did nothing to deter her largesse. The meeting ended with her extending Rilke an invitation to her storied "Castle by the Sea." For centuries, Duino Castle had served as Italy's elite refuge for artists and intellectuals dating back to Petrarch, who was buried nearby, and Dante, who was rumored to

have written part of *The Divine Comedy* there during his exile from
Florence.

The following day, Rilke mailed the princess some roses and a let-
ter thanking her for the lovely afternoon and her generous invitation.
More than a much-needed vacation, he already seemed to know that
Duino would be his salvation from the last days of the Hôtel Biron.

CHAPTER
14

✳

SECRETLY, RILKE WELCOMED THE POSSIBILITY OF EVICTION. It was an excuse for him to leave the site of so much misery from the past year. The illnesses, the mourning over Becker, the draining battle with Malte—even his faith in Rodin had faltered during his time at the Hôtel Biron.

"He wants to give these rooms up. They have collected so many sad memories for him," wrote Count Kessler after a visit to the poet's "princely" quarters in October. "So many things that he thought he knew had shown him another side that his entire world had been rocked, so to speak. As one of the things that changed for him, he named Rodin." When Rilke first met the artist eight years earlier, he saw him as an example of how to live. He told Kessler that, at the time, Rodin had shown him "how an artist growing old could be beautiful. I knew that, or believed to know it, from the example of Leonardo, Titian, etc., but Rodin for me was the living proof. I said to myself, So I too would like to become old in beauty."

But after a year of living under the same roof as Rodin at the Hôtel Biron, he saw how pitilessly age had treated the sculptor. The older he got, the more he reminded Rilke of a child, indiscriminately pawing at the things he wanted—often women—and sucking on

hard candies whose sweet smell hovered in the air around him every-
where he went.

To Rilke, Rodin's womanizing was an embarrassment and the ulti-
mate French cliché. Once the Apollonian intellectual, impervious to
temptation, Rodin had degenerated into the Dionysian hedonist, ruled
by the body. It also struck Rilke as a desperate defense against old
age. "It suddenly turned out that growing old is something terrible for
him, exactly as terrible as for your average person," Rilke told Kessler.
"So he came running here to me one day, seized by a nameless fear of
death. Death, he had never even thought of death!"

Before then, Rodin had brought the subject up to Rilke on only one
occasion. They had been looking out over the valley in Meudon when
Rodin lamented what he saw as the tragic irony of his life, that he had
only come to understand the purpose of his art at the point when it
was about to all come to an end. The cessation of work—that was the
meaning of death to Rodin back then.

But now it was the plain, primitive fear of mortality itself that
frightened Rodin. "Things that I had assumed he had made his peace
with some thirty years ago have now seized him for the first time,
when he's old and no longer has the energy to be rid of them. And so
he looked to me, the young person, for help," Rilke said.

Now that his body could no longer perform the physical labor it
once had, his unrealized ideas overwhelmed him. His sculpture had
become serialized, and the majority of his large-scale works were
being fabricated by others out of town. There was nothing for him to
do now except make little sketches and entertain guests at the Hôtel
Biron. This was the worst part of all to Rilke—that Rodin suddenly
seemed *bored*. "One day he came here to me in the studio and said to
me, 'I am bored,'" Rilke told Kessler. "And how he said it, I saw how
he observed me, how he peeked secretly—almost frightened—to see
what kind of impression this confession would make on me. He was
bored and seemed not to be able to understand it himself."

Rodin had never had trouble concentrating in the past. To know that
his mind was slipping away from him now, and to have no power over

it, terrified the old man. It had become apparent to others, too. He was often seen wandering around the Hôtel Biron muttering to himself. He forgot about important letters in his pockets for weeks at a time and lost track of which employees he had paid and whether he himself had been paid. When he misplaced something he would overturn drawers, shouting that he'd been robbed, even of something as small as a candle or a book of matches. If he forgot to bring his "Thoughts" notebook, filled with meditations on everything from ancient goddesses to the nature of bulls, with him out to the garden, he would write the notes on the cuffs of his sleeves instead. When Beuret would do the laundry, he'd cry out, "What are you doing? My god, my cuffs!"

The poet could no longer bear to watch his master become such an object of pity. When notice came announcing the sale of the Hôtel Biron, "all the others, as I hear, are inconsolable and spend their time resisting by turns." But, as he told Princess von Thurn und Taxis, "I am glad."

OVER THE YEARS, Rilke had compared Rodin to many different gods. He once called him an "eastern god enthroned," like the Buddha statue that meditated on the artist's hill in Meudon. "It is the center of the world," so self-contained and solitary, Rilke had said of it.

Rodin also once reminded Rilke of the god in Genesis. When he sculpted a hand, "it is there alone in space and it is nothing more than a hand. And God made only one hand in six days and poured water around it and arched a sky. When all was completed, he was at peace with it and it was a miracle and a hand."

Most recently Rilke had called him "a god of antiquity," and, for the first time, he had not meant it as a compliment. Once Rodin had seemed like a descendant of the great ancient traditions in art; now they held him captive. He was an obsolete god. His decline was now imminent, just as it was fated for every "Too-Great, the Transcendent, the Divine," Rilke wrote.

In a postscript to Westhoff the day after he had reunited with Rodin at the Hôtel Biron, he fantasized about how his own path to

"divinity" would come to pass. He could no longer stand around in idle worship of Rodin, like trees to the sun. It was time to make his own way to heaven. He was like a forager gathering mushrooms and medicinal herbs, he told Westhoff. Now he would mix them together into a deadly potion and "take it up to God, so that he may quench his thirst and feel his splendor streaming through his veins."

The Nietzschean tone of this letter is probably not a coincidence. Rilke owned a heavily marked-up copy of *Thus Spoke Zarathustra*, in which Nietzsche made his famous admonishment to disciples who risk becoming imitators of their masters: "One repays a teacher badly if one always remains only a pupil. Why do you refuse to pluck at my wreath? . . . Now I bid you lose me and find yourselves; and only when you have all denied me will I return to you."

Rilke's letter declares his intent to complete his literary transformation, from the disciple who began the *New Poems* to the Prodigal Son who authored *Malte*. Rilke was now ready to remake himself into the father. That spring, during the months he had declined to see Rodin, Rilke wrote the words that would commence this change.

AT SOME POINT, we do not know precisely where or when, Rilke came across a statue of Apollo with its head and limbs broken off, and only a naked torso remaining. It may have been a sculpture by Rodin or Michelangelo. Or it may have been the iconic *Belvedere Torso*. Others believe it was the muscular chest of a young Greek man from the ancient city of Miletus, which was on view at the Louvre while Rilke was in Paris.

Whatever the source, the statue inspired Rilke to choose Apollo, the Greek god of music and poetry—the origin of art itself—as his subject for a poem that spring. From this symbol of creative invention, Rilke would write his famous tale of reinvention, "The Arc of Apollo."

Rilke understood that god's defining achievement was human form. Yet it had been a year since Rilke experiment

uration in his poem "Alcestis," which had led him to conclude that his relationship to models was "certainly still false." He went on occupying himself with "flowers, animals, and landscapes" for the time being instead. But a year later, "Apollo" would become for Rilke what *The Age of Bronze* had been for Rodin, his first full-scale figurative work.

For a metaphysical poet trying to ground himself in the physical world, the body of a god entombed in stone was a fitting metaphor. Why he chose a headless, broken god probably had to do with the same reason that Rodin often chopped off his figure's heads, and with them the most expressive features of the human anatomy. A faceless figure could no longer wink at or point to an intention. But to Rilke, Rodin's amputated bodies were no less whole: "Completeness is conveyed in all the armless statues of Rodin: Nothing necessary is lacking," he wrote in his monograph on the sculptor.

The headless torso was a tabula rasa. To the nonbeliever, it was nothing more than a sleeping stone, but to those who had faith in this kind of god, it became a kind of mirror on which to project their inner lives. This was how Rilke, out of the absences of a broken, anonymous statue, crafted "The Archaic Torso of Apollo," an almost perfect sonnet, the most tightly unified of poetic forms.

> *We cannot know his legendary head*
> *with eyes like ripening fruit,*
> *And yet his torso*
>
> *is still suffused with brilliance from inside,*
> *like a lamp, in which his gaze, now turned to low,*
> *gleams in all its power.*
>
> *Otherwise*
> *the curved breast could not dazzle you so, nor could*
> *a smile run through the placid hips and thighs*
> *to that dark center where procreation flared.*

Otherwise this stone would seem defaced
beneath the translucent cascade of the shoulders
and would not glisten like a wild beast's fur:

would not, from all the borders of itself,
burst like a star: for here there is no place
that does not see you. You must change your life.

One can almost hear Rodin's voice speaking through the stone, like the oracle to which Rilke had once asked that almighty question, "How should I live?" Rodin had answered then, *work, always work*. And in the beginning of the poem, Rilke seems to obey this directive. He guides us on a perceptual journey down the torso's parts: the eyes, the chest, the hips, the place where reproduction once happened.

Then the encounter transcends his one-sided observation as Apollo begins to look back. The statue does not need eyes to stare, a mouth to speak or genitals to procreate—it carries its own birth inside it, the way Malte carried his death. As the Apollo and Rilke search each other, breaking down the borders that separate them, Rilke starts to relay the experience to the world as a poem.

But then he seems to abruptly decide that a poem is not quite enough. If it were, the sonnet could have ended just before that startling last line, with Rilke remaining a dutiful conduit, a secretary of god. But seeing was not enough for Rilke anymore. He wanted new eyes. He wanted to be not merely in the presence of god, but to become the creator. When Apollo speaks to him, Rilke consummates the empathic union of object and beholder, author and reader. This new being could now communicate; it was whole. Rilke had acknowledged art, gave its god life and it changed him.

THE WINTER THAT RILKE published "Apollo," Franz Kappus broke a four-year silence with the poet. He wrote a letter from a remote army

fort to tell Rilke that he had decided to accept a position in the military. He had given up poetry for good.

Rilke responded in his tenth and final letter to the young poet that he had been thinking of him often in recent months and was happy to hear from him again. Surprisingly, Rilke said he was even happier to hear of Kappus's new job. "I am glad you have that steady, expressible existence with you, that title, that uniform, that service, all that tangible and limited reality."

This courageous career, Rilke wrote, was preferable to those "half-artistic" professions of journalism or criticism for which poets so often settled. Those were pitiful attempts to cling to the art of others, whereas Rilke believed that any artist who approached his work halfway should relinquish it altogether. He'd be better off grasping onto a concrete job, like the military, which Rilke believed would at least keep Kappus grounded in a "rough reality."

Rilke probably would have been disappointed to learn that, years later, Kappus went on to become a newspaper editor, first at the *Belgrade News* and later at the *Banat Daily*. After fighting on the Eastern Front during World War I, he also wrote several action novels, including the *The Red Rider*, which was turned into a film in 1935. Kappus later admitted that "life drove me off into those very regions from which the poet's warm, tender and touching concern had sought to keep me."

But for now Rilke comforted Kappus one last time as he entered this new phase of life, urging him to trust in his solitude on those nights stationed alone in "the empty hills." The poet repeated some familiar wisdom about how all a person needs to feel at home in the world is to stand "before big natural things from time to time."

In the last moment of his letter, however, Rilke makes a surprising reversal in the doctrine he had been ministering to Kappus for so long. He rejected Rodin's rigid ultimatum between art and life, now imploring the young poet not to regret his decision to abandon poetry for a more stable way of life—for "art too is only a way of living."

CHAPTER
15

✧

A LIQUIDATOR APPOINTED TO SELL OFF THE HÔTEL BIRON
scheduled the auction for the end of June 1909. It was expected
that a real estate developer would buy the dilapidated mansion, raze it
and build a more desirable, modern building in its place.

"Imagine the shock and indignation of the old master upon
receiving this announcement! His beloved Hôtel Biron was to share
the fate of many another antique of Paris and fall victim to com-
mercial vandalism," wrote Sylvia Beach, future proprietor of the
Shakespeare and Company bookstore, of Rodin's likely reaction to
the news.

Shocked and indignant only began to describe Rodin's feelings
about the government's plans to demolish his studio and "enchanted
abode," as Choiseul called their secret lair. In the old days, kings per-
sonally housed the great artists in their palaces; now his country
wanted to throw him into the street. Rodin would not endure this
indignity without a fight. He wrote to a city councilman in late 1909
with a serious proposal. He would donate all of his works to the state
upon his death, including the sculptures in "plaster, marble, bronze,
stone, and my drawings, as well as my collection of antiquities," to
open a Rodin Museum on the site. The only condition was that he be

allowed to stay there for as long as he lived. Rodin pointed out that his art already had a permanent home in America, at the Metropolitan Museum, so it seemed only appropriate that his homeland should honor him in at least equal fashion.

The government promised to consider Rodin's offer, but in the meantime many of the building's tenants didn't want to hang their fate in the balance, and the artist enclave started to disband. The looming sale gave Matisse the final push he needed to move to the countryside. His academy had been taking up too much time, and he had grown disillusioned by the ambivalent treatment he had received in the Parisian press. His 1908 manifesto "Notes of a Painter" was an attempt to settle the score with critics, who were alternately calling him too academic—André Gide said his *Woman with a Hat* was "the result of theories"—and too wild. But the essay backfired and only opened him up to more attack. Now he was eager to withdraw from society altogether and paint alone in peace. He had even begun practicing abstinence as a way to preserve his "creative" resources for his art. The bacchanalian climate at the Hôtel Biron had not been especially conducive to his efforts.

Even Cocteau would soon leave, albeit against his wishes. His mother had found out about his forbidden hideaway when her ladies' club, the Friends of the Louvre, heard about the historic site and asked her if her son might be able to invite them in for a visit. Apparently everyone knew about his secret *garçonnière* except Madame Cocteau.

She was appalled that her well-bred son would keep company with such a depraved bunch of artists. Most likely she had the openly gay actor Édouard de Max, known for wearing eye shadow both on- and offstage, in mind. Even though the French public, living in a post–Oscar Wilde era, largely accepted de Max as a kind of *monstre sacré*, not everyone was so open-minded. "De Max was like the ocean, and like the ocean he was dreaded by mothers," Cocteau said.

She threatened to suspend her son's allowance if he did not move out immediately. The Friends of the Louvre took their tour and then, with great sadness, Cocteau said goodbye to his "fairytale kingdom."

Rilke spent the winter packing up his room. His publisher had invited him to Leipzig to finish the manuscript for *Malte*. There he could dictate his notes to a typist, rather than transcribing them all himself, so he paid a courtesy visit to Rodin to wish him farewell before leaving the Hôtel Biron, possibly for good. Rodin gave the poet a drawing as a Christmas present and wished him good luck. Then, on January 8, 1910, Rilke boarded the train for Germany, a suitcase full of loose notebook pages in hand, ready to lay Malte to rest once and for all.

"SO THIS IS WHERE people come to live; I would have thought it was a city to die in." So begins the story of young Malte Laurids Brigge's arrival in Paris. It is the first entry in a novel comprised entirely of impressionistic sketches, dated like journal entries. The first opens "September 11, Rue Toullier"—a variation on Rilke's first address in Paris: 11 Rue Toullier.

From there the similarities between Rilke and his twenty-eight-year-old foil multiply. Malte is a gloomy northerner displaced in a merciless metropolis, an aspiring poet whose obsession with death and decay is drawn out in passages lifted directly from the author's own notebooks. While *Malte* is indisputably a work of fiction, it is worth remembering that Rilke nearly named it *The Journal of My Other Self*. One of the earliest modern novels, Malte's journey involves little plot. It instead takes its protagonist on a meandering search for identity, and for an answer to Rilke's own persistent question, How should one live?

Malte's story is one of eternally unfulfilled striving. He is a human sponge, steadily absorbing the pain of others. As Malte begins to harness his hyper-receptivity, he discovers its eye-expanding possibilities. "I am learning to see," he says in the beginning. "I don't know why, but all enters into me more deeply and nothing remains at the level where once it used to cease."

In the end, Malte returns home from Paris, a kind of Prodigal

Son. We do not know whether he is back for good, only that he is there for now. But in Rilke's retelling of the parable Malte does not seek his family's forgiveness; "How could they know about him?" He belonged to nobody now. For Malte, the Prodigal Son parable was really "the legend of a man who didn't want to be loved." This was both his strength and, "in the end, is the strength of all young people who have left home."

Rilke ends his story there, before we know how the young poet turns out. "He was now terribly difficult to love, and he felt that only One would be capable of it. But He was not yet willing," read the novel's last lines. It's not that Malte didn't know what he had to do—he understood Baudelaire's challenge—he simply was not able to ultimately achieve it. "This test surpassed him," Rilke wrote, "so much so that he sought it out instinctively until it attached itself to him and did not leave him any more. The book of Malte Laurids, when it is written sometime, will be nothing but the book of this insight, demonstrated in one for whom it was too tremendous . . ." He was one who would have been overpowered by the sight of the convulsive man in Paris, like the old Rilke was and like Kappus probably would have been. But Malte's failure marked Rilke's transformation.

The doppelgänger had been a hallmark of German Romanticism for a hundred years when Rilke became one of the first modernist authors to revive the literary device in the twentieth century. Rilke had to destroy his doppelgänger, traditionally a harbinger of doom, in order to liberate himself. At a time when psychologists were developing theories on mirroring and narcissism, many literary critics saw the doppelgängers of Rilke, Kafka and Hofmannsthal as vehicles for self-psychoanalysis. At one point Rilke asked Andreas-Salomé if she could tell that Malte "perishes in order to keep *me*, as it were, from perishing."

She could, she said, writing, "Malte is not a portrait, but rather the use of a self-portrait precisely for the purpose of making a self-distinction from it." Whether it was through the unrealized

potential of Malte or Rilke's late sister, the poet felt he could be reborn only when the soul of another died.

At the end of the month, Rilke wrote the final words of the book in Leipzig, at what his office mates at the publishing house had come to call "Malte Laurid's desk." "It is finished, detached from me," he said. Not that this accomplishment gave him much joy, naturally. Instead it was followed by a feeling of emptiness, from which he distracted himself with travel.

He went to Berlin, where he briefly reunited with Westhoff, who was on her way back to Worpswede after spending three months sculpting a bust of their friend the writer Gerhart Hauptmann, in the small village near the Sudeten mountains where he lived. Then, in April, he traveled to Italy once more, this time for a few days at the princess's castle. But he was disappointed to find that he was not her guest of honor. She was also hosting her son and the Austrian writer Rudolf Kassner, whom Rilke found intellectually intimidating. In conversation, Rilke, who never completed a university education, felt like he was failing a test he shouldn't have been taking in the first place. Although he and Kassner would become good friends in later years, at this time Rilke could not get away from him and Duino fast enough. He promised himself to return again when conditions were more conducive to work.

Then news came that the state had halted the sale of the Hôtel Biron to give officials more time to consider Rodin's proposal for a museum. The tenant exodus the previous year had left a private apartment vacant on the third floor, farther away from Rodin. It had a bedroom, a small kitchen and an office, and was separated from the other residents by a long hallway. A window spanning from floor to ceiling looked out onto a bright green linden tree in the garden. Rilke figured that if he had to endure proximity to other people it may as well be in the place where he had been most productive. He rented the space and made his way back to Paris in May 1910, even bringing some furniture and books along to make it feel like a home.

———

RILKE'S RETURN TO PARIS marked the start of a series of endings in the poet's old way of life. No longer a sapling cowering beneath the shade of Rodin, he stepped into the sunlight of Paris that spring with more independence than ever before.

He had learned to manage his crowd anxiety and the intrusion of other people's lives upon his own. Ever since he had mastered the art of "inseeing" he could not only penetrate the interior worlds of objects and animals with his mind, he could also reverse the strategy to defend himself against penetration by others. In the past, going to the Louvre had meant bracing himself for an onslaught of flesh and faces, the real often indistinguishable to him from those on canvas. But now he learned to pause before his senses overwhelmed him, close his eyes and imagine fortifying his body's borders, as if they were castle walls.

"[I] stretched my contours, as one stretches violin strings, until one feels them taut and singing, and suddenly I knew I was fully outlined like a Dürer drawing." With his psychic composition reinforced, he could now stand with the crowd before the *Mona Lisa* and appreciate her for the "incomparable" beauty she was.

At this point, Rilke's address book listed twelve hundred names, and he didn't hesitate to use it. When the Ballet Russes came to town Rilke joined Cocteau, Diaghilev and Vaslav Nijinsky for a party after the performance at the nightclub Larue's. He soon befriended the sculptor Aristide Maillol, and Count Kessler introduced him, at last, to André Gide.

Gide was by then a writer of such stature that he seemed to have far more than six years on Rilke. He had already traveled extensively in North Africa, the landscape of his casually chilling 1902 novel *The Immoralist*. And the previous year he founded Paris's leading literary journal, *La Nouvelle Revue Française.*

In June Gide invited Rilke to a luncheon at his recently renovated west Paris mansion, Villa Montmorency, once home to Victor Hugo. Rilke was becoming proud of his French language abilities by then,

and he spoke fluently with Gide and the two Belgians who joined them, the artist Théo Van Rysselberghe and the interior designer Henry van de Velde, who had decorated both Count Kessler's home and the Nietzsche Archive in Weimar. The lunch marked the start of a meaningful and mutually beneficial friendship. When Rilke's publisher Insel-Verlag sent him the proofs of *Malte* that month, Rilke sent Gide one of the first copies.

The book was not greeted with much fanfare when it was released in July. The German-language press was largely favorable to Rilke's sensitive portrait of a young artist, but some were befuddled by its nonlinear narrative. "The *Notebooks* were not written for many, but the few for whom it was written will like it," read one early review from Berlin. Another critic found Malte's hyper-susceptibility to stimuli "appropriate" for a moment in history that was characterized by "our yearning for internalizing."

Like many of Gide's books, Rilke's philosophical novel attracted more of a cult intellectual following than a popular mainstream audience. But Gide helped bring *Malte* to a wider readership in France the following year when he published excerpts of it in *La Nouvelle Revue*. The writers would go on to swap translations of their parallel books: Rilke rewrote Gide's *Prodigal Son* in German, and Gide translated *Malte* into French. Rilke said he was amazed that anyone could so ably translate his "inaccessible prose" into a foreign language.

In the United States, *Letters to a Young Poet* cemented Rilke's celebrity more than any of his other books; in France, it was *Malte*. When the complete French translation came out in the early 1920s, the book's themes of alienation, futility and consciousness pushed to the extreme helped shape the language of Existentialism in the decade to come. Jean-Paul Sartre largely modeled his 1938 novel *Nausea* after *Malte*. Rilke's protagonist's desire "to have a death of one's own" informed Sartre's belief that life is but a long unfolding of death. "You had your death *inside* you as a fruit has its core. The children had a small one in them and grown-ups a large one," Malte says in the book. "You *had* it, and that gave you a strange dignity and a quiet pride."

Rilke's struggle to write *Malte* had felt a bit like this long-gestating death. The self-destructive book had grown and grown inside him until at last it came into its own, was published and left Rilke feeling hopelessly barren. No amount of acclaim could undo that. Rilke believed that art was its own kind of death because it consumed its artist. The only way to go on was to begin the process again. But for Rilke that now seemed impossible. How could he bear to endure that suicidal cycle again? What would he even write about? Perhaps Malte had already said everything Rilke wanted to say. Maybe it was time to enter a more practical profession now, like medicine, he thought. Apart from artists, Rilke believed that doctors were the people who lived closest to god.

He wondered to Andreas-Salomé whether the book had left him "stranded like a survivor, my soul in a maze, with no occupation, never to be occupied again?" So far, his choice of paths typically deposited him in one of three corners: Paris, Italy or Germany. Maybe he needed to try another direction. So desperate to escape the pattern of his old life, Rilke packed his bags in November for uncharted territory: Africa.

The French fascination with "primitive" art and the "untamed" minds of its makers—what Claude Lévi-Strauss later dubbed *la pensée sauvage*—drove many artists to visit the country's colonies in North Africa in the early twentieth century. The Orientalist mythology had inspired Rodin's Cambodian drawings, while André Gide said the five years he spent traveling the lonely deserts of North Africa shaped his writing above all else. Now, following in Gide's—and Westhoff's—footsteps, Rilke set out for his own African journey in late 1910, a copy of *Arabian Nights* in hand.

Arriving first in Tunisia, Rilke felt the presence of divinity around him as never before. He was shocked at how palpably Muslim the colonies felt. In the holy Tunisian city of Kairouan, "The Prophet is like yesterday, and the city is his like a kingdom"; in Algiers, "Allah is great, and no power but his power is in the air." He considered meeting one of Gide's lovers in Biskra but decided against it once it became evident that the man might be impoverished enough to rob him.

After a few weeks he began to wonder what he was doing there. The colorful textiles, the white architecture and the spice-filled souks impressed him, but mostly the trip felt like an extravagant waste of time and money. It was procrastination, plain and simple, he realized, and an unfortunately costly way of doing it. Before he left, a dog bit him in Tunisia and he figured he deserved it. The dog had "simply expressed in his own manner that I was completely in the wrong, with everything," Rilke wrote.

A few months after he returned to Europe, another chapter came to a close. His correspondence with Westhoff had grown less frequent, sometimes at his encouragement. Once he suggested that she "write only briefly, we each have so much else to do." When she did send mail, it mainly consisted of impersonal matters, like feedback on his work, or texts that she had typed for him. Thus, it was not altogether surprising when, in mid-1911, Westhoff asked for a divorce.

Rilke did not object. He sympathized with his wife's dilemma, lamenting to Andreas-Salomé how she was "not with me and yet cannot move on to anything free of me." He believed that Westhoff had never fully come into herself as an individual, instead devoting her life to Rilke and the "alternating function of ingesting me and expelling me." He supported her decision to leave Ruth with her parents for a while and undergo psychoanalysis in Munich with the young doctor Viktor Emil von Gebsattel, a friend and sometime lover of Andreas-Salomé. Rilke hoped the therapy would succeed in ridding her mind of his presence—"(apparently a pest in her nature after all)." Then perhaps she could resurrect herself as the young woman she was before she met him, and make a path of her own this time.

Rilke wrote to a lawyer in Prague to explain that the couple had been living separately for years and requested legal documents now only to validate a situation that had been the reality for some time already. But the poet quickly learned that a divorce would not be so simple, and the amicable nature of their relationship would do little to ease the bureaucratic nightmare that lay ahead.

Because Rilke had failed to officially leave the Catholic Church

until after his marriage, he was bound to its stringent divorce policies. Meanwhile, the couple's residencies in various countries over the years complicated matters of jurisdiction further. In the end, Rilke spent a small fortune on lawyers' fees and still was never able to finalize the divorce before his death.

CHAPTER
16

⊰⊱

IN OCTOBER 1911 THE STATE ORDERED ALL THE TENANTS
of the Hôtel Biron, including Rodin, to leave the premises by the end
of the year. The government had still not officially declined Rodin's
proposal for a museum, but at the same time there were too many
doubts to go ahead with it. Some officials opposed it on principle, hold-
ing the belief that museums should never honor living artists. Others
argued that Rodin's sacrilegious display of nude drawings in a former
convent should alone disqualify his proposal. It had also occurred to
the state to use the palatial property for its own interests, perhaps as
government offices or a hotel to house foreign dignitaries.

Rilke hired movers to pack up his room that month. One of them
estimated that the books in his library alone would require seven
crates. He put it all into storage and wrote to Princess von Thurn und
Taxis to inquire if he might visit her again at Duino. He did not know
whether he would be better able to concentrate this time or not, but he
hoped at least to find some quiet time to work on a few translations.

By then, Rilke had lived in Paris longer than any city except
Prague. Although it would continue to lure him back as a visitor
over the years, any lasting tenure in the city was now coming to a
close. Rilke believed a place should function less as a home than as

a vantage point, and other views awaited him now. "Paris is itself a work, a huge, wearing work which you accomplish without noticing it," he once wrote. He finally felt like he had mastered its crowds, its language, its art, and taken from it all he needed to write the *New Poems* and *Malte*. "I have it to thank for the best work I have done so far," he decided.

The princess told him she would send a car and driver to pick him up. He could stay in Duino as long as he wished. Rilke disliked cars in theory—even typewriters were too modern for his bohemian tastes—but he was secretly thrilled to travel in such luxury. He directed the chauffeur to take his preferred route, through Avignon and Cannes, then on to San Remo and Bologna. It would take nine days to reach Duino and to leave behind "the memorable, the tiresome, the strange house in the rue de Varenne" for good.

RODIN, ON THE other hand, had no intention of leaving. He was incredulous that the city wouldn't jump to accept his generous gift. Refusing to accept the government's order, he went straight to the press with the news that the city wanted to deny the public a free museum. To win over journalists who were less sympathetic to him as an artist, he launched a campaign to landmark the building as a historic monument.

By the beginning of the following year, Rodin had enlisted the support of several key editors and preservationists. He and his friend Judith Cladel also gathered signatures from leading artists and patrons for a petition protesting Rodin's eviction. They passed out brochures including statements from Monet and Anatole France supporting the proposed museum. "No one is more deserving than he of such special honors," testified Debussy. Perhaps most importantly, in January 1912, Rodin's old friend Raymond Poincaré was elected prime minister of France.

But just as the tide seemed to be turning in Rodin's favor, it crashed to an abrupt halt in May. A public spat had broken out between Rodin

and the editor of the newspaper *Le Figaro* over a recent performance of the Ballet Russes in Paris. Sergei Diaghilev had worried that the final scene of the ballet, *Afternoon of a Faun*, might cause a stir when the dancer Vaslav Nijinsky pantomimed an orgasm. Sure enough, *Le Figaro*'s editor, Gaston Calmette, wrote a front-page story decrying Nijinsky's "vile movements of erotic bestiality and gestures of heavy shamelessness."

Calmette's opinion was in the minority among artists, many of whom had collaborated with the dance company over the years. (Matisse, Picasso, and Coco Chanel all designed costumes for them.) Rilke, too, was so moved by Nijinsky that he once said the desire to write a poem about him "haunts me, it keeps on calling to me: I must, I must . . ."

Rodin agreed to write a piece for a rival newspaper, *Le Matin*, defending Diaghilev's serpentine star. "When the curtain rises to reveal him reclining on the ground, one knee raised, the pipe at his lips, you would think him a statue; and nothing could be more striking than the impulse with which, at the climax, he lies face down on the secreted veil, kissing it and hugging it to him with passionate abandon."

The editor of *Le Figaro* retaliated, writing that he was not surprised that Rodin would defend the indecent performance. After all, Rodin was responsible for producing an even lewder spectacle: that of his own nude drawings, desecrating the walls of a convent. It was a blasphemy that only "swooning admirers and self-satisfied snobs" would condone. But then Calmette delivered the nearly fatal blow: "It is inconceivable that the state—that is, the French taxpayers—has paid five million francs for the Hôtel Biron, simply to house our richest sculptor. This is the real scandal, and it is the business of the government to put a stop to it."

The provocation quickly led other newspapers to pile on the outrage. One published a cartoon of a nude model asking Rodin where to put her clothes. He responds, "Next door in the chapel." Never mind that Rodin was far from the only tenant in the building, that he didn't

live in the chapel, and that he of course paid rent. The press delighted in the scandal and soon highlighted the questionable reputations of Rodin's other housemates, namely Édouard de Max, who also had been accused of turning the chapel into a den of iniquity. The bathtub he had installed in the priest's sacristy became the linchpin of a Catholic campaign against the tenants.

Rodin immediately regretted making the rare decision to participate in a public controversy. The denouncement was so targeted and scathing that the damage to his campaign felt insurmountable. At the end of May, his friend Count Kessler saw how devastated Rodin was and assembled Nijinsky, Diaghilev, and Hugo von Hofmannsthal into a "war council" to meet with him and devise a plan of action on his behalf.

A trembling Choiseul answered the door. Teary-eyed, she told them that Rodin was "taking this very hard," as if "someone had wilfully destroyed one of his finest marble statues." She vowed that if the government forced him from the building she would personally ensure that not a single Rodin sculpture would stay in France.

Rodin emerged then, looking disheveled. Choiseul swept a strand of hair from his forehead with a diamond-weighted hand. He told them that he was not as vengeful as his lover. If he had retaliated against every attack in the press he would have spent his whole career on the battlefield and never made any work. There was not much Kessler's "council" could do now except drink their tea and try to console the old man.

The face-off between Rodin and the media dragged on for months until Poincaré's cabinet made its historic decision to accept Rodin's donation and grant his request to remain in the building, as its sole occupant, for as long as he lived.

Calmette, meanwhile, continued his provocations until, in 1916, the wife of France's finance minister walked into Le Figaro's office with a gun. She was enraged that Calmette had published her husband's old love letters to her, written while she was still his mistress, and shot the editor dead.

—

BY 1912 THE City of Light was descending into darkness. The end-
less glow of the twenty-four-hour street lanterns had not scared off
criminals, it simply spotlighted the violence day and night. Anarchists
were protesting in the streets while city-sanctioned brutality took
place in the form of public guillotining.

Theft was rampant. One morning a burglar walked out of the
Louvre with the *Mona Lisa* under his arm. The police investigated
the crime for two years—questioning Apollinaire and Picasso as sus-
pects along the way—before the culprit was finally caught trying to
sell the painting to a Florentine art dealer. Meanwhile, street gang-
sters known as apaches terrorized pedestrians. As fashionable as they
were savage, the apaches stalked, robbed and stabbed their bourgeois
victims, all the while sporting snug sailor pants and neckerchiefs.

The crime wave petrified the Duchesse de Choiseul, who took it
upon herself to personally protect her aging lover. She started stash-
ing guns around the studio and told a friend that she once had to fight
off a pair of night intruders. They had tried to blackmail Rodin, then
seventy-two, "But I was luckily there!" she said. "And I had pistols too!"

She bought a German shepherd to guard him and arranged for
a policeman to accompany him every evening on his commute home
from Paris to Meudon. Some nights the officer even slept in a chair at
Rodin's bedside. This lasted for about a month before the continuous
company started to annoy the artist and he dismissed the man from
his duties.

Some of Rodin's friends had started to warn him that it was Choi-
seul he should be afraid of, not gangsters. Rumors were spreading that
the duchesse was scheming ways to wrest control of Rodin's estate.
Some believed that she had conned him into signing over to her the
rights to all posthumous reproductions of his work. Others heard that
she was trying to break up his relationship with Rose Beuret so that
he would name her the sole benefactor in his will.

She paraded their affair in front of Beuret and did not hide it from

her husband, either. At one point the duke wrote to Beuret, "It is unendurable that you tolerate the state of things which I can no longer abide. I refer to the constant presence of my wife . : . in the atelier of M. Rodin."

He assumed Beuret would want a separation after hearing this news, but he underestimated the woman's long-standing tenacity. Beuret endured Rodin like a teacup set under a waterfall, Rilke once said. In the years following Rodin's affair with Camille Claudel, the artist sometimes made reference to his "beautiful" former assistant, causing Beuret to tremble with rage. If he noticed her reaction, he'd just chuckle and say, *Mon chat, I always loved you most. That's why you're still here.*

It was no secret that Choiseul and her gambling husband's financial troubles were worsening. Rodin sometimes bailed them out of debts, and never gave it a second thought. When the duchesse's sister died, Rodin paid for her husband to accompany her to America for the funeral. For years Rodin either ignored the gossip surrounding Choiseul or pretended not to hear it. Perhaps he could not bear the thought of her betrayal. Or he may have believed women were too simpleminded for such conspiring.

But then a trusted friend came to Rodin with a set of more serious claims. He had heard that Choiseul was stealing artwork directly from Rodin's studio—and he had already gone to the police with the matter. Now that Rodin thought about it, he remembered that a box of drawings *had* gone missing in June.

Rodin confronted Choiseul about the lost works. She denied having anything to do with it and turned the accusation against his secretary, Marcelle Tirel, instead.

Rodin might normally have fired the assistant on the spot, but Tirel had worked for him for six years, far longer than most had lasted in her position. When he questioned her about the missing art, she pointed the finger back at Choiseul. She told Rodin that she had seen with her own eyes the duchesse tucking the drawings into her stockings.

Rodin leaned back against his statue of Ugolino and started to sob. He knew what he had to do. After seven years, he ended the relationship

PART THREE

...

Art

and

Empathy

CHAPTER
17

❊

ONE LATE SUMMER DAY IN 1913, SIGMUND FREUD TOOK a walk in Munich with "a young but already famous poet" and his "taciturn" friend. It may have been in a park or on the outskirts of the city, where the fifty-seven-year-old Viennese professor had traveled to attend the fourth Psychoanalytic Congress. It was a tense juncture in Freud's life, with the conference marking the last time he would ever see his friend and former heir apparent, Carl Jung, then thirty-eight.

The two psychoanalysts had been close colleagues since 1906, when Jung was a budding Swiss doctor just starting to make a name for himself. When Jung discovered that Freud's word association studies supported his own theory of unconscious repression, Jung sent a letter to Vienna to tell him about it. They had been engaged in a lively exchange of ideas ever since. But tensions arose as Jung began to doubt Freud's belief that sexuality formed the basis of all human behavior. Meanwhile, Jung's interests were branching out into the fields of mysticism and the occult, which Freud feared would discredit his fledgling discipline of psychoanalysis and supply its critics fodder for attack. When Jung refused to yield to Freud's theories or to suppress his own, the elder doctor interpreted Jung's defiance as an

oedipal desire to overthrow his "father." Jung claimed that he never wanted to be seen as a protégé, only as an equal. Shortly before the conference, Freud severed all personal communication with his former friend.

By early September, everyone in the psychoanalytic community knew about the dispute and it divided the congress: the researchers from Zurich sided with Jung at a table on one side of the room, while the Viennese joined Freud on the other. Hanging over the entire room was the question of whether the International Psychoanalytical Association would reelect Jung as its president. Since Jung had no challenger, Freud loyalists encouraged voters to cast blank ballots. Twenty-two of the fifty-two participants did, but it was not enough to unseat Jung and he narrowly kept his post. But his defection from traditional Freudian psychoanalysis was now definitive.

As this uncongenial event was underway, Freud was relieved to see his friend Lou Andreas-Salomé enter the hotel with the poet Rainer Maria Rilke. She had by then begun her own serious study of psychoanalysis, which she said was motivated in part by the years she spent sharing in "the extraordinary and rare spiritual destiny of another person"—Rilke. She was Freud's student and one of the first women to attend the inaugural congress in 1911. A photograph of the group shows Andreas-Salomé, wrapped in a long fur, seated before Jung and Freud. When she had asked Freud during the conference if he would allow her to study with him, he just laughed. No formal psychoanalytic training centers existed yet, and he could not fathom why she would want to learn, "since the only thing I do is teach people how to wash dirty linen."

But Andreas-Salomé persisted, studying for another six months on her own, then going to Vienna to prove her dedication. She and Freud soon struck up a long, affectionate correspondence and she began training with him in Vienna in October 1912. It was she who urged him to look more closely at the role of the mother in early childhood. Soon, Freud entrusted her with treating his own daughter, Anna.

Now Andreas-Salomé was not only Freud's peer, but one of his staunchest allies. She took a seat firmly on his side of the room, writing in her journal from the conference, "there was nowhere I would have preferred to sit than right by his side." It pained her to see Freud repress his sadness "over his break with his 'son' Jung, whom he had loved." He spent the entire conference worrying that any questions or contradictions he raised during the lectures would make him look like the patriarchal tyrant Jung had portrayed him as.

Freud found some respite from the stressful meetings by taking a walk with Andreas-Salomé and Rilke, with whom he was familiar mostly because of his children. His son Ernst and daughter Anna had memorized Rilke's poems in school and when Anna heard that her father had met him on this trip, she wrote, "Have you really met the poet Rilke in Munich? Why? What is he like?"

It seems Freud found him fascinating. Two years later, in his essay "On Transience," Freud described his encounter with the "young but already famous poet," who scholars widely believe was Rilke, and his "taciturn" friend, who also remains unnamed, but is thought to be Andreas-Salomé. Freud recounted how the poet marveled at the natural beauty of the summer afternoon, but confessed that he took no pleasure in it. Come winter, it would all wither and die, he said, just as everything one cared about would someday die. All that the poet would "otherwise have loved and admired seemed to him to be shorn of its worth by the transience which was its doom," Freud wrote.

Freud could not refute this morbid observation; of course all living things had to die. But he disagreed that this inevitability diminished their value in the present. On the contrary, the scarcity of life only made it more precious, he said. But Freud was surprised to find that his maudlin companion was unconvinced by what he thought were these irrefutable truths.

An explanation for Rilke's sadness later came to Freud, at a time when he was confronting his own sequence of sorrows: growing anti-Semitism in Europe, threats to the legitimacy of psychoanalysis

and the onset of a world war in which his children would serve. He wrote in the essay that in Rilke's anticipation of death, he was also anticipating the mourning that would accompany it. Unable to bear that impending grief, he had built up a resistance to ever experiencing its beauty in the first place. One could not mourn what one never loved.

Freud advocated in his essay for adopting a more hopeful and therapeutic outlook. He admitted that the war had "robbed the world of its beauties." It destroyed nature and demolished historical monuments. "It made our country small again and made the rest of the world far remote. It robbed us of very much that we had loved, and showed us how ephemeral were many things that we had regarded as changeless."

But unlike Rilke, Freud insisted that the joy of beauty outweighed the cost of mourning it. Even if beauty disappears, grief, too, departs just as abruptly as it arrives. With each ending would come a beginning, Freud said, and with it the opportunity to rebuild "on firmer ground and more lastingly than before."

The paper helped establish Freud's seminal research on defense mechanisms, the belief that people unconsciously manipulate their perceptions in order to guard themselves against painful emotions. Without knowing it, Rilke, too, may have anticipated this logic even earlier in the first of his *Duino Elegies*. He writes in it of his fear that an angel's love will engulf him: ". . . For beauty is nothing / but the beginning of terror which we can still barely endure." The longer we admire it, the more devastating its loss will be.

PERCHED ON A STEEP cliff overlooking the Adriatic Sea, the Duino Castle struck Rilke as a cold, unfeeling colossus when he arrived in the winter of 1911. The dark water was a "featureless, outspread void," cloaked in mist. There was no green, no sign of vegetation anywhere on the rocky terrain. Situated near the border of Slovenia, this was a

far cry from the Italy Rilke had come to know during his vacations to sandy Capri.

He moved into a corner room facing the sea and opened the window to let the salty air flow in. The austere environment should have instilled Rilke with a sense of discipline, but instead he felt like a prisoner within its stone walls. It enclosed him, too, with an anxiety that had been plaguing him since he left the Hôtel Biron.

Witnessing Rodin's decline had awoken in him the possibility that if he did not confront his fears now, they might continue pursuing him until they one day caught up to him when he was too weak to do anything about it, as Rodin's fear of death had done to him. "The experience with Rodin has made me very timid toward all changing, all diminishing, all failure, for those unapparent fatalities, once one has recognized them, can be endured only so long as one is capable of expressing them with the same force with which God allows them," he told the princess. For the first time, he thought that therapy could be a useful way to identify and excavate those fears.

Rilke had always been somewhat frightened of Freud and his new science of the mind. He told Andreas-Salomé that he found the psychiatrist's writing "uncongenial" and "in places hair-raising." He believed psychoanalysis was bleach for the soul, a clearing out. Each time Freud had tried to cultivate a friendship with Rilke over the years, the poet tended to decline his invitations. The year after Freud published "On Transience," his then-twenty-three-year-old son Ernst "at last met his hero Rilke," but the encounter did not occur at Freud's house: "Rilke was not to be persuaded to visit us a second time," Freud wrote.

But in his isolation at Duino, Rilke started to see how a branch of medicine as narratively driven as psychoanalysis could have its benefits for a writer. Rilke was writing so little then anyway, therapy seemed unlikely to make matters worse. He wrote to Andreas-Salomé to see whether she thought Freud's talking cure could help him. "Dear Lou,

I am in a bad way when I wait for people, need people, look around for people . . ." he wrote.

When she received the letter she skimmed through his complaints of depression, muscle pains and loss of appetite before reaching a truly disturbing passage. It did not concern any of his usual ailments, but instead described the way he had written his most recent poem.

It took place on a gusty January day. In Duino, the cold northern wind from the Hungarian lowlands could collide with warm gales coming up from the Sahara Desert and cause storms as apocalyptic as an El Greco painting. On one such afternoon, Rilke stepped out for some air just as the sky was darkening. He was too preoccupied with an important letter he had to write to notice the weather. From the castle, the princess watched him pacing the cliff, hands jammed in his pockets, head bowed in thought.

Then he heard a voice in the wind: "Who, if I cried out, would hear me among the angels' hierarchies?" it said. Rilke stopped in his tracks and listened. He wrote the sentence down in his notebook, and with it the first line of his *Duino Elegies*. When he went back inside the castle, the rest of the poem poured out of him. In describing this surge of inspiration to Andreas-Salomé, he admitted that he hardly felt like its author at all. He felt like he had been inhabited by a higher power. "The voice which is using me is greater than I," he later told the princess.

Rilke's account troubled Andreas-Salomé. From the way he told it, it was as if the hand that wrote the words had not existed at all. The disembodied description bordered on self-denial and was an extreme manifestation of the bodily alienation that she had long thought caused his recurrent illnesses. So when Rilke asked her whether he should go to Munich to undergo psychoanalysis, she encouraged him.

He also ran the idea by Westhoff, who was already in therapy, and she told him he'd be a coward not to at least try it. Rilke then wrote to Westhoff's psychiatrist to inquire about his candidacy for treatment.

He told the doctor that he believed his work had been "really noth-ing but a self-treatment" all along. The problem was that it no longer seemed to be having its effect.

But before Rilke could make the trip, Andreas-Salomé rushed him a telegram: Don't do it, she pleaded. She had a sudden change of heart and now believed that the risk that analysis posed to his cre-ativity was too great. It might well chase out the angels along with the demons.

Rilke decided that she was right. Perhaps he needed a little mad-ness to push him through the rest of the *Elegies*. Had the opportunity for treatment arisen during his long battle with Malte, he might have jumped at it. And if he opted to one day transition into a "noncreative" profession, as he had contemplated doing after he finished that book, he would consider it again. But for now he had made up his mind not to undergo psychoanalysis so long as he was a poet.

Instead, he would finish out the miserable winter walking bare-foot in the frost of Duino and Andreas-Salomé would continue acting as his unofficial therapist, as she had been doing for nearly fifteen years. She had recently also begun analyzing his dreams. In one, Rilke told her he stood in a zoo, encircled by cages of animals. One of them contained a pale lion, which he told her had triggered associations with the French words for "remembered" and "mir-rored." At the center, a nude man posed, enveloped in violet and gray shadows, like a figure model in a Cézanne painting. The man was not a lion tamer, but was himself "put on exhibit with the ani-mals," Rilke said.

Andreas-Salomé did not record her interpretation of the dream, which contained so much imagery from Paris and the *New Poems*. But she suggested that, in lieu of psychoanalysis, perhaps Rilke ought to return there for a while. She had not cared for his *New Poems*, which to her felt emotionally barren, but at least they had grounded him in the physical world. After all his recent talk about voices in the wind at Duino, she thought he could use a dose of harsh Parisian reality once more.

———

RILKE TOOK HER ADVICE in the spring of 1913. He returned to his old apartment on the Rue Campagne-Première and promised to fulfill one final favor to Westhoff. She was still living in Munich, with Ruth now as well, when she told him of her enduring wish to sculpt a bust of Rodin. The artist had already given her his consent, but she wasn't sure if it was sincere because he had since gone silent. Rilke promised he would talk to him for her.

Trusting that Rilke would come through, Westhoff arrived in Paris to begin work in April. Over the next two months, Rilke wrote repeatedly to Rodin, pleading with him to pose for her. He told him how a museum in Mannheim had already commissioned the bust and now her professional reputation depended on it. When that failed to elicit a response, he tried appealing to Rodin's ego, making the case that a subject as great as him could be just the thing to awaken Westhoff's latent genius. He quoted to him a letter in which she had written, "I never dared hope that Rodin would sit for me."

In return, Rilke received only a polite response that seemed to deliberately avoid mention of the favor. Finally Rilke told Westhoff that Rodin simply did "not want to hear of sitting for the bust for the moment." The artist had not officially declined, but he wouldn't commit, either. They had one last chance to plead their case in May, when Rodin invited Rilke and Westhoff to join him for breakfast in Meudon. They spent a lovely morning together and before they left Rilke confirmed plans to come by again with his publisher a few days later. They were to pick up some photographs of Rodin's work to illustrate a new edition of the monograph.

Rodin had agreed to release the images, but when Rilke returned on the appointed day, the artist had inexplicably changed his mind. He refused to give Rilke the photos and he would not say why. Rilke vowed that this second broken promise would be the last he would tolerate from Rodin. Westhoff knew that she had no chance of convincing Rodin to sit for her on her own, so she returned to Munich

and settled on sculpting a bust of Rilke's friend the Czech baroness Sidonie Nádherný.

"He can't be counted on for anything anymore," Rilke concluded. Rodin's reckless mood swing was "as unexpected" now as it was when he fired Rilke eight years earlier. But this time the poet knew the rift was "probably final and not to be made up."

CHAPTER
18

❄

A S THE AVANT-GARDE BROKE GROUND IN THE CITY, RODIN defiantly declared himself a member of the *avant-derniers*. At the 1913 Salon de la Société Nationale, Rodin displayed a thoroughly unfashionable marble bust of Puvis de Chavannes, an artist whose reputation for decorative, "wallpaper" painting was driving his descent into irrelevance in the fifteen years since his death. But Rodin maintained he was a genius and was willing to risk his own reputation in his defense.

Already operating on the margins of Paris's contemporary art scene, Rodin began to flee farther from the city still. He started spending weekends in the south, learning to paint with Renoir, and teaching him sculpture in return. The painter was by then so old and arthritic that he had to tie the brush to his wrist. Rodin, too, had some difficulty, but it brought him a childlike joy to learn a new skill at his advanced age.

He also made pilgrimages to his beloved cathedrals, observing them with all the unjaded awe that he had as a boy in boarding school. He began sketching their columns, moldings, stained glass and canopies and jotting down his impressions. Since he had been paying homage to past masters lately, he could not forget the buildings to

An aging Rodin,
circa 1913.

which he owed his education more than anyone. The cathedral was the mother of all sculpture, the body that bore carvings on her surfaces for centuries before the reliefs, ornaments and statues climbed off her walls to stand on their own as individual works of art. Rodin couldn't imagine sculpture as we know it existing at all without cathedrals.

In early 1914, Rodin published these meditations alongside a hundred free-associative drawings in a book, *Cathedrals of France*. The chapters follow his meanderings from Chartres to Beauvais to Laon, eventually arriving at Reims, the thirteenth century Gothic masterpiece ninety miles northwest of Paris, and his most beloved of all the cathedrals.

Rodin devotes the longest chapter in the book to Reims Cathedral, where he would stand for days "in terror and in rapture" before it. It had an almost "Assyrian character," he wrote, but its effect was even more profound than that of the pyramids. He filled thirty-six pages with technical observations taken from the front, from three-quarter angles, from his hotel window, from within the hollow nave, and during the day and at night. An evening spent in the nave gave him the feeling of being in a grotto where, at any moment, Apollo might rise in resurrection. He imagined how nicely *The Thinker* would

look sitting in these chambers. The crypt's "immense shadow would have fortified that work."

He wrote about the bells, which seemed to ring at the same rhythm as the clouds passing by, and about the hunched gargoyles, which lunged from the walls into his nightmares. By the end of the chapter, Rodin still felt he had fallen short of conveying even a fraction of the cathedral's fascinations. "Who indeed would dare to boast of having seen them all? I give only a few notes."

Reims was his religion, Rodin said. "The artists who built this Cathedral brought the world a reflection of divinity." That's why he considered the fifty years of crude restorations it had undergone to be nothing short of blasphemy. The cheap, synthetic materials these barbarian conservators used on Gothic cathedrals signified "a sick France . . . a France ravaged by selfish interest . . . that France of the schools where people talk and no longer know how to work," he said.

To Rodin, the Gothic cathedral embodied the essence of France, just as the Parthenon embodied Greece. Yet cathedrals had become symbols to him of a lost art and their obliteration marked the end of France's genius. Yet the public didn't even seem to care. Rodin believed that the cathedrals were so in need of prayer that his collaborator on the book, the Symbolist poet Charles Morice, described the sculptor as "a prophet conducting his people to the promised land."

The book is part anguished *cri de coeur* and part call to action. Rodin begged his readers to save the cathedrals for France's children and implored the public to visit them in person. Photographs would not do; a camera lens has no sense of touch, whereas the eye could caress. He also begged visitors to be patient and humble before the cathedrals, studying them like apprentices before their masters.

Given Rodin's essential complaint—that no one defends the old anymore—the artist's evangelizing may have been as much a lament for himself as it was for the cathedrals. "Who can believe in progress?" he asked. "We should long ago have been gods if the theory of indefinite progress were true." When Rodin returned to Meudon to finish the book, his colleague felt the outsized pressure of the task bearing

down upon him. He scrambled to decipher many of the book's notes from Rodin's shirtsleeves, and once said that the artist "goes out of his way to be unpleasant to me."

When the book came out in May 1914, Rodin and Morice staged a reading at the Hôtel Biron to mixed reviews. Some critics believed that Morice had ghostwritten the whole thing. He certainly played an important role, yet it's hard to imagine anyone so precisely mimicking Rodin's singularly magniloquent style of prose. He makes such forceful aesthetic judgments that they often strike the reader as unquestionable facts. The book offers "vibrant notes, noble thoughts, beautiful metaphors," wrote the critic Émile Mâle, but he and others emphasized that it should not be mistaken for serious scholarship. Some critics went further and accused Rodin of deliberately deceiving readers into thinking that his prominent status as an artist somehow made him an expert on Gothic architecture, too.

Rodin did not have time to defend himself before the entire world turned its attention to the crisis unfolding on the global stage and promptly forgot about Rodin's little book. Europe was balancing on the brink of war and Rodin's prayer to preserve the symbols of France suddenly became a prayer for the survival of France itself.

RILKE DID NOT ATTEND the reading at the Hôtel Biron, nor did he ever see Rodin in Meudon again. He had gone there once in early 1914 as a favor to his friend Magda von Hattingberg, who had asked if he could introduce her to Rodin during a visit to Paris. But Rodin was not there on the afternoon they arrived; he was off painting with Renoir.

Rilke walked von Hattingberg around the yard instead, and the countryside looked every bit as enchanting as she had imagined it would. But the house looked so cold and uninviting, she told Rilke. This was how Rodin lived, he explained to her: in a dilapidated home, without heat and surrounded by friends eager to exploit him. The whole scene struck her as "so hopeless: human weakness and genius combined in a great creative personality that is growing old in loneli-

ness and unhappiness," she wrote in her diary. "I wish we had not gone to Meudon."

It wasn't only Rodin's refusal to pose for Westhoff, or to turn over the promised photographs for his book, that kept Rilke away from the artist at the end of his life. It was the sight of Rodin's graceless aging, his submission to desires and earthly entanglements, that repelled him. Rodin had harbored the poet when he was at his most vagrant. "Deep in himself he bore the darkness, shelter, and peace of a house, and he himself had become sky above it, and wood around it," Rilke wrote in 1903.

More than sheltering him, the sculptor had taught Rilke the meaning of structure. He had given him the blueprint to build his poetry like a carpenter builds four walls around him. "But to make, to make is the thing," Rilke had understood. "And once something is there, ten or twelve things are there, sixty or seventy little records about one, all made now out of this, now out of that impulse, then one has already won a piece of ground on which one can stand upright. Then one no longer loses oneself."

This was the gospel Rilke had followed for so long. When Rodin said to work, always work, Rilke had taken it to mean that one must not live. The poet was willing to make that sacrifice for a while, when he still believed that his obedience would be rewarded with mastery. Rilke had isolated himself and diverted his love for people onto objects. He acted as if he lived underwater, in a climate inhospitable to humans. Should someone dare to comfort him in this "airless, loveless space," as Westhoff had attempted, it would be only a matter of time before their support would age and die "in a withered and terrible state." Rilke worked himself to the brink of madness in those years. And yet, try as he might, he could never fully extinguish his desire to live.

On one of their last visits together, Rodin had wondered to his old friend, "Why leave all this?" At rest in the garden at Meudon, the artist, then in his seventies, gazed out over the marble and plaster figures who had been some of his closest companions in life. He looked so satisfied in that moment with all his beautiful things around him, his faithful companion Beuret inside and his memories of great loves, that

Rilke realized that Rodin had not made any of the sacrifices that he, Rilke, had. Rodin was no martyr for his art. How did he live? Full of pleasure, and exactly as he pleased, it turned out.

Rodin could not have realized how the words he had uttered a decade earlier might deprive the poet of life's most sacred experiences. When Rilke had heard the directive *travailler, toujours travailler,* he followed it literally, abandoning life in anticipation of future payoff. When he saw that Rodin had not followed this mandate himself, he felt betrayed. But his mistake was failing to grasp that Rodin could never tell Rilke how to live. The best any master could do was encourage their pupil and hope they find satisfaction in the work itself. In art, Rilke had started to realize, there was never anything waiting on the other side: There was no god, no secret revealed, and in most cases no reward. There was only the doing.

One morning in late June, just before the outbreak of the war, Rilke wrote a poem about the high price he had paid for his work. He had sat around empty hotel rooms, stared at cathedral towers and caged lions, slept in empty beds. But deep within the body of this lifelong observer was the trace of a "still feelable heart" that had been "painfully buried-alive" by images.

Just as his narrator reached the limits of objective observation, Rilke had decided, "Perhaps I shall now learn to become a little human." He sent Andreas-Salomé a copy of the poem, which he titled "Turning" because it represented the turning "which surely must come if I am to live."

> *Work of the eyes is done, now*
> *go and do heart-work . . .*

THE ARCHDUKE FRANZ FERDINAND was shot on June 28, 1914. Two weeks later, Rilke packed a bag for what he thought would be an ordinary trip to Germany: a visit to Andreas-Salomé in Göttingen, then to his publisher in Leipzig, and finally to Munich, where he would

meet with Ruth and join back up with Andreas-Salomé. Assuming he would return after the brief trip, he left all his belongings—the desk from Rodin, his family's coat of arms framed on the wall, a daguerreotype of his father—behind in the apartment. As he stood waiting for his taxi on the Rue de Campagne-Première, his landlady started to sob. Rilke, oblivious to the reality that Europe was on the brink of collapse, didn't understand why.

Rilke arrived in Germany in mid-July, two weeks before Austria declared war on Serbia. News of faltering diplomatic relations sounded throughout the continent and Rilke remained fairly indifferent to it all. He dismissed Russia's threats of mobilization as posturing and carried on with his plans to travel to Munich and meet Andreas-Salomé, acting "as the child he was in everything concerning politics," as a friend said of him at the time. But Andreas-Salomé did not take that risk, thinking better of boarding a train that might leave her stranded in another city. She was wise. It would be six years before Rilke made it back to Paris.

On August 2, two weeks after Rilke had unintentionally evacuated Paris, soldiers seized Rodin's car as he was passing through the city gates on his way home to Meudon. All travel in and out of Paris had been shut down. The seventy-three-year-old artist and his plaster assistant had to walk back to the suburbs. Luckily a peasant took pity on them along the way and let them ride in his cart.

When Rodin arrived home that evening, he found that his employees had been called in for military duty. Even his old, disabled horse Rataplan had been requisitioned. Then came a telegram advising him to move his art to the cellar of the Hôtel Biron within forty-eight hours. Rodin had not fully comprehended the scale of the conflict when flyers went up around Paris notifying citizens that mobilization was underway.

The next day, Germany declared war on Russia and France. Rodin hired a team of movers, including his son, Auguste, to rush his sculptures into storage and arrange to send as many of them as possible to England. By the end of the month, German forces were closing in on Paris and blanketing the city with pamphlets warning that surrender was its only hope.

On September 1, Rodin realized that it was time to leave town. He and Beuret pushed through crowds of incoming troops at the railway station, leaving Auguste behind in Meudon while they boarded a train to England. A relative of Rodin's temporarily took over the artist's country estate and converted it into a field hospital during the Battle of the Marne, which narrowly saved Paris from German occupation one week later.

Rodin and Beuret took shelter at the London family home of their friend Judith Cladel. Rodin found a silver lining in his English exile in that he would now at least get to witness the unveiling of his *Burghers of Calais* in the gardens of the House of Parliament that fall. But at the last minute the curator decided it would be in poor taste to celebrate this monument to the sacrifice of Calais at a time when German soldiers literally had the French port town under siege.

Although the decision disappointed Rodin, it did not begin to match the devastation that came a few weeks after his arrival in London. Rodin had opened a copy of the *Daily Mail* one morning and plastered across the page was a photo of the Reims Cathedral, bombed to rubble.

Reims under bombardment in September 1914.

"He turned pale as if he was dying, and for two days, white and mute from sorrow, he himself seemed to have turned into one of the statues of the mutilated cathedral," Cladel said. The Germans, fully aware of Reims' role as a national symbol of French ingenuity, fired shells at its

skeleton for another four years. In the future, Rodin predicted, "One will say 'the fall of Reims' as one says 'the fall of Constantinople.'"

For perhaps the first time, Rodin found himself passionate about politics. He wrote to a pacifist writer who had lived at the Hôtel Biron, Romain Rolland, telling him, "This is more than a war. This scourge of God is a catastrophe against humanity that divides the epochs." His patriotism hardened, Rodin donated eighteen sculptures to London's Victoria and Albert Museum in November—a gift to his English brothers in the fight against Germany. When he received the unlikely offer of 125,000 francs to sculpt a bust of the German Emperor, Kaiser Wilhelm II, Rodin rejected the commission, saying, "How could I do the portrait of an enemy of France?"

Two months after the fall of Reims, Rodin and Beuret moved on from London to Rome, where he had been commissioned to sculpt a bust of the Pope. Benedict XV had consented to twelve sittings, but dropped out after just three. He did not seem to enjoy holding poses for prolonged periods of time and told Rodin that he was too busy to continue. When an assistant dared bring Rodin photos of the Pope to use a substitute, the sculptor untied his apron and stormed out. A friend who had helped arrange the session ran into Rodin on the Vatican staircase that day. Tears welling in the sculptor's eyes, the man had to help the distressed old artist down the steps.

When the fighting shifted from France to Belgium a few months later, Rodin returned to Paris and continued working on the papal bust. It bore a fine resemblance to the man but, he lamented, it would never be the "masterpiece" it could have been had the Pope cooperated.

WHILE RODIN WAS DISPLACED from Paris during the early months of the war, Rilke enjoyed an unusually fortunate turn of events. In September, his publisher informed him that an anonymous donor who was going into battle had bestowed twenty thousand Austrian kronen upon him and another poet, Georg Trakl. Rilke never knew the name of his mysterious benefactor, but it was later revealed to be

the Viennese philosopher and steel heir Ludwig Wittgenstein, who had admired Rilke's early lyrical poetry.

To the poet, this was "no less astounding than the existence of the unicorn." It was the start of an uncommonly comfortable season in Rilke's life. In the summer of 1915, he got a girlfriend, the painter Loulou Albert-Lasard, and a rent-free riverfront apartment in Munich, courtesy of a vacationing patroness. In her living room Rilke gazed daily at a wonderfully strange painting of six forlorn circus performers, Picasso's *Family of Saltimbanques*, which would later make an appearance in one of Rilke's *Duino Elegies*.

But then, at the end of November, Austria began losing ground in the war. The military extended the age limit for soldiers and suddenly Rilke qualified to be drafted and "whisked off to who knows where." When his birth date was called up for medical board review, officials declared the poet fit for service. He was ordered to report for duty in the mountain town of Turnau in January.

Rilke rushed a letter to Princess von Thurn und Taxis to see if she had any authority to save him from this nightmare. She made every effort to mobilize her contacts, but it was no use. The government insisted Rilke enlist in the second reserve. "I'm scared, scared," he told the princess.

Nearly forty, Rilke found himself buttoning up the stiff military collar of his youth to report to boot camp. It was just as traumatic as he remembered. The other soldiers still bullied him and, now that he was known once again by his given name René, taunted him for its girlish sound. After three weeks, Rilke's influential connections finally arranged for his transfer to a desk job in Vienna. According to some reports, the princess personally came to the barracks to escort him away.

Rilke's new job was in the War Archives, where he was to write short, glorified accounts of the battles being fought. Rilke loathed this revisionist "hero grooming," as he called it. Nonetheless, he devoted himself to the task with all the diligence he would normally reserve for his poetry. On one shift, he crumpled up page after page, unable to get the narrative just right. When he explained to his superiors that he was

suffering from writer's block, the colonel brought Rilke a stack of paper and a measuring stick and told him to hand-rule each sheet instead.

"Industriously he drew vertical and horizontal lines, for hours on end. Sometimes the spaces between the lines were only two millimetres wide, but he worked with perfect accuracy and a genuine humility," remembered one of his colleagues in the department.

Thus, for five months, Austria had its greatest living poet ruling sheets of paper, until the military at last released Rilke from service in June 1916.

THE PAPAL BUST WAS one of the last works Rodin would undertake in his lifetime. He had returned to Paris "tired; the war overawed him, aroused his fears," said his secretary, Marcelle Tirel. He spent his last two years sculpting very little at all. He visited the Hôtel Biron now only for important appointments, spending most of his time in Meudon with Beuret.

Some of his friends urged him to marry her before it was too late. It seemed only fair, given her loyalty to him over all these years. Rodin finally agreed and, on January 28, 1917, he married his companion of more than half a century. The mayor of Meudon performed the rite amid explosions at a nearby munitions factory. The couple's son and a few close friends and employees joined, noticing that Rodin smiled throughout the brief ceremony, often eyeing the pastry table. Beuret wore her usual scowl.

A few days after the wedding, Rodin's new bride caught a terrible cough. Between lozenges she confessed to his secretary, Tirel, "I don't the least mind dying," but she did not want to go before Rodin and leave him alone. Two weeks later, on Valentine's Day, Tirel came home to find Rodin standing in the center of the room staring at Beuret "like a statue." Tears ran down his face as he whispered, "I'm all alone." She had died that day of pneumonia. Tirel changed Beuret's clothes into a white dress and they buried her in a joint grave in the garden at Meudon, beneath a statue of *The Thinker*.

The tomb of Rodin and Beuret.

Rodin's health declined rapidly after that. An infection in his lungs prevented him from leaving Meudon, where he lived out his last months in near-solitude. A resentful nurse kept him caged up in the house like a child, he complained. Only his most devoted past mistresses and a few vulturous acquaintances, hoping to acquire a last drawing or photograph, came to visit him now. His son returned to the house for a while, too, but even he departed after learning that his presumed inheritance would be donated to the state. In the eyes of the law, Auguste was Beuret's son alone and therefore entitled to nothing of Rodin's without a will.

For five days Rodin lay in bed shivering, attended to by three nurses, whom he called "his Three Fates." On November 18, 1917, water filled his lungs. In his last breath he reportedly groaned a defense of his late hero: "And people say that Puvis de Chavannes is not a fine artist!"

THE NEWS OF RODIN'S death reached Westhoff before it did Rilke. She was living in Worpswede again, building her final home with Ruth, when she delivered Rilke the sad announcement. She told him that Paris would seem "wholly desolate without him."

Rilke was about to write Westhoff a belated birthday note when he received her letter instead. Although he and Rodin had not mended their most recent differences, the news devastated the poet, and super-

seded all other matters in his life then. "Like me you will be steeped in memories and sorrow and, with Paris and all we have lost in it, will have to go through this now so final loss," he wrote Westhoff.

He maintained from that day forward that Rodin's influence on him outweighed that of anyone else. Rilke thought that perhaps the artist's death would have been easier to mourn had it not occurred during the war, which would rage on for still another year. But the letters of condolences that started streaming into Rilke's Munich apartment only compounded his sense that life was almost surreally inhumane.

His friend Count Kessler attempted to comfort the poet one day by telling him that he had managed to find some meaning in his time serving in the war. He told Rilke how moved he had been just by the sheer number of men sacrificing their lives all around him.

Rilke dropped his head into his hands. There was nothing meaningful about death during war, he said. The only worthwhile sacrifice was a sacrifice made in the name of art. Only a Rodin bronze, or a Michelangelo marble, or the dark sea at Duino were worth fighing for, he told Kessler. War was merely a pastime for the vocationless.

Kessler confided in his journal that he realized then how little Rilke understood about human nature. Fighting must have been too real, too physical for this poet who lived entirely in the realm of the spirit. Apollo, he concluded, was Rilke's only god.

There was not much one could say to comfort those who, like Rilke, emerged from the war wounded and morale-beaten. But the writer Sylvia Beach saw some hope for Parisians with the opening of the Musée Rodin in 1919. The fighting had delayed its official ratification for several years, but now that the soldiers would "return from the preoccupations of the war to the eternal beauty of art, many will be the pilgrims from all countries of the world to this shrine of beauty, the Musée Rodin," she wrote. Today the museum remains home to the largest collection of Rodin works in the world. A plaque on the side of the building reads, "In this mansion, to which he introduced Auguste Rodin, Rainer Maria Rilke lived from 1908 to 1911."

CHAPTER
19

⁑

SINCE THE OUTBREAK OF THE WAR, RILKE HAD BEEN ASKING himself, *Where do I belong?* There was a time early in the fighting when the sound of soldiers singing on trains filled his heart with pride for his Austrian homeland. But that patriotism deteriorated rapidly as he saw the waste of war firsthand, and he gradually began to align himself with the growing pacifist movement.

He returned to Munich after his release from the military, but felt allegiance to no nation. "I have behind me so many years that are lost or at least have almost eluded me, that I am now ruthlessly living toward a certain inner ownership," he wrote. The dissolution of the Austro-Hungarian Empire in 1918 only confirmed his lifelong sense of homelessness. Suddenly Rilke found himself a Czechoslovakian citizen by law, and yet he didn't even speak the language.

By that time Rilke felt little connection to his native tongue, either. Now that he had mastered French, he could never find the words he needed to express himself in German. Take "palm": the French had *paume*, the Italians had *palma*, but the Germans had nothing to describe the inner plain of the hand, he said. The closest word Rilke could find was one that translated to "hand plate." That it conjured an image of

a beggar asking for alms perfectly evoked the impoverishment that characterized the German language to Rilke.

In the last phase of Rilke's life, he settled in a French-speaking region of Switzerland and changed his name back from Rainer to René. Anti-German sentiment still ran high in French-speaking nations then, and Rilke soon began writing in French and even found himself thinking in French. Writing poetry in a foreign language was a challenge, but rediscovering how to express himself made him feel like a child, experiencing the world with new eyes.

BEGINNING IN 1919, Rilke saw through the emotional "turning" that he felt stirring in him just before the war. He would remain a fundamentally solitary poet, but he was now ready to do the "heart-work" he had denied himself for so long. For once, he wanted to give something to others.

The black-haired Polish painter Baladine Klossowska was still married when she and Rilke first met more than a decade earlier in Paris. Her husband, the German art historian Erich Klossowski, had also written a book for *Die Kunst*, the series of art books that included Rilke's monograph on Rodin. The two writers ran into each other periodically over the years, including in Paris the year after Rodin fired Rilke, and the poet had invited the couple back to his little apartment to hear him read from his *Book of Hours*.

After the war, Baladine Klossowska, a German citizen, was forced to leave Paris. She settled in Geneva and separated from her husband in 1917. Two years later, Rilke looked her up while he was in town giving a reading. His five-day visit stretched into fifteen as the old friends speedily became lovers.

Soon they were writing each other letters three times a day and, by the summer of 1921, they began renovating a home together. Set atop a steep cliff in the Rhône Valley, the thirteenth century chateau known as Muzot was a sturdy stone square, as if a castle had collapsed and only one defensive tower remained. Its violetish gray walls

and turrets were reminiscent of a Cézanne mountain, while its barren interiors—crumbling stone walls and no water or electricity—would have pleased Rodin.

Rilke became an adoring and protective father figure to Klossowska's two boys, who were both budding young artists. The eldest, Pierre, was a writer, while little Balthasar was just eleven and already a gifted artist. When Balthasar, a tall, lanky troublemaker, was denied entry into an advanced class at school, Rilke protested to the headmaster that it was not the boy's grades that were at fault, but rather the "extreme pedantry on the part of the school."

At some point, a stray Angora cat wandered into the house and joined the family, too. They named it Mitsou and it became Balthasar's closest companion. When it ran away one day, the boy drew a series of forty thick-lined ink drawings that illustrated the memories they had shared. They slept together, ate together, spent Christmas together. The final image was a self-portrait of Balthasar wiping away his tears.

Rilke was stunned by the raw skill and vulnerability of the drawings. He found them to be so good, in fact, that he arranged to have them published in a book. They titled it *Mitsou* and Balthasar took

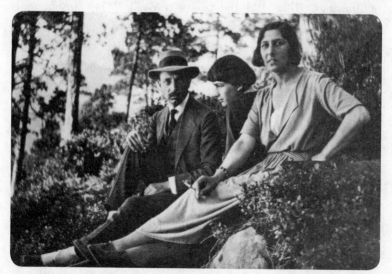

Rilke, a young Balthus and Baladine Klossowska in Switzerland.

Rilke's advice and signed it with his nickname, Balthus, an alias that stuck with the artist throughout his long career as one of modern art's most celebrated and provocative painters.

Rilke supplied the foreword to the book, a meditation on the elusive nature of cats and his first text published in French. It opened with a question, "Does anyone know cats?" Unlike dogs, whose unflinching worship for humans feels both wonderful and tragic, "Cats are just that: cats. And their world is utterly, through and through, a cat's world. You think they look at us?" Hardly, he says; even as their eyes are upon us they are already forgetting we exist.

After the book came out, Kurt Wolff, the first publisher of Franz Kafka, came across it and called the drawings "astounding and almost frightening." And the Postimpressionist painter Pierre Bonnard wrote to "Madame" Rilke with a letter "full of praise" for *Mitsou*. It is no wonder that in all the years after Balthus rose to fame he continued to praise Rilke. He was "a wonderful man—fascinating. He had a wonderful head, with enormous blue eyes. He had a sort of dreamy voice and an extraordinary charm."

The poet had always treated the boy as an equal. Of one series of drawings, Rilke told the twelve-year-old, "Their invention is charming, and their facility proves the wealth of your inner vision; the arrangement unfailingly enhances the excellent choice you have made." Given the chance to look at them side by side, he imagined the two artists would share "an entirely parallel, virtually identical joy."

After *Mitsou* came out, Rilke shut himself up in Muzot for a long, cold winter, and, in February 1922, he wrote all fifty-five of his *Sonnets to Orpheus*. The book was inspired by the death of his daughter's teenage friend Wera Knoop, a dancer who had turned to music after leukemia had ravaged her body. Like the *Elegies*, Rilke said the *Sonnets* came to him almost unconsciously. Critics would later classify the *Sonnets* as the crossroads that guided Rilke to his most mature poetic phase. But to him they were merely the spiritual overflow of the *Elegies*, which he also completed in one final "storm of spirit" that year.

That spring, his daughter Ruth married a young lawyer named

Carl Sieber. Rilke missed the wedding and never met her husband. "I have a great desire to do nothing," Rilke told Balthus around this time. "If you imagine that an evil sorcerer changed me into a turtle, you'd be close to the reality: I wear a strong and solid shell of indifference toward any challenge."

Klossowska found him increasingly absent from her life, too. The couple stayed together for five years, but he insisted on spending much of the time away or locked in solitude. She took his absences hard. "But we are human beings, René," she said to him upon one of his many departures. Eventually Klossowska found herself unable to make a living on her painting—Rilke apparently did not help—and she took the boys to Berlin to stay with her sister. They lived between Germany and Switzerland for the next two years, with Klossowska updating Rilke often on Balthus's progress. "He's beginning to have a public," she wrote. "René, he'll be a great painter, you'll see . . ."

Although Rilke's relationship with Klossowska ended in much the same way it had with other women, with Rilke choosing solitude over intimacy, he remained a zealous supporter of her sons. When Pierre Klossowki turned eighteen, Rilke secured him a job working as a secretary for Gide in Paris and assisting him on his novel *The Counterfeiters*. Rilke inquired to his friend endlessly about how much money the boy would need, what he should study and what kind of work he should aspire to do. Eventually Pierre went on to write influential books on Nietzsche and the Marquis de Sade, to translate Kafka, and become a painter in his own right.

Around the same time, Rilke suggested that Balthus, then sixteen, should go to Paris, too. Like Rilke, the young painter would end up forgoing school and letting the city be his teacher. He had already received recognition incredibly early thanks to *Mitsou*. Rilke gave Balthus a copy of Wilhelm Worringer's history of panel painting and sent him off to Paris, also in the care of Gide.

In January 1925, Rilke dedicated his newest poem to Balthus. Titled "Narcissus," it reimagines a sixteen-year-old boy's extreme self-regard as a condition for his artistic awakening. That fall, Balthus spent all his

days in the Louvre copying Nicolas Poussin's painting *Echo and Nar-
cissus*, incorporating his dedication, Á René, onto the surface of a stone.

Throughout Balthus's career, the early themes from his life with
Rilke manifested in his work. He became notorious for his almost
single-minded focus on painting cats, and on girls who lounged lan-
guorously like cats. His biographer Nicholas Fox Weber wrote that
Balthus came to identify himself with the feline spirit as a young man,
emanating in life and self-portraiture "the same haughty confidence
and inaccessibility." He sometimes signed his work, "H.M. The King
of Cats."

Another dominant motif in Balthus's work was windows—often
with women falling or gazing out of them. The window was the place
in the house where Balthus's mother spent much of her time as she
waited for Rilke to return. She decorated the sill with flower boxes
to greet him upon his arrival, and to give her something to look at
while she sat there. Sometimes his absence would last so long that she
would watch the buds bloom and then wither and die before he came
back. For Klossowska, Rilke's comings and goings were as fleeting
and unpredictable as a cat's.

Rilke had been fascinated by windows since he and Klossowska took
a trip to a small Swiss town early in their relationship. He thought about
how all the windows of the little cottages looked like picture frames for
the lives taking place inside. Someday he'd like to write a book about
windows, he said. He never got that far, but he did write a cycle of poems,
"Windows," which Klossowska illustrated. In it, windows become many
things for Rilke: they are eyes, a frame of vision, a measurement of
expectations. Windows were an invitation, tempting you to come closer,
but also an invitation to fall; they could be the beginning of terror. "She
was in a window mood that day," begins one poem, "to live seemed no
more than to stare." Klossowska published them in a little book, *Win-
dows*, a year after Rilke died.

Windows also communicated the essence of the term *Weltinnen-
raum*, or "worldinnerspace." Rilke coined the word in his later years to
describe the space where the barriers between the internal and exter-

nal collapsed onto a single plane. It is a realm where the self is like a bird flying soundlessly between the sky and the soul, he said. Rilke accepts the concept as both a contradiction and a reality in a poem titled "Worldinnerspace": ". . . O, wanting to grow, / I look out, and the tree grows *in* me," he writes. Worldinnerspace returned Rilke to the philosophy education that began three decades earlier in Munich. His old aesthetics professor Theodor Lipps might have appreciated the idea while he was trying to explain how it felt to watch dancers whose movements seemed to occur both onstage and in his own muscles.

Rilke at the Chateau
du Muzot in
Switzerland, 1923.

This in-between realm was the only place Rilke understood as home, the space where all things came to settle at last. For him, the house was a container and he was the air slipping out its windows; the cat running away at night. He was a ghost and a myth, first of a dead sister and then, at last, as the author of his own death, for which he created a final perfect metaphor.

———

ONE OCTOBER DAY in 1926 Rilke pricked his finger on the thorn of a rose as he was gathering a bouquet from his garden. The wound worsened as the days wore on. A septic infection spread into his arm and then to the other arm before invading his entire body. Bloody black blisters erupted on his skin and ulcers flared from the front of his mouth down to his esophagus, making it impossible to quench his desperate thirst. By December, he knew he was nearing the end.

On his last day of life, Rilke asked his doctor to hold his hand, and to squeeze it from time to time. If he was awake, he would squeeze back. If not, the doctor should sit him upright in bed to return him to the "frontier of consciousness." Rilke did not fear illness, a place he knew well from his youth, nor did he fear death.

Death was simply the laying out of a life. It was the transformation of a conscious being into purely physical matter, which would at least provide conclusive evidence that the person had been real—a fact that was not always self-evident to the poet. To Rilke, death was a "thing" to be examined like any other thing. In "The Death of the Poet," a poem he'd written shortly after his father died, in 1906, Rilke had described the face of the dead: "tender and open, has no more resistance, / than a fruit's flesh spoiling in the air." Now it was his own death to which he was to bear witness.

After seeing how much the fear of death had diminished Rodin at the end of his life, Rilke now believed that the only way to face the indignity of his disease was to embrace it. In his bedside notebook, Rilke summoned it like a spirit, beginning his final poem, "Come, you last thing, which I acknowledge . . ." At the end of the page, he made a note to himself to be sure to distinguish this final "renunciation" of death from his childhood sicknesses. "Don't mix those early marvels into this," he wrote.

Up until his last hour, Rilke refused painkillers. He refused hospitals, where people died en masse. He refused company, including his wife and daughter. He refused to know the name of his disease. He had

already decided it was the poisonous rose—and his death would be his own. When it came on December 29, 1926, three weeks after his fifty-first birthday, he met it with his eyes wide open.

Rilke had his final words etched into his tombstone: "Rose, O pure contradiction, desire to be no one's sleep beneath so many lids." And when the ground unfroze that spring, the roses awoke, undaunted by the headstone bearing down upon the soil. They gathered around the stone, their young petals opening gently around sleeping, oblivious centers, like mouths and eyelids, ready to receive.

A BRIEF CATHOLIC CEREMONY was held the Sunday after Rilke's death. A violinist and organist played Bach inside the church, while children gathered outside in a foot of snow, forming a circle around the open grave. Rilke's longtime editor Anton Kippenberg attended, along with several of the poet's Swiss patrons. By some accounts Balthus, too, made the journey, and then wept in the mountains for days.

Twenty years later, when Balthus was nearly forty, he published a series of letters that Rilke had sent him in the years leading up to his death. The collection was titled *Letters to a Young Painter*. In the first, written to Balthus when he was twelve, Rilke recounted a story Rodin had told him about reading *The Imitation of Christ*, the fifteenth century guide to leading a spiritually fulfilled life. Rodin had said that each time he came across the word "God" he would replace it in his head with the word "sculpture." It worked brilliantly, resulting in chapters with such titles as, "We Must Walk Before Sculpture in Humility and Truth" and "To Despise the World and Serve Sculpture Is Sweet."

Rilke instructed Balthus to do the same with *Mitsou*. Each time the boy came across Rilke's name, he should replace it with his own. "Your part of this work was all labor and sorrow," Rilke told him, while his was "minor and all pleasure." Balthus had proven himself with this book and was now on his way to becoming a master. Seeing it was the first step toward feeling it.

ACKNOWLEDGMENTS

I would like to thank Matt Weiland for his painstaking but always spirited editing across many drafts. Thanks also to Remy Cawley at Norton for always having a patient answer, and to my agent, Larry Weissman, for his early and enduring encouragement.

I am grateful to all the individuals and institutions that allowed me to reproduce the images in these pages. The descendants of Rainer Maria Rilke, in particular Bettina Sieber-Rilke, granted me access to their archive, and in doing so generously enriched this book.

Anyone writing on Rilke and Rodin today will rely on the accomplishments of scholars, translators and biographers such as Ralph Freedman, Stephen Mitchell, Edward Snow, Frederic V. Grunfeld and Ruth Butler. I was particularly inspired by the work of Geoff Dyer, William Gass and Lewis Hyde, all of whom have contributed deeply perceptive essays to the literature on Rilke and Rodin.

Many friends supported me throughout this undertaking: Whitney Alexander, Stephanie Bailey, Charlotte Becket, Lauren Belfer, Ben Davis, Natalie Frank, Andrew Goldstein, Ryan McPartland, Emmy Mikelson and Kathryn Musilek. I owe special thanks to Rainer Ganahl for his thoughtful translations and readings. Finally, I am indebted to my mother, my stepfather, my brother Tyler and my grandparents, especially Babička Olga, for their abiding kindness and faith all these years.

NOTES

•

FREQUENTLY CITED

Rainer Maria Rilke, *Letters of Rainer Maria Rilke, 1910–1926*. Translated by Jane Bannard Greene and M. D. Herter Norton. New York: W. W. Norton, 1969. All of Rilke's letters are from this book unless otherwise noted.

AR—Rainer Maria Rilke, *Auguste Rodin*. Translated by Jessie Lemont and Hans Trausil. New York: Sunwise Turn, 1919, 39.

BT—David Kleinbard, *The Beginning of Terror: A Psychological Study of Rainer Maria Rilke's Life and Work*. New York: NYU Press, 1995.

CF—Auguste Rodin, *Cathedrals of France*. Translated by Elisabeth Chase Geissbuhler. Boston: Beacon Press, 1965.

DF—Eric Torgersen, *Dear Friend: Rainer Maria Rilke and Paula Modersohn-Becker*. Evanston, IL: Northwestern University Press, 2000.

DYP—Rainer Maria Rilke, *Diaries of a Young Poet*. Translated by Edward Snow and Michael Winkler. New York: W. W. Norton, 1997.

FG—Frederic V. Grunfeld, *Rodin: A Biography*. Boston: Da Capo Press, 1998.

LB—Lou Andreas-Salomé, *Looking Back: Memoirs*. Edited by Ernst Pfeiffer. Translated by Breon Mitchell. New York: Paragon House, 1991.

LC—Rainer Maria Rilke, *Letters on Cézanne*. Translated by Joel Agee. New York: Macmillan, 2002.

LP—Ralph Freedman, *Life of a Poet: Rainer Maria Rilke*. Evanston, IL: Northwestern University Press, 1998.

LYP—Rainer Maria Rilke, *Letters to a Young Poet*. Translated by M. D. Herter Norton, New York: W. W. Norton, 1934; revised edition, 1954.

LYR—Marcelle Tirel, *The Last Years of Rodin*. Translated by R. Francis. New York: Robert M. McBride, 1925.

JA—Harry Graf Kessler, *Journey to the Abyss: The Diaries of Count Harry Kessler, 1880–1918*. Translated by Laird Easton. New York: Vintage, 2011.

PMB—Paula Modersohn Becker, *Paula Modersohn Becker: The Letters and Journals*. Edited by Günter Busch and Liselotte von Reinken. Translated by Arthur S. Wensinger and Carole Clew Hoey. Evanston, IL: Northwestern University Press, 1998.

PR—Anthony Mario Ludovici, *Personal Reminiscences of Auguste Rodin*. Philadelphia: J. B. Lippincott, 1926.

RA—Albert E. Elsen, *Rodin's Art: The Rodin Collection of Iris and B. Gerald Cantor Center of Visual Arts at Stanford University*. Oxford: Oxford University Press, 2003.

RAS—Rainer Maria Rilke and Lou Andreas-Salomé, *Rilke and Andreas-Salomé: A Love Story in Letters*. Translated by Edward Snow and Michael Winkler. New York: W. W. Norton, 2008.

RL—Wolfgang Leppmann, *Rilke: A Life*. Cambridge, UK: Lutterworth Press, 1984.

RP—Ruth Butler, *Rodin in Perspective*. Upper Saddle River, NJ: Prentice-Hall, 1980.

RR—Anna A. Tavis, *Rilke's Russia: A Cultural Encounter*. Evanston, IL: Northwestern University Press, 1997.

RSG—Ruth Butler, *Rodin: The Shape of Genius*. New Haven, CT: Yale University Press, 1996.

INTRODUCTION

x **"Perhaps all the dragons"**: Rainer Maria Rilke, *Letters to a Young Poet*. Translated by Stephen Mitchell. New York: Random House, 1984, 92.

PART ONE · CHAPTER ONE

4 **"with head raised"**: CF, 252.

8 **"Art is essentially"**: Quoted in Horace Lecoq de Boisbaudran, *The Training of the Memory in Art: And the Education of the Artist*. London: Macmillan, 1914, xxvi.

9 **"You were born"**: RSG, 17.

9 **"walking temple"**: Albert E. Elsen, *Rodin's Art: The Rodin Collection of Iris and B. Gerald Cantor Center of Visual Arts at Stanford University*. Oxford: Oxford University Press, 2003, 186.

10 **"The day will come"**: RSG, 15.

10 **"Think about words"**: RSG, 13.

10 **"hold the keys"**: PR, 51.

11 **"When one is born"**: RSG, 18.

11 **"You don't go" . . . "I understood"**: Judith Cladel, *Rodin: The Man and His Art, with Leaves from His Notebook.* New York: Century, 1917,113.

12 **"How I should love"**: Ronald R. Bernier, *Monument, Moment, and Memory: Monet's Cathedral in Fin de Siècle France.* Lewisburg: Bucknell University Press, 2007, 69.

12 **"transitory intoxication"**: Frederick Lawton, *The Life and Work of Auguste Rodin.* New York: C. Scribner's, 1907, 16.

12 **"Where did I learn"**: Jennifer Gough-Cooper, *Apropos Rodin.* London: Thames & Hudson, 2006, 20.

13 **Rosa Bonheur:** Frederick Lawton, *The Life and Work of Auguste Rodin.* New York: C. Scribner's, 1907, 19.

13 **"All right, that's"**: PR, 2.

13 **"The lion is dead"**: Quoted in Glenn F. Benge, *Antoine-Louis Barye: Sculptor of Romantic Realism.* University Park: Pennsylvania State University Press, 1984, 37.

14 **"They ran" . . . "Barye had found"**: FG, 29.

14 **"takes up the art"**: Quoted in FG, 270.

CHAPTER TWO

15 **"too big"**: Kaja Silverman, *Flesh of My Flesh.* Redwood City: Stanford University Press, 2009, 68.

17 **"wanted something indefinite"**: To Ellen Key, April 3 1903, p. 98.

18 **"Once when I was struck"**: RL, 27.

18 **man named Pölten:** Magda von Hattingberg, *Rilke and Benvenuta.* Translated by Cyrus Brooks. New York: W. W. Norton, 1949, 134.

18 **"History of the Thirty-Years War"**: BT, 141.

19 **"dungeon of childhood"**: Arnold Bauer, *Rainer Maria Rilke.* New York: Ungar, 1972, 10.

19 **"scorn and uneasiness"**: To Ludwig Ganghofer, April 16, 1897.

19 **"dream children"**: LP, 55.

19 **"not an artist"**: To Ludwig Ganghofer, April 16, 1897.

19 **"a bright"**: J. F. Hendry, *The Sacred Threshold: A Life of Rainer Maria Rilke.* Manchester, UK: Carcanet New Press, 1983, 20.

20 **"The only progress"**: RR, 6. **"death of God"**: Friedrich Nietzsche first described this in *The Gay Science,* published in 1882, then again in *Thus Spoke Zarathustra,* 1884.

20 **"be breathed"**: RL, 56.

21 **"thought meter"**: *Wilhelm Wundt in History: The Making of a Scientific*

Psychology. Edited by R.W. Rieber. New York and London: Plenum Press, 1980, 36.

22 **"beholder's involvement"**: Alois Riegl, *The Group Portraiture of Holland.* Los Angeles: Getty, 2000, 11.

22 **"feeling into"**: Nancy Eisenberg, *Empathy and Its Development.* Cambridge: Cambridge University Press Archive, 1990, 18.

22 **"move in and with"**: James Henderson, *Reconceptualizing Curriculum Development.* London: Routledge, 2014, 115.

22 **"striving and performing"**: Theodor Lipps, "Empathy, Inner Imitation, and Sense-Feelings." Translated by Max Schertel and Melvin Rader. In *A Modern Book of Esthetics: An Anthology.* Edited by Melvin Rader. California: Holt, Rinehart, and Winston, 1935, 379.

23 **"immersed" himself**: *The Complete Letters of Sigmund Freud to Wilhelm Fliess.* August 26, 1898. Translated by Jeffrey Moussaieff Masson, Belknap Press of Harvard University Press, 1985, 324.

23 **"the courage and capacity"**: Sigmund Freud, *Wit and Its Relation to the Unconscious.* New York: Moffat, Yard, 1917, note on 4.

23 **"putting of oneself"**: Fritz Wittels, *Freud and His Time: The Influence of the Master Psychologist on the Emotional Problems in Our Lives.* New York: Liveright, 1931, 71.

24 **"stand at the"**: To Frieda von Billow, August 13, 1897.

24 **"dreamer, floundering"**: Quoted in Jens Peter Jacobsen, *Niels Lyhne.* Introduction and translation by Hanna Astrup Larsen. New York: American-Scandinavian Foundation, 1919, vi.

24 **"by far the smartest"**: RL, 73.

24 **"holy trinity"**: Carol Diethe, *Nietzsche's Sister and the Will to Power.* Champaign: University of Illinois Press, 2003, 45.

25 **"Pythagorean friendship"**: Biddy Martin, *Woman and Modernity: The (life)styles of Lou Andreas-Salomé.* Ithaca: Cornell University Press, 1991, 64.

25 **"I really ought"**: Walter A. Kaufmann, *Nietzsche: Philosopher, Psychologist, Antichrist.* Princeton University Press, 2013, 61.

25 **"enormous quantity"**: Weaver Santaniello, *Nietzsche, God, and the Jews.* Albany: State University of New York Press, 2012, 32.

25 **"Thou goest"**: Friedrich Wilhelm Nietzsche, *Thus Spake Zarathustra, a Book for All and None.* London: T. Fisher Unwin, 1908, 87.

27 **"gentle dreamy"**: LP, 68.

27 **"no back"**: LP, 60.

27 **"the famous writer"**: RR, 23.

27 **"Yesterday was not"** . . . **"I can think"**: RAS, 3-4.

27 **"must not"**. . . **"manly grace"**: LB, 68-69.

27 **"style of gentle"**: Julia Vickers, *Lou von Salomé: A Biography of the Woman Who Inspired Freud, Nietzsche and Rilke.* Jefferson, NC: McFarland, 2008, 111.

27 **"fling themselves"**: LYP, 55.

28 **"pageboy"**: Quoted in Angela Livingstone, *Salomé: Her Life and Work*. East Sussex, UK: M. Bell Limited, 1984, 109.

28 **"his mother or"**: LP, 113.

28 **"I am still soft"**: BT, 88.

28 **"your very name"**: Quoted in Simon Karlinsky, *Marina Tsvetaeva: The Woman, Her World, and Her Poetry*. Cambridge: Cambridge University Press Archive, 1985, 163.

29 **"What!"**: RR, 96.

29 **"made a dragon"**: J. F. Hendry, *The Sacred Threshold: A Life of Rainer Maria Rilke*. Manchester, UK: Carcanet New Press, 1983, 32.

30 **"LAID IN THE HANDS"**: Rainer Maria Rilke and Lou Andreas-Salomé, *The Correspondence*. Translated by Edward Snow and Michael Winkler. New York and London: W. W. Norton, 2006, 157.

30 **"[Y]ou took my"**: BT, 91.

30 **"Put out my eyes"**: With permission—Rainer Maria Rilke, *Poems from The Book of Hours*. Translated by Babette Deutsch. New York: New Directions, 1975, 37.

30 **"be more by"**: Julia Vickers, *Lou von Salomé: A Biography of the Woman Who Inspired Freud, Nietzsche and Rilke*. Jefferson, NC: McFarland, 2008, 142.

31 **"go away"** . . . **"I would be capable"**: Quoted in Daniel Bullen, *The Love Lives of the Artists: Five Stories of Creative Intimacy*. Berkeley, CA: Counterpoint, 2013, 33.

CHAPTER THREE

32 **"terribly hideous"** . . . **"seemed so dreadful"**: Quoted in Robert K. Wittman and John Shiffman, *Priceless*. New York: Broadway Books, 2011, 37.

33 **"There are a thousand voices"**: Quoted in Victor Frisch and Joseph T. Shipley, *Auguste Rodin*. Frederick A. Stokes, 1939, 410.

34 **"There is nothing ugly"**: Auguste Rodin, Paul Gsell, *Art: Conversations with Paul Gsell*. Oakland: University of California Press, 1984, 19.

34 **"The mask determined"** . . . **"It was the first"**: Albert E. Elsen, *In Rodin's Studio*. New York: Phaidon, 1980, 157.

35 **"She didn't have"**: RSG, 48.

35 **"tough as a cannon ball"**: FG, 618

35 **"I had put"** . . . **"she attached herself"**: RSG, 48–49.

35 **"It is necessary"**: To Clara Westhoff, September 5, 1902. [Rilke's letter quoted Rodin in French, *parce qu'il faut avoir une femme*.]

36 **"unknown"**: RSG, 49.

36 **"Dinant is picturesque"**: FG, 93.

36 **"Hold on!"**: FG, 95.

36 **"not directly of his works"**: FG, 95.

37 **"the great magician"**: Catherine Lampert, *Rodin: Sculpture & Drawings*. New Haven, CT: Yale University Press, 1986, 13.

37 **"study rather than"**: Quoted in T. H. Bartlett, "Auguste Rodin," *American Architect and Architecture*, volume 25. March 2, 1889, 99.

37 **"in the absolute"**: RP, 3.

38 **"I am literally"**: RSG,110.

38 **"a very rare"**: Jacques De Caso and Patricia B. Sanders, *Rodin's Sculpture*. San Francisco: Fine Arts Museum of San Francisco, 1977, 44.

40 **"with a fury"**: Quoted in Albert E. Elsen, *Rodin's Art: The Rodin Collection of Iris and B. Gerald Cantor Center of Visual Arts at Stanford University*. Oxford: Oxford University Press, 2003, 21.

40 **"like an egg"**: Quoted in Marie-Pierre Delclaux, *Rodin: A Brilliant Life*. Paris: Musée Rodin, 2003, 114.

40 **"his feet"** . . . **"The fertile"**: Albert E. Elsen, *Rodin's Art: The Rodin Collection of Iris and B. Gerald Cantor Center of Visual Arts at Stanford University*. Oxford: Oxford University Press, 2003, 175.

41 **"whole body"**: AR, 49.

41 **"It is my door"**: Albert E. Elsen, *The Gates of Hell by Auguste Rodin*. Redwood City, CA: Stanford University Press, 1985, 60.

42 **"mishmash"** . . . **"a man of"**: Edmond De Goncourt and Jules de Goncourt, *Paris and the Arts, 1851–1896: From the Goncourt Journal*. Ithaca, NY: Cornell University Press, 1971, 234.

42 **"Your favourite qualities"**: Odile Ayral-Clause, *Camille Claudel: A Life*. New York: Harry N. Abrams, 2002, 67.

43 **"Have pity"**: RSG, 184.

43 **"rapid and luminous"**: Odile Ayral-Clause, *Camille Claudel: A Life*. New York: Harry N. Abrams, 2002, 50.

44 **"He's not proud"**: Quoted in Alex Danchev, *Cézanne: A Life*. New York: Pantheon Books, 2012, 281.

45 **"I merely"**: Stefan Zweig, *The World of Yesterday: An Autobiography*. Lincoln: University of Nebraska Press, 1964, 149.

45 **"Zola of sculpture"** . . . **"touched by"**: Frederick Lawton, *The Life and Work of Auguste Rodin*. New York: C. Scribner's, 1907, 247.

46 **"hit me like a"**: FG, 233.

47 **"This young nude"**: Quoted in Angelo Caranfa, *Camille Claudel: A Sculpture of Interior Solitude*. Plainsboro, NJ: Associated University Presses, 1999, 103.

47 **"her soul, genius"**: Quoted in John R. Porter, "The Age of Maturity or Fate." *Claudel and Rodin: Fateful Encounter*. Paris: Musée Rodin, 2005, 193.

47 "I am so"... "millionaire": Angelo Caranfa, *Camille Claudel: A Sculpture of Interior Solitude.* Plainsboro, NJ: Associated University Presses, 1999, 28.

CHAPTER FOUR

48 "Behind those walls"... "the great emporium": Janine Burke, *The Sphinx on the Table: Sigmund Freud's Art Collection and the Development.* New York: Bloomsbury, 2009, 74.

50 "Napoleon"... "wilderness of": Quoted in Asti Hustvedt, *Medical Muses: Hysteria in Nineteenth-Century Paris.* London: A&C Black, 2012, 12–15.

50 "Charcot was perfectly": Ernest Jones, *Sigmund Freud: Life and Work: The young Freud, 1856–1900.* London: Hogarth Press, 1953, 228.

50 "a man who sees": Quoted in Peter Gay, *Freud: A Life for Our Time.* New York: W. W. Norton, 2006, 51.

51 "whitewash"... "screaming": Max Simon Nordau, *Degeneration.* New York: D. Appleton, 1895, 28.

51 "Does an inspired"... "I had to": Albert E. Elsen, *In Rodin's Studio.* New York: Phaidon, 1980, 183.

52 "Help me"... "I did not": RP, 94.

53 "absolutely beautiful": Quoted in Sylvie Patin, *Monet: The Ultimate Impressionist.* New York: Harry N. Abrams, 1993, 142.

53 "goregous": Quoted in RSG, 317.

53 "the hope that in": Quoted in "Rodin and Monet," Musée Rodin Educational Files.

54 "I have made": FG, 384.

54 "financial disaster": RP, 94.

54 "Motor cars"... "When Rodin's": RSG, 384.

55 "Like Rembrandt": William G. Fitzgerald, "A Personal Study of Rodin." In *The World's Work: A History of Our Time,* volume 11. New York: Doubleday, Page, 1905, 6818–6834.

55 "Once you had seen": FG, 406.

58 "Unfortunately I won't"... "then I'll ask": DF, 53.

58 "Smaller men": FG, 406.

59 "If Paris": William G. Fitzgerald, "A Personal Study of Rodin." In *The World's Work: A History of Our Time,* volume 11. New York: Doubleday, Page, 1905, 6818–6834.

59 "royal road": Sigmund Freud, *The Interpretation of Dreams.* Translated by James Strachey. New York: Basic Books, 2010, 604.

60 "a phantasmagoria": Walter Benjamin, "Paris, Capital of the Nineteenth Century." In *Walter Benjamin and the Demands of History,* Michael P. Steinberg. Ithaca, NY: Cornell University Press, 1996, 139.

61 **"There's not even"**: FG, 411.

62 **"Where is his head?"** . . . **"Don't you know"**: Isadora Duncan, *My Life*. New York: W. W. Norton, revised and updated edition, 2013, 55.

62 **"the most modern"** . . . **"literally epoch-making"**: RP, 104.

62 **"I was there"** . . . **"has captured"**: PMB, 185, 192.

CHAPTER FIVE

64 **"How large the"**: DYP, 163.

64 **"I place great trust"** . . . **"Here I can"**: DYP, 175.

65 **"contrived"** . . . **"labored"**: DYP, 143.

65 **"a difficult"** . . . **"battle of"**: PMB, 198.

66 **"beautiful dark face"** DYP, 155–156.

66 **"I shake hands"**: DYP, 146.

66 **"sickening"**: DYP, 155–156.

66 **"disfigured"**: DYP, 157.

66 **"half held in thrall"**: Daniel Joseph Polikoff, *In the Image of Orpheus*. Wilmette, IL: Chiron Publications, 2011, 202

67 **"The Russian journey"**: DYP, 195.

67 **"we made toward"**: DYP, 168.

67 **"blond painter"**: DYP, 151.

67 **"a delusion"**: AR, 18.

68 **"my speeches with"**: To Clara Westhoff, November 18, 1900.

68 **"*I* wanted to be the wealthy"** . . . **"the most insignificant"**: BT, 117.

68 **"maiden"**: Common reference throughout DYP.

68 **"Clara W."**: PMB, 496.

68 **"have his welfare"** . . . **"be guided"**: PMB, 242.

69 **"Cooking, cooking"** . . . **"You know"**: PMB, 255.

69 **"I no longer seem"** . . . **"I have to first"**: PMB, 265.

69 **"last appeal"** . . . **"worst hour"**: RAS, 41–42.

69 **"sink like suns into"**: To Clara Westhoff, October 23, 1900.

70 **"the meaning of"**: To Julie Weinmann, June 25, 1902.

70 **"the beautiful biblical"**: DF, 113.

71 **"Life has become"**: To Julie Weinmann, June 25, 1902.

71 **"little creature"**: To Countess Franziska von Reventlow, April 11, 1902.

71 **"so very housebound"** . . . **"I now have everything"**: PMB, 267.

71 **"I don't know"** . . . **"please, please"**: PMB, 268–269. (Note: Becker's misspelling of Rilke's name as "Reiner" may have been an intentional double entendre, alluding to his pretension: "Reiner" is the German word for "pure.")

72 **"rejoice"** . . . **"I consider"**: PMB, 270.

72 **"lofty wife"** . . . **"The fact that"**: PMB, 273.

73 **"a frost, in which"** . . . **"would be like":** To Gustav Pauli, January 8, 1902.

74 **"to feel, to be real":** J. F. Hendry, The Sacred Threshold: A Life of Rainer Maria Rilke. Manchester, UK: Carcanet New Press, 1983, 43.

74 **"to work in libraries":** To Julie Weinmann, June 25, 1902.

74 **"How appalling:"** DF, 139.

74 **"What an artist":** FG, 440.

74 **"a single word":** H. F. Peters, "Rilke In His Letters to Rodin." *Modern Language Quarterly,* volume 4, University of Washington, 1943, 3.

75 **"utterly absorbed"** . . . **"growing and":** To Arthur Holitscher, July 31, 1902.

75 **"the whole sky":** Rainer Maria Rilke, *Stories of God.* Translated by M. D. Herter Norton. W. W. Norton, 1992, 77.

75 **"It is the most":** To Auguste Rodin, August 1, 1902.

PART TWO · CHAPTER SIX

79 **"drying up"** . . . **"right through":** To Lou Andreas-Salomé, July 18, 1903.

81 **"like eyes":** J. F. Hendry, *The Sacred Threshold: A Life of Rainer Maria Rilke.* Manchester, UK: Carcanet New Press, 1983, 45.

81 **"The sculptor is":** Robert Descharnes and Jean-François Chabrun, *Auguste Rodin.* Translation from Edita Lausanne. Secaucus, NJ: Chartwell Books, 1967, 118.

81 **"sparsely filled":** AR, 115.

82 **"ship out"** . . . **"like a child":** To Clara Westhoff, September 2, 1902.

83 **"compressing hours":** To Clara Westhoff, April 19, 1906.

83 **"He is very dear"** . . . **"That I knew":** To Clara Westhoff, September 2, 1902.

84 **"untroubled happiness":** Anita Leslie, *Rodin: Immortal Peasant.* New York: Prentice-Hall, 1937, 167.

84 **"I do not approve":** RSG, 366.

85 **"gives one the":** RSG, 363.

85 **"To this I devoted":** Quoted in Donald A. Prater, *A Ringing Glass: The Life of Rainer Maria Rilke.* Oxford, UK: Clarendon Press, 1986, 90.

86 **"work of a century"** . . . **"inhabitants of":** To Clara Westhoff, September 2, 1902.

87 **"smashed up":** Anita Leslie, *Rodin: Immortal Peasant.* New York: Prentice-Hall, 1937, 219.

87 **"no bigger":** To Clara Westhoff, September 2, 1902.

88 **"I read it in your":** With permission. Rainer Maria Rilke, *Poems from the Book of Hours.* Translated by Babette Deutsch. New York: New Directions, 1941, 17.

88 **"I am glad"** . . . **"My eyes are":** To Clara Westhoff, September 2, 1902.

88 **"past the shy":** To Clara Westhoff, September 5, 1902.

88 **"grafted on":** Auguste Rodin and Paul Gsell, *Art: Conversations with Paul Gsell.* Oakland: University of California Press, 1984, 34.

89 **"*Voilà*":** To Clara Westhoff, September 5, 1902.

90 **"look neither right"** . . . **"one must choose":** To Clara Westhoff, September 5, 1902.

90 **"one night will":** LP, 174.

90 **"I spoke of":** To Clara Westhoff, September 5, 1902. [Rilke's original letter quoted Rodin in French: *"Oui, il faut travailler, rien que travailler. Et il faut avoir patience."*]

91 **"disarm even"** . . . **"Why do I":** To Auguste Rodin, September 11, 1902.

91 **"become the example"** . . . **"It is not just":** RSG, 375.

91 **"Look, it only"** . . . **"That's good":** FG, 500.

92 **"not like a house"** . . . **"but only":** Jean Cocteau, *Cocteau's World: An Anthology of Writings.* Edited by Margaret Crosland. New York: Dodd, Mead, 1972, 357.

92 **"too great"** . . . **"earthly angels":** Quoted in Sue Roe, *Gwen John: A Life.* London: Chatto & Windus, 2001, 101.

92 **"without knowing":** Rainer Maria Rilke, *Rodin and Other Prose Pieces.* Translated by G. Craig Houston. London: Quartet Books, 1986, 52.

92 **"The creative artist":** Rainer Maria Rilke, *Auguste Rodin.* New York: Parkstone Press International, 2011, 131.

93 **"miracle"** . . . **"never have":** To Clara Westhoff, September 26, 1902.

94 **"to work is to live":** To Auguste Rodin, September 22, 1902.

CHAPTER SEVEN

95 **"common and touching":** Rainer Maria Rilke, *Auguste Rodin.* New York: Parkstone Press International, 2011, 6.

96 **"Fame is":** AR, 7.

96 **"At last!":** Charles Baudelaire, *Paris Spleen.* Translated by Louise Varèse. New York: New Directions, 1869, 1970, 15.

96 **"What was your life"** . . . **"Then I was like":** AR, 145.

97 **"who affected me":** RAS, 116.

98 **"To Clara. The beloved":** LP, 176.

98 **"The nearness"** . . . **"of being set":** DF, 140–141.

98 **"Already flowers":** To Lou Andreas-Salomé, August 8, 1903.

98 **"tool of my art":** To Lou Andreas-Salomé, August 10, 1903.

99 **"was his Africa":** Quoted in Lisa Gates, "Rilke and Orientalism: Another Kind of Zoo Story." *New German Critique.* No. 68, Spring–Summer. Durham, NC: Duke University Press, 1996, 69.

100 **"Though you may"** . . . **"if I tell you":** To Magda von Hattingberg, February 17, 1914.

100 **"cheerful yellow":** Jon E. Roeckelein, *Dictionary of Theories, Laws, and Concepts in Psychology*. Santa Barbara, CA: Greenwood Publishing, 1998, 308.

100 **"beholder's involvement":** Alois Riegl, *The Group Portraiture of Holland*. Los Angeles: Getty, 2000, 11.

100 **"C'est beau"** . . . **"And from this":** To Clara Westhoff, September 27, 1902.

101 **"mood-images":** Quoted in Donald A. Prater, *A Ringing Glass: The Life of Rainer Maria Rilke*. Oxford, UK: Clarendon Press, 1986, 92.

102 **"Poems are not":** Rainer Maria Rilke, *The Notebooks of Malte Laurids Brigge*. Translation by Stephen Mitchell. New York: Vintage, paperback, 1985, 19.

102 **"thing-poems":** Rainer Maria Rilke, *New Poems (1907)*. Translation and introduction by Edward Snow. San Francisco: North Point Press, 1984, x.

102 **"as revolutionary":** John Banville, "Study the Panther!" *The New York Review of Books*. January 10, 2013.

102 **"still nothing":** . . . **"course through":** RAS, 72–73

102 **"more visible"** . . . **"for which I yearn":** RAS, 92.

103 **"time-worn lecture":** Stefan Zweig, *The World of Yesterday: An Autobiography*. Lincoln: University of Nebraska Press, 1964, 39.

103 **"Poems of Rainer"** . . . **"hoped to find":** LYP, 11–12.

104 **"I cannot buy":** LYP, 32.

104 **"the beautiful"** . . . **"Time flows":** To Otto Modersohn, December 31, 1902.

104 **"That dreadful":** PMB, 226.

105 **"bound to the plow":** DYP, 150.

106 **"trumpet gloom":** PMB, 293.

106 **"Ever since":** DF, 149.

106 **"Rilke is gradually":** PMB, 305.

106 **"We shall see":** DF, 149.

106 **"wife of a":** E. M. Butler, *Rainer Maria Rilke*. Cambridge: Cambridge University Press, 2013, 107.

106 **"he doesn't"** . . . **"worship":** PMB, 303.

107 **"Work, that is my pleasure":** DF, 151, in French.

107 **"Yes, whatever":** PMB, 303.

107 **"I can't stand":** PMB, 308.

108 **"I cannot bring":** Quoted in Hugo Caudwell, *The Creative Impulse in Writing and Painting*. New York: Macmillan, 1951, 16.

108 **"I must wait":** Robin Skelton, *The Poet's Calling*. London: Heinemann, 1975, 5.

108 **"My Dear Sir"**: LYP, 17.

108 **"beautiful"** . . . **"weighed"**: LYP, 12.

108 **"Search for the"** . . . **"always come down"**: LYP, 17–19.

109 **"growing and evolving"**: LYP, 13.

110 **"long terrifying"**: Quoted in Michael Jackson, *The Other Shore: Essays on Writers and Writing*. Berkeley and Los Angeles: University of California Press, 2013, 95.

110 **"I have written"**: To Ellen Key, April 3, 1903.

<div align="center">CHAPTER EIGHT</div>

111 **"I underlined"**: Rainer Maria Rilke, *Selected Letters of Rainer Maria Rilke*. Translated by R. F. C. Hull. London: Macmillan, 1946, 19.

112 **"There is here no measuring"**: LYP, 30.

112 **"sunk in"** . . . **"dug a deep"**: To Lou Andreas-Salomé, August 8 1903.

112 **"About its depth"**: LYP, 25–26

112 **"I actually experienced"** . . . **"the nearness of something"**: Lou Andreas-Salomé, *You Alone are Real to Me: Remembering Rainer Maria Rilke*. Rochester, NY: BOA Editions, 2003, 54.

113 **"He has created bodies"**: AR, 48.

113 **"From no other"** . . . **"can we deduce"**: Rainer Maria Rilke, *Poems of Rainer Maria Rilke*. Introduction by H. T. Tobias A. Wright. New York: Tobias A. Wright, 1918, xxxiv-xxxv.

113 **"enthusiastic"** . . . **"It is a poem"**: Henry F. Fullenwider, "Rilke and His Reviewers: An Annotated Bibliography." Lawrence: University of Kansas Publications, 1978, 6–8.

113 **"For with this little book"** . . . **"from this moment on"**: Rainer Maria Rilke, *Briefe an Auguste Rodin*. Leipzig: Insel-Verlag, 1928, 67. [Translated from the German: *"Denn mit diesem kleinen Buch hat Ihr Werk nicht aufgehört, mich zu beschäftigen . . . und von diesem Moment an wird es da sein in jeder Arbeit, in jedem Buch, das zu vollenden mir noch erlaubt sein wird."*]

113 **"to hear your voice"**: Rainer Maria Rilke, *Briefe an Auguste Rodin*. Leipzig: Insel-Verlag, 1928, 68. [Translated from the German: *"um Ihre Stimme zusammen mit denen des Meeres und des Windes zu hören."*]

114 **"Please receive"**: RSG, 375.

114 **"restlessness and violence"**: Rainer Maria Rilke, *Selected Letters of Rainer Maria Rilke*. Translated by R. F. C. Hull. London: Macmillan, 1946, 21.

114 **"But if it's *you*"**: LB, 79.

115 **"For weeks I have"**: Rainer Maria Rilke and Lou Andreas-Salomé, *The Correspondence*. Translated by Edward Snow and Michael Winkler. New York and London: W. W. Norton, 2006, 44.

115 **"a peasant woman"**: Rainer Maria Rilke and Lou Andreas-Salomé, *The Correspondence*. Translated by Edward Snow and Michael Winkler. New York and London: W. W. Norton, 2006, 90.

115 **"psychic reorientation"**: RAS, 67.

115 **"That you gave yourself"** . . . **"beyond doubt"**: Rainer Maria Rilke and Lou Andreas-Salomé, *The Correspondence*. Translated by Edward Snow and Michael Winkler. New York and London: W. W. Norton, 2006, 65.

115 **"From now on"**: RAS, 67.

115 **"I won't complain"**: Rainer Maria Rilke and Lou Andreas-Salomé, *The Correspondence*. Translated by Edward Snow and Michael Winkler. New York and London: W. W. Norton, 2006, 45.

116 **"I can ask"** . . . **"two old"**: LP, 184.

116 **"There is nothing real"**: To Lou Andreas-Salomé, August 8 1903.

116 **"drawn along"**: To Lou Andreas-Salomé, July 18, 1903.

116 **"I was as if"**: RAS, 56.

117 **"You have become"**: RAS, 59.

118 **"small and"**: DF, 133.

118 **"in the process"**: DF, 130.

118 **"There is a lot"**: PMB, 305.

119 **"man"** . . . **"good man"**: Rainer Maria Rilke and Lou Andreas-Salomé, *The Correspondence*. Translated by Edward Snow and Michael Winkler. New York and London: W. W. Norton, 2006, 62.

119 **"Roman winter"**: Rainer Maria Rilke and Lou Andreas-Salomé, *The Correspondence*. Translated by Edward Snow and Michael Winkler. New York and London: W. W. Norton, 2006, 88.

119 **"Jacobsen's city"**: RL, 194.

119 **"It was difficult to reach"** . . . **"He had no"**: Stefan Zweig, *The World of Yesterday: An Autobiography*. Lincoln: University of Nebraska Press, 1964, 141.

119 **"having a hard time"**: To Clara Westhoff, July 27, 1904.

120 **"beautiful concern"** . . . **"sure and calm"**: LYP, 33–39.

120 **"Do not write love-poems"**: LYP, 19.

120 **"things that hardly anyone"**: LYP, 34.

120 **"mental nausea"**: RAS, 261.

120 **"nameless horror"**: To Ellen Key, April 3, 1903.

120 **"words about words"**: To Lou Andreas-Salomé, May 13, 1904.

121 **"firm, close-knit"**: To Lou Andreas-Salomé, May 12, 1904.

121 **"There are starry"**: RAS, 117.

121 **"enable me to"**: RAS, 119.

121 **"To love is good"** . . . **"difficult."** LYP, 53.

121 **"Love is at first"** . . . **"as burden and"**: LYP, 54–58.

122 **"teacher of"** . . . **"questions and"**: Rainer Maria Rilke and Lou

Andreas-Salomé, *The Correspondence*. Translated by Edward Snow and Michael Winkler. New York and London: W. W. Norton, 2006, 137.

122 **"protective"** . . . **"intensification"**: Quoted in Scott Appelrouth and Laura Desfor Edles, *Classical and Contemporary Sociological Theory: Text and Readings*. Thousand Oaks, CA: Pine Forge Press, 2008, 262–273.

122 **"Every intensification"**: Rainer Maria Rilke, *Letters to a Young Poet*. Translated by Stephen Mitchell. New York: Random House, 2004, 101.

123 **"By inventing a new"**: Quoted in Debora L. Silverman, *Art Nouveau in Fin-de-siècle France*. Berkeley and Los Angeles: University of California Press, 1992, 313.

123 **"one should not draw"**: Rainer Maria Rilke, *Selected Letters of Rainer Maria Rilke*. Translated by R. F. C. Hull. London: Macmillan, 1946, 76.

124 **"inner history"** . . . **"indispensable"**: To Clara Westhoff, June 16, 1905.

124 **"cuddly"** . . . **"getting to see"**: PMB, 375.

124 **"one tear after"**: Quoted in Diane Radycki, *Paula Modersohn-Becker: The First Modern Woman Artist*. New Haven, CT: Yale University Press, 2013, 130.

124 **"What Paula"** . . . **"very much under"**: PMB, 377–378.

125 **"My very dear"**: LP, 228.

125 **"It is the need to see you"**: Auguste Rodin, *Correspondance de Rodin*, *II*, Editions du Musée Rodin, 1987, 167. [From the French: *C'est le besoin de vous revoir, mon Maître, et de vivre un moment la vie ardente de vos belles choses, qui m'agitent.*]

125 **"so you can talk"**: To Clara Westhoff, September 7, 1905, in French.

125 **"its garden"**: To Clara Westhoff, September 7, 1905.

125 **"Follow my example"**: DF, 178.

126 **"Without doubt"**: DYP, 166.

126 **"blocks of sound"**: Quoted in Malcolm MacDonald, *Varèse: Astronomer in Sound*. London: Kahn & Averill, 2003, 15.

126 **"revolting slaughter"** . . . **"doesn't know how"**: FG, 497.

127 **"asininities as if"**: Louise Varèse, *Varèse: A Looking-Glass Diary*. New York: W. W. Norton, 1972, 34.

127 **"didn't know a damn"**: FG, 493.

127 **"We have actually three"** . . . **"sound projection"**: Edgard Varèse, "The Liberation of Sound." *Audio Culture: Readings in Modern Music*. Edited by Christoph Cox and Daniel Warner. London: A&C Black, 2004. Originally published in 1936. 18.

127 **"Much more world"**: To Clara Westhoff, September 15, 1905.

127 **"It is wonderful how"**: Rainer Maria Rilke, *Selected Letters of Rainer Maria Rilke*. Translated by R. F. C. Hull. London: Macmillan, 1946, 78.

127 **"like a big dog"** . . . **"recognizing me"**: To Clara Westhoff, September 15, 1905.

128 **"make good the"**: FG, 502–503.

128 "My pupils" . . . "They are all": FG, 495.

129 "head spin": FG, 493.

129 "his deepest desire": LB, 78.

129 "I shall come" . . . "He wants me": To Countess Luise Schwerin, September 10, 1905.

129 "if you'll deign": FG, 493.

130 "has become a stanza": To Arthur Holitscher, December 13, 1905.

130 "*joie de vivre*": FG, 492.

CHAPTER NINE

131 "Rilke plunged" . . . "For the first": Victor Frisch and Joseph T. Shipley, *Auguste Rodin*. Frederick A. Stokes, 1939, 272.

131 "everything": FG, 492.

132 "how necessary": To Arthur Holitscher, December 13, 1905.

132 "He shows you everything": Rainer Maria Rilke, *Selected Letters of Rainer Maria Rilke*. Translated by R. F. C. Hull. London: Macmillan, 1946, 77.

132 "The smallest things": To Arthur Holitscher, December 13, 1905.

132 "blossoming in this": Rainer Maria Rilke, *Selected Letters of Rainer Maria Rilke*. Translated by R. F. C. Hull. London: Macmillan, 1946, 82.

132 "flinging themselves" . . . "unspeakable": Rainer Maria Rilke, *Selected Letters of Rainer Maria Rilke*. Translated by R. F. C. Hull. London: Macmillan, 1946, 81.

133 "good and faithful": Rainer Maria Rilke, *Selected Letters of Rainer Maria Rilke*. Translated by R. F. C. Hull. London: Macmillan, 1946, 77.

133 "white bird": Clara Westhoff, December 2, 1905.

134 "Acropolis of France": CF, 203.

134 "The chief thing": Auguste Rodin, "The Gothic in France." *The North American Review*, volume 207, 1918, 116.

135 "suppleness": CF, 206.

135 "There's a storm" . . . "But you don't": Rainer Maria Rilke, *Selected Letters of Rainer Maria Rilke*. Translated by R. F. C. Hull. London: Macmillan, 1946, 81. [Rodin's quote translated from the original French].

136 "outrage inflicted": FG, 503.

136 "liberation": FG, 421.

136 "mass of untransformed": Rainer Maria Rilke, *Selected Letters of Rainer Maria Rilke*. Translated by R. F. C. Hull. London: Macmillan, 1946, 84.

136 "the most elevated": Ralph Freedman, "Das Stunden-Buch and Das Buch der Bilder: Harbingers of Rilke's Maturity." In *A Companion to the Works of Rainer Maria Rilke*, Edited by Erika A. Metzger and Michael M. Metzger. Rochester, NY: Camden House, 2001, 90.

137 **"But I need 'only time'"**: Rainer Maria Rilke, *Selected Letters of Rainer Maria Rilke.* Translated by R. F. C. Hull. London: Macmillan, 1946, 83.

137 **"incapable of love"**: BT, 131.

138 **"suggests a scatalogical"** . . . **"bestial countenance"**: FG, 504.

138 **"I avenge myself"**: RSG, 427.

138 **"need of my support"**: To Karl von der Heydt, Wednesday after Easter 1906.

139 **"had left the prime"** . . . **"In the first fifteen"**: George Bernard Shaw, "G.B.S. On Rodin." *The Nation.* London, December 1912.

140 **"indescribable delight"**: RSG, 391.

141 **"M. Shaw does not"**: RSG, 390.

141 **"Bernarre Chuv"**: FG, 511.

141 **"Rarely has a"**: RSG, 390.

141 **"this truly creative"**: RP, 120.

142 **"No photograph yet"** . . . **"except their suits"**: Alvin Langdon Coburn, *Alvin Langdon Coburn, Photographer.* Edited by Helmut and Alison Gernsheim. New York: Dover, 1978, 40.

142 **"luminous"**: FG, 570.

142 **"He saw me"**: George Bernard Shaw, "G.B.S. On Rodin." *The Nation,* London, December 1912.

143 **"Shaw, Bernard:"** Quoted in Sally Peters, *Bernard Shaw: The Ascent of the Superman.* New Haven, CT: Yale University Press. 1996, 235.

CHAPTER TEN

144 **"mince-meat"** . . . **"They've opened up"**: LYR, 75–76.

145 **"ounce of fat"**: FG, 522.

145 **"He is mad, brutally"**: FG, 517.

145 **"Of course I'm a sensual"** . . . **"not the sensuality"**: FG, 514.

145 **"understand me better"**: Frederick Lawton, *The Life and Work of Auguste Rodin.* New York: C. Scribner's, 1907, 276.

146 **"erotomania"** . . . **"The whole of Paris"**: Quoted in Auguste Rodin, Dominique Viéville, *Rodin: The Figures of Eros : Drawings and Watercolours, 1890–1917.* Paris: Musée Rodin, 2006, 64.

146 **"Sultan of Meudon"**: Alexander Sturgis, *Rebels and Martyrs: The Image of the Artist in the Nineteenth Century.* New Haven, CT: Yale University Press, 2006, 166.

146 **"Nothing is so amusing"** . . . **"She takes off"**: LYR, 75–76.

146 **"some girl or other"**: Alma Mahler, *Gustav Mahler: Memories and Letters.* Translated by Basil Creighton. New York: Viking, 1946, 136.

147 **"The details hardly"** . . . **"She wanted to live"**: Jean Cocteau, *Paris Album: 1900–1914.* London: W. H. Allen, 1956, 108–109.

148 **"He ran his hands"** . . . **"How often"**: Isadora Duncan, *My Life.* New York: W. W. Norton, revised and updated, 2013, 74–75.

149 **"little wife"**: RSG, 457.

149 **"very poorly dressed"**: FG, 487.

150 **"Yes, I am proud"**: RSG, 415.

150 **"No use disturbing"**: Bernard Harper Friedman, *Gertrude Vanderbilt Whitney: A Biography.* New York: Doubleday, 1978, 288.

150 **"The Influenza"**: James Wyman Barrett, *Joseph Pulitzer and his World.* New York: Vanguard, 1941, 288.

151 **"astonishing intensity"**: Rainer Maria Rilke, *Selected Letters of Rainer Maria Rilke.* Translated by R. F. C. Hull. London: Macmillan, 1946, 86.

152 **"Rodin's disposition had"** . . . **"brutally and"**: Judith Cladel, *Rodin.* Translated by James Whitall. New York: Harcourt, Brace, 1937, 203.

152 **"like a thieving"**: To Auguste Rodin, May 12, 1906.

152 **"poor Rilke"** . . . **"difficult person"**: William Rothenstein, *Since Fifty.* Volume 3. London: Faber & Faber, 1939, 314–315.

152 **"When he was through"**: Lou Tellegen, *Women Have Been Kind: The Memoirs of Lou Tellegen.* New York: Vanguard, 1931, 80.

152 **"always called a spade"**: Quoted in FG, 564.

153 **"uneducated, coarse"** . . . **"very much beneath"**: Anthony Ludovici, online excerpt from *Confessions of an Anti-Feminist: The Autobiography of Anthony M. Ludovici.* Edited by John V. Day. Counter-Currents.

153 **"unflinching sympathy"**: PR, vii.

153 **"the proverbial"**: Anthony M. Ludovici, "Rilke's Rodin." *London Forum,* 1.1, 1946, 41–50.

154 **"Monsieur Rodin"**: RSG, 480.

154 **"in a violent quarrel"**: Anthony Ludovici, online excerpt from *Confessions of an Anti-Feminist: The Autobiography of Anthony M. Ludovici.* Edited by John V. Day. Counter-Currents.

154 **"the demands"** . . . **"to say anything"**: To Clara Westhoff, June 28, 1907.

155 **"Rilke was much"**: Anthony M. Ludovici, "Rilke's Rodin." *London Forum,* 1.1, 1946, 41–50.

155 **"I'm not Modersohn"**: PMB, 384.

156 **"happy"**: To Clara Westhoff, May 12, 1906

156 **"I am profoundly"**: To Auguste Rodin, May 12, 1906.

156 **"a private secretary"** . . . **"in reality a"**: LB, 78.

156 **"It was not to your"** . . . **"I understand"**: To Auguste Rodin, May 12, 1906.

156 **"what should have"**: To Clara Westhoff, June 14, 1906.

157 **"It's Modersohn"**: Quoted in Diane Radycki, *Paula Modersohn-Becker: The First Modern Woman Artist.* New Haven, CT: Yale University Press, 2013, 136.

157 **"Please spare both"**: PMB, 408.

158 **"kneel down"**: To Clara Westhoff, June 29, 1906.

158 **"What do you know"**: Rainer Maria Rilke, "L'Ange du Méridien." *New Poems.* Translated by Edward Snow. New York: Macmillan, 2001, 5.

159 **"This is no figure of a son"**: Rainer Maria Rilke, *Rodin and Other Prose Pieces.* Translated by G. Craig Houston. London: Quartet Books, 1986, 39.

159 **"This last period"**: To Karl von der Heydt, July 31, 1906.

160 **"interior marriage"**: LP, 175.

161 **"I will not give up"**: To Clara Westhoff, December 17, 1906.

161 **"To be loved"**: Rainer Maria Rilke, *The Notebooks of Malte Laurids Brigge.* Translation by Stephen Mitchell. New York: Vintage, paperback, 1985, 250.

161 **"Since that first contact"**: Rainer Maria Rilke, *Selected Letters of Rainer Maria Rilke.* Translated by R. F. C. Hull. London: Macmillan, 1946, 115.

162 **"I have again stored"**: To Elisabeth von der Heydt, February 10, 1907.

162 **"My god"**: RAS, 192.

162 **"the space around"**: Rainer Maria Rilke, *Letters to a Young Poet.* Translated by Stephen Mitchell. New York: Random House, 1984, 40.

CHAPTER ELEVEN

164 **"in a contact"** . . . **"in a sudden"**: Wilhelm Worringer, *Abstraction and Empathy: A Contribution to the Psychology of Style.* Chicago: Ivan R. Dee, 1997, xvi–xvii

165 **"more editions"**: Ursula Helg, " 'Thus we forever see the ages as they appear mirrored in our spirits': Wilhelm Worringer's Abstraction and Empathy as :longseller, or the birth of artistic modernism from the spirit of the imagined other." *Journal of Art Historiography*, number 12, June 2015, 3.

165 **"the effect of establishing"**: Wilhelm Worringer, *Abstraction and Empathy: A Contribution to the Psychology of Style.* Chicago: Ivan R. Dee, 1997, xxx.

165 **"in absolute agreement"**: Quoted in Neil H. Donahue, *Invisible Cathedrals: The Expressionist Art History of Wilhelm Worringer.* University Park, PA: Penn State Press, 1995, 1.

166 **"Finally, for once"**: Quoted in Neil H. Donahue, *Invisible Cathedrals: The Expressionist Art History of Wilhelm Worringer.* University Park, PA: Penn State Press, 1995, 70.

166 **"little cubes"**: Quoted in Alex Danchev, *Georges Braque: A Life.* New York: Arcade, 2005, 79.

166 **"weapons"** . . . **"Les Demoiselles"**: André Malraux, *Picasso's Mask.* Boston: Da Capo, 1995, 11.

167 **"Spanish in origin":** Quoted in Mary Ann Caws, *Pablo Picasso.* Clerkenwell: Reaktion, 2005, 32.

167 **"young people want"** . . . **"striving for":** Herman Bernstein, *With Master Minds: Interviews.* New York: Universal Series, 1913, 126.

167 **"For the majority":** *Quoted in Leaving Rodin behind? Sculpture in Paris, 1905–1914.* Edited by Catherine Chevillot. Paris: Musee d'Orsay, 2009.

167 **"When I began to"** . . . **"His works":** FG, 578.

168 **"nothing grows":** Quoted in David W. Galenson, *Old Masters and Young Geniuses: The Two Life Cycles of Artistic Creativity.* Princeton, NJ: Princeton University Press, 2011, 115.

168 **"It is impossible":** Pam Meecham and Julie Sheldon, *Modern Art: A Critical Introduction.* London and New York: Routledge, 2000, 88.

168 **"He told me I":** Dorothy M. Kosinski, Jay McKean Fisher, and Steven A. Nash, *Matisse: Painter as Sculptor.* New Haven, CT: Yale University Press, 2007, 106.

168 **"fuss over it":** André Gide, *Journals: 1889–1913.* Translated by Justin O'Brien. Urbana and Chicago: University of Illinois Press, 2000, 174.

168 **"merely showed"** . . . **"He could not":** Henri Matisse, Jack D. Flam, *Matisse on Art.* Berkeley: University of California Press, 1995, 126.

169 **"the reverse"** . . . **"replacing explanatory":** Jean Leymarie, *Henri Matisse,* Issue 2. Berkeley: University of California Press, 1966, 20.

169 **"a man of the Middle Ages":** Catherine Lampert, *Rodin.* London: Royal Academy of Arts, 2006, 15.

169 **"At home, I have"** . . . **"talk to me":** Jennifer Gough-Cooper, *Apropos Rodin.* London: Thames & Hudson, 2006, 56.

170 **"Stripped of all":** RSG, 407.

171 **"wonderful palace"** . . . **"my daughter":** Mary French, *Memories of a Sculptor's Wife.* Boston and New York: Houghton Mifflin, 1928, 203.

171 **"a young American":** FG, 530.

171 **"astonishing how":** JA, 495.

171 **"was not among his best":** FG, 570.

171 **"All the world sees":** Helen Zimmern, "Auguste Rodin Loquitur." *The Critic,* volume 41, 1902, 518.

172 **"no vertical lines":** Quoted in Jerry Saltz, *Seeing Out Loud: The Village Voice Art Columns.* Great Barrington, MA: The Figures, 2003, 38.

172 **"the Professor":** Quoted in Hilary Spurling, *The Unknown Matisse: A Life of Henri Matisse: The Early Years, 1869–1908.* Oakland: University of California Press, 2001,378.

172 **"I have simply":** Henri Matisse, Jack D. Flam, *Matisse on Art.* Berkeley and Los Angeles: University of California Press, 1995, 81.

174 **"An uproarious horde":** Quoted in Francis Steegmuller, *Cocteau: A Biography.* New York: Little, Brown, 1970, 38.

174 **"to mark the end"**: Jean Cocteau, *Paris Album: 1900–1914*. London: W. H. Allen, 1956, 134.

<div align="center">CHAPTER TWELVE</div>

176 **"a night café"** . . . **"overpowers"**: To Clara Westhoff, June 7, 1907.

177 **"I couldn't go away"**: To Clara Westhoff, June 13, 1907.

177 **"no longer so full"** . . . **"the sort of woman"**: PMB, 413.

177 **"Poor little creature"**: PMB, 409.

177 **"If only we can"**: PMB, 418.

177 **"inattentive"**: Quoted in Kaja Silverman, *Flesh of My Flesh*. Redwood City, CA: Stanford University Press, 2009, 72.

178 **"strange and"**: To Clara Westhoff, August 30, 1907.

178 **"would have been an"** . . . **"through the circumstances"**: To Clara Westhoff, June 26, 1907.

178 **"I at once grasped"**: To Clara Westhoff, June 19, 1907.

179 **"with sharply bent"**: To Clara Westhoff, June 21, 1907.

179 **"tar and turpentine"** . . . **"scream the"**: To Clara Westhoff, September 13, 1907.

179 **"Salon de Bouguereau"**: Alex Danchev, *Cézanne: A Life*. New York: Pantheon, 2012, 3.

179 **"color-drunk"**: Jacqueline Munck, "Vollard and the Fauves: Derain and Vlaminck." *Cézanne to Picasso*. New York: Metropolitan Museum of Art, 2006, 127.

180 **"laughed themselves"**: Quoted in Hilary Spurling, *The Unknown Matisse: A Life of Henri Matisse: The Early Years, 1869–1908*. Oakland: University of California Press, 2001, 371.

180 **"as if at a bad"**: LC, 31.

180 **"unquestioning, matter-of-fact"**: LC, 74–75.

181 **"All of reality"**: LC, 27.

181 **"the first and ultimate"** . . . **"The interior"**: LC, 71.

181 **"that painting is made"**: LC, 28.

181 **"gray"** . . . **"I should have"**: LC, 76.

181 **"Not since Moses"**: Quoted in LC, x.

181 **"thunderstorm blue"** . . . **"wet dark"**: LC, xix–xx.

182 **"Homeric elders"**: Anna A. Tavis, "Rilke and Tolstoy: The Predicament of Influence." *The German Quarterly*, 65.2, Spring 1992, 192–200.

182 **"so totally"**: JA, 539.

182 **"I will astonish"**: Paul Cézanne, *Conversations with Cézanne*. Edited by P. Michael Doran. Oakland: University of California Press, 2001, 6.

182 **"It is the turning"**: LC, 57.

182 **"the right eyes"**: LC, 39.

182 **"You can imagine"** . . . **"I know much":** To Clara Westhoff, October 19, 1907.

183 **"It was his task"** . . . **"whether you can":** Rainer Maria Rilke, *The Notebooks of Malte Laurids Brigge.* Translation by Stephen Mitchell. New York: Vintage, paperback, 1985, 72.

183 **"lines like reliefs:"** AR, 29.

183 **"through his own":** LC, 305.

184 **"This angel is a figure":** Hans Belting, *The Invisible Masterpiece.* Translated by Helen Atkins. Chicago: University of Chicago Press, 2001, 247.

185 **"in a state of blissful"** . . . **"For me":** FG, 520.

185 **"ghastly old ladies":** RL, 232.

185 **"pitiful, pleasure-seeking":** To Valery David-Rhonfeld, December 4, 1894.

185 **"like a relapse":** LB, 83.

186 **"just as factually":** To Clara Westhoff, November 4, 1907.

186 **"très belle":** BT, 193.

186 **"We have need"** . . . **"so many":** To Clara Westhoff, November 11, 1907. [Translated from French in a note.]

186 **"I could hardly believe"** . . . **"The dear":** To Clara Westhoff, November 11, 1907.

186 **"I have an infinite"** . . . **"I am proud":** BT, 193.

186 **"full, resonant":** Quoted in RL, 234.

187 **"It seems to me":** PMB, 424.

187 **"fifty-six"** . . . **"If it were not"** : PMB, 425.

188 **"A pity":** DF, 222.

188 **"and Paula was no":** DF, 223.

CHAPTER THIRTEEN

189 **"Scarcely three steps":** To Clara Westhoff, June 14, 1906.

190 **"rumor"** . . . **"temporarily":** To Alfred Schaer, February 26, 1924.

190 **"Come to Meudon":** *Correspondance de Rodin, III.* Editions du Musée Rodin, 1987, 39. [From the French: *venez vous demain dans l'après midi à Meudon, si vous le pouvez*]

190 **"locked in my house":** *Correspondance de Rodin, III*, Editions du Musée Rodin, 1987, 44. [From the French: *je suis enfermé chez moi comme le noyau l'est dans son fruit.*]

190 **"It would be a pleasure to see you":** *Correspondance de Rodin, III.* Editions du Musée Rodin, 1987, 44. [From the French: *j'aurai du plaisir à vous voir, à causer, à vous montrer des antiques.*]

191 **"very scared":** FG, 297.

192 **"great fertile plain":** Quoted in Christian Borngräber, *Berliner*

Design-Handbuch. Berlin: Merve, 1987, 61. [From the German: *"die große fruchtbare Ebene."*]

192 **"This is Rodin":** BT, 195.

192 **"an old country house":** JA, 554.

192 **"You ought to see":** FG, 551.

192 **"No friend have I" . . . "to need us now":** To Clara Westhoff, September 3, 1908.

194 **"no one will find":** To Clara Westhoff, September 3, 1908.

194 **"a pool of silence":** RSG, 459.

194 **"How long I wait":** FG, 554.

195 **"which nobody wants":** To Clara Westhoff, November 3, 1909.

195 **"modulate silence":** Quoted in Malcolm MacDonald, *The Symphonies of Havergal Brian*. London: Kahn & Averill, 1983, 249.

195 **"as before a great" . . . "he used to":** To Clara Westhoff, November 3, 1909.

195 **"Come live here" . . . "Yes, but":** Frederick Brown, *An Impersonation of Angels: A Biography of Jean Cocteau*. New York: Viking, 1968, 30–31.

197 **"I believed I knew" . . . "Success had put me":** Jean Cocteau, *Paris Album: 1900–1914*. London: W. H. Allen, 1956, 135.

197 **"but one wish":** William H. Gass, Reading Rilke: Reflections on the Problems of Translation. New York: Knopf, 1999, 132. [1.5 lines.]

197 **"I have my dead":** Rainer Maria Rilke, *Selected Poems/Ausgewahlte Gedichte: A Dual-Language Book*. Edited and translated by Stanley Appelbaum. New York: Dover, 2011, 141.

198 **"I accuse all men":** Rainer Maria Rilke, *Selected Poems: With Parallel German Text*. Translated by Susan Ranson and Marielle Sutherland. Oxford: Oxford University Press, 2011, 53.

198 **"Do not return":** Rainer Maria Rilke, *Requiem and Other Poems*. Translated by J. B. Leishman. London: Hogarth, 1949, 136.

198 **"where men were" . . . "tell us where it hurts":** Rainer Maria Rilke, *Requiem: And Other Poems*. Translated by J. B. Leishman. London: Hogarth, 1949, 139–140.

199 **"to let go":** Rainer Maria Rilke, *The Selected Poetry of Rainer Maria Rilke*. Translated by Stephen Mitchell. New York: Vintage, 1989, 29.

199 **"Prose wants to be" . . . "I would have to":** To Auguste Rodin, December 29, 1908.

200 **"through a little sliding":** To Anton Kippenberg, January 2, 1909.

200 **"'had not accomplished'" . . . "I feel more affection":** RAS, 164.

201 **"even now my best":** To Jakob Baron Uexküll, August 19, 1909.

201 **"air-baths":** To Lou Andreas-Salomé, October 23, 1909.

201 **"as if spider webs":** JA, 495.

201 **"which I answered clearly":** F. W. van Heerikhuizen, *Rainer Maria Rilke: His Life and Work*. London: Routledge and Kegan Paul, 1951, 241.

201 **"infinitely stronger"**: LP, 299.

202 **"Poor Malte"**: To Anton Kippenberg, Good Friday 1910.

202 **"religion is the art"**: Quoted in Rainer Maria Rilke, *The Book of Hours: Prayers to a Lowly God*. Translated by Annemarie S. Kidder. Evanston: Northwestern University Press, 2001, x.

202 **"the very great task"**: To Georg Brandes, November 28, 1909.

203 **"I was not seeking"**: Alan Sheridan, *André Gide: A Life in the Present*. Cambridge, MA: Harvard University Press, 2000, 221.

203 **"imperiously and urgently"**: *The Letters of Rainer Maria Rilke and Princess Marie Von Thurn und Taxis*. New York: New Directions, 1958, 1.

203 **"Herr Rilke"**: Quoted in Rainer Maria Rilke, *Sonnets to Orpheus*. Translation and introduction by Willis Barnstone. Boston and London: Shambhala, 2013.

204 **"delicate lordliness"**: Angela Livingstone, *Salomé, Her Life and Work*. East Sussex, UK: M. Bell, 1984, 101.

204 **"Those Rilke-hags"**: Quoted in Ulrich Baer, *The Rilke Alphabet*. New York: Fordham University Press, 2014, 53.

204 **"I believed that he was"**: Nora Wydenbruck, *Rilke, Man and Poet: A Biographical Study*. Westport, CT: Greenwood Press: 1950, 181.

204 **"Castle by the Sea"**: *The Letters of Rainer Maria Rilke and Princess Marie Von Thurn und Taxis*. New York: New Directions, 1958, 3.

CHAPTER FOURTEEN

206 **"He wants to give these"** . . . **"And how he said it"**: JA, 495.

208 **"What are you doing?"** LYR, 32.

208 **"all the others . . . I am glad"**: *The Letters of Rainer Maria Rilke and Princess Marie Von Thurn und Taxis*. New York: New Directions, 1958, 23.

208 **"eastern god"** . . . **"It is the center"**: To Clara Westhoff, September 15, 1905.

208 **"it is there alone in"**: Lou Andreas-Salomé, *You Alone Are Real to Me: Remembering Rainer Maria Rilke*. Rochester: BOA Editions, 2003, 51.

208 **"a god of antiquity"**: To Clara Westhoff, September 3, 1908.

208 **"Too-Great, the Transcendent"**: Rainer Maria Rilke, *Selected Letters of Rainer Maria Rilke*. Translated by R. F. C. Hull. London: Macmillan, 1946, 359.

209 **"take it up to God"**: To Clara Rilke, September 4, 1908.

209 **"One repays a teacher"**: Friedrich Wilhelm Nietzsche, *Thus Spake Zarathustra: A Book for All and None*. Translated by Thomas Wayne. New York: Algora, 2003, 59.

210 **"certainly still false"** . . . **"flowers, animals"**: To Clara Westhoff, June 24, 1907.

210 **"Completeness is conveyed"**: Rainer Maria Rilke, *Auguste Rodin.* Translated by Jessie Lemont and Hans Trausil. New York: Sunwise Turn, 1919, 39.

212 **"I am glad you have"** . . . **"rough reality"**: LYP, 77–78.

212 **"life drove me off"**: LYP, 13.

212 **"the empty hills"** . . . **"art too"**: LYP, 76–78.

CHAPTER FIFTEEN

213 **"Imagine the shock"**: Sylvia Beach, "A Musée Rodin in Paris." *The International Studio,* volume 62, 1917, xlii–xliv.

213 **"enchanted abode"**: RSG, 461.

213 **"plaster, marble,"**: RSG, 462.

214 **"the result of theories"**: Quoted in Henri Matisse, *Matisse on Art.* Edited by Jack Flam. Berkeley and Los Angeles: University of California Press, 1995, 261.

214 **"De Max was like"**: Francis Steegmuller, *Cocteau: A Biography.* New York: Little, Brown, 1970, 21.

214 **"fairytale kingdom"**: Jean Cocteau, *Paris Album: 1900–1914.* London: W. H. Allen, 1956, 133.

215 **"So this is where"**: Rainer Maria Rilke, *The Notebooks of Malte Laurids Brigge.* Translation by Stephen Mitchell. New York: Vintage, paperback, 1985, 3.

215 **"I am learning to see"** . . . **"I don't know"**: Rainer Maria Rilke, *The Notebooks of Malte Laurids Brigge.* Translation by Stephen Mitchell. New York: Vintage, paperback, 1985, 6.

216 **"How could they know"**: Rainer Maria Rilke, *The Notebooks of Malte Laurids Brigge.* Translation by Stephen Mitchell. New York: Vintage, paperback, 1985, 260.

216 **"the legend of a man"**: BT, 51.

216 **"in the end"**: Rainer Maria Rilke, *The Notebooks of Malte Laurids Brigge.* Translation by Stephen Mitchell. New York: Vintage, paperback, 1985, 189.

216 **"He was now terribly"**: Rainer Maria Rilke, *The Notebooks of Malte Laurids Brigge.* Translation by Stephen Mitchell. New York: Vintage, paperback, 1985, 260.

216 **"This test"** . . . **"so much so"**: To Clara Westhoff, October 19, 1907.

216 **"perishes in order"**: Rainer Maria Rilke, *Selected Letters of Rainer Maria Rilke.* Translated by R. F. C. Hull, London: Macmillan, 1946, 184.

216 **"Malte is not a"**: Quoted in George C. Schoolfield, "Malte Laurids Brigge." In *A Companion to the Works of Rainer Maria Rilke.* Edited by Erika A. Metzger and Michael M. Metzger. Rochester, NY: Camden House, 2001, 185.

217 **"Malte Laurid's desk"**: LP, 300.

217 **"It is finished, detached"**: LP, 301.

218 **"[I] stretched my"** . . . **"incomparable"**: To Clara Westhoff, July 6, 1906.

219 **"The *Notebooks* were not written"** . . . **"our yearning"**: Henry F. Fullenwider, *Rilke and His Reviewers: An Annotated Bibliography.* Lawrence: University of Kansas Publications, 1978, 2–3.

219 **"inaccessible prose"**: LP, 314.

219 **"to have a death of one's"** . . . **"You *had* it"**: Rainer Maria Rilke, *The Notebooks of Malte Laurids Brigge.* Translation by Stephen Mitchell. New York: Vintage, paperback, 1985, 9–10.

220 **"stranded like a survivor"**: Rainer Maria Rilke, *Selected Letters of Rainer Maria Rilke.* Translated by R. F. C. Hull. London: Macmillan, 1946, 184–185.

220 **"The Prophet is like"**: To Clara Westhoff, December 21, 1910.

220 **"Allah is great"**: To Clara Westhoff, November 26, 1910.

221 **"simply expressed in"**: Quoted in Lisa Gates, "Rilke and Orientalism: Another Kind of Zoo Story." *New German Critique*, No. 68, Spring-Summer 1996, 61.

221 **"write only briefly"**: To Clara Westhoff, November 3, 1909.

221 **"not with me"** . . . **"(apparently a pest"**: RAS, 190.

CHAPTER SIXTEEN

224 **"Paris is itself"** . . . **"I have it to thank"**: Rainer Maria Rilke, *Selected Letters of Rainer Maria Rilke.* Translated by R. F. C. Hull, London: Macmillan, 1946, 125.

224 **"the memorable, the tiresome"**: To Viktor Emil von Gebsattel, January 14, 1912.

224 **"No one is more deserving"**: FG, 605.

225 **"vile movements"**: RSG, 471.

225 **"haunts me"**: *The Letters of Rainer Maria Rilke and Princess Marie Von Thurn und Taxis.* New York: New Directions, 1958, 18.

225 **"When the curtain"**: Sjeng Scheijen, *Diaghilev: A Life.* Oxford: Oxford University Press, 2010, 248–249.

225 **"swooning admirers"**: Quoted in Derek Parker, *Nijinsky: God of the Dance.* Wellingborough: Equation, 1988, 125.

225 **"It is inconceivable"**: FG, 606.

225 **"Next door in the"**: RSG, 472.

226 **"war council"** . . . **"taking this"**: JA, 601.

226 **"someone had wilfully"**: Sjeng Scheijen, *Diaghilev: A Life.* Oxford: Oxford University Press, 2010, 249.

227 **"But I was luckily there!"** . . . **"And I had pistols"**: FG, 600.

228 **"It is unendurable"**: RSG, 458.

228 *Mon chat*: LYR, 56.

229 **"nothing"** . . . **"exercised too great"**: "Rodin and Duchess Quarrel," *New York Times*. September 16, 1912.

229 **"delivered of its"**: RSG, 474.

229 **"frightful"**: To Princess Marie von Thurn und Taxis, March 21, 1913.

229 **"I have ceased to live"**: RSG, 474.

229 **"grotesque and ridiculous"**: To Lou Andreas-Salomé, December 28, 1911.

229 **"If you could only see her."**: RSG, 474.

229 **"Show Madame out!"**: FG, 608.

229 **"I am like a man"**: Mary McAuliffe, *Twilight of the Belle Epoque: The Paris of Picasso, Stravinsky, Proust*. Lanham: Rowman & Littlefield, 2014, 231.

230 **"moist red mouth" and "tranquil"**: Denys Sutton, *Triumphant Satyr: The World of Auguste Rodin*. New York: Hawthorn, 1966, 80.

PART THREE · CHAPTER SEVENTEEN

233 **"a young but already"** . . . **"taciturn"**: Sigmund Freud, "On Transience." In *Writings on Art and Literature*. Redwood City, CA: Stanford University Press, 1997, 176.

234 **"the extraordinary and rare"**: Julia Vickers, *Lou von Salomé: A Biography of the Woman Who Inspired Freud, Nietzsche and Rilke*. Jefferson, NC: McFarland, 2008, 159.

234 **"since the only thing I"**: LB, 104.

235 **"there was nowhere"**: Lou Andreas-Salomé, *The Freud Journal*. New York: Basic Books, 1964, 169.

235 **"over his break with"**: Lou Andreas-Salomé, *The Erotic*. New Brunswick and London: Transaction, 2012, 24.

235 **"Have you really met the poet"**: Anna Freud, *Gedichte, Prosa*, Übersetzungen. Wien, Köln, Weimar: Böhlau Verlag, 2014, 48. [From the German: *"Hast Du in München wirklich den Dichter Rilke kennengelernt? Wieso? Und wie ist er?"*]

235 **"otherwise have loved"**: Sigmund Freud, "On Transience." *Writings on Art and Literature*. Redwood City, CA: Stanford University Press, 1997, 176.

236 **"robbed the world"** . . . **"on firmer ground"**: Sigmund Freud, "On Transience." *Writings on Art and Literature*. Redwood City, CA: Stanford University Press, 1997, 178-179.

236 **". . . For beauty is nothing"**: Rainer Maria Rilke, *The Poetry of Rilke*. Translated by Edward Snow. New York: Macmillan, 2009, 283.

236 **"featureless, outspread"**: *The Letters of Rainer Maria Rilke and Princess Marie Von Thurn und Taxis*. New York: New Directions, 1958, 21.

237 **"The experience with Rodin"**: To Princess Marie von Thurn und Taxis, July 12, 1912.

237 **"uncongenial"** . . . **"in places hair-raising"**: To Lou Andreas-Salomé, January 20, 1912.

237 **"at last met his"** . . . **"Rilke was not to"**: Sigmund Freud and Lou Andreas-Salomé, *Letters*. Edited by Ernst Pfeiffer. Translated by William and Elaine Robson-Scott. New York: Harcourt Brace Jovanovich, 1966, 39.

237 **"Dear Lou"**: To Lou Andreas-Salomé, December 28, 1911.

238 **"Who, if I cried out"**: Rainer Maria Rilke, *Duino Elegies and Sonnets to Orpheus*. Translated by Stephen Mitchell. New York: Random House, 2009, 3.

238 **"The voice which"**: *The Letters of Rainer Maria Rilke and Princess Marie Von Thurn und Taxis*. New York: New Directions, 1958, 30.

239 **"really nothing but a"**: To Viktor Emil von Gebsattel, January 14, 1912.

239 **"noncreative"**: To Viktor Emil von Gebsattel, January 24, 1912.

239 **"remembered"** . . . **"put on exhibit with"**: Lou Andreas-Salomé, *The Freud Journal*. New York: Basic Books, 1964, 184.

240 **"I never dared hope"**: LP, 364.

240 **"not want to hear"**: *The Letters of Rainer Maria Rilke and Princess Marie Von Thurn und Taxis*. New York: New Directions, 1958, 95.

241 **"He can't be counted"**: LP, 364.

241 **"as unexpected"** . . . **"probably final"**: LP, 365.

CHAPTER EIGHTEEN

243 **"in terror and in rapture"** . . . **"Assyrian character"**: CF, 184.

244 **"immense shadow"**: CF, 186.

244 **"Who indeed would dare"**: CF, 161.

244 **"The artists who built this"**: CF, 160.

244 **"a sick France"**: CF, 118.

244 **"a prophet conducting"**: FG, 619.

244 **"Who can believe"** . . . **"We should long ago"**: CF, 245.

245 **"goes out of his way"**: FG, 620.

245 **"vibrant notes"**: FG, 621.

245 **"so hopeless"** . . . **"I wish we had not"**: Magda von Hattingberg, *Rilke and Benvenuta*. Translated by Cyrus Brooks. New York: W. W. Norton, 1949, 66.

246 **"Deep in himself"**: To Lou Andreas-Salomé, August 8, 1903.

246 **"But to make"** . . . **"And once something"**: To Clara Westhoff, September 5, 1902.

246 **"airless, loveless"** . . . **"in a withered"**: LP, 378.

246 **"Why leave all this?"**: FG, 596.

247 **"still feelable heart"** . . . **"painfully buried-alive":** RAS, 244.

247 **"Perhaps I shall now":** To Princess Marie von Thurn und Taxis, August 30, 1910.

247 **"which surely must come":** RAS, 242.

247 **"Work of the eyes":** Rainer Maria Rilke, *The Selected Poetry of Rainer Maria Rilke.* Translated by Stephen Mitchell. New York: Vintage, 1989, 313.

248 **"as the child he was":** Nora Wydenbruck, *Rilke, Man and Poet: A Biographical Study.* Westport, CT: Greenwood: 1950, 264.

249 **"He turned pale":** RSG, 496.

250 **"One will say":** RSG, 496.

250 **"This is more than a war":** Ruth Butler, *Hidden in the Shadow of the Master.* New Haven, CT: Yale University Press, 2008, 300.

250 **"How could I do":** FG, 613.

250 **"masterpiece":** Albert E. Elsen, *Rodin's Art: The Rodin Collection of Iris and B. Gerald Cantor Center of Visual Arts at Stanford University.* Oxford: Oxford University Press, 2003, 490.

251 **"no less astounding:"** Nora Wydenbruck, *Rilke, Man and Poet: A Biographical Study.* Westport, CT: Greenwood Press: 1950, 269.

251 **"whisked off to":** RAS, 273.

251 **"I'm scared, scared":** Quoted in LP, 406.

251 **"hero grooming":** LP, 407.

252 **"Industriously he drew":** Nora Wydenbruck, *Rilke, Man and Poet: A Biographical Study.* Westport, CT: Greenwood Press: 1950, 278.

252 **"tired; the war overawed":** LYR, 145.

252 **"I don't the least mind":** LYR, 188.

252 **"like a statue"** . . . **"I'm all alone":** LYR, 192.

253 **"his Three Fates":** LYR, 216.

253 **"And people say that Puvis":** Judith Cladel, *Rodin.* Translated by James Whitall. New York: Harcourt, Brace and Co., 1937, 328.

253 **"wholly desolate without":** LP, 416.

254 **"Like me you will be steeped":** To Clara Westhoff, November 19, 1917.

254 **"return from the preoccupations":** Sylvia Beach, "A Musee Rodin in Paris." *The International Studio,* volume 62, 1917, xlii–xliv.

CHAPTER NINETEEN

255 **"I have behind me so many":** To Helene von Nostitz, January 27, 1914.

255 **"hand plate":** Patricia Pollock Brodsky, *Rainer Maria Rilke.* Boston: Twayne, 1988, 35.

257 **"extreme pedantry":** Nicholas Fox Weber, *Balthus: A Biography.* New York: Knopf, 1999, 41.

258 **"Does anyone know"** . . . **"Cats are just":** Balthus, *Mitsou: Quarante*

Images. Preface by Rainer Maria Rilke. Translated by Richard Miller. New York: Metropolitan Museum of Art, 1984, 9.

258 **"astounding and almost"**: Sabine Rewald, *Balthus.* New York: Metropolitan Museum of Art, 1984, 13.

258 **"Madame" . . . "full of praise"**: Nicholas Fox Weber, *Balthus: A Biography.* New York: Knopf, 1999, 19.

258 **"a wonderful man—" . . . "an entirely parallel"**: Nicholas Fox Weber, *Balthus: A Biography.* New York: Knopf, 1999, 42.

259 **"storm of spirit"**: Quoted in Donald A. Prater, A Ringing Glass: The Life of Rainer Maria Rilke. Oxford, UK: Clarendon Press, 1986, 347.

259 **"I have a great desire"**: Rainer Maria Rilke, *Briefe, 1914 bis 1926.* Insel-Verlag, 1950, 509. [From the French: *"J'ai grande envie de ne rien affirmer. Si vous vous imaginiez qu'un mauvais sorcier m'a changé en tortue, vous seriez tout prés de la réalité: je porte une forte et solide carapace d'une indifférence à toute épreuve . . ."*]

259 **"But we are human beings"**: Quoted in Donald A. Prater, *A Ringing Glass: The Life of Rainer Maria Rilke.* Oxford, UK: Clarendon Press, 1986, 320.

259 **"He's beginning to have" . . . "René, he'll be"**: Nicholas Fox Weber, *Balthus: A Biography.* New York: Knopf, 1999, 102.

260 **"the same haughty"**: Nicholas Fox Weber, *Balthus: A Biography.* New York: Knopf, 1999, 51.

260 **"H.M. The King of Cats"**: Sabine Rewald, *Balthus.* New York: Metropolitan Museum of Art, 1984, 62.

260 **"She was in a window" . . . "to live seemed"**: Rainer Maria Rilke, *The Roses and the Windows.* Translated by A. Poulin, Jr. Minneapolis: Graywolf Press, 1979, 95.

261 **". . . O, wanting to"**: Quoted in Ritchie Robertson, "From Naturalism to National Socialism." In *The Cambridge History of German Literature.* Edited by Helen Watanabe-O'Kelly. Cambridge: Cambridge University Press, 1997, 351.

262 **"frontier of consciousness"**: J. F. Hendry, *The Sacred Threshold: A Life of Rainer Maria Rilke.* Manchester, UK: Carcanet New Press, 1983, 149.

262 **"tender and open"**: William H. Gass, *Reading Rilke: Reflections on the Problems of Translation.* New York: Knopf, 1999, 187.

262 **"Come, you last" . . . "Don't mix"**: Rainer Maria Rilke, *Uncollected Poems.* Translated by Edward Snow. New York: Farrar, Straus and Giroux, 1996, 251.

263 **"Your part of this"**: Rainer Maria Rilke, Balthus, *Rilke-Balthus: Lettres à un Jeune Peintre Suivi de Mitsou Quarante Images par Balthus.* Paris: Somogy Èditions d'Art, 1998, 27. [From the French: *Votre part à cette oeuvre était toute travail et douleur; la mienne sera mince et elle ne sera que plaisir.*]

IMAGE CREDITS

INDEX

Page numbers in *italics* refer to illustrations.